# Writing Himself into History

# Writing Himself into History

Oscar Micheaux,
His Silent Films,
and His Audiences

**PEARL**
**Bowser**

**LOUISE**
**Spence**

RUTGERS UNIVERSITY PRESS
NEW BRUNSWICK, NEW JERSEY, AND LONDON

Library of Congress Cataloging-in-Publication Data

Bowser, Pearl
    Writing himself into history : Oscar Micheaux, his silent films, and his audiences /
Pearl Bowser and Louise Spence.
       p.   cm.
    Includes bibliographical references and index.
    ISBN 0-8135-2802-X (cloth : alk. paper) — ISBN 0-8135-2803-8 (pbk. : alk.
paper)
    1. Micheaux, Oscar, 1884–1951—Criticism and interpretation.   I. Spence, Louise.
II. Title.
PN1998.3.M494 B69 2001
791.43'0233'092—dc21

                                                99-055380

British Cataloging-in-Publication data for this book is available from the British Library

Manufactured in the United States of America

In memory of Toni Cade Bambara (1939–1995)

# Contents

# Foreword

THE APPEARANCE of this book on the life and work of Oscar Micheaux is a long-awaited event, and its publication could not be more timely. As we begin the twenty-first century, we look back at the rise of modernism at the beginning of the twentieth—called by some the American Century. We also look back on one hundred years of the rise of popular culture, a global culture profoundly shaped by African American life and art. Scholars of popular culture, including Pearl Bowser and Louise Spence, are asking questions first addressed by many in the early twentieth century, including by filmmaker and novelist Oscar Micheaux.

*Writing Himself into History* provides a fascinating portrait of the complex life of Black communities only a few decades out of slavery. Students born and raised in suburbs and unfamiliar with the ways in which community is shaped, and scholars who construct abstract ideas of global villages, will find real community-building in these pages. The early days of Black media outlets and organizational culture are explored here in ways that illuminate how a diverse and scattered population of slavery survivors and Black immigrants shaped a nation within a nation. From such origins came the novels and films of Oscar Micheaux, who through his craft helped lay the groundwork for today's multifaceted Black popular culture.

The network of small communities that fed Micheaux, let him shoot films in their living rooms and set up chairs there for screenings, also fought over his ideas in Black newspapers. And they spread the word. We used to call it "putting it on the drum"—a sometimes ironic reference to an

ancient African means of communication that is still a succinct metaphor for how the constant innovations in our culture get around so fast, especially elements of style, music, and image.

The drum, if you will, is the reason Oscar Micheaux could support himself writing novels and making films in the 1910s and 1920s. This would be an amazing accomplishment in any period. And the same drum (among Black women alone!) made novelist Terry McMillan a household name before her publishers invested a dime in advertising her books. McMillan, who promoted her first two books single-handedly and got two made into movies, is one of the descendants of Oscar Micheaux the writer.

The drum of Black popular culture is the reason why expressions like "right on" and "wannabe," "be-bop" and "dis" appear in the most proper of papers, and why Bill Cosby, Michael Jordan, and other African Americans often top worldwide popularity lists. It is why Chuck Berry and Little Richard got to "blow the minds" of four guys in Liverpool. It is why Elvis, why dreadlocks in Tokyo, why baggy pants, and why loose laces in Kosovo elementary schools.

Most important, perhaps, as Bowser and Spence allow us to see time and again, the urges, motivations, arguments, and dreams of Micheaux's time are very much the same today. Micheaux's work brought into the popular sphere ideas and debates held heatedly and repeatedly in Black ivy towers and on street corners of every town.

*Writing Himself into History* is based on exhaustive research into the life and work of the most widely known pioneer African American filmmaker. That research leads the authors to ask some fundamental questions, including questions about fame and legacies. A body of work such as Micheaux's, including approximately forty films and seven novels, would be celebrated even today. It was a miraculous accomplishment in his time, but Micheaux received none of his due in the way of recognition or patronage that benefited other writers, composers, and artists who thrived during the 1920s and 1930s. But then, true to his myth, he was a man working at the margins, like jazz musicians, in a new medium that was both an upstart form and, in his case, "Black" in its expression.

By way of six linked essays and an epilogue, Bowser and Spence accomplish a great deal. They delve into the creation of Micheaux's myth by

Micheaux himself. They reveal his ability to speak to the central issues of his time and to use film as a tool for creating discourse on these issues in society. And they define and describe the audiences for Race films, while examining Micheaux's unique vision and contribution as an artist.

A pioneer in any discipline lays a foundation of ideas and techniques with the texts and images he creates; but he also establishes a mythic groundwork, a character sketch, if you will, fashioned from the ephemeral qualities of his personality. Micheaux's admixture of hard work, celebration of the self, race consciousness, and what the authors call a "trickster"-like ingenuity became the trademark of African American filmmakers who followed. Whether or not individual directors personally encountered Micheaux's work, the myth of the man who drove from state to state showing films he'd made himself lives on. His is one of those names thrown out during interviews, and his story is often mentioned in successful Black filmmakers' replies to questions asked about their own work.

The myth of a person who could make films free from the censorious eyes of white producers or nervous distributors and get them directly to his audience still exists. I imagine it fuels the sardonic freedom shown by Charles Burnett's *To Sleep with Anger;* tales of John Singleton's free use of his credit card as circumstance necessitates, and the community-based activist work of filmmaker Louis Massiah's Scribe Video Center. Spike Lee has often said he is *not* like Micheaux (his need to distance himself tells us something); while Haile Gerima has expressed open admiration of Micheaux as both artist and businessman; one sees this in *Sankofa,* and his successful self-distribution of it on film and video.

Like many a fictional self-made hero, the Oscar Micheaux emerging in these pages was a man in a hurry, a man who had to do it all himself, a man capable of shortcuts and compromises in the heat of getting the work done. And like any good mythmaker, Micheaux advertised the authenticity of his work, always emphasizing the true existence of the film settings, the reality of Black accomplishments, and the veracity of his narratives.

Exaggerated as any myth, Micheaux's still left an expectation with audiences that independent Black film could tell the *real* truth as we know it. The need for such films, of course, stays with us as racism and ignorance persist. And, even though Micheaux understood that audiences

primarily expected pleasure from film, his image and legacy represent that desire in the larger African American community to hold artists to a standard, a standard that shows concern for our lives.

Today's scholars of modernity (themselves not dreamt of in Micheaux's time) ask how we can define "the Black experience" and how it influences the broader popular culture. After a century of social change, we ask if "Black" is the operative definition of the work created by African Americans and people of the African Diaspora.

Can popular culture be political? Can it resist forces of oppression, racism, and the denial of African humanity and still remain popular? To paraphrase Salman Rushdie, the operative rule of thumb has been that the more expensive the form, the less subversive it is. Writing is the cheapest, film the most expensive. Draw your own conclusion. Does popular culture need to resist?

One hears questions daily about the connections between culture and "community." What are the interactions between artists and community? And perhaps more important these days, does the community from which artists spring itself need rebuilding? This last seems like a new question, given the depredations of the decades following the 1960s, but community building was the central activity of the survivors of slavery and their children and grandchildren.

Although it might astound Oscar Micheaux to see that these communities of long standing have suffered such deterioration—he seems after all to have had enormous faith in our progressive march toward better lives—community building was where he began. Anyone interested in these issues and concerned with African American community, popular culture, or simply how we got to this fascinating moment in time will revel in *Writing Himself into History*.

As Bowser and Spence show, Micheaux was enraptured not only by the idea of going west to seek his own fortune and making a new beginning as a Black man and homesteader but also by the prospect of getting others to go and build new communities on the land that was offered. It is impossible to grow up in this culture without being introduced to the dream of finding a new land where one can live freely. It is the basis of the country's very existence and the key to its expansion to its present borders. This is bedrock Americana in literature, and film as well.

Part of this American dream is often the notion of remaking the self. An African American version of this would be remaking one's self as free, or at least freer. Bowser and Spence find Micheaux's idea of spreading the word of his own (if slightly exaggerated) success a "call implicit or explicit for the transformation of the system of values that undermined self-confidence, opportunity, and the possibility of accomplishment" for African Americans. Micheaux's infatuation, then, with his own attempt at homesteading was a rich mix of this archetypal American dream of the frontier with a variant version of remaking the self by staking out territory far from the racist strictures of established communities in the South and what we used to call Up South—the Northeast and Midwest. It is wonderful ground for other research.

In his work, Micheaux created an African American view of frontier life. Few such accounts have survived. As he was writing his first book, *The Conquest: The Story of a Negro Pioneer,* he was building on the life narrative tradition (sometimes called the slave narrative tradition by scholars) in African American literature. As he moved to film, he pioneered the crossover of such stories to the new medium. Many subsequent films made for and by Blacks, some memorable, many not, tell the heroic tales of triumph over bias, poverty, or other circumstances that have been part of the larger African American Grand Narrative. During the same period, Zora Neale Hurston did the same in her accounts of building all-Black townships such as her native Eatonville, Florida. Toni Morrison works in this same tradition in her recent novel *Paradise,* telling stories of migration to self-reliant Black villages in the West.

Micheaux's story also testifies to the truth of stories belonging to Malcolm X's parents' homesteading in Nebraska, to the hardy survivors of Black Tulsa who were burned out and then rebuilt, to Ralph Ellison's roots "out in the territory." Micheaux's mixture of frontier dreaming and desire for autonomy appears throughout his body of work: in his newspaper appeals to Blacks to move west, in his novels, and in his films.

Bowser and Spence reveal in great detail how Micheaux defined the Black experience of his time. He shows lives enduring daily repression, violence, and hardship, or resisting these conditions, and of dreaming and working for better. The writer and filmmaker described here was a man who saw his world and his own life as a counterdiscourse to the

FOREWORD

prevailing view of his race. He was a man, the authors tell us, whose work was driven by "grand gestures and broad moral themes."

These forces are echoes of Micheaux's time, a period when "social uplift" was a jubilant theme among leaders, artists, and many in the public sphere, a theme expressed with the triumph heard in the 1900 anthem "Lift Every Voice and Sing." It is a theme heard in February 1919, when his first film, *The Homesteader,* premiered just as Black troops returned from World War I, a theme nearly quashed by the racial violence of the Red Summer of 1919.

In detailing Black life in these years, the authors show how Blacks took to film to make "proper propaganda" for a race much maligned by the media of the time. Educator Booker T. Washington used film to advertise his work and to raise money for Tuskegee Institute. Nationalist leader Marcus Garvey, ever mindful of image and of the uses of modernity's tools, made films, too. Others made movies just to exhibit the "progress" and new accomplishments of Blacks in various fields, or to advertise local fairs, orphanages, teams, schools, and other community activities and concerns.

These films, which were intended for Black audiences, bring to mind how intensely Blacks felt the need for "positive," or, more important, "realistic" representation within the relative privacy of the community as well as in mainstream media. They prove, as the authors point out, an impulse to "validate one's own self-perceptions" and to "counterbalance notions of 'inferiority'" within Black communities. Credible images were considered of prime importance and making them was, we are reminded, "in itself transgressive" at the time. To quote: "By bringing Black voices and visibility to popular culture, by portraying identities more diverse and more complex than had previously been expressed in mainstream commercial culture, by declaring their own identity, they were writing their world into existence."

When Micheaux was starting out in 1918, he had been optimistic about gaining broad audiences; he thought it possible to make films that everyone would clamor to see. He was born of a time when dreams of "realistic" and "true" Black film were everyday stuff. His early novels, which depicted the life of his white homesteading neighbors in South Dakota as well as his own struggle, were, after all, not limited to recounting

"Black experience." But for most of his life, Micheaux's world of Black audiences defined how he made his work, down to where he shot his films and slept at night, to how much he could reasonably expect to earn and how much impact he could hope to have on the mainstream culture of the day.

In this light, it is fascinating to read Bowser and Spence's discussion of Micheaux's reaction to the emergence in the 1940s of Richard Wright, one of the first Black "crossover" artists, and his reaction to Wright's being reviewed outside his community late in his career. The whole issue of white audience was one that Micheaux keenly understood as he attempted to promote himself in the 1940s. With an eye to Wright, he assessed how certain narrative content (such as miscegenation) would draw in white audiences. It is an awareness he possessed in 1918 but did not exploit. His goal extended beyond merely gaining acceptance.

Oscar Micheaux the writer, filmmaker, and businessman is shown in these pages as inseparable from, impossible without, the idea of a Black community. During the last days of his career, a radical change was taking place in this country. White audiences could sometimes access Black representation and expression beyond exposure to music and movies. Though it would occur in small increments, the interaction between Black and white culture in America was shifting and the pace was accelerating. Richard Wright was "first," but only a first. In the 1940s, artists were able to dream the dream of wider audiences.

Even a slight "integration" of mainstream culture has reinforced the need for Black expression that is honest and free to critique mainstream representations. Those independent Black filmmakers who have gained success did so by virtue of having white industry competitors making Black-cast musicals and "blaxploitation" flicks. In other words, an oppositional pattern continues to hold. With greater success in distribution, a wider discourse on representation would have taken place and would be taking place today. As Bowser and Spence suggest:

> And if . . . critical attention is focused on the ideological and iconographic forces that functioned intraracially (to which Race films inescapably and subtly responded), Micheaux's films of the thirties and forties might be seen to have had different possibilities open to them, precisely because they served different

social purposes than Hollywood movies and circulated in a different sort of cultural economy. The films, then, would be seen as part of a complex multilevel dynamic of social, cultural, political, and discursive forces.

Until the very end, Oscar Micheaux was, as Bowser and Spence explain, "unacknowledged by the dominant society and literary and film-making establishment, and [still] publicly expressing attitudes—a particular angle of vision and worldview—that were not always well accepted in Black or white communities." Ultimately, he preferred to be true to his vision. His is the proper ending for a legend, a mythmaker, the promoter of the self-reliant individual, an African American artist who wanted to be "real."

Is an Oscar Micheaux possible today? One can only say there are very few around. Thanks to Pearl Bowser and Louise Spence, he leaves us still more to think about. We can ask ourselves about a time when "motion pictures were seen by many to have a role in . . . building people's social awareness, [to serve as] a force for social betterment and . . . to make a strong moral statement." And we can think about a man who made such motion pictures.

# Preface

MUCH IS MISSED and missing in the very act of understanding, appreci-
ating, describing. Where one looks, or does not, often determines the
story that one tells. What one sees, or does not, often determines how
the story will be told. This book maps some of our adventures looking
for Oscar Micheaux (1884–1951), the most prolific and important
African American independent filmmaker in the first half of the twen-
tieth century. While his film career spans three decades, we concentrate
on the years preceding the Great Depression. We look at Micheaux's silent
films (and several of his novels) in the context of the social and politi-
cal history of the products of popular culture made for and about
African Americans in his era. Since it is certain that we have not found
all the source material that bears on Micheaux's career, and since it is
also certain that others would interpret this evidence differently, our goal
has been to explore not only Micheaux's life and work, but also certain
problems about the nature of historical inference.

The volume is not meant to establish a unity of discourses, an inte-
gration, synthesis, or totality. Instead, it is a journey through some of the
landscapes of Micheaux, in the form of six linked essays and an epilogue.
It grew out of dissatisfaction with erstwhile critiques of his work that saw

him as simply reacting to [mis]representations of Blacks[1] and that were unwilling to engage with the symbols, artifacts, and social realities of Black popular life and culture. Our search has tried to resist such binary thinking, fixed identities, and racial essentialism by historically and culturally locating Micheaux, his spectators, and the texts.

Because of the paucity of extant films, the challenge has been to research history and a body of work when the preferred evidence, the product, is no longer available. Using scattered and heterogeneous sources (such as Micheaux's novels and other published writing, business correspondence, promotional materials and coverage in the press, censorship records, people's memories, other writing of the period), we sought answers to myriad questions. But such documents do not speak for themselves. Any historian imposes an interpretative structure—an illusory coherence—on an accumulation of evidence,[2] and any history is a conversation among different voices. There are a number of points of view to be heard in these essays.

Questions about Oscar Micheaux and the meaning of his movies and novels *in their time* were generating forces for our work. He was living and working in a situation very different from our own and participating in a culture that, no matter how strongly it speaks to us today, no longer exists. While writing this book, we were, in a way, remembering a past we never knew; fascinated not only by difference but also by familiarity and continuity.

But there was often a note of dissonance between our sensibilities and what we imagined Micheaux's were; there were times when he seemed infuriatingly pompous and moralistic. And yet, as a threesome, we were very intimate. We sometimes found ourselves speculating on Micheaux's dreams, illusions, and secrets.

In short, we have not only been searching for Oscar Micheaux, but creating him anew.

---

WHAT LIES AHEAD in the chapters that follow? Who is this Oscar Micheaux we are presenting? A novelist and maverick writer, director, producer, and, in the silent years, distributor of his own Race films, films made for African American audiences, Oscar Micheaux was born just nineteen years

PREFACE

after Emancipation, growing to his teens during the prolonged end-of-the-century depression, and beginning to publish novels and produce films in a period of extreme racial polarization. He made popular movies, and yet he also managed to speak out about many issues that concerned Black America. His silent pictures and early novels not only reveal the details of one man's experience and his personal pursuit of success, but offer a particular point of view and commentary on the upward movement of a people in the wake of decades of migration out of the South. The work of this one filmmaker, Oscar Micheaux, stands apart from the other survivors of a sector in American film history that has just begun to receive critical attention. Perhaps the reason for this is not just that he was so prolific, but that the visual record he left behind helps to illuminate voices within the community that might otherwise be silent.

This book is organized into three parts, three different takes on Micheaux and his work. The first, chapter 1, "Writing Himself into History," looks at how Micheaux constructed and used his "biographical legend" (to borrow from Boris Tomashevsky) in the creation and promotion of his work. Many of his creative endeavors drew upon and built a personal image, an image that was shaped by his world view and sense of self. Of course this image was neither sole nor unitary. Perhaps Micheaux himself was searching for a unifying vision of his life through narratives of achievement.

The second part, chapters 2 and 3, "In Search of an Audience, Parts I and II," is devoted to the context of Micheaux's filmmaking practice. Rather than looking at early Race pictures through the history of non-Black films, we propose a community-based history; that is, seeing Race movies in the light of a counterpublic sphere (a separate space for public discourse), looking at other Black entrepreneurial efforts and amusements, and how the African American community visualized itself. It is a reception-oriented history that speculates on possible relations between films and their viewers. Rather than privileging Micheaux's first motion picture, *The Homesteader* (1919), as a monumental moment in African American film history, we look at it as part of a larger movement, the continuation of (and an improvisation on) an expressive tradition. No bystanders to social change, early African American filmmakers pioneered specific cultural forms and popularized them for a broad audience.

These entrepreneurs were able to postulate a positive and distinctive mode of existence for Black Americans: a richly textured response to the social conditions that circumscribed all cultural production.

Chapter 2 investigates the audience, as well as theaters, traveling showmen, and the press—the foundation necessary for an African American filmmaking practice to thrive. Chapter 3, the other half of the dyptych, concentrates on discussions surrounding the early films, their production, and the Race picture "industry." Together, these two chapters illuminate not only the context of Micheaux's filmmaking practice and, as Raymond Williams put it, the "structure of feeling" of the period, setting the scene for Micheaux's work. They also help us to imagine how millions of people, unknown to each other, might see themselves as a community.

The third part considers three of Oscar Micheaux's silent films. With the recent repatriation from European archives of two of his 1920 films—*The Symbol of the Unconquered* and *Within Our Gates*—there has been a renewed interest in Micheaux's work as well as in Race pictures in general.[3] Although chapters 2 and 3 explore the audiences for these pictures in the United States, the history of these prints from Spain and Belgium, including their audiences in those countries, has yet to be documented. Were they originally imported by a distributor, an exhibitor, an individual showman, or a ciné club? Who were the intended audiences of the Spanish- and French/Flemish-titled prints? Did they play in Africa and/or Latin America? Did the subject matter of the two recovered prints, and *The Brute* (also released in 1920 and sold abroad )[4] play a role in their sale? All three dealt with themes that were contentious or explosive in the United States. What part did that play in the European interest in these films?[5]

The 35mm nitrate print of *Body and Soul* (1925), Micheaux's other extant silent film, remained in the George Eastman House vaults from 1955 until the early seventies, when it was restored and a 16mm safety print was struck. *The Symbol of the Unconquered* rested "undiscovered" in the Royal Film Archive in Belgium for thirty years before the Museum of Modern Art in New York acquired it in an exchange. The politics of what is "lost, stolen or strayed," to quote a late sixties documentary,[6] is also an important area of research and speculation. What precipitates the "discovery"

of a film in an archive? Why only three of an estimated twenty-five silent features attributed to Micheaux? Although we do not know how many prints of *Within Our Gates* or *The Symbol of the Unconquered* were struck, Micheaux's company claimed to have had nine prints of *The Brute* circulating;[7] yet none has surfaced—so far.

And, importantly, how should we look at these early photoplays? Do the resources and methods that we have developed over the past thirty years of academic film history and textual analysis illuminate early African American cinema? Certainly the extant versions of Micheaux's silent films indicate that his reworking of the conventions of melodrama from a point of view within the Black community, his depictions of Black family life and social institutions, and of racial violence seem unlike white-made antecedents. With such a marginalized film practice, it is probably more fruitful to contextualize a film within its social and cultural histories and the political realities of the time than to simply situate it within mainstream film history and comparing it to those models. Such a comparison would tempt us to apply categories and conceptual units as we have done in the past, instead of developing a critical methodology that allows us to look at specificity as other than difference. Chapters 4 through 6 look closely at these three surviving films in the order of their release, not to explain them but to expand on the possibilities inherent in Micheaux's texts. They interweave textual analysis with contextual investigation.

In chapter 4, we discuss *Within Our Gates* in light of the social discourses on rape, lynching, and concubinage of the time. Some scholars and a recent television documentary have seen the film as a response to D. W. Griffith's *The Birth of a Nation* (1915).[8] Although the film certainly refutes Griffith's racial ideology, such a single causality does not wrestle with the crisis and uncertainty of the time and the many powerful stories in the African American community of lynchings and the rape of Black women, even before Griffith's social melodrama was released. We suggest that this "Grand Narrative" is important in understanding not only the film but how African American audiences saw it at the time. We also look at the theme of education in *Within Our Gates* and speculate on some of the many reasons the film may have offended censor boards, exhibitors, and local authorities.

Chapter 5 examines *The Symbol of the Unconquered* and Micheaux's treatment of miscegenation and passing. In chapter 6, we look at *Body and Soul* and some of the critical discourses of the time. This film, with its controversial representation of a clergyman, was criticized by those who would have preferred images infused with dignity, the "representative" Negro by which the Race might be judged. At a time when the class structure within the African American community was becoming more stratified, the cultural judgements, the politics of racial identity, and the quest for racial unity were also becoming more complex.

Finally, the epilogue proposes some ways we might investigate Micheaux's later career in the context of the changes in production, distribution, and reception that came about with sound. It also looks at how some of Micheaux's concerns and disappointments were articulated in his later works, as well as how his biographical legend has been remembered today.

What follows, then, is a book about more than Oscar Micheaux's films. It is a book about the social dynamic of community.

# Acknowledgments

HAVING WORKED on this project for so long, both together and separately, we have drawn upon the knowledge, kindness, and friendship of many individuals and institutions. Some have gone out of their way to help us; others, in the example of their own work, have served as inspiration and encouragement along the way. It will clear to many upon reading this book that, over the years, we have incurred more than the usual debts.

It makes us enormously happy to be able to thank the talented staff at the Schomburg Center for Research in Black Culture, especially Betty Odabashian, Genette McLaurin, Gilsa Stewart, Mary Yearwood, Diana Lachatanere, James Murray, Jean Blackwell Hudson, and Chief Howard Dodson. For their courtesies and general assistance, we thank William P. Gorman at the New York State Archives; Jim Sherraden at the Hatch Show Print Collection in Nashville; Madeline Matz at the Library of Congress; Eileen Bowser, Steven Higgins, Charles Silver, and Bill Sloan at the Museum of Modern Art; Jim Hatch and the Hatch-Billops Collection; Alice Carol Tuckwiller, Virginia Room, Roanoke City Public Library; Dan Den Bleyker, Mississippi Department of Archives and History; Dr. Jessie Mosely and David Taylor at the Smith Robertson Museum and Cultural Center, in Jackson, Mississippi; Judy Peiser and the Center for Southern Folklore in Memphis; and Carol Turley, Department of Special Collections, Charles E. Young Research Library, UCLA. We would also like to thank the librarians and staff at Fiske University Special Collections, Goucher College, and the Ryan Matura Library, Sacred Heart University.

We are also indebted to John R. Alley, Lynn Bachleda, Karen Backstein, Lee Barry, Serafina Bathrick, Matthew Bernstein, Sheila Biddle, Jackie Bobo, Gillian Bowser, Ruth Bradley, John Butler, Mayme Clayton, Manthia Diawara, Susan Dolton, Jane Gaines, Nancy Gallo, Gloria Gibson, Greg Golda, Michael Goldberg, Sid Gottlieb, Ron Green, Richard Grupenhoff, Bill Gwaltaey, Mabel Haddock, John Hanhardt, Don Heller, George Heller, Charles Hobson, Nancy Horowitz, Deliah Jackson, Albert Johnson, Francie Johnson, Helen Johnson, Martin Keenan, Phyllis Klotman, Arthur Knight, Kate Levin, Carl Lewis, James Lucas, Louis Massiah, George W. May, Bill Miles, Charles Musser, Kathleen Newman, Pamela Nordin, Richard Papousek, Charlene Regester, Larry Richards, Henry T. Sampson, Sandra Pearl Sharp, Robert Sklar, Ernie Smith, Harry Smith, Dan Streible, Elaine Summers, Clyde Taylor, Bob Vietrogoski, Mary Grace Whalen, and James Wheeler. Norma Spector carefully scrutinized the text from early drafts to the final manuscript. We thank the staff at Rutgers University Press. And without the qualified patience and judicious persistence of our editor Leslie Mitchner, we would still be energetically researching.

If we have forgotten anyone, it is not that we are ungrateful—just absentminded.

Financial support in different stages of our work came from:

National Endowment for the Humanities
American Council of Learned Societies
Ford Foundation
Sacred Heart University Research/Creativity Grant
New York University Department of Cinema Studies
National Black Programming Consortium
Office of University Seminars at Columbia University

Parts of the book were written during residencies at the MacDowell Colony, the Blue Mountain Center, the Virginia Center for the Creative Arts, and the Ragdale Foundation. We are very grateful to the staffs at these sites for their congeniality and for looking after our needs and material comforts.

While we were working on the manuscript, we were privileged to present parts of our research at the 1997 American Studies Association Conference, a 1995 conference "Oscar Micheaux and His Circle" at the Whitney Humanities Center, Yale University, the 1995 Society of Cinema

Studies Conference, the 1994 Modern Language Association Conference, the Columbia Seminar on Cinema and Interdisciplinary Interpretation in 1994 and 1999, the Rutgers Center for Historical Analysis in 1992, the Langston Hughes Festival at The City College of New York in 1991, the Schomburg Center for Research in Black Culture in 1991, and the University Film and Video Association Annual Conference in 1989.

Parts of chapters 1 and 5 have been published as "Identity and Betrayal: *The Symbol of the Unconquered* and Oscar Micheaux's 'Biographical Legend,'" in *The Birth of Whiteness: Race and the Emergence of United States Cinema,* edited by Daniel Bernardi, Rutgers University Press, 1996. A shorter version of Chapter 6 appeared in *Cinema Journal* 39:3 (spring 2000), as "Oscar Micheaux's *Body and Soul* and the Burden of Representation."

Oscar
Micheaux

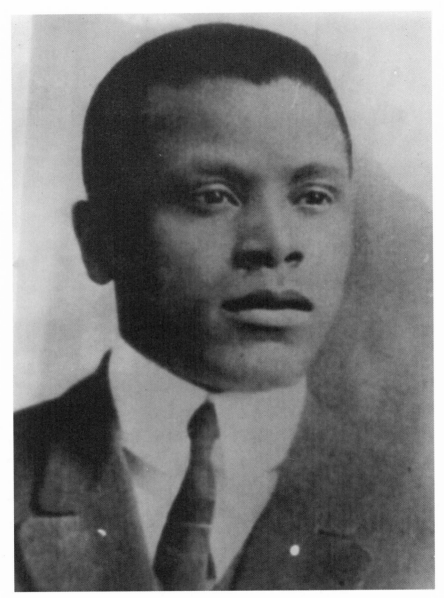

Portrait of Oscar Micheaux from the frontispiece of *The Conquest* (1913).
Courtesy of African Diaspora Images.

# 1 Writing Himself into History

[W]e need today more than ever,—the training of deft hands, quick eyes and ears, and above all the broader, deeper, higher culture of gifted minds and pure hearts. The power of the ballot we need in sheer self-defence,—else what shall save us from a second slavery? Freedom, too, the long-sought, we still seek,—the freedom of life and limb, the freedom to work and think, the freedom to love and aspire.

—W.E.B. Du Bois, *The Souls of Black Folk*, 1903

"In an increasing degree we must be an optimistic race. There is no hope for a despairing individual or a despairing race."

—Booker T. Washington, speech to the National Negro Business League, 1909

It is claimed the touch of the romance woven in *The Homesteader* is coincident with the author's own life but this is still a matter of conjecture.

—*The Half-Century Magazine*, April 1919

IN THE WINTER of 1910, a young Black man, surrounded by the vast expanse of prairie horizon, wrote to the *Chicago Defender,* a nationally circulated Black weekly, about his life as a "resident, pioneer and landowner" in Gregory County, South Dakota. Oscar Micheaux began the March 19 article with a story about an indecisive young Negro railway employee who was engaged to a Chicago society woman and considering whether to acquire land on the Cheyenne River and Standing Rock Indian Reservation. He related, with a patronizingly superior air, how he had discouraged the wavering novice from settling in the Northwest. The story, however, must certainly have been a rhetorical device, as he went on to praise the monetary gain possible in Northwest agriculture, and declared,

"Any energetic young man with as little as $1000 and up and willing to give all his time and attention to the upbuilding of the future can go into Wyoming, Montana, Idaho, get a homestead . . . which costs from $25 to $45 per acre . . . and in ten years time be independent."

Micheaux, a young man still in his twenties, a former railway worker himself, believed strongly in the unique opportunities offered by the opening of the land in the Northwest. A couple of years later, after losing most of his land to foreclosure and bitterly disappointed that his wife had abandoned him to return to Chicago, Micheaux created the fictional character, Oscar Devereaux, a lone Black settler in Megory, South Dakota, writing in longhand the details of his life in a composition notebook. This manuscript, *The Conquest: The Story of a Negro Pioneer,* written "by the Pioneer," was published by Micheaux himself in 1913. Here he reflects on his eight years in South Dakota as a homesteader and includes significant incidents affecting the changing character of the landscape, the towns, and the lives of the settlers. Writing in the first person, Micheaux seems to have been a keen observer of the events he witnessed and of the lives of the people whose paths he crossed. Barely disguising his own name and the identity of places, Micheaux situated his hero Devereaux's particular history—an unfolding tale of adventure, intrigue, and forbidden romance— at the center of stories of the people and the events he came to know in Gregory County. Once involved in an agrarian enterprise and failing, he was now marketing that romantic past. The idea of an essential proving ground, which he once adventurously pursued, was now being adventurously reenacted as commercial entertainment for the same people whom he had been unable to attract to the Great Plains wilderness in that early *Defender* article.[1] Today *The Conquest* has become part of the local folklore and history of what some consider to be one of the last great land offerings: the U.S. government's appropriation of Indian territories, the Rosebud Reservation, for settlement in the early part of this century.[2] In a career that spanned thirty years, Oscar Micheaux, besides writing seven novels, made approximately forty films, with approximately half of his total output produced in the first decade (1918–1929). His personal vision, the narrative and business strategies he chose to articulate that vision, and the historical and cultural context of his work intertwine in a dialectical relation to one another and tell us much about the construct "Oscar Micheaux."

The three silent films now extant (*Within Our Gates* [1920], *The Symbol of the Unconquered* [1920], and *Body and Soul* [1925]), his novels, promotional materials, and correspondence illuminate the degree to which Micheaux used his "biographical legend" (his socially constructed identity, political point of view, and status as Negro entrepreneur) to create, promote, and shape the reception of his works.[3] Writing himself into history, he used his own life in his films and novels (a selection of actual and imaginary events), which gave credibility to his role as an entrepreneur and pioneer.

During this first decade, Micheaux developed the public persona of an aggressive and successful businessman and a controversial and confident maverick producer—an image that was to sustain him for the next twenty years, although little of his creative work after his first sound picture, *The Exile* (1931), would seem to justify it.[4] But let's look at how Micheaux built and used this biographical legend and some of the many contradictions in his attempt to be true to his vision of himself and entrepreneurial at the same time. We start with *The Conquest.*

Oscar Devereaux, Micheaux's self in the narrative, tells us about his humble but secure beginnings on the family farm on the Ohio River about forty miles north of Cairo, Illinois. His father (i.e., Calvin Swan Micheaux) had been born in slavery and his father's father sold off to a slave owner in Texas. The continuity of the family name, which went back three generations, was a source of pride for the young Oscar; he made frequent references to the uniqueness of the name and his own feelings of being special. A bookish, inquisitive youngster, he had a preference for verbal communication over work in the fields. The portrait Oscar paints of himself is that of a young man eager for challenge, with a thirst for knowledge and adventure. Micheaux writes of this early stage in his life as though he had already determined to become someone notable, "a personage of much importance" (p. 68).

In *The Conquest,* Micheaux, the product of a generation of African American migrants who left the land in search of "the freedom of life and limb, the freedom to work and think, the freedom to love and aspire,"[5] tells of Oscar's family migrating from rural southern Illinois to the nearby town of Metropolis (population 3,573 [630 "colored"]), for better educational opportunities for the children (p. 12). Oscar, the fifth child of eleven, recalled his mother (i.e., Bell Willingham Micheaux)

declaring "emphatically" that she wanted none of her sons "to become lackeys" (p. 13).[6]

After his elder sister graduated high school and moved to Carbondale to teach, two of his elder brothers enlisted in the army, and the third left for a job as a waiter, Oscar, at the age of seventeen, left Metropolis in search of a career. Working his way North to his sister's home to finish his education, and then to Chicago, he supported himself at odd jobs, shining shoes, bailing water in a coal mine, laboring in a factory, the steel mills, the stockyards, and finally, on the railroad as a Pullman porter.[7]

Railroads were important in the African American community, a people "conscious of their [new] power to move freely throughout the country where they may improve their condition," not only as symbols of freedom, but also as vehicles of mobility.[8] For the restless Micheaux, eager to make his mark, the railroads held a certain mystique. He writes about them as conveyers of knowledge, carrying entrepreneurs in pursuit of investment and profits and conquering new territories. He chose a way of life that put him on the road, where he could converse with strangers, learn new things, see places he had read about; a way of life that offered him a measure of independence and freedom.

Micheaux wrote in some detail of Devereaux's participation, while working as a Pullman porter, in a widespread scheme to pocket some of the money collected by the conductors from customers paying cash for their sleeping accommodations. On runs off the mainline (through Idaho and Oregon, for instance) where station agents might not be available, the white conductors collected fares for berth tickets and "had for many years mixed the company's money with their own" and shared a portion of it with the Colored porters (p. 42). With the relish of a muckraker, he wrote an elaborate justification for this practice of "knocking down" the company. "In justice to the many thousands of P[ullman] porters, as well as many conductors, who were in the habit of retaining the company's money, let it be said that they are not the hungry thieves and dishonest rogues the general public might think them to be, dishonest as their conduct may seem to be. They were victims of a vicious system built up and winked at by the company itself" (p. 48). "The greedy and inhuman attitude of this monopoly toward its colored employees . . . is demoralizing indeed. Thousands of black porters continue to give their services in

return for starvation wages and are compelled to graft the company and the people for a living" (p. 50). He provided details of the company's capitalization, dividends, and the profits gained from the labor of its eight thousand porters working in "near-slave conditions" at twenty-five to forty dollars a month out of which they were forced to buy their own caps and uniforms, and pay for lodging, laundry, and board. "As for myself, the reader has seen how I made it 'pay' and I have no apologies or regrets to offer" (pp. 50–51). Devereaux was ultimately turned in to the company by a conductor annoyed by his insolence when he demanded a more equitable share of the cut.[9]

In *The Conquest,* by the time Oscar Devereaux finally left the railroad at the age of twenty-one, he had saved enough money to make his first investment in land (p. 61), and in the fall of 1904, he purchased a homestead, a 160-acre relinquishment, on the Rosebud Indian Reservation near Winner, South Dakota (pp. 64–65). In a second article Micheaux wrote for the *Chicago Defender,* he identified himself as a "government crop expert" and claimed to have been successful at wheat and flax farming. He again urged his readers to take advantage of the opportunities in the unsettled territories of the Northwest and was clearly proud of his own accomplishments. Declaring that he had paid seven dollars per acre and eighteen months later the land was worth twenty dollars an acre, he announced, "I have confidence that when our people are properly guided that they will have as much courage and ambition as our white brothers."[10]

His early writings suggest that, like many of his immigrant neighbors who made land purchases based on the prospects of the railroad extending westward, Micheaux hoped to turn a profit on the value of his holdings. However, in order to secure title to the land, it was necessary to establish residence and cultivate the soil. In *The Conquest,* he wrote that as a boy he preferred selling the family crop to working in the fields and that he knew little about farming (pp. 14–15). Undeterred by lack of experience, armed with government pamphlets, almanacs, and the challenge to conquer the untamed land and reap the rewards of that first harvest, he taught himself the rudiments of Great Plains agriculture, a process he described in painful detail, including purchasing mules, getting the right equipment to "break the prairie," and turning the sod over day after

day (pp. 74–85). He also reflected on the need, as the only "colored man" engaged in agriculture in Gregory County, to demonstrate to his white neighbors that he was an honest, hardworking Negro determined to succeed (p. 145). Bent on disproving the widely held belief that "the Negro," when faced with hardships of homesteading, would opt for the "ease and comfort" of the city, Micheaux claimed to have "broken-out" three times as many acres as his neighbors.

Working hard for several years, Micheaux had amassed more than five hundred acres by the time he was twenty-five. He had borrowed money on his original allotment to take advantage of the opening of new lands in the territory. Quickly selecting a wife in order to meet the deadline of the next lottery, in 1909 he purchased claims in the name of his sister Olive, his grandmother Melvina Michaux [sic],[11] and his wife-to-be, Orlean McCracken (p. 205).[12] He placed Orlean on a site in Tripp County near where the railroad was expected to build its western terminus. Because residency was required to establish a claim, the couple were forced to live apart for much of the time, with Oscar shuttling between the sites to work the land.[13]

Micheaux approached homesteading with the same philosophy he was later to apply to his book and movie businesses: he was independent, persistent, and willing to take risks when a small investment had potentially large returns. One chapter of *The Conquest* digresses to report the history of two towns, detailing the townsfolk's speculation on the route of the railroad's expansion. Although the "objective reporting" of the details and key players obviously attempts to distance the author from those speculators, it is given such prominence in an otherwise "personal" chronicle that one cannot help but wonder what role he had in the scheme. Indeed, the image of Micheaux as land speculator seems more in tune with Micheaux-the-entrepreneur than with Micheaux-the-farmer. As he writes in his semi-autobiographical third novel, *The Homesteader* (1917), "[he] was possessed with a business turn of mind."[14] For example, the hero of that novel, Jean Baptiste, boasts about how, after handwriting "his own story" in a tablet and having a publisher reject it, he financed the book himself.[15] With borrowed money for a suit and a trip to Nebraska, he struck a deal with a printer there and then raised money for the first payment through advance sales to his neighbors in South Dakota (pp. 401–411).

OSCAR MICHEAUX

Although Micheaux acquired a large holding, he lost land to fore-closures in 1912, 1913, and 1914.[16] In the early *Defender* articles, he had neglected to mention—or perhaps was unaware of—the hazards involved in such land investment, in particular the necessity to accrue cash profits from crop yields to meet mortgage payments. But in *The Conquest,* he tells of liens on Devereaux's homesteads and the hero's strug-gling to pay interest and taxes so he would not lose his land. Many other homesteaders who had settled with great optimism were forced to abandon their claims because of prolonged droughts.[17] As he writes in *The Homesteader,* foreclosures were so common, they "occasioned no comment" (pp. 400–401).

While *The Conquest* leaves it unclear whether his alter ego lost title to his land, or sold the property, or stopped working it to devote all of his time to writing, in *The Homesteader* Micheaux does write of the hero being unable to pay his mortgage and relates, with some anger, how the homestead he had purchased in his wife's name was lost when she left him and returned to her father's house in Chicago (p. 400).[18]

By the time Micheaux wrote his second novel, *The Forged Note* (1915), he was nostalgic about returning to the Rosebud Reservation.[19] The central character of the story, a writer on the road selling his book door-to-door, once again resembles the author's own persona. Written either during or after an extended period traveling in the South, the novel suggests the author took a hiatus from the homestead—"his beloved Rosebud"—and was embarking in earnest upon a career as a writer. By 1916 Micheaux had returned to the West, moving to Sioux City, Iowa, where he published *The Homesteader* and sold his two earlier works through his new firm, the Western Book Supply Company.

As a writer, Micheaux was self-taught. An avid reader (of such diverse literature as dime Westerns, Ida Tarbell's *The History of the Standard Oil Company,* Owen Wister's *The Virginian,* Jack London's *Martin Eden,* and *Up From Slavery* by Booker T. Washington), he learned to write by "devour-ing books, studying each detail of construction, and learning a great deal as to style and effect" (*The Homesteader,* p. 407). Once he made the deci-sion to write, he tackled the job with the same enthusiasm and determi-nation that he had displayed as a homesteader. Within five years he had three novels, which he aggressively distributed himself.

IN 1918 GEORGE P. JOHNSON, general booking manager of the Lincoln Motion Picture Company of Los Angeles, who had by then already released three films, initiated a correspondence with Oscar Micheaux, now an author publishing and marketing his own books. Johnson wrote to the Western Book Supply Company about his discovery of *The Homesteader* in a *Defender* advertisement and inquired about the film rights to the book.[20] His brother and founder of the company, the actor Noble M. Johnson, later reviewed the novel and proposed that parts of it—the romance between the Black homesteader and his white neighbor, most likely—were too controversial for them to deal with, adding, "It is a little too advanced on certain subjects for us yet and unless we would change [it] so decidedly that it would hardly be recognizable, we could not expect much support from white houses."[21]

There followed a rapid exchange of correspondence over three months between Micheaux and George P. Johnson. Johnson tried to convince Micheaux that he had more expertise in "the picture game," and promised that he could mold the book "into a first-class feature." And Micheaux, just as he had learned to farm by interrogating farmers, probed for information from the Lincoln Company, at the same time asserting rather grandiosely that his five-hundred-page novel warranted a big picture, at least six reels, not the Johnsons' usual two- or three-reel product.[22] He was also apparently convinced that, far from being a liability, the controversial nature of such themes as interracial marriage would be a very good selling device and should be exploited: "Nothing would make more people as anxious to see a picture than a litho reading: SHALL THE RACES INTERMARRY?"[23]

With no movie experience at all, Micheaux ultimately decided to produce *The Homesteader* himself, incorporating under the name of the Micheaux Book and Film Company. Even before he had completed the scenario of his first photoplay, he wrote to George P. Johnson, "Although Sioux City is mentioned as the office city, that is only because I expect to sell most of the stock to Sioux City people and in that vicinity and do not feel that they would appreciate the main office being so far from where they live. But as soon as the subscribed stock has been paid up, incorporation completed, etc., I expect to establish the main office

in the business district of Chicago, get a Dodge Roadster, and make my home and main office there, since it is obvious that that is the proper place for the main office for such a proposition." On the letterhead, he listed himself as president and boldly added the line, "Special Features Only— Micheaux Pictures—New York, Chicago, Sioux City."[24]

A Race man at the beginning of a new career, full of energy, enthusiasm, and optimism, but with no film experience, he was able to persuade many small investors in Iowa, Illinois, South Dakota, and Nebraska to buy shares in his newly incorporated company to make the first Negro feature photoplay. His stock prospectus stated: "Aside from the general public, who themselves having never seen a picture in which the Negro race and a Negro hero is so portrayed, . . . twelve million Negro people will have their first opportunity to see their race in stellar role [sic]. Their patronage, which can be expected in immense numbers, will mean in itself alone a fortune." The offering budgeted $15,000 for the total cost of the film, including four prints, overhead, and advertising lithos. Interestingly, this was minimum amount suggested for a feature in 1917 articles in the fan magazine *Motion Picture Classic* and the trade paper *The Dramatic Mirror.*[25]

Bragging to Lincoln that he was able to raise $5,000 in less than two weeks, with most of the stock sold in the Midwest,[26] Micheaux went on to produce an eight-reeler, the longest African American film at that time. He advertised it as "Oscar Micheaux's Mammoth Photoplay," premiered it in Chicago's Eighth Regiment Armory, February 20, 1919, and declared that it was "destined to mark a new epoch in the achievements of the Darker Races."[27] The program included a patriotic short on the homecoming of "the 'Black Devils' who sent the Kaiser into oblivion," as well as a musical selection from *Aida* by the tenor George R. Garner, Jr., and the Byron Brothers Symphony Orchestra playing music written by Dave Peyton.

His first ad, a half page in the *Chicago Defender,* included his own photo along with those of the main performers and solicited support: "Every Race man and woman should cast aside their skepticism regarding the Negro's ability as a motion picture star, and go and see, not only for the absorbing interest obtaining herein, but as an appreciation of those finer arts which no race can ignore and hope to obtain a higher plane of

thought and action." Such promotional material tells us a bit about the persona with which Micheaux confronted the world. Through his self-assurance and powers of persuasion, he won the confidence of noted author C. W. Chesnutt, for instance, who granted him the right to film his 1900 novel, *The House Behind the Cedars,* as well as that of Robert S. Abbott, owner, publisher, and editor of the *Chicago Defender,* who printed two of this unknown writer's articles on the front page of his newspaper.[28]

Perhaps Abbott was persuaded because, as something of a visionary himself, he shared a number of Micheaux's aspirations. Certainly when Micheaux made the decision to write his first novel and talked his neighbors into purchasing advance copies, he had to be convincing. Maybe he made them feel it was about *their* dreams and ambitions. "Why not as a change from the usual run of Magazine stories and novels by white authors . . . try this book?" extolled Micheaux in a later advertising piece for his novel *The Homesteader,* addressing a Black reader. "Consider it in the light of a gift to relatives or dear friends and let your order be for more than one copy." In a pitch to convey the uniqueness of his endeavor, he included the race of the author and the race of the book's illustrator, the Chicago painter and teacher W. M. Farrow, claiming it was the first "instance where a Negro artist has been offered the opportunity of illustrating an American novel."[29]

After *The Homesteader*'s Armory premiere, the movie was scheduled for a theatrical release a week later at the Vendome Theater on State Street, the main business and entertainment thoroughfare for Blacks in Chicago. However, three ministers, objecting to the representation of a clergyman in the film (the villain, Reverend N. J. McCarthy, a thinly disguised portrayal of Micheaux's father-in-law, Chicago's Reverend N. J. McCracken), appealed to the censor board to halt the screening. Responding to their appeal, the censor board invited a group of prominent citizens, including such notables as Mr. and Mrs. Robert S. Abbott, journalist Ida B. Wells-Barnett, Councilman Oscar DePriest, Bishop S. T. Fallows, Colonel John R. Marshall, and *Defender* entertainment columnist Tony Langston, to review the film. Enthusiastic about the picture, the group overrode the objections of the ministers and a permit was granted.[30] What better approval rating could Micheaux have achieved than the endorsement of these prestigious figures!

OSCAR MICHEAUX

The theatrical debut at the Vendome was advertised as "passed by the Censor Board despite the protests of three Chicago ministers who claimed that it was based upon the supposed hypocritical actions of a prominent colored preacher of this city!" and many subsequent ads included mention of the ministers' protest and trouble with the censors.[31] Already indulging his inclination for exploiting controversy, Micheaux wrote in the *Half-Century Magazine* of "certain race men" trying to prevent the showing of *The Homesteader* because, "they claimed, I had chosen to portray one of their ministers in a hypocritical role."[32] Some of the ads quoted Bishop Fallows—described as one of those called by the Chicago censors to "sit in judgement"—as saying, "I can see no just cause for the personal objection to this [photo]play. Every race has its hypocrites. Frequently they are found in the churches."

Oscar Micheaux's self-promotion prompted the *Half-Century* to declare him "the most popular author in the city," in a 1919 article on Negro life in Chicago. They also praised *The Homesteader* as "the best motion picture yet written, acted and staged by a Colored man" and suggested, "When . . . *The Homesteader* played to big crowds at the Eighth Regiment Armory the 'know-alls' predicted it had run its course in Chicago. Quite to the contrary, it has filled fourteen other engagements on the South Side and the show houses are clamoring for its return." The magazine declared forcefully, "It deserves all the loyal support the race has given it."[33] Micheaux placed an ad in same issue. Addressing both moviegoers and theater owners, he proclaimed the picture, "The First Great Photoplay to Feature AN ALL STAR NEGRO CAST." With the release of his first picture, Micheaux joined the growing number of small companies producing Black-cast films for African American audiences. By the end of 1920, he had moved to New York (still maintaining an office in Chicago) and had four features in circulation.

The correspondence between Lincoln Motion Picture Company and Micheaux's company (from 1918 to 1923) about the possibility of doing business together is a rich area of archival research. The letter writers debated such issues as the relative profitability of shorts versus features, adaptations of novels versus original screenplays, war movies versus domestic fiction, and, importantly, representations of racial progress versus more combative racial themes. Their exchanges dealing with "Race propaganda" pro-

vide some insights into the social construction of racial identity, notions of an appropriate Race agenda, and the ways Micheaux acted to facilitate the acceptance of potentially contentious racial material.

In Micheaux's silent films based on his own novels, his original scripts, and his adaptations of stories by C. W. Chesnutt, T. S. Stribling, Henry Francis Downing, and others, he endeavored to represent African American life as he saw it (his moral vision of the world) and to raise his audience's consciousness about social injustice. These films were then known as "Race pictures," a term of pride that identified them as products generated by and for the community. Although "the community" may never have been as homogeneous as the discourses of the time implied, Race consciousness and identification were cohesive and binding forces and these movies were an articulation of self that challenged the dominant culture's ordering of reality.

An examination of Micheaux's films, letters, ads, and press coverage suggests that, in his silent movies, he persistently chose themes that were explosive in their time. By addressing such contemporary social issues as rape, concubinage, miscegenation, peonage, and lynching, he created a textured and expressive response to the social crises that circumscribed Negro life. *Within Our Gates,* for example, strips away the anonymity of the mob, exposing its members as ordinary townsfolk: men, women, and even children who participate in hunting down and lynching a Black family. *The Symbol of the Unconquered* reveals the economic underpinnings of the Ku Klux Klan. In *The Gunsaulus Mystery* (1921), a reworking of the Leo M. Frank case, a Black man is wrongfully accused in the murder of a white woman.[34] Promotion for *The Dungeon* (1922) touted the film as dealing with the then-pending Dyer Anti-Lynching Bill, and *The Brute* (1920) condemned racketeering and the abuse of women. Crossing the color line is the central theme of *The House Behind the Cedars* (1925); *Body and Soul* (1925) confronts hypocrisy and duplicity in the church; and racially restrictive real estate covenants are challenged in *Birthright* (1924).

These films generated heated debate and were subject to censorship by official censor boards, community groups, and individuals such as local sheriffs and theater owners. For instance, one southern police official ordered a Race theater to discontinue showing *Within Our Gates* because, in his estimation, the lynching scenes would incite a riot.[35] The Virginia

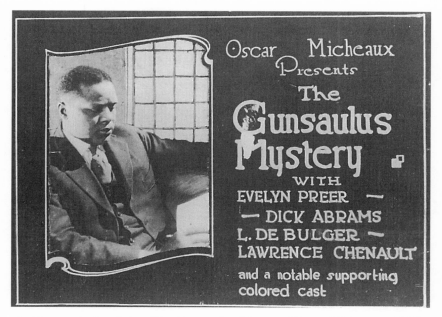

Lobby card advertising *The Gunsaulus Mystery* (Oscar Micheaux, 1921)
with a photo of the filmmaker. Courtesy of the Photographs and Prints
Division, Schomburg Center for Research in Black Culture,
The New York Public Library, Astor, Lenox and Tilden Foundations.

State Board of Motion Picture Censors rejected the full version of *The House
Behind the Cedars* for "presenting the grievances of the negro in very
unpleasant terms and even touching on dangerous ground, inter-marriage
between the races."[36]

Micheaux sometimes defied censor boards by showing a film before
submitting it for a license or without eliminating passages deemed "offen-
sive" by a censor board;[37] on occasion, he would use the controversy over
a picture in one town to promote it—and himself—in other locations. For
one run of *Within Our Gates* in Omaha, for example, an article in a local
newspaper announced the forthcoming showing as "the Race film pro-
duction that created a sensation in Chicago, [and which] required two
solid months to get by the censor board."[38] For the four-day run in Feb-
ruary 1920 at Chicago's Atlas Theater, Micheaux advertised that he had
restored the cuts to *Within Our Gates*: "Race People of Chicago—Please
Note! The Photoplay WITHIN OUR GATES, was passed by the Censor, but
owing to a wave of agitation on the part of certain Race people (who had

not even seen it) 1200 feet was eliminated during its first engagement. This 1200 feet has been restored and the picture will positively be shown from now on as originally produced and released—no cut-outs.—OSCAR MICHEAUX."[39] Three weeks later, at the States Theater in Chicago, Micheaux issued a press release announcing that the film "will be shown without the cuts that were made before its initial presentation, so patrons . . . will see it in its entirety, exactly as the famous producer intended."[40] In his 1923 film, *Deceit,* Micheaux fictionalized the censoring of *Within Our Gates,* again keeping his encounters with censors in the public eye. His fictional filmmaker, Alfred Du Bois, confronts the people who condemned his film, aptly titled *The Hypocrite.*[41]

Oscar Micheaux was first and foremost a businessman. Generally, he would not submit a film for licensing until he had a booking; then he would try to pressure the censor board to make a timely decision in order for him to meet his obligation.[42] An assertive and enterprising salesman, Micheaux promoted himself to censor boards the same way he promoted himself to theater owners. In the letters that accompanied his applications for a license, he often tried to cajole the boards to move favorably on his submission and to impress them with the importance of his business. His letterhead during this period listed all the films he had in distribution and described his firm as "Producers and Distributors of High Class Negro Feature Photoplays."

As a Black filmmaker, Micheaux was constantly in conflict with the ruling hierarchy. The state censor board forced him to cut four of the nine reels of *Body and Soul* in order to show the film in liberal New York State. When he presented *Birthright* to the Maryland State Board of Motion Picture Censors, the board demanded twenty-three eliminations. Even though the film was based on a popular novel by T. S. Stribling, a white southerner,[43] the board members found objectionable scenes and intertitles in all but two of the ten reels. They were particularly offended by suggestions of miscegenation, the questioning of white authority, and the depiction of racist attitudes of whites in the everyday interactions between the races. When Micheaux showed the film in Baltimore without making all the cuts, the print was confiscated.[44]

In Virginia, he deliberately ignored the jurisdiction of the state censor board and affixed a bogus seal from another picture on a print of

*Birthright.* The movie played at the Attucks Theatre in Norfolk, the Idle Hour in Petersburg, the Dixie in Newport News (and perhaps other theaters) before the censor board found out. This set off a flurry of activity around the state, with the board corresponding with mayors, chiefs of police, and theater owners, as well as a network of informants, to prevent future screenings.[45] Although the members of the board had not examined the film, they sent letters saying that *Birthright* was "a photoplay released by a negro concern which touches most offensively on the relations existing between whites and blacks."[46]

Since local authorities in states without formal censorship often honored the seal of neighboring states with boards, the censor board had the power to cut off access to colored theaters in the entire region.[47] After eight months, with a booking at the Attucks Theatre for his new film, *A Son of Satan* (1925), and an ad already placed in the *Norfolk Journal and Guide,* Micheaux responded to the board with a letter of apology that also included a request for a license for his new release. His tardy reply illuminates how he manipulated the system to make it work to his advantage, while avoiding the undesirable consequences of his own misdemeanors. Setting the scene for a melodrama, and playing the role of the trickster, he struck a note of "contrition," saying he had been traveling in cinder-infested Jim Crow cars throughout the South all summer and "was just so tired and distracted half the time" that he never felt composed enough "to set down and explain the why of." Playing to the paternalism of the board, he pleaded poverty and reminded them that his films were only shown to Negro audiences, anyway.[48] The state settled for a twenty-five-dollar fine, the minimum penalty.[49]

To survive in this business, Micheaux drew upon all his considerable resourcefulness. He acted shrewdly, often with guile and not infrequently with subterfuge. Trading on white fears and fantasies—and mocking them—he implanted himself squarely in the center of the Virginia censor board's racist typecasting to beat it at its own game. His use of calculated flattery and psychological trickery to outwit his foes is reminiscent of certain Black folktales. Consider, for example, wily Br'er Rabbit, who gleefully snatches victory from the forces trying to overwhelm him; or High John the Conqueror, pandering to his master's assumptions about the slave's loyalty and lack of intelligence, who successfully

juggles the situation in which he finds himself and proceeds to extract more than what is being offered. As Julius Lester puts it in his version of the High John story, "He was what you call a *man*."[50] Micheaux could have been singing Bert Williams's song, "I may be crazy, but I ain't no fool."

Four months after fining Micheaux, following their first viewing of *The House Behind the Cedars,* the Virginia censors found the film "liable to cause friction between the races." When they called together an outside committee of "intelligent men and women" to guide them in their final decision, Micheaux tactfully asked if they had included any "representative colored citizens." "If you regard the colored Tax payers and leaders of being capable of thought, which I am sure you do, I could more fully appreciate your effort. For I can recall an incident of this kind in Texas, one in Louisiana, two in Georgia and other points both North and South, where objections were raised. In every instance, however, representative Colored people were called in to express their opinion. And, as you know, over all the Southland inter-racial congresses are in vogue now to determine . . . the welfare of the colored folk." In order to get a seal of approval, Micheaux had to agree to eliminate the entire second reel and several other sections, but not without questioning the validity of the board's decision and, by implication, the authority of the board itself, because of its racial composition. He also chastised the board members for being "unduly alarmed as to how my race is likely to take even the discussion in the second reel. There has been but one picture that incited the colored people to riot, and that still does, that picture is *The Birth of a Nation* [which the board had recently licensed]."[51] Displaying a cunning realism about how he could maneuver within the constraints placed upon a Black man in the South, he was not simply accommodating the censor board, but challenging the very system.

Micheaux strove—with a sense of daring, optimism, and resolve—in a field filled with many roadblocks. He pursued areas and opportunities that were assumed to be closed to Negroes, and he was determined to succeed. One reason for our fascination with Micheaux today is that, in spite of his less than privileged position and without having the protections of post–New Deal and Civil Rights movement entitlements, he stood up to institutional barriers. He struggled not only for the advancement of the

Race, but for changes within the system to make it more equitable. Like the "bruised speculator" Thomas W. Lawson, whose book, *Frenzied Finance,* Micheaux praised in his first novel, Micheaux wanted to reform the system to make it work for him.[52]

Although our research suggests that there was a social distinction between Micheaux and the intellectuals of the Harlem Renaissance—Micheaux and his popular melodramas were either ignored or not taken seriously—he apparently felt a strong kinship with these artists. Sharing their belief that the Negro would gain acceptance once reasonable men saw that they were people of culture, strivers, and activists, he envisioned himself among those who worked for a better understanding between the races. He saw himself as progressive, as an "active citizen" who embraced Booker T. Washington's ideal of pulling oneself up by one's own bootstraps. Such an ideal could serve as a concrete policy for "the uplift of the Negro" (what we would now call a proactive stance), in contrast to the more "reactionary" stance of "[that] class of the negro race that desires ease, privilege, freedom, position, and luxury without any great material effort on their part to acquire it" (*The Conquest,* p. 250).

Rather than holding on to "the time-worn cry of 'no opportunity,'" he urged Negroes to accept personal responsibility. For Micheaux, placing the blame on discrimination robbed people of the impetus, inspiration, and motivation to better themselves. In *The Conquest,* he complained that the notion of racial bigotry preventing the Race's progress had been used by some as an excuse for "the negro's lack of ambition" (p. 17). And in the *The Forged Note,* he cautioned, "Dwell[ing] upon the white man's prejudice, we will surely become pessimists. Who is not aware of it? But it is the purpose of the practical Negro to forget that condition as much as possible. To allow our minds to dwell upon it, and predict what is likely to happen, is only to prepare ourselves for eternal misery. So far as I believe, it is my opinion that the white man will always hate the Negro. It may be argued that it is un-Christian-like, which is true; but the fact to be reckoned with, and which remains, is that the white man dislikes Negroes. But, when we have our own welfare to consider first and last, it is logical that we turn our energies to a more momentary purpose" (p. 461). One of his greatest tasks in life, he explained, was "to convince a certain class of my racial acquaintances that a colored man can be anything."[53]

At the beginning of his career, striking out on his own and settling on the land, Micheaux was greatly influenced by Booker T. Washington's philosophy, "not of destruction, but of construction; not of defense, but of aggression; . . . not of hostility or surrender, but of friendship and advance," where "usefulness in the community where we resided was our surest and most potent protection."[54] Entering into the ongoing debate on the ideas espoused by Washington and those of W.E.B. Du Bois, whom Micheaux referred to as the "professor in a colored university in Georgia" who espoused "literary training," Micheaux was outspoken about his affinities with Washington. He saw industrial training as more productive, "the first means of lifting the ignorant masses into a state of good citizenship."[55] Washington's exhortations of self-help, individualism, and social piety carried more weight with Micheaux than Du Bois's arguments on the harmful effects caused by the Negro's "special grievances": white prejudice, systematic exclusion, and discriminatory wages, rents, and living conditions. *The Conquest* was dedicated to the Honorable Booker T. Washington, and many of Micheaux's other books and movies aimed to galvanize the spirit of success through examples of individual triumphs. In *Body and Soul,* Micheaux used Washington's image as a visual tag to identify laudable character traits. His picture hangs in the industrious Sister Martha's modest home and is often center-frame. In *The Symbol of the Unconquered,* a portrait of Washington appears on the wall of the pioneer's frontier cabin. In the 1910 *Defender* article, Micheaux stated that he was "not trying to offer a solution to the Negro problem, for I don't feel that there is any problem further than the future of anything, whether it be a town, state or race. . . . It depends first on individual achievement, and I am at a loss to see a brilliant future for the young colored man unless he first does something for himself." The persona he was constructing in the homesteading stories was not that of the folkloric peasant who lived in dignified poverty (a figure prevalent in the literature being written by whites), but the self-reliant citizen farmer struggling to make a go of it.

Early in his writing for the *Chicago Defender,* Micheaux acknowledged the challenge to build something for himself. His nostalgia for the Rosebud Reservation included all of his achievements there: building a little sod house, learning how to handle the animals, breaking the

prairie, harvesting a successful first crop, and winning the respect, through hard work and perseverance, of his neighbors in South Dakota and those who knew him in Chicago. Micheaux's call for individual action and agency outshouted hostile institutions and structural discrimination. This idealization of the individual was compatible not only with Washington's political philosophy but also with Micheaux's use of melodrama. That is, his melodramas gave structure to the aspirations of the individual. His use of the genre's moral tableaux and moral certainties reiterated the ideals of the Protestant ethic: a faith in work, duty, and the redemption of the just and virtuous.

In a telling note to C. W. Chesnutt, Micheaux suggested that the screenplay for his adaptation of *The House Behind the Cedars* make the blacksmith Frank more striving—in order to make Rena's affection for him more believable! "I would make the man Frank more intelligent at least towards the end of the story permitting him to study and improve himself, for using the language as he does in the story, he would not in anyway be obvious as a lover or that the girl could have more than passing respect for him."[56]

Frank's self-improvement and industry elevate him from a minor role in the novel to a more exemplary status in the film, and render him a model hero, amazingly like Micheaux's own biographical legend. Rather than claiming to represent the political and social aspirations of the Negro, by necessity speaking for the majority, as many of the Black intelligentsia did, Micheaux felt that the majority needed models, heros, to mold public opinion and for the elevation of public sentiment. In *The Homesteader,* the pioneer proposes that his people needed examples, "and such he was glad he had become" (p. 147). Mildred Latham, the love interest of the homesteader, author, and itinerant book peddler in *The Forged Note,* admires the hero as "a Negro pioneer . . . [who would] blaze the way for others" (p. 48).

Convinced of the truthfulness of his own experience, Micheaux saw himself as a role model and as an instructive voice from within the Black community. In his desire to have his life serve as an example for others, Micheaux played up certain aspects of his life, made artistic use of his personal history, and dramatized particular motifs. Not only did his heroes embody characteristics he saw in himself, but they also undertook

ennobling adventures that illuminate the ability of the individual to overcome adversities and achieve great things. The central character of his film *The Millionaire* (1927), for example, is a soldier of fortune, "a man who as a youth possessing great initiative and definite objectives, hies himself far from the haunts of his race" to the pampas of South America, the "wild, billowy plains of The Argentine," and returns to the community as a rich man.[57] In his autobiographical sketch on the flyleaf of one edition of *The Forged Note,* Micheaux describes himself as "young, courageous, persistent in a contention that the Negro did not put forward the effort he could and should, from an industrial point of view, for his ultimate betterment."[58] With such stories, Micheaux created a public persona that continues to exist and exert influence today, even though many of his films are lost and forgotten. The construct "Oscar Micheaux" still speaks to us about racial identity, and the challenges of both inter- and intra-group differences and conflicts.[59]

In Micheaux's 1932 sound remake of *The House Behind the Cedars,* retitled *Veiled Aristocrats,* Frank tells Rena that the Race has allowed "the grass to grow under our feet." "And it's up to the Negro Race now to individualize his [sic] efforts, by which I mean that each and every one of us must make a concerted drive toward success."[60] While we will probably never know if the faulty pronoun, the switch from the plural to the singular, from the group to the individual, was Micheaux's writing or the actor Carl Mahon's alteration, the change is significant. It makes each and every person responsible for improving his or her lot in life. In his writings Micheaux expressed the belief that his work would have an impact on the future of the Race. In a 1924 letter to the *Pittsburgh Courier,* he articulated a sense of personal responsibility and effectivity: "It is only by presenting those portions of the race portrayed in my pictures, in the light and background of their true state, that we can raise our people to greater heights."[61]

A Micheaux-like character in the movie *God's Stepchildren* (1938), Jimmy, worked as a railroad porter and saved money to buy a farm. In a scene where he tells his fiancée, Eva, his plans for the future, she asks, "Why is it that so many, most all of our men, when they go into business it's got to be a crap game, a numbers bank or a policy shop? Why can't they go into some legitimate business, like white people?" Jimmy replies,

"They could, but they made no study of economics. Their idea of success is to seek the line of least resistance. The Negro hates to think. He's a stranger to planning. . . . For that is the failure of our group. For we *are* a failure, you know. . . . For it seems that we should go right back to the beginning and start all over again. That's what I've decided to do. . . . I'm going to buy a farm and start at the beginning."

A similar pastoral image appears in Booker T. Washington's *Up from Slavery:* he wishes he could "remove the great bulk of . . . people into the country districts and plant them upon the soil, upon the solid and never deceptive foundation of Mother Nature, where all nations and races that have ever succeeded have gotten their start—a start that at first may be slow and toilsome, but one that nevertheless is real."[62]

If one accepts Jimmy as a voice of Micheaux, he is once again adapting Booker T. Washington's attachment to the land, his philosophy of meritorious work and proving oneself to the outside world. Twenty-five years before Jimmy's speech, Micheaux had declared his own decision to seek a homestead, going West to "the land of real beginning" (*The Conquest,* p. 47).

Jimmy's rebuke of urban Blacks reveals more about Micheaux's nostalgia for his youth and simpler times than about the work attitude of urban youths. The speech is an echo from the past voicing Micheaux's attachment to the land, even after his own failure in that area, and his disappointment in not being able to attract others to the opportunities he saw opening up in agriculture in the early part of the century. Although the language in Jimmy's speech is more strident than earlier statements in Micheaux's writings, there is a familiar ring to it. In the 1910 *Defender* article cited earlier, Micheaux had confessed, "I return from Chicago each trip I make, more discouraged year after year with the hopelessness of [the young Negro's lack of] foresight. His inability to use common sense in looking into his future is truly discouraging. . . . Isn't it enough to make one feel disgusted to see and read about thousands of poor white people going west every day and in ten or fifteen years' time becoming prosperous and happy, as well as making the west the greatest and happiest place on earth? . . . In writing this I am not overlooking what the Negro is doing in the south nor the enterprising ones of the north, but the time is at hand—the Negro must become more self-supporting."

In 1938, even after the Great Depression, he still held on to the romantic ideal that the hard work and sacrifices of land ownership and farm life offered the possibility of independence and prosperity and he continued to lament urban youth's preference for an easy time.[63]

The film *Swing* (1938) includes a barroom interlude in which a city slicker preys on a newly arrived migrant, counseling him on how to get on welfare and avoid work, in exchange for a percentage of his relief check. In the utopian ending of *The Wind from Nowhere*, Micheaux's 1943 novel, which once again reiterated his biographical legend, the young couple accumulate wealth from magnesium deposits on their land; they then buy up thousands of acres of farmland, which they divide into ten-acre tracts to sell to "worthy and industrious" individuals they brought back from the East, "unfortunate families of their race that had been forced on relief." They provide each family with a cow, a horse, chickens, and pigs, and also give the men work a few days a month in food-product factories and magnesium alloy plants. "Twenty-five years hence, a great Negro colony will call Rosebud Country home and be content, prosperous, and happy."[64] Much as Jimmy's speech about the ideals of individual success and land ownership must have seemed outdated to audiences after the lingering impact of the Depression, Micheaux's ten acres and a cow, harking back to the cherished forty acres and a mule, must have seemed even more outmoded in the context of the increased industrialization brought about by the war in Europe.

Micheaux's characterization of urban Blacks in *God's Stepchildren* offended some of his audience. The story also has a fair-skinned woman abandoning her husband, a dark-skinned farmer, their child, and their home. Giving credence to the lie of Black inferiority, she runs off to the city to pass for white. She later commits suicide. The film was protested in New York because, as Beatrice Goodloe of the Young Communist League explained, "it slandered Negroes, holding them up to ridicule," and set "light-skinned Negroes against their darker brothers."[65]

Micheaux, himself a man of darker hue, disproved these images of inferiority in his biographical legend. It is almost as though Micheaux felt that in order for him to rise, he had to uplift the Race, and criticism of negative behavior would help to advance that cause. Although he did not take an essentialist position (Micheaux was convinced that, with education

and guidance, people could change), the rub, of course, is that, for the comparison to work, the character on whose back he builds his own legend of success must be held in ever-present contempt.

Jean Baptiste in *The Homesteader*, a more clearly autobiographical character than Jimmy, "had confidence in education uplifting people; it made them more observing. It helped them morally."

> He had studied his race . . . , unfortunately as a whole their standard of morals were not so high as it should be. Of course he understood that the same began back in the time of slavery. They had not been brought up to a regard of morality in a higher sense and they were possessed with certain weaknesses. He was aware that in the days of slavery the Negro to begin with had had, as a rule only what he could steal, therefore stealing became a virtue. When accused as he naturally was sure to be, he had resorted to the subtle art of lying. . . . They were given still to lustful, undependable habits, which he at times became very impatient with. His version was that a race could not rise higher than their morals. (pp. 160–161)

With the arrogance of the self-taught and self-made, Micheaux projected himself as upright and highly moral; he also set himself apart from others as a superior, righteous being. Part of the means by which he built the appearance of success included singling out those of the Race whom he characterized as immoral, or without ambition and perseverance, and censuring them for impeding the progress of the Race, and therefore holding *him* back. When he said there was no Negro problem, just the problem of individuals, he was acting on the premise that individual acts affect the entire group, a dynamic imposed by a racist system. That was his "burden of Race." By setting himself up as a model of one who had risen above the prevalent notion of the Negro as "inferior," he was inadvertently reinforcing the very attitude he imagined he was overcoming—the idea that the morality, ambition, and abilities of the Negro was "the problem." Colonel Hubert Fauntleroy Julian, a flamboyant aviator and barnstormer who was also the associate producer of two of Micheaux's films, was still using the same discourses in 1940. Describing *Lying Lips* in *Time* magazine on January 28, he said, "It's about a beautiful girl who is led astray because she wants beautiful things. . . . You see, I am trying to build up the morals of my race."

Micheaux's notions of racial uplift and individual responsiblity challenged white definitions of race without actually changing the terms. Some of his contemporaries—Sterling Brown, Langston Hughes, and Zora Neale Hurston, for example—questioned those terms, demanding new definitions of Race from within Black America. Hurston's work recodified both language and story by bringing out the richness of the African American vernacular, oral culture, and folktales. Hughes wrote of his own use of Black culture: "Jazz to me is one of the inherent expressions of Negro life in America: the eternal tom-tom beating in the Negro soul—the tom-tom of revolt against weariness in a white world, a world of subway trains and work, work, work; the tom-tom of joy and laughter, and pain swallowed in a smile." Hurston and Hughes, and other New Negroes, saw themselves as reclaiming images of blackness, an attempt, as Alain Locke put it, to build Americanism on Race values.[66]

Like Brown, Hurston, and Hughes, Micheaux spoke as a Negro; the "blackness" of the author is a strong presence. He shared their optimism in spite of failed promises. However, because of his sense of responsibility for uplifting the Race, he envisioned himself as an instructive voice and an empowering interpreter of Black life *for* the community. He took the position early in his career that a strong story and "accurate" depiction of Black life was what the public wanted. In a 1919 magazine article, he wrote that the "Negro . . . can [n]ever be thoroughly appreciated until he appears in plays that deal in some way with Negro life as lived by Negroes in that age or period, or day. The fact [is] that we can with a degree of success portray all the leads in the great plays that we are and have been in, [but] the public will never accept us fully until the play is written to fit the people who appear and their particular condition, for every play has in some way a moral or an immoral." And after only a year in the film business, he surmised that "the appreciation my people have shown my maiden efforts convince me that they want Racial photoplays depicting Racial life, and to that task I have consecrated my mind and efforts." He later described moving picture's potential as a "miniature replica of life, and all the varied forces which help to make life so complex, the intricate studies and problems of human nature."[67]

MICHEAUX SAW the audience for his films in the growth of urban Black communities and in smaller towns in the South, where Negroes were hungry for success stories and eager to see themselves in identifiable roles. In the beginning of his film career, he fought tenaciously to gain a foothold in those markets, aggressively selling the racial themes in his films. Although there were networks of picture houses catering to African American audiences in the cities, he formulated a distribution and exhibition strategy to create demand in smaller towns, offering to mail (without charge) heralds, imprinted with the theater name, address, and dates the films were to play, to every resident in the local directory. Describing his specialty as "Negro features," Micheaux promised to "work-up the interest" in the community by pursuing bookings "in all the worth while [sic] towns in [the] territory and then advertise the picture conspicuously in the daily papers."[68] It appears from the exhibition

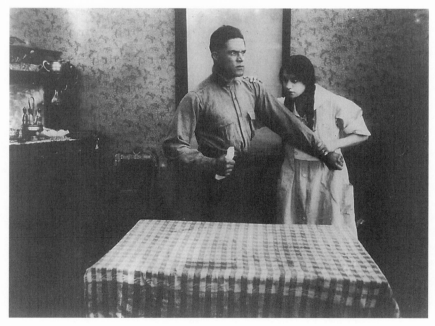

Jean Baptiste and Orlean (Charles Lucas and Everlyn Preer)
in a still from Oscar Micheaux's *The Homesteader* (1919).
Courtesy of African Diaspora Images.

dates of the initial run of *The Homesteader* that this strategy was success-
ful in the South.

On a personal trip, Micheaux was able to book what he advertised as
a "Great Southern Tour" in May, June, and July of 1919, with a week in
New Orleans and one- to three-day runs in Louisville, Kentucky; Pensacola,
Florida; Nashville, Chattanooga, and Memphis, Tennessee; Florence,
Sheffield, Decatur, Birmingham, Bessemer, Mobile, and Montgomery,
Alabama; Shreveport, Alexandria, Monroe, and Baton Rouge, Louisiana;
Spartanburg, Columbia, and Greenville, South Carolina; Macon and
Atlanta, Georgia; Reidsville and Durham, North Carolina. He advertised
the tour in the *Chicago Defender* by calling it the "longest picture engage-
ment in the history of the South."[69]

This bold newcomer was laying the cornerstone for a career. By launch-
ing it in the *Defender*, with two-thirds of its circulation outside of Chicago,
he was creating a mystique across the country around the exhibition of his
movie. Through such tactics, Micheaux not only attracted new southern
sites and notified patrons of specific show dates, but also impressed theater
owners and potential investors in Chicago and other centers of capital. With
his very first film, *The Homesteader*, Micheaux presented himself as if he were
an experienced distributor; he was both confident and professional. He pro-
moted the "uniqueness" of the film by announcing in the ads that "Negro
Productions such as this are restricted . . . to Negro Theaters and cannot
be booked through regular exchanges on the usual basis" and insisting that
the film would never be shown for less than a twenty-five-cent admission.
On this tour, the Micheaux Book and Film Company received a percent-
age of the ticket price while building a market and charting new territo-
ries for Race movies. With his second film, *Within Our Gates,* after only a
little more than six months' experience distributing films in the South, he
was able to book, in the first three months of 1920, one- and two-day runs
in twenty-six sites in North and South Carolina, and Georgia alone.[70]

While we know very little about the total returns from *The Home-
steader*,[71] it seems that the company earned enough and had sufficient con-
fidence to go on to produce the eight-reel picture *Within Our Gates*, a film
his ad said "COST MORE THAN ANY 10 RACIAL FILMS EVER MADE" and
"MOST COSTLY RACIAL FILM EVER MADE."[72] At the beginning of 1920, with
only two pictures under his belt, Micheaux sent out a press release with

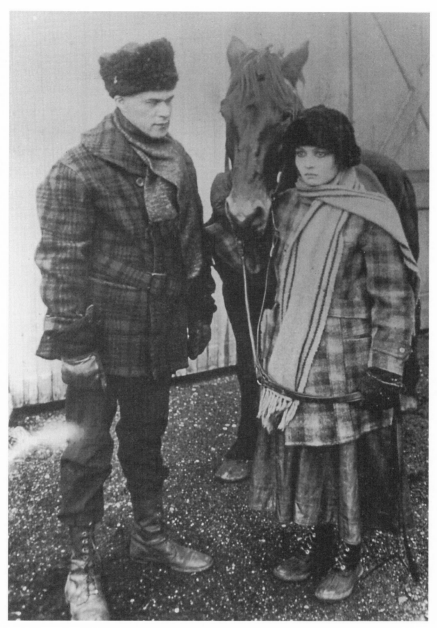

Jean Baptiste and Agnes Stewart (Charles Lucas and Iris Hall)
in a still from *The Homesteader*.
Courtesy of the Photographs and Prints Division,
Schomburg Center for Research in Black Culture,
The New York Public Library, Astor, Lenox and Tilden Foundations.

his photograph to Black newspapers, announcing that he planned a trip to Europe to arrange "world distribution" of his films.[73] Eight months later, having released its third film, *The Brute,* and while shooting the fourth, the Micheaux Book and Film Company spoke with pride of having sold "all of our Foreign Rights on *Within Our Gates* and *The Brute* and [are] shipping a bunch of prints this week."[74] In the January–February 1921 issue of the *Competitor* magazine, Micheaux announced that his productions were "now being shown in all of the leading countries of Europe, including England, France, Italy, Spain, and in Africa and the leading South American Republics." Later that year the company letterhead listed Joseph P. Lamy as foreign distribution agent. Audaciously looking for opportunities to establish himself in what was one of the fastest-growing industries of the time, Micheaux, like Hollywood firms, was trying to capture new markets. How lucrative Europe must have seemed to him in the wake of the success stories from such Black entertainers as Madame Sissieretta Jones, Williams and Walker, J. Rosamond Johnson, and James Reese Europe!

In a stock offering a little more than two years after the release of *The Homesteader,* having completed five films, the company claimed earnings of almost $40,000 in the previous six months (with four films in distribution), and anticipated, "with a more frequent release and better organization of distribution," that 1921 earnings would exceed $100,000.[75] Although Micheaux had other salesmen working for him, more than two-thirds of the contracts were written by Oscar Micheaux himself.[76] The company planned a publication, *The Brotherhood,* for its customers, the exhibitors: "a journal of finish and high aspirations; a journal which, all who wish to keep abreast of race filmdom, should have at their finger's tips [sic] at all times." "Pass this copy along and, of course, with it you will pass along the spirit of good cheer—a happy by-product of the screen industry."[77]

After making several films, Micheaux was able to package multiple titles.[78] Scheduling an engagement for one picture, he would use stills and the script of his next production to try to convince theater owners to invest in the new movie. The *Competitor* interview quotes him as saying, "Arrangements have practically been concluded to make at least one production a month in which scores of the leading performers of the country are to be used." He remarketed his novel *The Homesteader* with a new cover reading, "Oscar Micheaux's Mammoth Photoplay," and pictured it in some

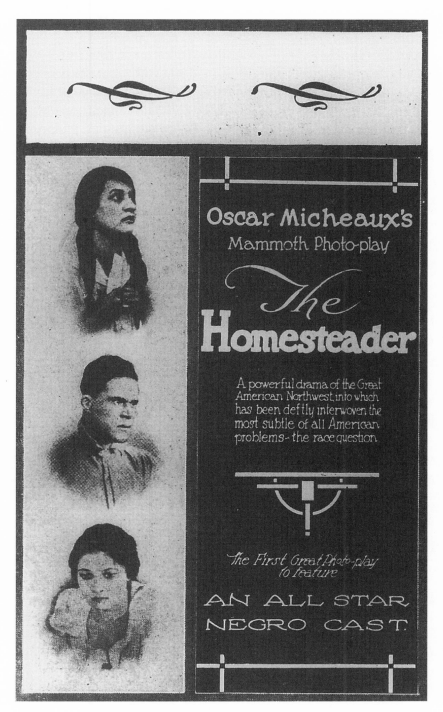

Advertisment for Oscar Micheaux's *The Homesteader* picturing his novel, with photos of the film's stars replacing the original drawings.

ads for the film. Having used the book to raise money for the production, he was optimistic that the movie's publicity could now increase the novel's revenues.[79] And he continued to seed the entertainment columnists in the Black press with information about booking trips in the South, excursions to Latin America and Europe, plans to film a new story, and the signing of stars for his next picture.[80] What an enormous sense of possibility Micheaux must have felt!

Although he did not seem to be a part of a literary establishment, in a 1920 letter to George P. Johnson, Micheaux spoke of plans "to meet James W[eldon] Johnson; Du Bois; Charles W. Chestnutt [sic] whose *Conjure Woman* I am now reading with a view to filming." He boasted that "two or more of these men have stated their desire to attempt writing for us."[81] Unable to compete with such highly repected Black writers as an author, he was trying to position himself among them as a filmmaker. Indeed, when he did approach C. W. Chesnutt about the possibility of filming his work, Chesnutt, whose own book sales were in decline, and who had seen one of Micheaux's films, was open to the idea.[82]

The correspondence between Oscar Micheaux and George P. Johnson reveals the highly competitive nature of Race pictures in the late teens and early twenties. While Johnson was trying to acquire the rights to *The Homesteader* and bring Micheaux into the Lincoln Motion Picture Company on salary, Micheaux was busy trying to woo Clarence A. Brooks, an actor and officer of Lincoln, to join *his* company.[83] He was also careful to mention that Metro and Triangle also had copies of the book.[84] However, by 1920, Lincoln was experiencing a hiatus in film production; Noble M. Johnson was no longer associated with the company and George P. Johnson was pursuing an offer of a job with Micheaux's company.[85]

Within a year and a half of premiering his first movie, Micheaux had three feature films in distribution, establishing his company as the top-producing Black house in the country. A year later, in 1921, with five feature-length pictures produced, Micheaux's competitive instincts pushed him to describe his Chicago-based company in a stock offering as founded in 1913 (the year of his first novel), predating the Lincoln Motion Picture Company's 1916 founding by three years!

The first half of 1921 brought a downturn in business nationwide. Nevertheless, in a letter to C. W. Chesnutt that fall, Micheaux still waxed

enthusiastic about new outlets—even while he was trying to convince Chesnutt to accept stock in lieu of overdue payments for the rights to *The House Behind the Cedars*. "Any body [sic] specializing in Negro feature production will find it slow doing business . . . restricted to about 300 colored houses in this country. . . . I can say to you that the future of the Negro photoplay depends on the ability to market the productions abroad in which way we would make up the deficit forced on account of the restricted showing in this country. I am personally going to South America in September 1922 to establish our connections there; to Africa the next winter, to India, Japan and in the next five years to keep going until MICHEAUX PRODUCTIONS are being shown throughout the world. So if you would accept $200 in stock or bonds on the last two notes in payment for 'THE CEDARS' you would help us that much to expedite this effort" (capitalization in the original).

But the slump in business did affect the new Micheaux Film Corporation, and, despite the stock offering, by the end of 1921 the company seems to have been experiencing cash-flow problems. Although Micheaux was obliged to take six months off from production to raise money, the company continued to produce films at a rate of approximately two per year. (Indeed, in the same letter where Micheaux asked Chesnutt to consent to taking stock or bonds in lieu of the late payments, he also asked him to write two original stories to be filmed the following year.)[86] But with the increasing number of Race films being produced (historian Henry T. Sampson cites 1921–1922 as the peak of production, estimating forty-seven companies formed during those two years), competition for investors and bookings was getting more difficult.[87] Despite these problems, Micheaux was quoted on December 22, 1922, in D. Ireland Thomas's column "Motion Picture News" in the *Chicago Defender:* "They all thought that I was finished, but I am only started."[88]

Micheaux was scouting locations (and no doubt sources of capital) in the South. After seriously considering Jacksonville, Florida, at the beginning of 1922, and probably other southern sites,[89] he established a southern base for his moviemaking in Roanoke, Virginia, in the spring of 1922, where he shot the exteriors of *The Virgin of Seminole*. From his distribution trips, he had certainly been aware of this railroad town—indeed, he had just visited there the previous fall. He was familiar with Roanoke's sizable

middle-class Negro community, people proud of Race achievements, as well as with its lively nightlife and thriving underground economy; here there were people of means who might support his venture.

Working out of the Hampton Theatre building (later called the Strand Theatre), he apparently adopted the business style (according to his self-portrait in *The Forged Note*) of introducing himself to the community and then probe it for its resources. Roanoke businessmen C. Tiffany Toliver, A. C. Brooks, and W. B. Crowell worked with Micheaux, for a time were officers of the Micheaux Film Corporation, and may very well have invested in his enterprise. (Toliver was president of the Hampton Theatre and had recently founded Congo Film Service, a distribution company; Crowell was in insurance and managed the Hampton Theatre; Brooks was in real estate.) When they were shooting, the actors and crew were housed in the homes of local people, and several people's houses were also used as sets. A local beauty, Louise Borden, who lived in the same Gilmer Avenue apartment building as Toliver, was cast in a role. Alma Sewell, who also resided on Gilmer Avenue, had some roles as well, and Oliver Hill remembers being given a small walk-on part in *House Behind*

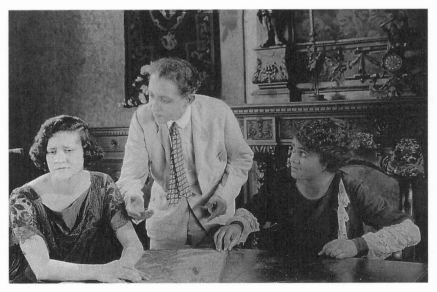

Evelyn Preer, Lawrence Chenault, and Alma Sewell in a still from *The Conjure Woman* (Oscar Micheaux, 1926), an adapation of C. W. Chesnutt's novel. Courtesy of African Diaspora Images.

*the Cedars* when he was a young man.[90] When asked why her grandmother would consent to having a movie made in her Roanoke home, Theresa Dawkins Holmes said that people wanted to help out. They were excited, impressed with Micheaux's ambition, and pleased that "someone of our race [was] making a movie."[91]

A tall heavyset man in a chauffeur-driven car, Oscar Micheaux could easily attract attention when he arrived in a new community.[92] People who knew him describe Micheaux as an imposing figure, an articulate man, who "could come into a room and dominate it with his sheer personality."[93] With his powers of persuasion and winning charm, he was capable of manipulating others to his own advantage. For example, in 1921, he was able to assure a Steelton, Pennsylvania, deacon and his wife, an elocutionist, that their sixteen-year-old daughter, Elcora "Shingzie" Howard, would be perfectly safe moving to New York City to work for his moving-picture company. Later the star of several of the pictures shot in Roanoke, Howard remembered the hospitality of the residents and how taken they were with Micheaux: "Here was a moving picture company coming to little Roanoke with this great pompous, arrogant and garrulous man!" "It was sensational," she recalled. "We were received with open arms. It was just fantastic how we were just swept off our feet by the zeal of the people, 'Oh! Here they are from New York, there are actors and actresses!' If we weren't careful, we would have gotten big heads!"[94] Such tales added to his reputation so that people came to expect (and respect) what writer Toni Cade Bambara described as "his ability to collar people, his ability to talk."[95]

Micheaux sometimes made guest appearances during showings of his films. An advertisement in the *Pittsburgh Courier* announced his appearance with *Within Our Gates* at the Schenley Theater in Pittsburgh; the film was accompanied by "good music and extra attractions" for the special event.[96] He appeared at a preview showing of *House Behind the Cedars* for invited guests at the Royal Theatre in Philadelphia and explained how he adapted the novel.[97] His younger brother, Swan, manager of the firm's Chicago office, accompanied *Birthright* when it played at the Temple Theatre in Cleveland, Ohio. A press release announced that he would be available to "talk with anyone desiring information regarding colored pictures."[98]

Shingzie Howard, who worked in Micheaux's office, helped to edit some of his films, and acted in five of his silent films, in a portrait from the early twenties. Courtesy of African Diaspora Images.

WHETHER IT WAS hustling money, taking shots on the sly at the front door of an absent resident's attractive house, or exploiting the censor board's preconceived notions of Blacks, Micheaux had a certain brashness about him. Although he was convinced that anyone with gumption and a willingness to work could succeed, at times he seemed to find the need to exile himself in order to do so. He nurtured the notion of himself as someone special, striking out in new territories. In *The Conquest* he mentions that after just three years as a pioneer in South Dakota, he was received back in Illinois as "a personage of much importance" (p. 68), and back on the prairie, as a former railway worker, he was approached for his opinions on the likely route of the railroad (p. 107).

Micheaux now saw himself as a "self-help hero" on two fronts: his success as a filmmaker and novelist established him as an exemplar businessman, and the success of his autobiographical films and novels refreshed and popularized his reputation as a pioneering African American homesteader. At the heart of this seemingly egocentric discourse was a call, implicit or explicit, for the transformation of the system of values that undermined self-confidence, opportunity, and the possibility of accomplishment.

Oscar Micheaux's films and novels were acts of recollection and imagination, creations and re-creations shaped by his personal experience *and* the desire to construct an image of himself for his audience. "That which any writer has been more closely associated with, are the things he can best portray," Micheaux wrote in the "publisher's note" to the reader in *The Homesteader*. "Oscar Micheaux has written largely along the lines he has lived, and, naturally of what he best knows." Suspended between autobiography and commerce, memory and dreams, his stories, though often personal, were not unique; they were woven with threads of commonality and communality. He spoke from his living history and from the specific realities of his time, mobilizing familiar symbols so that his stories made references to what lay beneath or beyond the particular.

However, the decision to work in the autobiographical mode—a form of personal and collective self-fashioning—may have been partially an economic one. Whereas there were only a handful of commercially published African American novels in 1913, there had been a tradition

of financially successful first-person narratives in early Negro literature.[99] Writing himself over and over again, Micheaux continued with variations on a successful formula—ebullient new tellings of a proven success. This pattern of recurrence and repetition, in which each telling is both familiar and new, was not uncommon in African American expressive culture, where retellings were often valued for their spontaneous inventiveness; by putting a new interpretation on a known story, joke, or tune, one left one's own stamp on the material.

Sometimes Micheaux took an incident in one story and transformed it into a revealing incident about a major character in another (Mr. Woodring, passing for white, and running a hotel in the West in *The Conquest*, for example, transmutes into Driscoll, the hotelier, passing for white, and sending Negro travelers to the barn in *The Symbol of the Unconquered*). Sometimes certain characters or types of characters were repeated. For instance, the heroines in both *The Homesteader* and *The Symbol of the Unconquered* are rural women of progress. Their independence, strength,

Eve Mason (Iris Hall) in *The Symbol of the Unconquered* (Oscar Micheaux, 1920) riding to warn the hero of the Klan attack.

OSCAR MICHEAUX

and bravery make them ideal partners for the hard frontier life. Both characters are involved in a life-and-death struggle against forces of evil, and both are triumphant in the rescue of the hero. The heroines in *Within Our Gates* and *The Forged Note* are educated Race women, working toward the betterment of the group, one raising funds for a school and the other for a Negro YMCA.

The grand gestures and broad moral themes that drove his work are also integral to the African American oral tradition: Much African American storytelling—folktales and jokes, for instance—are interlaced with wisdom and advice. Hence Micheaux's retelling and moral lessons should not be judged solely by modern, Western, or commercial standards (of uniqueness, individualism, etc.), but within non-Western traditions, as variations on stock forms and ideas. He worked within the framework of the popular, communicated to the masses, and people knew what he was talking about.

————

AS WE HAVE SEEN, Micheaux refused to dwell upon the depredations of racism or white America's moral and social corruption, was committed to optimism and the uplifting of the Race, and believed in the work ethic and in the importance of strength of character. But none of this precluded him from picturing some tragic and frightening oppressions in his films. Just as he fashioned a contradictory hero in Jean Baptiste—who decides to marry to take advantage of a business proposition, but moralizes about the qualities of good character the woman should have—there are contradictory, even multiple, Micheauxes (even within the legend he built for himself).

There's the Micheaux writing from Gregory, South Dakota, in an article headlined "Where the Negro Fails," instructing his reader not to seek advice from "the average colored man around Chicago or . . . his brother porters or waiters. . . . Ask the president of the Saint Paul [rail]road or the president of the First National Bank or any other great man and see what they say."[100] But, three years later, in *The Conquest*, in a chapter also titled, "Where the Negro Fails," he names muckrakers—Ida M. Tarbell, Ray Standard Baker, and Thomas W. Lawson—not the captains of industry, as worthy authorities (pp. 142–143).

There is the Micheaux who was remembered by his sister-in-law and her husband as being a perfectionist and by one of his leading ladies as exacting,[101] and who, upon the completion of his first scenario, pronounced that he wanted to make his film "in every detail so absolutely perfect that the people in leaving the theatre will be compelled to say: 'My, but that was a wonderful picture.'"[102] And there's also the Micheaux who compromised his "perfection" when business called for it: the Micheaux who edited footage, without reshooting, in *The Symbol of the Unconquered,* even though the too-wide shot revealed that the rain hoses had hit only part of the barn. There is Micheaux-the-producer who praised *The Brute* as being "in a class by itself," but went on to note, "It has some faults—none of us have as much money to make the best picture we might think up, as fine as it should be in technical detail."[103] And there is the Micheaux who wrote to Charles W. Chesnutt expressing admiration for his novel *The House Behind the Cedars,* assuring the author it would be filmed "with the utmost care and the finest possible skill" but suggesting that it would be "much more profitable from a financial point of view" if the heroine did not die in the end.[104]

These multiple Micheauxes reveal much about how Oscar Micheaux worked. Because of the constraints on his filmmaking practice—financial, commercial, and political—he was constantly trying to maneuver within restricted circumstances. He was known to shoot footage when the opportunity arose, compiling bits and pieces of film for future use. Shingzie Howard recalled that they once went to a white neighborhood early in the morning and, with no one at home, quickly shot her at the door of an elegant house.[105] Howard also remembered that when she was working in the company's office, a woman wearing a fur coat arrived for an appointment. Micheaux guided the woman into an interior office and quickly shot Howard with the fur on.[106] In *Ten Minutes to Live* (1932), there is a sequence of a woman getting into taxi cab at Pennsylvania Station in New York City, on the way to a home in Westchester. However, the shots of her traveling through the city show her in an open touring car. Perhaps this is another example of footage taken on separate occasions. Did Micheaux have only temporary access to the automobiles? Or did the camera operator need an open car to light the closer shot of the actress?

Some of the footage looks as though it were shot by inexperienced operators and, in some cases, as if Micheaux might have used different camera people in the same film. In *Symbol of the Unconquered*, for example, there are spectacular nighttime shots of the Klan's ride, shot with the natural light from the riders' torches. Could those have been taken by the same camera operator who shot the awkwardly framed and lit woman running out of the barn at night? Or was the Klan's ride stock footage? We know little about Micheaux's hiring practices and the makeup of his crews. We know he brought a crew to Winner, South Dakota, to shoot the exteriors of *The Homesteader*. Were they experienced workers from Chicago? Or people he knew from Sioux City? When he shot on location in the South, did he use local people or journeymen? If he brought technicians with him, were they able to train local workers?

Some of his aesthetics were certainly determined by his brisk production schedule (single takes, little time for rehearsals) and the limitations of his budget. But much might also have been driven by his own personal philosophy. In *The Conquest*, Micheaux writes that when he finally established a decent bank account, rather than inviting frivolity, he "put everything foolish and impractical entirely out of my mind, and economy, modesty and frugality became fixed habits of my life" (p. 42).

But perhaps there were also limitations on how he was able to shoot. He seems to have had at least one white man in his crew. As a Black man instructing a white person in public, perhaps he chose some of his locations and times of shooting with a view toward avoiding confrontations. Maybe this explains the sparseness of some of his exteriors. In *Body and Soul*, for instance, shot in the Bronx, when the main character goes to the grocery store, there is no one else on the street! Was the loneliness of the mise-en-scène a limitation of funds (no money to control crowds, to stage or rehearse extras)? One wonders how much this was also determined by the difficulties of shooting on the streets. Did he avoid locations where the authorities might have had an inhospitable reaction (hostility toward a crowd of Blacks and/or toward a Black man giving orders)? Perhaps he preferred to shoot at times when people were not around. How self-contained or self-ruled was the Black community in Roanoke? Were the residents able to assemble after dark? Or perhaps the police weren't concerned at all with what was happening "across the tracks"![107]

Evelyn Preer (1896–1932), a member of the Lafayette Players
stock company, appeared in nine of Micheaux's silent features.
Courtesy of African Diaspora Images.

MICHEAUX CREATED a star system by casting the same lead actors and actresses in several films and touring them together. Evelyn Preer, his first leading lady, a member of the acclaimed dramatic company, the Lafayette Players, appeared in nine of his silent features.[108] He built a following for her through public appearances, providing the press with announcements of her activities, using her photo in his ads, sometimes even allowing her name to be larger than his own. For example, in one advertisement for the Baltimore release of *The Spider's Web* (1927) in the *Afro-American*, a Baltimore weekly, a portrait of Preer as "The Screen's Most Beautiful Colored Star," covering almost half the space, with her name nearly as large as the film's title and the name of the theater.[109] Besides Preer, members of the Lafayette Players, including Ida Anderson, Andrew Bishop, Laura Bowman, Lawrence Chenault, Inez Clough, A. B. De Comathiere, Cleo Desmond, Alice Gorgas, Iris Hall, Lionel Monagas, Susie Sutton, and Edward Thompson, were cast in both leading and supporting roles in Micheaux photoplays. He also gave popular and seasoned vaudevillians

The Lafayette Players (1924), left to right: Andrew Bishop, Edward Thompson, Carlotta Freeman, Charles Moore, two unidentified actors, A. B. De Comathiere, Evelyn Preer, Susie Sutton. Courtesy of Dr. Francesca Thompson, O.S.F.

WRITING HIMSELF INTO HISTORY

opportunities to play dramatic roles. E. G. Tatum, for example, appeared in seven of Micheaux's silent films, along with Salem Tutt Whitney, J. Homer Tutt, and S. T. Jacks.[110] Many of these performers came with a following; people who had heard about their stage work or had read about them in the Black weeklies could now see them on screen.

But Micheaux also seems to have made casting decisions with a player's appearance and personal wardrobe in mind. Lorenzo Tucker looked very debonair in his tuxedo in the publicity still from *The Wages of Sin* (1928). Interviews with performers confirm that Micheaux generally asked them to provide their own clothes as costumes.[111] He also tended to mix amateurs with professionals. Needing to reshoot some scenes in *The Spider's Web* while he was in Baltimore, he cast two local businessmen in parts, then made sure that the press knew of their presence in the film when it played in their hometown. The ad in the *Afro-American* teased, "Several Well-Known Baltimore Actors—YOU'LL BE SURPRISED—COME AND SEE THEM." Micheaux sometimes advertised for extras in local newspapers—

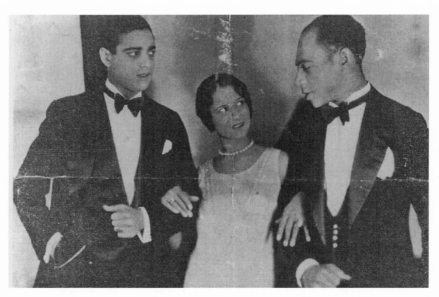

Publicity photo, *The Wages of Sin* (Oscar Micheaux, 1928),
with Lorenzo Tucker, Katherine Noisette, and William A. Clayton, Jr.
Courtesy of the Photographs and Prints Division,
Schomburg Center for Research in Black Culture, The New York
Public Library, Astor, Lenox and Tilden Foundations.

putting people from the community, his potential audience, on the screen.

While shooting *The Brute,* he placed three prerelease advertisements in the *Chicago Defender* beginning two months before the film's debut, using images from the movie being shot. Creating fanfare around the forthcoming film, he involved the community in the production and ultimately, in the fourth ad, invited them to the Royal Gardens to participate as audience members in a staged boxing match with Sam Langford ("the man Jack Johnson refused to fight"): "See yourself in the movies by being a spectator at the ringside during this mighty battle."[112] Through such devices, Micheaux hoped to build both press coverage and audiences for the film's upcoming release five weeks later at the Vendome Theater in Chicago. When shooting *The Millionaire* in Chicago, he asked "well-dressed persons" to join a cabaret scene filmed at the Plantation Café, and he included Robert S. Abbott and his wife in another scene.[113] By drawing on such known figures as Abbott and the popular pugilist Sam Langford, as well as including the names of familiar places and events (such as the Plantation Café, the Piney Woods School, the Battles of San Juan Hill and Carrizal, and so on), Micheaux was employing shared points of identification to build audiences and, by surrounding himself with known people and identifiable names, validating his role as a moviemaker.

However, Micheaux's preference or tendency for long takes sometimes resulted in films with inept performances that had been shot without retakes. Was he restricted to using actors who did not have better-paying engagements? Perhaps some dramatic players felt that performing in Race pictures or working with casts that included nonprofessionals and/or vaudevillians might hinder their career. But other performers might have felt that work in Race pictures would help them gain public recognition. Or they might have been willing to work for little in order to play the types of roles Race pictures offered.

The uneven acting is especially evident in the early sound films because of the clumsy delivery and bungling of lines. In contrast to some of the awkward acting, the continuous recording of the specialty numbers (generally in one shot) has a very professional look. These routines were already established acts, already well rehearsed, with their own lavish

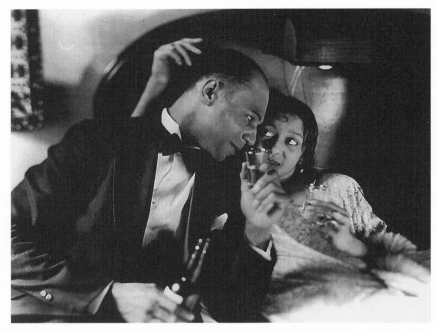

William A. Clayton, Jr., and Ione McCarthy in a still from *The Wages of Sin*. Clayton plays motion picture producer Winston Le Jaune's younger brother, who steals money from the company and spends it on "women in cabarets" and "wild parties." Courtesy of the Photographs and Prints Division, Schomburg Center for Research in Black Culture, The New York Public Library, Astor, Lenox and Tilden Foundations.

costumes. Along with the uneasy integration of specialty numbers with the narrative, their fluid—almost documentary—look contrasts with the dramatic enactments' often stilted dialogue (a graceless combination of realism and artifice).

Perhaps Oscar Micheaux was also limited, even impatient, as a director. He seems to acknowledge his limitations in an appreciative letter about the performances in *The Brute:* "The acting is so fine. To the Lafayette players I owe this. They were able to carry out my direction as fine as I knew how to give it to them."[114] In one scene of the early sound film *Ten Minutes to Live,* he so wanted lines delivered in a particular way that when the actor, Carl Mahon, failed to achieve the desired effect, Micheaux recorded his own flat Midwestern voice, substituting it for Mahon's crisp West Indian accent, and cut to the villain overhearing the dialogue.[115]

And then there was Micheaux's personality: he did everything himself. Certainly, this was partly because he lacked money to hire others, but he also seems to have wanted to exercise control over the whole operation, from script to advertising and distribution. Because of this, in the late twenties, he was still producing a handmade product in a period of increasing rationalized production in the rest of the film industry.

The world never quite managed to conform to Oscar Micheaux's biographical legend, and his work, like anybody's, was always constrained by the symbolic and material resources at his disposal. He invented himself in opposition to others, but as these multiple Micheauxes show, his lofty ambitions and ideals were sometimes in conflict with his own nature as well. There were many contradictions in his efforts to be entrepreneurial and expose the stigma of blackness in America at the same time.

But how did an audience used to seeing Hollywood films about "high-class people mak[ing] luxurious love on the screen," to quote a character in Claude McKay's *Home to Harlem*,[116] respond to the occasional Race film they saw in the same picture houses? Did Oscar Micheaux's photoplays speak to the audience in a different way? After all, Hollywood images of intimacy and affection never spoke that audience's name, never had that audience's face. The experience of seeing an African American woman arriving at a New York train station, traveling by automobile through the city streets uptown to a private residence in the suburbs, must have conveyed the awe and excitement of a new migrant's arrival to the big city, a first step toward a promising future. Similar shots in *Body and Soul* of the railway station and the rooftops of Atlanta must have held a resonance for both the migrants and those "down home" they left behind. Perhaps this warm recognition outweighed any technical imperfections. Any discussion of these motion pictures would have to take into account the life and times of the film spectator. (This call for a film history that considers the meaning of the films for the audiences of the period is taken up in the following pages.) Imagine the delight of seeing your life, your dreams, your neighbors, characters who loved, laughed, sorrowed, and struggled, even a famous actress you have read about in the Negro weeklies, all bigger than life at the picture show on Saturday night!

# PART Two

# His Spectators

# In Search of an Audience, Part I

**2**

So dawned the time of *Sturm und Drang:* storm and stress to-day rock our little boat on the mad waters of the world-sea; there is within and without the sound of conflict, the burning of body and rending of soul; inspiration strives with doubt, and faith with vain questionings. The bright ideals of the past—physical freedom, political power, the training of brains and the training of hands—all these in turn have waxed and waned, until even the last grows dim and overcast.
            —W.E.B. Du Bois, *The Souls of Black Folk,* 1903

I want to get my famely out of this cursed south land down here a negro man is not good as a white man's dog.
            —anonymous man, Greenville, Mississippi, 1917

DURING THE DECADE preceding World War I, with the economic collapse of the southern plantation system and its offspring, sharecropping, individuals, families, sometimes whole parishes moved from one county to the next, or migrated to urban areas, often heading North. Growing numbers of Black farmworkers rebelled against the increasingly hostile and oppressive system of tenancy and debt peonage by deserting the fields, abandoning labor contracts, and refusing to fulfill crop liens.[1] To a people newly able to move freely throughout the country, mobility meant the opportunity to assert one's independence, to sell one's labor power, and to reconnect with family. With the demands of the impending war and the drastically reduced flow of immigrants from Europe, the need for labor expanded and factory, mine, and mill owners were willing to pay higher wages than many workers had previously earned in the agricultural

sector. According to sociologist Charles S. Johnson, between 1890 and 1920 the percentage of Negroes living in cities more than doubled, and by 1910 most southern Black farmers had moved at least once in the previous four years and almost one-third had lived in their homes less than one year.[2] "Goin' North" sometimes meant moving first from rural areas in the South to southern towns and cities. For many, this meant becoming wage earners and adopting a more regular working schedule and a shorter work-week. With the resulting increase in leisure time and discretionary income, diversions such as commercial amusements and recreational sports, which traditionally belonged to some of the more privileged classes, were now more accessible to an expanding Black working class.

The new migration patterns contributed to the economic and social restucturing of urban America and had effects on many facets of every-day life. As record numbers of African Americans resettled in towns and cities, a new class of builders and entrepreneurs rose from their ranks. They built hotels, restaurants, banks, theaters, and newspapers, established Black towns, and created their own Black metropolises in such cities as New York and Chicago, Memphis, Tulsa, Detroit, Cleveland, Philadelphia, Pittsburgh, Washington, D.C., and Kansas City. These new communities demanded social structures and organizations to serve their growing populations. With the social displacements and physical dislocations, new patterns of fellowship and communication emerged.

Our search for Oscar Micheaux, then, must be more than a quest for the details of one man's life; it is also an exploration of community, a search for his audience. This chapter looks at the context of Oscar Micheaux's early filmmaking practice, concentrating on factors that made Race pictures possible: the Black communities and their values, the Race theaters where African Americans came together to see images of themselves and their community, and the Black press that informed their viewing experience. Race pictures appeared at a moment when there were more Black Americans in urban areas than ever before, from a range of social classes and regional and occupational backgrounds. How did migration and urbanization affect people's use of their free time? What patterns of continuity can be found during this period of sweeping change? How did all of this affect the social experiences and consciousness of early African American filmgoers? Can we speculate on how movies and other enter-

tainments were experienced—and perhaps even shaped for their own pur-
pose—by audience members?

Micheaux's own family migration story sounds a familiar theme that
links the search for education and self-improvement, work opportunities,
and citizens' rights. He writes of his family being farmers from Ken-
tucky. (They were considered fairly substantial farmers "for a colored fam-
ily.") Later, they settled on a farm near Metropolis, Illinois, and eventually
moved to the town of Metropolis, so the children wouldn't be so isolated
and would have more social and educational opportunities.[3] He tells of
his own migration as a young man: north to Chicago, and finally to
South Dakota.

Other migration stories, however, were not so voluntary. In 1922, the
*Chicago Defender* published a photograph of a family of six, one of the cases
from an article titled "Black Book of Hell," with the caption, "After hav-
ing their home set afire three times, this family, typical of residents of the
farm section, fled to another state for safety. They had committed no
offense, only incurred the wrath of the neighboring whites by their pros-
perity and industriousness."[4] Taken from an official pamphlet originat-
ing in the Georgia governor's office citing cases that came before the court
system, selective examples of 135 cases of mistreatment of Negroes in 1919
and 1920, the report was headlined, "Startling Facts to Indict White Civ-
ilization in the South." One man dragged from his bed at 2 A.M., by
"unknown" people, was told to leave the district by Saturday night or there
would be "war." A signed warning posted on the Negro schoolhouse
threatened the thirty other families of the area: "Notice to the Colored
people: If you haven't got a job you had better get one at once. If you are
not done gathering your crop you had better finish and settle your
accounts. If you are disposing of your crop you had better be at home by
dark, if you haven't got a lawful excuse for being out." The notice was
signed "WHITE CAPS."[5] The by-then former governor pointed out, "In some
counties the Negro is being driven out as though he were a wild animal;
in others he is being held as a slave; in others no Negroes remain. In only
two of the one hundred and thiry-five cases cited is the 'usual crime' against
white women involved."[6]

Stories of brutalities in the South were featured in almost every edi-
tion of the *Defender*. On January 16, 1917, under the headline "Why

They Leave the South," the newspaper published the lynching record for the previous year, and on August 4 of that year, owner and publisher Robert S. Abbott (a native of Georgia who had come North in the nineties) entreated in a signed editorial, "I appeal to all members of my Race throughout the United States to crush this damnable disgrace." Calling upon readers to use their labor as an economic weapon, he beseeched them to leave any position where they felt humiliated. "If ever there is a time to strike for freedom in its broadest sense, that time is right now. Supply and demand regulate everything; our services are more in demand now than ever before. . . . For God's sake, open your eyes, strike now, walk out from any job that robs you of your manhood or womanhood. . . . let them put the would-be men, who lynch you, as porters and depot attendants. . . . Of course, they may crush you, but they cannot conquer you. You won't starve. Make your own destiny."

According to historian James R. Grossman, the *Chicago Defender*'s militancy and sensationalism, combined with its vast promotion and distribution network, caused the paper's circulation to skyrocket along with migration. Purchased in churches and barbershops, from railroad men and traveling entertainers, passed around from reader to reader, recited out loud to nonreaders, the paper was responsible for "pumping a constant flow of trusted information into southern black communities." "To black southerners, the *Defender* represented unapologetic black pride, dignity, and assertiveness. From its inception [in 1905], it offered itself as a crusader against the white South."[7]

There were many motivations to migrate. Writer Amiri Baraka tells of his father, Coyette LeRoi Jones, leaving suddenly after unfortunate altercations with white ushers in a movie theater. His grandfather migrated after having had "two grocery stores and a funeral parlor burned out from under him in Alabama."[8] A farmer in Dapne, Alabama, wanted to migrate because "we have not had no chance to have anything here. . . . We are humane but we are not treated such we are treated like brute by our whites here we dont have no privilige no where in the south. We must take anything they put on us."[9] Many women and young girls were sent North to escape concubinage and rape.

Some families headed from rural to urban areas to seek educational opportunities, fewer restraints on voter participation, less restrictive

working conditions, and higher wages; others were forced to abandon their land by natural disasters (such as the boll weevil infestation or the floods of 1912 and 1913), the subsequent loss of crops, and increasing indebtedness. As one verse from the fields put it:

De white man he got ha'f de crap
Boll Weevil took de res'.
Ain't got no home.
Ain't got no home.[10]

The North, to many, represented the possibility to begin again on a more hopeful and humane footing. One Mississippian noted: "Just a few months ago they hung Widow Baggages's husband from Hirshberry Bridge because he talked back to a white man. He was a prosperous Farmer owning about 80 acres. They killed another man because he dared to sell his cotton 'off the place.' These things have got us sore. Before the North opened up with work all we could do was to move from one plantation to another in hope of finding something better." A carpenter in Chicago wrote to his brother in Hattiesburg, Mississippi: "I should have moved here 20 years ago. I just begin to feel like a man. It's a great deal of pleasure in knowing that you have got some privilege. My children are going to the same school with the whites and I don't have to umble [sic] to no one. I have registered—Will vote the next election and there isn't any 'yes sir' and 'no sir'—its all yes and no and Sam and Bill."[11]

To some, moving was a way to get ahead. A man from Natchez, Mississippi, wrote to Abbott at the *Defender:* "I can write short stories all of which potray [sic] negro characters but no burlesque can also write poems, have a gift for cartooning but have never learned the technicalities of comic drawing. These things will never profit me anything in Natchez." He suggested Abbott serialize a couple of his stories. "By this means I could probably leave here in short and thus come in possession of better employment enabling me to take up my drawing which I like best."[12]

People learned of distant cities and the allure of urban life from letters sent back home, stories told by labor recruiters, railroad workers, itinerant tradespeople, entertainers, and ministers, returning family members, conventioneers, and from the Black press, moving pictures, and other popular entertainments. A Rudolph Fisher short story explained: "Ever since a traveling preacher had first told him of the place, King Solomon Gillis

had longed to come to Harlem. The Uggams were always talking about it: one of their boys had gone to France in the draft and, returning, had never got any nearer home than Harlem. And there were occasional colored newspapers from New York: newspapers that mentioned Negroes without comment, but always spoke of a white person as 'So-and-so, white.' That was the point. In Harlem, black was white."[13]

Ads recruiting workers appeared in newspapers that circulated in the South. Throughout 1915, the *(Indianapolis) Freeman* advertised: "Colored Men wanted to prepare as Sleeping Car and Train Porters, no experience necessary. Positions pay $65.00 to $100.00 per month. Steady work on standard railroads. Passes and Uniforms furnished when necessary. Write now." The Black weeklies ran stories about successful African Americans, including their business or profession, educational and other accomplishments. The *New York Age,* for example, on November 28, 1912, published a front-page article listing the many Negro businesses in a district on the west side of Manhattan known as San Juan Hill: "grocers, barbers, coal and wood dealers, restauranteurs, and photographers." On March 12, 1921, the paper reported on a successful chemist who, after apprenticing for twelve years with a French perfumery downtown, opened a Harlem powder, perfume, and toilet-article manufacturing establishment and took an option on a factory site in New Jersey. The same article told of a $50,000 Lenox Avenue bakery company with $14,000 worth of equipment and furnishings, under the direction of a new manager who gained his experience in Central America.

Amiri Baraka insists that Negroes made the *decision* to leave the South; it was not a historical imperative. And this decision was part of a "psychological realignment, an attempt to reassess the role of the black man within the society as a whole."[14]

This reassessment included a lively discussion in the teens and early twenties over the "proper name" of the community: Negro, Afro-American, Aframerican, Ethiopians, and others. The *Half-Century Magazine,* for a short period, used the term Libranians. They rejected the term Negro because

it is undesirable for the reason that in many sections of the country the term has been purposely twisted into 'nigger,' and then it has been as a general term for the blacks or their descendants regardless of habitat. . . . African does not apply to us

specifically any more than it does to the inhabitant of Morocco, Egypt, Tripoli, Algiers or the Transvaal. These people and their descendents are specifically known as Moroccans, Egyptians, Tripolitans, Algerians and Boers. . . . 'Colored' is not the best term to apply to the members of our race, for it really does not apply to us any more than it does to the white race. Our complexions range in color from that of the palest Caucasian to jet black, but so does the white man's. No white person has really a white skin. The Swedes and Danes who are nearest to white in color, are a very light cream—not one bit whiter than many of the members of our race.

The magazine also rejected any hyphenated name: "'Afro-American' should not be used, for since the World War sentiment in the United States has placed a taboo on the custom of hyphenating American citizens. It is just as much out of place to call one of us an 'Afro-American' as it is to call a descendent of a Frenchman in American a 'Franco-American.' . . . Liberia and Librania are derived from the Latin word 'Liber' meaning free. These two names, being derived from the same word, are a constant reminder to us and to the Liberians that we are by blood closely related. At the same time, the difference in ending serves to distinguish our race in America, the Libranians, from the citizens of Liberia."[15]

Objecting to the name of the theatrical company, the Colored Players, a writer in the *Freeman* explained:

I make this criticism knowing full well the dislike for the term "Negro" which some members of the race profess to harbor. But "colored" is too abstract a term to use in this instance. There is a difference between producing plays dealing with "colored life" and plays dealing with "Negro life." There is just as much difference between the two as plays dealing with "white life" and plays dealing with French or Irish life. The Negro has no more right to claim ownership to the term "colored" than the Indian, Japanese, Filipino, Chinaman, and Malay. "Negro" is the only distinctive race appellation that gives us the proper ethnological classification, and achievement only will win for the term "Negro" the proper recognition and respect a race title deserves.[16]

The *Chicago Defender* rejected the term "Negro," replacing it with "Race" and "Race men." And in his amusement column in the *Defender* on May

12, 1917, Tony Langston commented on the Ebony Film Corporation, noting, "The very name 'Ebony' is nauseating."

Clearly, these struggles concerned not only the terms themselves, but also the connotative fields of meaning.[17] Naming was an act of reinvention and self-definition, a recoding in the face of the discourtesies and indignities of Jim Crow, as well as the painful group memories of three centuries of slavery. Declaring one's own identity was an act of self-acclaim, an exercise of power. Looking back from the sixties at the "strangeness" of urban life for the newly arrived migrant and the "wider psychological space," Baraka noted that "the hand of the paternalistic society was subtler, and that subtlety enabled the Negroes to *improvise* a little more in their approach to it."[18]

———

DISCOURSES OF Race pride also informed, and continued to be formed by, a wide range of cultural products. "We want to have real Negro dolls in our home," announced a women's club convention holding the nation's first Black doll fair in 1908. The Baptist convention that year endorsed Negro dolls with the resolution, "Whereas, our people for half a century, because of the uncomely and deformed feature of Negro dolls have spent thousands of dollars upon white dolls for Christmas, therefore be it resolved that we do here and now give our endorsement and hardy approval of the Negro Doll Factory and not only urge the patronage of the people of our churches as Baptists but of the race throughout these United States." "A Gilt-Edged Racial Proposition with a Concrete Foundation," read a 1919 ad in the *Atlanta Independent*. The Harlem-based Berry and Ross Company, makers of "Berry's Famous Brown Skin Dolls," offered prospective stockholders 800 shares of stock at ten dollars each: "An Appeal to 12,000,000 Americans, Your Race is on Trial, Upon You Depends the Verdict." The *Half-Century Magazine*'s Christmas 1922 cover showed a small child cuddling a Black doll, with a white one neglected at her feet, a heavy-handed example of the power of consumption as cultural expression.[19]

With the caption, "Honor Manhood, Loyalty, Race," an ad by the National Afro-Art Company of Washington, D.C., offered busts of Frederick Douglass, Bishop Allen, and Booker T. Washington ("11 inches in

height, of perfect likeness and proportions, artistic, strong and inspiring"). Another firm advertised for sales agents for their Booker T. Washington Memorial Clock, which was "endorsed by the Executive Committee National Negro Business League. . . . It is a Memorial to the Greatest Man our race has produced. It is a Splendid Time Piece. It is a Beautiful Ornament." The Douglas Specialties Company offered pictures of Colonel Charles A. Young, "the highest ranking Colored Officer in the U. S. Army"; Bert Williams, "the world's greatest comedian"; plus Booker T. Washington, Frederick Douglass, W.E.B. Du Bois, Toussaint L'Ouverture, and others: "Show your pride. Show your appreciation for the sacrifices made by these men that yours might be recognized as a race among races!! Send In Your Order At Once."[20]

Black Americans had already developed many separate, though seldom fully autonomous, commercial institutions. Generally choosing lines of commerce that white competitors had not elected to pursue or those whose specific nature tended to make less effective the forces of white competition (such as barber shops and beauty parlors, food service establishments, hotels, mortuaries, life insurance, and journalism), they forged a separate and distinct system of racial businesses, independent undertakings that M. S. Stuart has called an "economic detour."[21] In contrast to most white workers, Black workers in the cities tended not to live near their workplaces, but instead were confined to Black neighborhoods.[22] An individual with access to venture capital could start up an enterprise to serve that neighborhood and not be barred because of race. And the Negro as consumer was now seen as a lucrative new phenomenon. As the *New York Age* put it on August 26, 1922: "The outstanding business successes of the Negro in the past have been achieved in the supplying of some service to the public. There are a number of business men of the race who believe that for Negro business to continue to develop, business men of the race must go in more for the manufacturing and selling of commodities as well as service."

Negro entrepreneurs had been marketing sheet music to Black consumers since before 1910; examples included N. Clark Smith and J. Berni Barbour in Chicago, Gotham-Attucks Music Publishing Company in New York City, and W. C. Handy and Harry H. Pace in Memphis. In 1919, the William Foster Record and Rolls Supply firm of Chicago advertised

"Lieut. 'Jim' Europe and the Famous 'Hell Fighters' Band Records . . . The First and Only Colored Band [that] Ever Made Records." In 1921, Harry Pace left his partnership with Handy to form a record company in Harlem; the *Chicago Defender* hailed it as the "First Phonograph Concern in the World Composed Only of Descendants of Slaves." Pace's firm, Black Swan Records, advertised its product in the Black weeklies as "The Only Record Made by Colored People," and in some ads (alluding to OKeh's line of "Original Race Records" and Paramount's "The Popular Race Records," which were also advertised in the same papers) announced that it produced "The Only Genuine Colored Record. Others Are Only Passing for Colored."[23]

The support for Race dolls, Race records, Race pictures, and the delight people felt in Black baseball teams, like the debates over naming, were expressions of a group consciousness, a collective subjectivity, a cohesive element among people from different backgrounds. In the early part of the twentieth century, African Americans were on the move geographically, culturally, politically, and existentially. Yet despite these changes, there were strong bonds based on a common consciousness and a sense of belonging (at a time when the newness of their experiences and the diversity of the community may have made it seem like they no longer shared common conditions). For many, there was a continuity in aspects of community: some church congregations, boardinghouses, social clubs, and lodges took advantage of railroad group rates and migrated together. But settling in a new locale also required new articulations of community. The growing vitality of Black neighborhoods and Race consciousness mobilized, engaged, and transformed both individual and social identities.

Exciting images of city life were part of the allure of migration, and the new migrants embraced urban leisure habits. Moving pictures were enormously popular, with the film industry, by the midteens, claiming to be the fifth largest industry in the United States. There were, however, reports of white-owned and -operated theaters overcharging Negroes to discourage them from frequenting their establishments. In the South, Blacks were often barred from orchestra seats or, in smaller theaters, relegated to one side of the central aisle.[24] There were sometimes separate entrances, so that their moviegoing experience frequently entailed "pay-

ing first class prices for the questionable privilege of climbing up a dark stairway in an alley to get a seat in the 'peanut gallery.' "[25]

In many northern communities, although Negroes had the legal right to sit anywhere in the house, de facto segregation kept them confined to certain areas. The Chicago Commission of Race Relations, formed after the bloody racial disturbances of the summer of 1919, interviewed the manager of a recently built State Street movie theater where African American patrons were steered to a separate section of the auditorium. Reporting that "nothing in his words would indicate any strong prejudice against Negroes, even when expressing his conviction that they should keep to places intended especially for them," the commission quoted the manager "in substance":

> Not many Negroes buy tickets—perhaps ten or a dozen a day. An effort is made to seat them in one section of the house, preferably the balcony, to which they are directed by ushers. Reason is the complaint by white patrons who object to sitting next to them for an hour, or hour and a half. Offensive odor [is the] reason usually given. White patrons often complain to manager as they go out if a Negro has been sitting near them.
>
> Conduct of Negroes is not often objectionable—runs about the same as all patrons. Occasionally one tries to "start something." Recently two Negroes came to manager in crowded lobby after they had attended the show and objected to their seats on the balcony to which they had been sent by ushers, saying there were vacant seats on the main floor. Wanted to know why they were discriminated against. Manager did not want an argument in the presence of other patrons, and told them that as they had seen the show, heard the music, and shared everything with other patrons, he did not see they had any real cause for complaint.[26]

As late as 1925, a motion picture house in Brooklyn, the Apollo Theater, was accused of ushering Blacks to gallery seats, and a dentist was awarded $2,000 in damages for the way the ushers mistreated him when he refused to take an inferior seat in Chicago's Tivoli picture house. The court, however, refused to convict the Tivoli of discrimination.[27]

But Jim Crow was not quietly accepted. People resisted, fought back, and the Black press celebrated those struggles, reporting instances of

discrimination against Blacks, their refusals to be seated separately, and their lawsuits over segregation or mistreatment. The press frequently investigated allegations and lawsuits, and sometimes even instigated community action. For example, on September 6, 1913, the *Defender* ran a front-page story about the new Avenue Theatre drawing the color line, with four sets of raging subheadlines, "Citizens Demand Theatre Licenses Revoked," "White People and Jews Only Allowed on Main Floor—Mr. R. Hill and Wife Refused Seats on Main Floor— 'You People Must Sit Upstairs!'—Still the Colored Man Must Shoulder A Rifle to Protect This Man's Property in Time of War," "The Grand Can—The Avenue Must!" and "The Grand Theater, Three Blocks Away, Sells Seats to All American Citizens—The Avenue Theatre Must Be Made to Respect Illinois, or the Management Should Be Deported to His Home Country." The article called for an immediate letter-writing campaign to the mayor and chief of police. One week later, the weekly thanked its readers for their support and proclaimed its success: "Avenue Theatre Eases Color Line."

In 1911, the *New York Age* wrote on September 28 about an Austin, Texas, theater charging Negroes double the price that whites paid; on December 23, under the headline "Another Theatre Manager Fined," the paper told of F. F. Proctor, operator of a chain of vaudeville and moving picture houses, being convicted in Troy, New York, of violating the Civil Rights Law of New York State for denying Mrs. S. Clarissa Evans access to an orchestra seat. In 1912, the paper reported on August 29 that it had sent representatives to investigate a small motion picture theater in Harlem accused of charging Blacks extra for the "reserved seats" in the gallery. When the Lafayette Theatre opened in Harlem the same year, showing "high-class vaudeville and photo plays," the paper reported on November 14 that management had tried to bar Negroes from first-floor seats. After community uproar, the theater changed management and placed an ad in the *Age* on February 20, 1913, reading, "Admission will be good for any part of the house: balcony, orchestra, and boxes; Courteous treatment accorded to all." When a Philadelphia magistrate upheld the right of a young woman, Madeleine Davis, to take any vacant seat in a moving picture house, the *Age* reprinted the coverage of the *Philadelphia Bulletin* and applauded both Magistrate Morris and Miss Davis in its March 19, 1914, issue.

Many suggested fighting the political and economic abuses of Jim Crow by building and patronizing "our own" theaters: for example, the *Birmingham (Ala.) Reporter* in 1910 beseeched "the colored people of Birmingham [to] make a practical settlement of their amusement problem as the colored people of Washington, New Orleans, and other Negro centers are doing, by providing theaters of their own . . . where they may march in through the front door without fear and trembling and occupy the best seats at a reasonable price of admission."[28]

The *Atlanta Independent,* in 1919, ran a series of front-page cartoons showing Jim Crow theaters, with threatening police officers and the Negro entrance in the alley. One, inscribed Montgomery, Alabama, had a policeman saying, "You niggers frum Tuskegee line up like the rest of these shines." Another had well-dressed patrons in Atlanta answering back, "Why don't we go to that Colored theatre on Auburn Avenue. You see the same pictures and do not go in from the alley." "Let us go there. We can go in the front and sit anywhere we want to and it is also run by a Colored man."[29]

In Louisville, Blacks boycotted the National Theatre in the winter of 1913 for its gallery seating and rear entrance. The *New York Age* reprinted an appeal from the *Louisville News:*

> So now it is up to the colored people. Will they give their patronage to such a theatre [the city's newest playhouse, the National Theatre] whose stockholders refuse them common decent treatment? Is their passion for pleasure greater than their self-respect? Will they stomach this insult in order to be amused? Will our women climb to the top of a three-story building and pay the same money as other people who get all together different and better accommodations? Will they brand their race as inferior and encourage other discriminations by accepting inferior treatment? These and kindred questions must thoughtful people consider and then ask themselves is it worth while. There is a certain class who will go, but surely no self-respecting race-loving man or woman will accept the accommodations of this new theatre.
>
> The solution is this: patronize the Ruby and Olio colored theaters owned by colored men, build up these places until they can give shows equally as good and so keep your self-respect and keep your money in your race.[30]

The *Age* praised the people of Louisville and the *Louisville News,* and called for Colored Americans, in sections of the country where they were unable to get legal redress, to stop patronizing theaters where they were insulted and debased by white theater managers.

Promotional material for the Black-owned and -operated Frolic Theater in Lexington, Kentucky, pointed out that "the other picture shows have either excluded the colored people or put them in a cramped cage." An article in the *Indianapolis World,* after arguing strongly against discrimination in movie theaters, noted that "the Negro consumes a great deal of time talking about discrimination and prejudice. He has wasted enough energy talking about the discrimination . . . to build and maintain a first-class theater of his own." A man from a small town in Mississippi wrote to motion picture columnist D. Ireland Thomas at the *Chicago Defender* asking for information on opening a moving picture theater for his Race, "as the white theater in that town only let the Race people go up stairs and sit on rough dirty benches."[31]

The significance of the moviegoing experience for African American patrons in African American theaters should be seen in the context of this exclusion and humiliation *and* in the context of Race loyalty. Loyalty to Black commercial endeavors positioned economic progress as a unifying force, a means to foster community. The progress of individual entrepreneurs reflected on the Race as a whole and the whole Race benefited from their accomplishments, so they deserved patronage. On February 24, 1912, Minnie Adams pleaded for support of Chicago's Pekin Theater in a *Defender* article titled "In Union Is Strength." While she admitted that the quality of the offerings might not compare to the white-owned theaters, "The efforts of individuals for the betterment and pleasures of the race should be met by the hearty cooperation of every man and woman."

The new Black theaters were described with excitement in the Black press as successful entrepreneurial efforts. (The *New York Age,* for example, announced with pride the 1912 opening of the Howard Theatre in Wilmington, "the first theater managed and owned by the race in North Carolina.")[32] Their construction was seen as the establishment of a separate social space, a space of agency and a site of community: a public space without the indignities of back staircases and the segregated seating of white theaters and where a Black cultural identity could be asserted.

The Frolic in Lexington advertised: "Colored People Take Notice: Come where you are welcome and meet your friends."[33]

In 1909, the People's Amusement Company of Baltimore opened "a First-class Moving Picture Parlor," showing films, illustrated songs, and light vaudeville, and touted its theater as "the only Moving Picture Parlor in the city that is absolutely owned, operated, and controlled by colored people, and open to all the people."[34] On February 24, 1912, the *Freeman* quoted the *Nashville Globe*'s glorious description of the new Majestic Theater, "a beautiful commodious playhouse, answering the needs of patrons and per-formers," a two-story modern brick building, a multiple-use space, with a "magnificent auditorium," "galvanized iron" projection booth, asbestos curtain, boxes on either side of the stage with "splendid entrances and exits," and an inclined balcony, with cushioned seats, and ventilation. Hail-ing the theater as a major mainstream cultural institution, the article con-tinued, "Success seems to be assured for just as the Negroes of Nashville have support two strong banking institutions, kept alive the educational enthusiasm that has been the means of Nashville maintaining her lead as an educational center, and as through their support and religious zeal they have made Nashville the religious publishing center of the United States, and as she is rightfully the home or at least the mother of denom-inational pride, just so she will make a success as a theater center."

William Foster, one of the earliest known African American filmmakers, under his pen name, Juli Jones, Jr., wrote in the *Half-Century Magazine* in June 1919 about the Colored theaters of the South: "The Southern 'cracker' has lost another weapon of his preducice when he lost the Jim Crow theatre in the South. . . . Now the Negro lad or lass can see the good pictures in his own neighborhood theatre run by a white man who 'caters' to them or better still run by a Colored man with a vision." As Charles H. Turpin, owner and manager of the Booker T. Washington The-atre in St. Louis, Missouri, put it, "My people are interested in our endeavor to furnish to the public clean, decent amusement and to keep within the channels of our own Race some of the profits necessarily spent for pleasure and edifying entertainment."[35]

Many of these theaters were named in honor of African American heroes: Booker T. Washington, Frederick Douglass, Crispus Attucks, and so forth. The Hampton Theatre in Roanoke, Virginia—which claimed to

be "the largest colored theater in [the] Southland" when it opened in 1917 —was named as a tribute to Hampton Institute.[36] The *New York Age* asked its readers to suggest a fitting name for the new theater being built on West 138th Street in Harlem. After considering the names of many "Negroes who made history for the race," directors of the Johnson Amusement Company chose to name the enterprise the Walker-Hogan-Cole, in tribute to performers George W. Walker, Ernest Hogan, and "Bob" Cole as a "high compliment to the colored theatrical profession" and its "important part in solving the so-called race problem."[37]

A major effect of urbanization in the 1890–1920 period was the beginnings of a merchant and professional class that had capital to invest and saw itself as dependent upon the Black community for its livelihood. Although segregation and other forms of racial alienation—the social dynamic imposed upon the Race—may have contributed to the growth of Black businesses and communal institutions, they were not the primary motivation for them. And it would be erroneous to equate the laws and social patterns that prohibited Blacks from occupying the same space or receiving the same treatment as whites (the function of which is to establish white supremacy) with the assertion of a separate social identity, a positive creative effort (the function of which is to nourish a sense of community, pride, and independence).[38]

In May 1919, Howard A. Phelps wrote in the *Half-Century:* "The stability of the Negro rests upon his financial independence. Independence means the employment of race men and women by race business men and women. The business world seems to be the sphere of life the Negro must exploit before we can give the signal that the Negro is ready to run the race of life with other races without being handicapped. Oppression has been squirming at another race's feet for hundreds of years and yet his financial status has forced the respect of the world."

The development of a substantial African American audience, who had attained a degree of economic security and leisure time, must have made motion pictures seem an ideal area for investment. Urban dwellers were reserving a good portion of their cash wages for commercial amusements, with workers spending a higher percentage than the professional classes. During World War I, higher-paying jobs gave Black Americans more money to spend. *Moving Picture World,* for example, reported on October

19, 1918, that the Negro soldiers quartered at Camp Taylor in Louisville, Kentucky, were packing the movie houses: "Wages are high, ordinary laborers making $3.00 a day and better, with the result that the negro houses are doing the best business in their history." The article also mentioned that movies were being shown every night at the YMCA on the camp grounds. In Chicago, in 1919, more than half of working people's amusement budget was spent on movies.[39]

---

RACE HOUSES could accommodate local taste in the selection of both films and nonfilm events, avoiding fare that might be offensive. The *Chicago Whip* announced on August 27, 1921, "Blue Bird Theatre [on Indiana Avenue in Chicago] Re-opens With Colored Picture Under Colored Management." The article said that "The Blue Bird Theatre is under the management of W. C. Gates and has been thoroughly renovated and equipped with facilities to give their patrons the best entertainment available for their money. Sanitary conditions and interior decoration make it the nicest and cleanest little theatre for our people in the city. 'We will pick our features to meet the tastes of our patrons,' says Manager Gates, 'and will give them value in entertainment and courteous service.'"

Theaters were also places for fraternal organizations and social clubs to hold lectures, pageants, and other special events. The Palace Picture Parlor in Louisville, Kentucky, in a 1917 effort to build its audience, scheduled Race orators along with the films a couple of nights a week: "Attention MR. NEGRO: . . . Have you a drop of real red blood in your veins? Is your spine built up of the bones and cartilage God intended, or have you so far degenerated that there is a fishing worm where your backbone ought to be? Haven't you been divided against your brother long enough? . . . Don't you think it is high time you were waking up and GETTING TOGETHER?" The rest of the ad, appealing to Race consciousness, described a venture to "stimulate the spirit of unity, race support and brotherly love" in which the theater would turn over a portion of its receipts to lodges, clubs, churches, and the like. These special events included a "high class picture program" and a ten-minute address by an orator provided by the club or organization, "RACE TALKS BY RACE MEN," an effort "to build up the race." The theater promised that the speeches, "while not to be

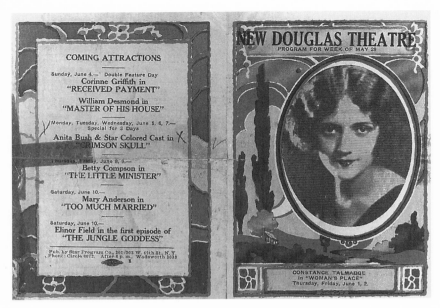

Program from the New Douglas Theatre in Harlem, 1921.
Race films shared the weekly bill with Hollywood productions.
Courtesy of African Diaspora Images.

inflammatory or offensive to other races of people, will teem with race grit and backbone that will thrill from head to foot."[40]

In Chicago from 1905 to 1913, there were at least twelve theaters offering movies, music, and vaudeville in the four-block stretch of South State Street known as the Stroll. This number increased to sixteen in the mid- to late teens and to more than twenty by the midtwenties.[41] However, in order for Colored theaters to show films regularly, they had to rely on white pictures. Even at the peak of African American film production, in the early twenties, there was never enough product for only Black programs. (See, for example, the accompanying illustration showing the 1921 program from the New Douglas Theatre in Harlem.) In 1923, the *Norfolk Journal and Guide,* in an article praising the theaters "serving Race patrons" for the variety and quality of their programs, mentioned that the theaters booked films from "Metro, First National, Paramount, Fox, Vitagraph, Ince, and occasionally a picture by Race producers."[42] The Broadway Theater in Washington, D.C., featured a Negro production once a month during a portion of the 1926–1927 season.[43] In 1925, The Dun-

HIS SPECTATORS

bar Amusement Company of Peoria, Illinois, enthusiastically informed the public that it intended to show Race movies one night a week every other week.[44] At the beginning of 1924, the Attucks Theatre in Norfolk, Virginia, advertised a bold new policy of showing an Oscar Micheaux film every Monday and Tuesday.[45] Subsequent ads, however, indicate that this policy was not carried out. Between 1922 and 1924, according to the censor's records, it appears that only seven Black films played the entire state of Virginia (six passed the censor board, and they noted that one was exhibited at several venues without a seal). But perhaps other Black films played in the state without the board's approval or knowledge.

Even when standard Hollywood fare was on the screen, it was viewed in familiar company. The continuous showings, shorter programs, frequent change of films, and lower costs of movies in neighborhood theaters made moving pictures more accessible to working people and encouraged repeated attendance. When Black actors played supporting roles or even bit parts in white productions, they were often given prominence in advertising directed toward African American audiences. For example, when Eddie Polo's western serial, *The Bull's Eye,* played at the Owl Theater in Chicago in 1918, Noble M. Johnson's full-length photo was featured in the newspaper ad: "COME AND SEE THE RACE'S DAREDEVIL MOVIE

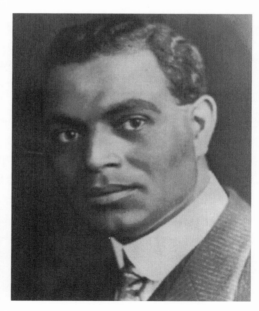

Noble M. Johnson, featured player of Universal Pictures, founded the Lincoln Motion Picture Company in 1916 and starred in its first four films. Courtesy of African Diaspora Images.

STAR."[46] When the Owl played Fox's *Soft Boiled* five years later, the theater ran a four-column ad in the *Defender* with the Fox cut on the left-hand side, featuring a picture of Tom Mix, "the stunt king," and Tony, "the wonder horse." On the right half, the theater ran a type-only ad declaring that Tom Mix was "assisted by" (in large bold type) "Tom Wilson, the celebrated Colored movie comedian in a riot of laughter."[47] In an ad for Jack London's *Adventure* at Chicago's Republic Theater, Noble Johnson got star billing, listed at the head of the cast before Tom Moore, Pauline Starke, and Wallace Beery.[48] The *Half-Century Magazine* asked, "Where is the red-blooded boy who can be attracted to the gallery to see 'mellerdrammer' when he can go to a movie and sit just as close as he wishes and gaze at Noble Johnson playing on the screen?" Another article in the *Half-Century* explained that "many of our people who would not attend an ordinary show will go when they know a Colored star is to be featured or a Colored [photo]play is to be shown. And as Colored stars are on the increase, the number of Colored movie fans is increasing rapidly also."[49]

The availability of Colored theaters, along with a population of motion picture fans with more disposable income, must have served as an impetus for the growing number of Black productions. These fans might also have been a catalyst for Black traveling exhibitors. One could, for example, rent the Globe Theatre in Norfolk, Virginia, with or without the house orchestra, for either a flat fee or a commission on the box office receipts and show a program of topical pictures.[50]

Movies also appeared in small towns and rural areas, even where there were no theaters for Colored patrons. Greg Waller's study of Lexington, Kentucky, mentions a traveling showman, Professor J. V. Snow, visiting Lexington churches in 1903 with a filmed Passion Play, comic shorts, newsreel footage, and musical accompaniment, and the Wilson Brothers bringing religious films, comedies, and trick films to local churches in 1909.[51] The Lincoln Motion Picture Company of Los Angeles had an operator, Professor A. A. Moncrieff, trooping through the South with a specially built portable screen in 1917, playing in "churches, halls, schools, and smaller towns that have no theatres."[52] Eddie Wilson also traveled in the Deep South. In 1919 (at the age of twenty-seven), he ordered a motion picture projector from a firm in Birmingham and, with the cooperation of local ministers and school trustees, traveled the back roads in a horse-drawn

wagon giving shows, with musical interludes, in churches and schools in small town and farm communities in Alabama and Mississippi.[53]

In 1920, the *Chicago Defender* had a small ad for a "MOVING PICTURE OUTFIT COMPLETE for sale . . . just right for halls and churches." The DeVry Corporation advertised a portable projector and generator system that fit under the hood of a car or truck, a complete outdoor moving picture show. "Be Independent and Get the Money! . . . Just the thing for one-night stands. Also, in the rural school house; at county fairs; or in the sticks or tanks!"[54] In 1922, D. Ireland Thomas wrote about a "successful" trip taking older Race films to communities in Florida "where a large number of our people . . . are anxious to see these productions but have no theaters or any way to see the pictures." Inviting others thinking of such undertakings to write to him at the Dunbar Theater in Savannah, Georgia, Thomas suggested that this distribution method was a good way to "get more money out of the films that are thrown aside as having played all the towns that had theaters."[55]

In 1923, Professor C. E. Hawk, working out of Atlanta, was thinking of selling his seventy-five reels of film, machines, Paige automobile, and his route through Georgia and Florida, in order to settle in California; however, in mid-1924 he was still on the road.[56] Professor Arthur Richards reported good returns with a Passion Play and the Colored Players Film Corporation of Philadelphia's *Ten Nights in a Barroom* in 1924.[57] As late as 1925, Thomas's *Defender* columns printed a request for information from a juggler who thought he might travel with a Race film included in his act, reported that Professor E. L. Delgardo, traveling in a Ford truck and generating his own lights, was doing good business in Virginia, and Lee Garner, traveling in a Dodge touring car around Charleston, South Carolina, was booking dates for the summer.[58] Mrs. S. Barnet from Zanesville, Ohio, the editor of a women's newspaper, announced the same year that she was planning "a tour with educational pictures, using a motion picture machine showing educational scenes and pictures showing the progress of our Race."[59]

While reports of glowing business may have stretched the truth to generate publicity, the sheer number of exhibitors on the road indicates that many people were able to see films in nonurban settings where there were few, if any, theaters.

D. Ireland Thomas
(1873–1955), columnist
for the *Chicago Defender.*
Courtesy of
Pearl W. Thomas.

Black newspapers writing about and carrying ads for popular amuse-
ments not only reached local patrons but, traveling south on railroad lines,
also reached a large network of potential moviegoers in outlying areas.
So people in Hattiesburg, Mississippi, read about what movies were play-
ing on the South Side of Chicago, and the people of Roanoke, Virginia,
knew the latest films showing in Pittsburgh. Frederick Detweiler claimed
that in the summer of 1921 there were over 450 Negro newspapers and
other periodicals,[60] and even after the crash of 1929, the 1930 bulletin
published by the Bureau of Foreign and Domestic Commerce listed 112
Negro weeklies.[61]

It would be difficult to conceive of early Race pictures without the co-
operation of the already established (and flourishing) Negro press. The
"Musical and Dramatic" pages of the *Chicago Defender,* "The Stage and
Athletics" page of the *New York Age,* and the amusements pages of the
*(Baltimore) Afro-American* and the *Pittsburgh Courier* were crowded with
ads from theaters, reviews of films and live acts, columns with news about
entertainers, filmmakers, and stories of prominent people attending
motion picture shows. The Black weeklies celebrated film culture; com-

mercial achievements and aspirations were often heralded as triumphs for the Race. On July 20, 1916, when the *New York Age* reviewed *The Colored American Winning His Suit* (1916), produced by the Frederick Douglass Film Company of Jersey City, New Jersey, the headline proclaimed it "The first five-reel Film Drama written, directed, acted and produced by Negroes."[62] A year later, on July 14, 1917, the paper suggested motion picture houses should book the company's second release, *The Scapegoat*, for two reasons: "First because it possesses undeniable merit; and secondly, because it is a racial business venture which ought to be encouraged by all managers who make their money off Negro patrons." A tribute to Peter P. Jones, wrote entertainment columnist J. A. Jackson, "is a tribute to the race that produced Jones."[63]

Such journalists as Tony Langston, D. Ireland Thomas, and Lester A. Walton positioned themselves alongside entrepreneurs of Race pictures, promoting the work through their regular columns; at times, receiving commissions for bookings; and, of course, attracting advertisements to their papers. Romeo L. Dougherty wrote the theatrical page of the *New*

Lester A. Walton (1882–1965), columnist for the *New York Age.* Courtesy of the Photographs and Prints Division, Schomburg Center for Research in Black Culture, The New York Public Library, Astor, Lenox and Tilden Foundations.

*York News* and, in a 1917 letter soliciting ads for his paper, attempted to sell himself as an important power in the entertainment world, emphasizing his connections with successful theater managers, performers, and owners, and pronouncing that he was "firmly convinced" of the influence he had with the owner of the New Lincoln theater.[64]

Many of the newspaper journalists were closely tied to the industry as bookers, theater managers, and artists' representatives and were intimately involved on many different levels with the very amusements about which they were reporting.[65] The Lincoln Motion Picture Company actively solicited newsmen and described itself in the corporate publicity that accompanied its 1917 stock offering as "hav[ing] as managers of our Exchanges Race men of ability and influence, with theatrical experience and newspaper connections. These men know the field and will give extensive publicity to the Lincoln Motion Picture Company and its productions."[66] George P. Johnson, Lincoln's general booking manager, wrote in 1918 of the firm's "national connection with Race papers."[67] Dougherty was, for a time, the New York agent for Lincoln. Tony Langston, while writing about theater and film for the *Chicago Defender*, was Lincoln's agent east of the Mississippi. Langston also worked for the Foster Photo Play Company and, later, booked the Royal Gardens Motion Picture Company's film of the Lincoln League's Chicago Convention.[68] D. Ireland Thomas, while a columnist for the *Defender*, booked Lincoln's product in the South. For a brief period, Thomas was also manager of the company's star, Clarence Brooks.[69] And George P. Johnson himself, while booking manager of the company, wrote on film and edited the Amusement pages of the *Western Dispatch*, a Los Angeles weekly, under the pen name George Perry.[70] Lincoln got excellent coverage in the Black press!

By the late teens, there was a well-developed Hollywood movie culture that included not only fan magazines (information on movie stars, film synopses, and star endorsements of products), but also information about making movies and how to get into the movie business.[71] In African American communities, there was also a dynamic concept of fandom that, of course, included moviegoing, but also embraced the possibility of moviemaking and the opportunity to invest in film-related enterprises. Although moviemaking opportunities were advertised in the trade papers, where professional vaudevillians and show-business

people might see the ads, many opportunities were also announced in Black newspapers and magazines aimed at the general population. The Gate City Feature Film Company of Kansas City advertised in the *Chicago Whip* for "Girls and Young Men . . . anyone between the ages of 18 to 30 considered" for "Colored Motion Pictures," and claimed, "NO EXPERIENCE NECESSARY, This is YOUR CHANCE to Get into the 'Movies.'" "Get into the Movies: Unusual opportunity for colored talent" read an advertisement in the *New York Amsterdam News.* The Klimax Film Company advertised in the *Chicago Whip* for "Colored Talent" for "a large movie project now organizing in Chicago." In ads in the *Defender,* the Royal Garden Motion Picture Company of Chicago advertised itself as producers and instructors ("We have unrivaled facilities for practical training in moving picture acting"), and the Eagle Movie Training Club of St. Louis, Missouri, announced it was in the business of teaching "our girls and boys . . . the art of screen acting."[72]

The Railroad Men's Amusement Association, a group of men mainly employed on the Rock Island system, notified the public in the spring of 1917 that it was planning to manufacture motion pictures employing Race people exclusively as actors and actresses and was opening a studio in Blue Island, Illinois, for "our young ladies and gentlemen to learn the art of motion picture acting." Promising to bring in an experienced director and producer from New York, the association offered free lessons to applicants "with references." "This will be a big contest, but not a voting or popularity contest; the poor girl or boy has the same equal chance as the rich." But, as with the acting schools, its motives weren't entirely altruistic: "All we are asking you to do is to boost our association by selling a few shares of stock to your friends."[73]

The Ebony Film Corporation, in April of 1917, advertised in the *Champion Magazine* that it was in the market for scenarios, "stories of colored American life only." Bessie Mae Byrd, of Jeffersonville, Indiana, wrote to D. Ireland Thomas in 1922 that she had "just finished a wonderful plot for a picture." She had nearly $300 to invest and was looking for a company to produce the photoplay.[74]

In 1923, the Magic Motion Picture Company advertised: "At Last, Something New For Chicago and Its Citizens, a Movie Making Exhibition and Grand Ball. Have you seen the moving picture cameraman in your

neighborhood? Well, he got a picture of you and it will be shown at the Movie Making Exhibition and Grand Ball so Don't Miss Coming and See- ing It." An accompanying article mentions that pictures would also be taken at the ball and would be shown at some of the local theaters. "Those who show-up best will be given a chance to take part in a big production which is soon to be filmed. In fact, this is a chance to become a candidate for 'stardom.'"[75] Not only was this an attempt to build an audience in Chicago (it was hoped that those the camera captured at the ball would return, with family and friends, to see themselves in the movie), it was also a way to acquire the kind of "classy" footage critics would praise as a "credit to the Race." These types of images must have conveyed a certain excite- ment to moviegoers in smaller towns as well.

By the early twenties, the "opportunities" were so prevalent that con- fidence games were becoming a problem. D. Ireland Thomas warned his readers in the *Chicago Defender* about a well-dressed white man who was offering to make a thousand-foot screen test for fifty dollars, payable in advance. "After he collects the money, he disappears. When last heard of he was working South Carolina." *Variety* reported a scam in St. Louis in which a loudly dressed man announced he was the general manager of the "greatest negro moving picture company in the world" and needed one hundred actors. After receiving $1.50 in fees from each of several hun- dred applicants, he too disappeared. And the *Afro-American* reported that a white man, Frank Hayes, had victimized a number of "movie folk" with a proposition in Cincinnati.[76]

Investment opportunities including low-cost stock offerings, were widespread. "Better than Banking," declared an advertisement for the Ama- zon Amusement Company, an enterprise "formed for the purpose of open- ing and conducting amusements [such as movie theaters, skating rinks, and pleasure parks] for colored people throughout the South."[77] Lincoln Motion Picture Company's 1917 stock offering, which appeared in the Black press (the *Chicago Defender,* for example), quoted Russell Sage, "the noted capitalist," on "the Secret of Getting Rich" and explained that the firm could borrow from white banks, but preferred to "ask a few members of our Race who want to make a SAFE and GOOD INVESTMENT." Lincoln offered stock at a dollar per share, with a ten-share minimum, "$2.50 down, $1.00 per month for seven and one half months."[78]

HIS SPECTATORS

An ad that ran in the *Afro-American* addressed prospective stock-holders for the construction of a "magnificent" new $400,000 theater in Baltimore and explained, "It is the desire of the company that the stock [at ten dollars per share] be distributed among a large number of investors, rather than be held by a few large buyers of securities, and for this reason the price of shares has been put at a price at which even the smallest investor may get in on this proposition. . . . If you are interested in the development of the race along cultural lines, here is your opportunity to do your part in bringing about this condition. Invest in the Douglass Amusement Corporation stock and help to make the Corporation a success and a distinct asset to the race."[79]

The Klimax Film Company advertised for investors: "Help in an enterprise that will help you and the Race at the same time." The Monumental Pictures Corporation's stock offering announced the company was "organized by Negroes TO MAKE MONEY FOR NEGROES" and will "produce superior motion pictures showing to the civilized world the honor, the beauty, the talent, the character and the soul of the American Negro." D. Ireland Thomas reported that Samuel McFall, Jr., director general of Samuel McFall Productions in St. Louis, Missouri, had related his intention to make newsreels and comedies, "and then tackle the big stuff," and had sold a good amount of stock in a trip through Kentucky (especially Fulton, his former home) and Tennessee.[80]

In an article in the *Half-Century Magazine* in 1919, Oscar Micheaux proclaimed, "Before we expect to see ourselves featured on the silver screen as we live, hope, act and think today, men and women must write original stories of Negro life, and as the cost of producing high class photoplays is high, money must be risked in Negro corporations for this purpose—some, many will perhaps fail before they have got to going right, but from their ashes will spring other and better men, some of whom in time will master the art in completeness, and detail and when so, we will have plays in which our young men and women will appear to our credit as finished silent drama artists." A couple of years later, Jean Voltaire Smith in the same magazine asked, "Would it not be better . . . to encourage more of our people to produce pictures—films of the clean, helpful sort, that will uplift; urge them to build first-class moving picture theaters, rather than discourage them from attending picture shows? This would help to

keep within the race at least a portion of the millions spent each year by Colored movie fans."[81]

Clearly, business-minded people were aware that African Americans were spending a certain amount of money on amusements—tent shows, nickelodeons, pageants, theater, vaudeville, expositions—and that there existed a market and potential opportunities for Race entrepreneurs. In Harlem alone, "Professor Mimm's open-air disco" was showing movies in 1908; the Pastime Airdome on 135th and Madison Avenue, a two-thousand-seat establishment, in 1911 advertised a three-hour show with "up-to-the-minute pictures" and an orchestra ("Classy Entertainment at an Unclassy Price"); and in 1912 Young's Casino on 134th and Park Avenue offered "Mammoth Sunday Night Concerts," with vaudeville acts, photoplays, and a full orchestra.[82] In Chicago, the Chateau de Plaisance, a skating rink "owned controlled and operated by our people," was showing movies in 1910; and the *Chicago Defender* reported in 1911 that the Pekin had shortened Jesse Shipp's play, *The Test,* "in order to give time for moving pictures and wrestling matches."[83]

For some, moving picture exhibition was a completely new venture; for others, it was a new endeavor in a show business career. C. H. Douglass, formerly the manager of a minstrel "tent-show" employing thirty-five to forty people and performing in fourteen states, opened the Douglass Theatre in Macon, Georgia, in 1911, where he presented a show of four to six reels of film, three to five acts "of the best class we can get," and a four-piece orchestra.[84] The Howard Theatre, in Willmington, North Carolina, was founded by a group of experienced vaudevillians.[85] Sherman H. Dudley was a well-known comedian, the star of the Smart Set Company, when he opened a theater for Black patrons. By 1913, he had invested in several theaters and announced that he would play only one more season before retiring from the stage to spend time enlarging his chain.[86]

The Black press regularly reported on new undertakings, job opportunities, and personal achievements in the movie business. A large, twenty-six line article in the *Chicago Defender* told of an African American projectionist who had passed the licensing exam and was being admitted to the operators union in Philadelphia. The *New York Age* spread the news that an African American would be managing the newest Chicago theater: "the new little 'chicken coop' picture house on State between Thirty-first

HIS SPECTATORS

and Thirty-second streets, has its frame brick wall up and while it is owned by a white man, like the other houses, it is rumored that Shelton Brooks is to be manager." The same paper, in 1914, announced that the "colored citizens of Chicago have won their fight to have one of their race made a member of the Film Censor Board." The *Freeman* ran a detailed two-column story including a photograph of the Moseley brothers, owners and managers of three theaters in Norfolk, Richmond, and Petersburg, Virginia; and the *Age* announced that the Crescent Theatre was, at last, employing a Colored piano player, Miss Hallie L. Anderson. "The spirit of race pride is yet in its infancy, and it will have to reach its maturity before all of us can appreciate the little things that operate for the fundamental good for all."[87]

---

SEGREGATED THEATERS, with the "crow's nest" or other areas set aside for Negroes, competed with "Colored theaters" for the Black audience. Competition could be intense. To lure African American patrons, theaters frequently advertised their amenities. In Baltimore a white-owned theater in the heart of a Black community, the Roosevelt, boasted that it had a $10,000 organ and a modern interior. The Regent, also in Baltimore, devoted one-third of its ad to its "New $18,000 Orchestra Organ," which "perfectly reproduces the human voice" and includes "rain, birds, and other marvelous effects." The New Grand Theatre on Chicago's South State Street, a vaudeville and moving picture house, proclaimed that it was for the "exclusive use and enjoyment" of the Colored patron. "This new temple of enjoyment . . . was designed to give the Colored people of Chicago the best accommodations for theater going that it has been possible to devise. . . . There are 800 comfortable seats and every patron will be treated with the utmost courtesy and made to feel at home." Within a week after the Frolic Theater, a Race house in Lexington, Kentucky, advertised that the "leaders of the colored population" had endorsed its new enterprise, a white-owned theater placed an ad in a Lexington paper assuring readers that the "Hippodrome admits colored people, it has a balcony for them and a separate entrance, with elegant brass railing to show them where to go." The Colonial Theatre, a segregated house in Portsmouth, Virginia, advertising to the African American community in

the *Norfolk Journal and Guide,* stressed their "inclusive" policies: "Our aim is to please the public at all times. . . . Plenty of room for all. . . . Prices within reach for all." But there must have been some rivalry with the Attucks Theatre, a Colored theater in nearby Norfolk that advertised itself in the same paper as "The 100 Per Cent Negro Theater."[88]

The grand opening of the Loyal Theatre in Omaha, without mentioning race or race loyalty at all, stressed the lower cost of the neighborhood Colored theater and its comfort: "Beat the high cost of living and save 50% on your amusement expenses. See the big stars and big features at 50% less than you have to pay at the down-town houses. Why spend from 16¢ to 64¢ carfare and from 30¢ to $1.20 admission to see the same photoplays down-town that you can see at the Loyal for 50% less. Come to the Loyal and save this extra cost." The Auditorium Theatre in Atlanta advertised *The Heart of Humanity* (1918) with a large box noting the price of all seats was a quarter and a smaller box informing the reader, "This picture is being shown at a leading Peachtree Theatre for 50 cents admission." The Washington D.C., Black-owned theaters ran an essay contest in the *Washington Tribune,* "Why theaters owned and operated by our people should be supported." First prize was twenty dollars and second prize was a month pass to any Black-owned theater in the city.[89]

Black theater owners in Black sections of southern towns were sometimes forced out of business by violence or local ordinances that favored white businesses. In Tyler, Texas, for example, in 1925, a Race man was considering giving up his neighborhood theater and moving to another town, because he felt it would no longer be profitable after a white man opened a competing Race theater downtown, where the city prohibited Negro owners.[90] On December 2, 1921, the *Afro-American* reported that the Dream Theatre in St. Petersburg, Florida, a house that was equipped for live shows but had been showing moving pictures lately, had been "bombed and totally wrecked." "The motive is unknown but it is said that the hostility against Jack Lively, who owned and operated the theatre exclusively for colored, was great because he took trade away from the Jim Crow section of white theatres." In Norfolk, Virginia, J. E. Reese opened the Dozier Theater to Colored patrons after the house had been dark for a long time. However, "local white citizens did not approve." On opening day, the theater was picketed and patrons were "warned away." At the evening's performance,

"a shot was fired from a shotgun and the audience was stampeded; the next day an injunction against operating the theater for Negroes was granted. This despite the fact that it is a Negro neighborhood."[91] In 1932, traveling showman Eddie Wilson built a theater in the Crattix quarter of Headland, Alabama, but was quickly forced out by whites.[92]

In areas with large African American populations, some theaters tried opening the gallery to whites and seated Blacks in the orchestra. The *Afro-American* noted this policy at the Belmont Theater in Pensacola, Florida, suggesting that it might be extended to all the theaters in the Managers and Performers Consolidated circuit, "provided of course that local sentiment is not definitely opposed to the innovation."[93] The owner of the Frolic Theater in Birmingham, Alabama, reserved several rows of seats in front of the projection booth for his white friends. "The Jim Crow law works both ways in the South," observed Clarence Muse and David Arlen in their book *Way Down South,* "and just as colored folks may not mix with whites in places of entertainment, so also whites are prohibited with equal sternness any social intercourse with their darker brethren."[94]

Colored theaters might also hold a special showing for whites or might, on occasion, invite white people to attend particular shows. The 81 Theater in Atlanta was a Colored vaudeville and moving picture house, except for Thursday midnight matinees when it was open for whites only.[95] In 1922, the Attucks Theatre in Norfolk tried special Friday midnight shows of Black-cast films to provide "an opportunity for such white people as were interested in colored shows to visit the theater. Its audience . . . was on these occasions augmented by a sprinkling of whites." The authorities, however, quickly passed an ordinance forbidding any theater or picture house from holding shows after midnight without first obtaining a permit from the director of public safety. "The proponents of the measure referred to this as 'unwholesome mingling of the races.' "[96]

The appearance of Race movies in Race-specific venues, first in the early teens, and in more numbers in the late teens and early twenties, should be seen as an inclusive experience. Although an ad hoc viewing collective, rather than a preconstituted community, the audience, nonetheless, appears to have had a conviviality and communality that were not seen in racially mixed company. Audience members responded as participants, laughing, commenting, urging characters on—perhaps more

akin to behavior in lodge halls, clubs, sporting events, and religious meetings than to that at a Hollywood film in a segregated picture palace.[97]

But this behavior was not welcomed by all. On April 23, 1910, even before the Pekin Theater was showing moving pictures regularly, the *Chicago Defender* ran an unsigned article titled, "Loud Talking in the Pekin," which complained that "some of our citizens who claim to be so refined and up-to-date certainly showed how they were raised. While the great Albini was trying to explain his work there was so much loud talking that he was forced to ask them to quit." The article went on to claim that "these same people will go to the Illinois, Grand or Lyric and in order to get their mouths open, one would have to use a crow bar." The paper asked, "Why is it then, in a house managed and controlled like the Pekin is, such disgraceful scenes must occur? We are sure it's not a hog-pen; why not respect it? We rather think it is our newcomers to the city who think that they are at a camp meeting."

Colored theaters were open to all in the Black community, but sometimes due to the location, the behavior of patrons, or the selection of films or acts, some might prefer to go to a segregated white theater. The Jacksons, a white family, owned two theaters in Ruleville, Mississippi. They showed Westerns at a cheap price at their "Colored theater." But people who wanted to see first-run Hollywood films would have to go to the balcony of the larger house. An article in the *New York Age* accused "certain classes of colored people" of preferring the insults of the balcony in a white house to a Colored theater, even if owned by members of the Race.[98] A woman interviewed in Harlem about the Lafayette Theatre's discriminatory seating policy was adamant about the injustice of it; however, she also expressed the desire that "some way should be found to protect the decent and respectable colored people from the riff-raff. The best element of our people must suffer for and through the worst element."[99] William H. Jones, a sociologist at Howard University, saw the small Mid-City Theater on the twelve hundred block of Seventh Street in Washington, D.C., as serving patrons who were, "for the most part, uneducated and emotional."[100] Paul K. Edwards, an economist at Fisk, suggested that the small Negro theaters often showed "inferior" entertainment and failed to attract "the best element of the population."[101]

Along with the Racial-uplift films and lecturers, the bid for solidarity and respectability included discussions of appropriate behavior in the Negro theaters. Social distinctions became submerged under the norms of middle-class values and standards of reception. These discussions, besides being an attempt to attract middle-class patronage, compare with other moves toward respectability (such as the Chicago Urban League's leaflets of advice to new migrants on how to behave in the city). An air of restraint and decorum in public among members of the middle class set them apart from the workers, many of whom were new city dwellers. That is, it is not that Black audiences were becoming more rowdy—indeed, as Lizabeth Cohen points out, yelling and jeering marked working-class and ethnic theaters in general[102]—but that the Black culture was becoming more differentiated. Edwards, the Fisk economist, wrote that not only did the "embarrassment" of segregated side entrances discourage some patrons, but the fact that all classes were seated together in the restricted part of the gallery was also disturbing.[103]

D. Ireland Thomas's *Defender* column, "Motion Picture News," also discussed conduct in Race theaters and compared "bad language" and "loud noises" there to the "quiet" and "order" in white houses, suggesting that, in the midtwenties, people still did not react in Race houses as they did in the gallery of white theaters. He commented that "the best people of the race" patronized the galleries of white theaters because "they see good projection, hear good music and above all there is good order."[104] Was this the anguish of an acculturated Black in response to loud and conspicuous public behavior of fellow Blacks? Or was it more pragmatic? Thomas claimed that when word got out that he wanted to open a theater on King Street, Charleston's main entertainment and shopping thoroughfare, he found an effort underway to move the theater. "But as soon as the people found that I wanted to operate a decent place, every one helped me."[105]

In smaller theaters where there was no orchestra, did patrons provide dialogue and sound effects? Were title cards read aloud to nonliterate neighbors? Perhaps with some embellishment? Eddie Wilson, while still a traveling showman, often recited the intertitles so that everyone in the audience could understand. According to his daughter, "He gained great skill and acquired a verve that added to the enjoyment of his movie

patrons." She described the audience as fascinated and enthusiastic, "laughter whooped, bouncing against the walls of the school assembly hall."[106]

But even in larger theaters, people were sometimes demonstrative. Maybelle Chew, a vaudeville columnist at the *Afro-American,* wrote about some members of the audience at the Royal in Baltimore talking aloud to the screen "tearfully and wrathfully," and Lester Walton described in the *New York Age* the response at the Lafayette Theatre to the scene in Oscar Micheaux's *The Brute* (1920) where Sam Langford knocks out Marty Cutler: "My, such noise from the audience! Men, women and children get excited as if at a real fight and cheer." Indeed, aspects of some films might have encouraged noisy participation. Evelyn Preer amused readers of the *Pittsburgh Courier* by reporting that when *Within Our Gates* (1920) opened in Chicago at the Vendome Theater, a man in the audience got so emotional during the scene where the character she played was being attacked by a white man that the spectator leaped to his feet yelling, "Kill him!" and uttering some other choice words Preer left to the reader's imagination. At one point in that same film, headlines in a racist newspaper differed so grossly from what the audience has just seen enacted that they seemed to invite the audience to respond. Likewise, the long patriotic speech at the end of the film also serves as a moment that invites an affirmative declaration from the audience, perhaps the 1920 equivalent of "right on!" The film offered a chance to speak out in both anger and affirmation. Back talk can be an act of resistance and daring, especially for those who have been taught to hold their tongue before whites or in mixed crowds.[107]

Some of the nonfilm events on the program—Race lecturers, vaudeville acts, musical and novelty numbers, song slide sing-a-longs, and amateur shows—may have also encouraged participation. Thus the picture house could become a public gathering with congenial interaction, where emotions were less restrained than in the hostile world outside.

The location of a theater and the character of the neighborhood could influence attendance as well. Waller points out that when the proprietors of the Frolic Theater sought a site for their new nickelodeon in 1907, they avoided the "Colored Main Street," which was known for its saloons and other houses of entertainment, and instead selected a small building on

the edge of the downtown commercial district, near a structure that housed the office of Lexington's Black weekly. D. Ireland Thomas, responding to a letter from the manager of a Race theater in Baltimore, implored, "Good order includes the lobby of your theater and the sidewalk in front of your place of amusement as well."[108]

Unlike lodge halls and wrestling matches, the movie theaters were places that welcomed families. A theater courting women and children, especially one located in a neighborhood associated with other types of amusements like pool halls or bars (places that may have shunned women or that the church deemed inappropriate for the family), would promote itself as serving the "respectable" family trade. Chicago's Phoenix Theatre on the Stroll, for example, advertised that it catered to ladies and children, showing "selected high class motion pictures, high class vocal and instrumental music, [and a] first class colored orchestra."[109]

A program including special music or special ticket pricing might attract a family trade. Micheaux's *Symbol of the Unconquered* (1920) opened at the Lafayette Theatre in New York on December 27 of that year, with music by the Exposition Jubilee Four, a violin selection by soloist Eugene Mars Martin accompanied by pianist Hazel Thomas, and the Lafayette Theatre Orchestra. The *New York Age* reported: "The presence on the bill of Eugene Mars Martin, the youthful violinist, is worthy of special mention. Aside from the fact that the audiences unmistakably show appreciation for high-class music when rendered with intelligence and skill, the incident should mark the beginning of a closer relationship between the Lafayette Theatre and such institutions as the Smith-Martin School, where talented young musicians of both sexes receive instruction."[110] When Lincoln Motion Picture Company's feature *By Right of Birth* (1921) opened at the 1,500-seat Trinity Auditorium in Los Angeles, tickets ranged from fifty cents to a dollar; the bill included a sixty-piece band led by John C. Spikes, as well as two vocal solos and four instrumental numbers. Spikes had written a song, "Juanita" (the name of the leading character), for the film, and it was sung at the Trinity Auditorium by Malcolm Patton.[111]

But no matter how "respectable" such special occasions might be, some Black Americans did not attend the movies. Whether because of religious reasons or less clearly defined codes of "gentility," a certain segment of

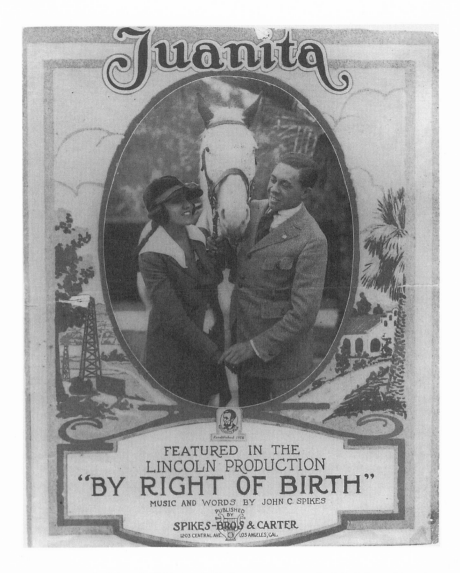

Sheet music "Juanita" (John C. Spikes, composer/lyricist) from Lincoln Motion Picture Company's *By Right of Birth* (1921). Courtesy of the George P. Johnson Negro Film Collection, Department of Special Collections, Charles E. Young Research Library, UCLA.

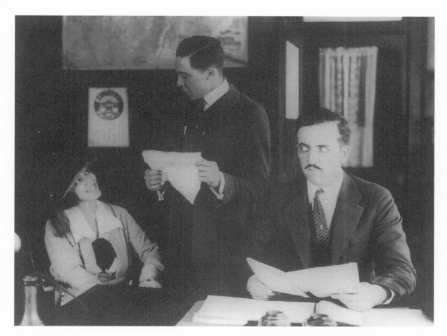

Still from *By Right of Birth,* from left to right: Anita Thompson,
Clarence Brooks, and W. E. Stanley Kimbrough.
Courtesy of the George P. Johnson Negro Film Collection, Department of
Special Collections, Charles E. Young Research Library, UCLA.

the Black society avoided the cinema altogether, whether it be a segre-
gated "picture palace" or a more modest "Colored theater." D. Ireland
Thomas advised one would-be theater owner that if he deducted the whites,
babies, and church folks from the population of his small town, there would
not be enough patrons to support a Colored theater.[112] Thomas's own
daughter-in-law did not go to the movies as a young woman. Although she
did not remember specific prohibitions, her entertainment centered on
church social groups, instead.[113]

Some church people did look down upon the movies. At the 1910
Interdenominational Ministerial Conference, Reverend M. W. Clair, pas-
tor of the Asbury M. E. Church in Washington, D.C., expressed concern
about the effects of moving picture theaters on church attendance and
the moral character of young people and called for a crusade against the
nickel-and-dime amusement places.[114] But others, such as Reverend
Adam Clayton Powell, Sr., pastor of Harlem's Abyssinian Baptist Church,

preferred a "campaign of purification" and felt that the photoplay could be used to attract people to the church.[115] Reverend James M. Webb announced in 1920 the founding of the Liberty Studio Film Company in Los Angeles, which would be filming his book and slide lecture, *The Black Man's Part in the Bible.*[116]

Some congregations showed films in church or held special meetings in movie houses. An interdenominational group of New York City ministers in 1910 instituted an effort to bring men back into the fold. Reverend Gilbert, pastor of Mount Olivet Baptist Church, stated that since the group intended "to see that the church seeks the sinners instead of waiting for sinners to seek the church," it was agreed "not to be any too particular where such meetings should be held." One Sunday service was held at the Crescent Theatre, on 135th Street, and featured a showing of the "entertaining as well as instructive" moving picture, *Star of the East,* along with a sermon on "The Wages of Sin." Three hundred men attended.[117]

In a biting critique in the *Half-Century Magazine,* Jean Voltaire Smith wrote that "long sermons against the movies, admonitions to stay away from them seem to result in empty pews. . . . And the number of movie fans is on the increase. The fact that the program is changed nightly in most theaters causes many of the patrons to attend several shows a week. Indeed a canvas of the schools in one of the large cities brought out the fact that some of the students as well as the teachers attended as many as nine shows a week. This means that an enormous amount of money is spent in the motion picture theatres, much of which might reach the church, if the movies were less popular." Smith noted the educational value of films: "Historical and Biblical [photo]plays, so popular just now, are giving school children as well as adults a clearer understanding of the Bible and history. Likewise current events of interest to all are flashed on the screen each week to keep informed, those who are too busy to read the papers carefully." The *Freeman,* too, discussed Race films as having a "mission . . . as sure and certain as those of the church and school room."[118] Indeed, early Race pictures were often discussed in terms of their edifying values. The next chapter will look more closely at the kinds of discourses that surrounded these films and their production and the nascent Race picture "industry."

# 3 In Search of an Audience, Part II

Sirs: Your article on Oscar Micheaux brought to my attention an untilled field in the race's life. The Negro is thirsty for the silent drama about his own. And there is big money there for the strictly businessman.
—George Jones, *Half-Century Magazine,* June 1919

Moving pictures have become one of the greatest vitalizing forces in race adjustment, and we are just beginning.
—Oscar Micheaux, *Competitor,* January–February 1921

ALTHOUGH FEW early African American films still exist, much can be learned from the discourses surrounding their production and exhibition. Motion pictures were seen by many as a tool for building people's awareness, a force for social betterment, and ought, they said, to make a strong moral statement. The Southern Motion Picture Company's *When True Love Wins* (1915; written by Isaac Fisher of Tuskegee Institute), for example, was described in the *Norfolk Journal and Guide* as showing "the Negro race as intelligent, refined characters." The manager of the Birmingham firm commented: "I was proud of the reception of our play but it only verifies our belief in the race pride of the colored people. I have long since been convinced that the better class of the colored people would soon get tired of always seeing their race shown on the screen either in a scrap or in a crap game and it was for this reason that we asked Mr. Fisher to write this play in which the better side of the race could be presented." In 1917, the Ker-Mar Picture Producing Corporation reported in the *Afro-American* its intention to make "pictures using colored performers

depicting incidents and happenings from long before slavery to the present day. Showing that, with the limited advantages they have had, colored people now rank among the foremost in all walks of life." The Royal Garden Film Company's *In the Depths of Our Hearts,* while still in pre-production, was described in the *Chicago Whip* as "teach[ing] a great moral lesson and will no doubt be one of the most instructive pictures recently placed on the canvas." When the film, a drama about a family of "blue veins" and their prejudice against those of darker hue, was released in 1920, the *Chicago Defender* applauded the "wonderful lessons" taught in the film. *A Giant of His Race* (1921) was praised in the *New York Age:* "the educational value surpasses anything ever attempted in a colored picture, and the strong thread of a well-told romance is full of inspiration." And the Unique Film Company's three-reel film *Shadowed by the Devil* (1916) was enthusiastically greeted by the *Champion Magazine:* "Its theme is morality."[1]

When *Realization of a Negro's Ambition* (1916), Lincoln Motion Picture Company's first release, a two-reel drama, played at the Lincoln Electric Park, in Kansas City, Missouri, during the week of the National Negro Business League's 1916 convention, it was heralded as "an interesting, inspiring and commendable educational love drama" and "a very clean, interesting drama, minus all burlesques and suggestive features."[2] When *Realization of a Negro's Ambition* and *Trooper of Troop K* (also 1916) played at Tuskegee Institute the following year, the *Tuskegee Student* wrote effusively, "Such pictures as these are not only elevating and inspiring in themselves, but they are also calculated to instill principles of race pride and loyalty in the minds of the colored people." In a promotional campaign in the *Chicago Defender* and other papers, Lincoln advertised that it would refund the admission price to anyone not "highly pleased or satisfied with the class, photography, dignity and morals of any Lincoln Race Feature."[3]

The Lincoln Motion Picture Company chose the route of gentle persuasion in "uplifting" films about honor and achievement, the rewards of good character, morality, and ambition, picturing strong, positive role models to strengthen race consciousness and identity. An ad for the Omaha run of *The Law of Nature* (1917), for example, described the picture as "classy" and having "a wholesome moral." In its 1921 stock offering, Lincoln described itself as the producer and distributor of "meritorious Negro Photo-plays."[4] As George P. Johnson, put it, Lincoln's "dignified

Jimmy Smith and Beulah Hall in a still from Lincoln Motion Picture Company's *Trooper of Troop K* (1916). Courtesy of the Photographs and Prints Division, Schomburg Center for Research in Black Culture, The New York Public Library, Astor, Lenox and Tilden Foundations.

classy Race photo-plays," were "unoffensive to the Race or to the Northern or Southern white man."[5] In its issue of January–February 1921, the *Competitor* magazine went so far as to claim that Negro photoplays might produce "a better understanding between the races."

"Too often," lamented the *New York News* on September 24, 1914, "white moving picture houses built for the patronage of colored people present pictures that are contrary to the true sentiment of our race. First of all they obtain comedy releases containing caricatures of the black race. These watermelon-eating, chicken-stealing comedies are elaborately billed in black belts as colored moving pictures. The young of our race who see too often these pernicious libels on our character become imbued with the loss of self-respect." The article went on to condemn the members of the Race who participate in the productions: "The pittance they earn is as vile as the pieces of silver Judas threw into the Potter's field." When *Realization of a Negro's Ambition* played at the Lincoln Electric Park,

one paper took the occasion to comment that "the trend of public sentiment among Race lovers of the silent drama is growing so antagonistic to the insulting, humiliating and undignified portrayal of the cheap burlesques, slap-stick comedies so universally shown as characteristic of the Afro-American ideals."[6]

While some members of the audience may have laughed at them, such comedies and their pejorative notions of Race were roundly denounced as being an inauthentic picture of Black America and an embarassment. Ebony Film Corporation, a Chicago firm with studios in both Chicago and Lake Winnebago, Wisconsin, was owned by whites and managed by Luther J. Pollard, the sole Negro officer of the company. It released many comic shorts in the late teens, including *A Black Sherlock Holmes, Spying the Spy, Spooks,* and *"Mercy" The Mummy Mumbled,* and employed a large stock company of Black performers. The company advertised its product in the trade press as "REAL NEGRO COMEDIES WITH REAL NEGRO PLAYERS, Animated with the Matchless Native Humor of the Race."[7]

Although Ebony's films were booked in both Black and white houses, the company's 1918 full-page advertisements in *Motion Picture World* seems to address a white exhibitor. ("Colored people are funny. If colored people weren't funny, there would be no plantation melodies, no banjoes, no cake walk, no buck and wing dance, no minstrel show and no black-face vaudeville. And they are funny in the studio.")[8] These films were heavily criticized in the Black press. One reader of the *Chicago Defender* wrote a letter of protest to columnist Tony Langston,

"I consider it my duty, as a member of the respectable class of theater patrons, to protest against a certain class of pictures which have been and are being shown at the theaters in this district. I refer to pictures being exploited by the Ebony Film Company [sic], according to the advertisements, and which make an exaggerated display of the disgraceful actions of the lowest element of the race. . . . It was with abject humiliation that myself and many of my friends sat through the scenes of degradation shown on the screen, and if they were meant for comedy, the meaning certainly miscarried. When the beastly actions of the degraded of our people are flaunted before our eyes in places of amusement it is high time to protest in the name of common decency."

Langston replied: "It would hardly be good policy for any theatre in this district to book pictures from a company whose photoplays carry 'comedy' that causes respectable ladies and gentlemen to blush with shame and humiliation. . . . I want to advise the members of the race to watch the booking advertised by the theaters in the 'belt,' and when you see one of these so-called 'all-colored comedies' advertised, keep your money in your pocket and save that dime as well as your self-respect. Some day we will have race dramas which will uplift, instead of rotten stuff which degrades."[9]

On May 12, 1917, the *Defender* ran a large two-column article about the Phoenix Theatre's refusal to play Ebony's *A Natural Born Shooter,* which it found to be degrading. "At no time has the *Defender* been asleep on this low comedy proposition; the exploitation of films which exhibit the depraved ideas which a certain set of cheap scenario writers have regarding the moral nature of our people will not go unchallenged. . . . We want clean Race pictures or none at all and the sooner that these detractors discover that the *Defender* is in the fight against their rotten stuff the better."

The complaints included not only comedies but also dramatic and documentary films that used the Negro as a comic element. On March 16, 1918, the *Defender* reported two theaters in the "belt" canceling the white-made serial *Son of Democracy,* about the life of Abraham Lincoln, after screening the fourth episode which pictured a "youthful member of the Race's inclination to pilfer poultry." On May 4 of that year, *New York Age* columnist Lester A. Walton wrote bitterly about a scene in a Universal Screen Magazine film playing in a Harlem theater that showed the New York State mounted police in action.

> All was true to life and interesting until the "comedy" feature of the picture was flashed. Then the police were shown in the act of arresting several colored men who had made a midnight raid on a chicken-house in the country. Although this piece of screen business was designed to make people laugh, I did not hear as much as a titter. . . . That the state police who are paid by the colored and white taxpayers should be a party to this disgraceful incident is surprising. . . . However, the worst offenders were the colored men who were so lacking in self respect as to pose as chicken thieves for a few paltry dollars. . . . If it is the mission

of the Universal Screen Magazine to reproduce real life on the reel, it is befitting that it stick to facts instead of wandering into the realms of imagination, where base misrepresentation oft-times lurks in the guise of "comedy."

In the August 24 issue, Walton was critical of two shorts depicting American soldiers fighting in France. One of these films, "after showing white Americans in the trenches at their best, portrayed a colored soldier, a most dumb specimen of humanity, sitting with book in hand trying to learn French. The man who posed for the picture was scratching his head and gazing into the book in bewildered fashion. Evidently he was as dumb as he looked for no intelligent, self-respecting colored soldier would permit himself to be used as a clown."

The second film, he wrote, showed "white troops engaged in fighting the Hun. Then a 'joke' was flashed in which one colored man called another 'niggah' in a controversy as to whether it would be safer to enlist in the army or navy. The implication behind this 'piece of humor' was that two badly frightened Negroes were figuring on the less dangerous way to serve their country." At a time of heightened awareness within the community of the valor of the African American soldier in the field, Walton's indignation must have been shared by many others.

George P. Johnson, of the Lincoln Motion Picture Company, wrote a militant and well-reasoned letter to the government's Committee on Public Information concerning war movies: "Owing to obvious reasons the colored people are not represented in the Motion Pictures Directors Association; hence the suppositions are that the plan to take care of the colored citizens will be merely to enact some humiliating farce in the way of burlesque comedy staged either by some white directors and actors or inexperienced colored actors." He suggested that his company would be better able to give the committee "a clearer and closer understanding of what our three years of experience has proven as necessary to give the colored people their fair and due representation in the film industry and propaganda, that their loyalty, patriotism and representation should entitle them to." Johnson ended by pointing out that "in the case of the $7,000,000 appropriation for Government War Film Propaganda, fully from 10% to 12% of this sum should be set aside and devoted exclusively to interests of the 12,000,000 colored Americans; . . . present[ing] the col-

ored man's side in a manner unhumiliating and worthy of the talent and ability we can put forth."[10]

Calls for cultural expression began in the late nineteenth century as a way to break from the past of slavery and the false promises of Reconstruction. Struggles for cultural visibility paralleled struggles for political visibility. These attempts to refashion self and society were thought to be not only empowering in themselves but also furthering the process of political consolidation. Editorials in African American newspapers enjoined their readership, in literary critic John S. Wright's words, to "begin building a new group personality, a new civilization, and a correspondingly new flowering of art," seeing the arts as both a reservoir of culture and a concise statement of a people's humanity. Anna Julia Cooper, in her 1892 book *A Voice from the South by a Black Woman of the South,* wrote of the need for "an authentic portrait, at once aesthetic and true to life, presenting the black man as a free American citizen, not the humble slave of *Uncle Tom's Cabin*—but the *man,* divinely struggling and aspiring yet tragically warped and distorted by the adverse winds of circumstance. . . . The canvas awaits the brush of the colored man himself." Echoing the importance of self-representation for cultural survival, Victoria Earle Matthews addressed the 1895 First Congress of Colored Women of the United States about the "unnaturally suppressed inner lives which our people have been compelled to lead" and suggested that a "Race Literature" would "enlarge our scope, make us better known wherever real lasting culture exists." Dr. M. A. Majors proclaimed in the *Half-Century Magazine* in 1919: "There is something that the Negro needs more than he needs food and raiment and finery and that is a dogged spirit to carve out his life into the history of the times. . . . We need books, and we need a deal of race pride to go with them. We need elevation of minds to go along with our better pride."[11]

Alex Rogers, considering the possibility of a great American Negro play, suggested, "It remains for the Negro to show the public that he understands his own people thoroughly and show it so strong that they all must understand." He goes on to quote W.E.B. Du Bois: "The history of art in this nation will not be written until the Negro has made his contribution." A theater critic for the *(Indianapolis) Freeman* pointed out that African American plays would also have the potential to benefit white America:

"The mission of the stage is twofold—to furnish wholesome entertainment and to instruct, and the Negro play can play a most important part in the solving of one of America's most vexatious problems, maybe so in a large measure because of the average white American's misconception of and indifference to what the Negro is really thinking and doing." Negro plays acted by Negro actors, according to this critic, would profit "the drama, America and the Negro" greatly.[12]

When Bert Williams was at the height of his success in 1915, and said to be earning an annual salary from Florenz Ziegfeld of $52,000, he told the *Chicago Defender* on March 27:

> I do not call what I am doing "art" by any means. I am now play-ing the first-class theaters. But I am doing piffle. That is, it is little in comparison with what I wish to do. Singing a half dozen coon songs and telling a few Negro dialect stories does not sat-isfy my ambition.
>
> I want to be the interpreter of the Negro on the stage; not the Negro you see me as now—that is, the burlesque Negro, just as the stage Jew is a Jew drawn with red paint and not the faith-ful black ink. The Negro has a place and a big one in the history of this country, and he has to be shown in the drama just as he exists in real life.
>
> For hasn't he heart throbs? Doesn't he lie awake nights smarting under the custom that makes him a pariah in the life of the community? Isn't the flow of his life being checked as it gets under way?

His lament anticipated Langston Hughes's "Minstrel Man" written ten years later:

> Because my mouth
> Is wide with laughter
> And my throat
> Is deep with song,
> You do not think
> I suffer after
> I have held my pain
> So long.
>
> Because my mouth
> Is wide with laughter,
> You do not hear

HIS SPECTATORS

My inner cry.
Because my feet
Are gay with dancing,
You do not know
I die.[13]

As early as September 9, 1915, in a *Defender* article titled "Moving Pictures Offer the Greatest Opportunity to the American Negro in History of the Race from Every Point of View," Juli Jones, Jr., observed: "In a moving picture the Negro would off-set so many insults to the race—could tell their side of the birth of this great race—could show what a great man Frederick Douglas [sic] was, the work of Tousant LaOverture [sic], Don Pedro and the battle of San Juan Hill, the things that will never be told only by the Negroes themselves. The world is very anxious to know more of the set-aside race, that has kept America in a political and social argument for the last two hundred and fifty years. . . . It is the Negro business man's only international chance to make money and put his race right with the world."

Discussing the educational and entertainment value of moving pictures, the *Freeman* in 1916 called for "pictures of ourselves by ourselves." The article praised the dramatic plots of heroic deeds and romance in Peter P. Jones's films as well as the documentation of "real and enduring" actualities. "A race will not amount to much if it has no ideals or 'idols.' " In 1920, Clarence Muse announced he and the Delsarte Players would soon be leaving for Haiti to film an epic about Toussaint L'Ouverture. Two years later, Leigh Whipper announced in the *Billboard* his intention to film the life of Frederick Douglass.[14]

These calls for ameliorative depictions of African American subjects and African American life were based on the conviction that African American filmmaking would express authentic social and psychological truths, truths validated by the authority of experiences. Cultural expression was thought to be simultaneously a measure of civilization and an agent for self-improvement. George P. Johnson opined that whereas books appeal to the educated, "photo-plays appeal to all regardless of age or degree of education. It is fast becoming the cheapest and most effective form of national publicity."[15]

In March 1919, the *Half-Century Magazine* called attention to *Shadowed by the Devil* as the initial effort of the screenwriter, a woman whom it never

named, and discussed her motivation: "Too much mockery, too much cheap fun, has been made of the Colored people in the movies. She believed that there exists a seriousness of nature in the Negro's heart that knocks for expression. She has no doubt but that the life of the Negro rightfully presented can interest the whole country." The article's author, Howe Alexander, called for "a race unity that will demand high class, serious motion picture drama. The race needs to know of its own life expertly and fascinatingly presented. . . . We want serious motion picture drama and will get it if we mass our efforts and insist that the motion picture houses that cater to Colored trade get them." He commended Colored people's success in supporting their own churches, running their own YW and YMCAs, and backing their own baseball teams. "Why has the motion picture drama lagged so far into the background? Surely we will group our desire and go after the best in the motion picture world that aims at portraying the race in its best clothes."[16]

Like so many of his contemporaries, Oscar Micheaux, trying to attract an audience with the very first newspaper ad introducing his pre-

Publicity photo from the Unique Film Company's *Shadowed by the Devil* (1916) in the the *Half-Century Magazine,* March 1919.
Courtesy of the Photographs and Prints Division, Schomburg Center for Research in Black Culture, The New York Public Library, Astor, Lenox and Tilden Foundations.

HIS SPECTATORS

miere film, drew on both the engaging and transformative powers of art: "In view of the great popularity of the Film-play, which, up to date, has given the Black Man and Woman almost no opportunity to display their stellar qualities, every Race man and woman should cast aside their skepticism regarding the Negro's ability as a motion picture star and go and see, not only for the absorbing interest obtaining therein, but as an appreciation of those finer arts which no race can ignore and hope to obtain a higher plane of thought and action."[17] In an article in the *Half-Century Magazine,* he went on to assert, "I can say now without fear or favor, the Negro will break into the movies, in the way he wishes to see himself portrayed when members of the race open the way, and only through race people."[18] A year and a half later, after having produced four films, he spoke of the moving picture as "one of the greatest vitalizing forces in race adjustment."[19]

Shortly after the Kansas Board of Censors viewed his first film, one white member of the board presented Micheaux with a scenario that she was interested in having produced. Micheaux described the encounter:

> She . . . gave me a synopsis of it, ending with the statement, 'And you cannot imagine what a perfectly lovely and original title I have given it! . . . *A Good Old Darkey"* . . . and looked kindly up into my face for approval. Now the point is here clearly illustrated. As in the case of this kindly disposed northern woman, it seems the white race will never come to look upon us in a serious light, which perhaps explains why we are always caricatured in almost all the photoplays we have even the smallest and most insignificant part in. Always the "good old darkey," our present environments and desires seem under a cover to them, and as the time is here when the black man is rightfully tired of being looked upon only as a "good darkey," my statement that the race will only be brought seriously into the silent drama when men of the race, through whose veins course the blood of sympathy and understanding of our peculiar position in our great American Society puts him in [sic].[20]

Oscar Micheaux was joining a long-standing discussion on the need for Black material in theater as well as film. In the midteens, the Anita Bush Stock Company, precursor of the Lafayette Players, had been chastised for relying on white authors for the plays it produced. Lester Walton wrote

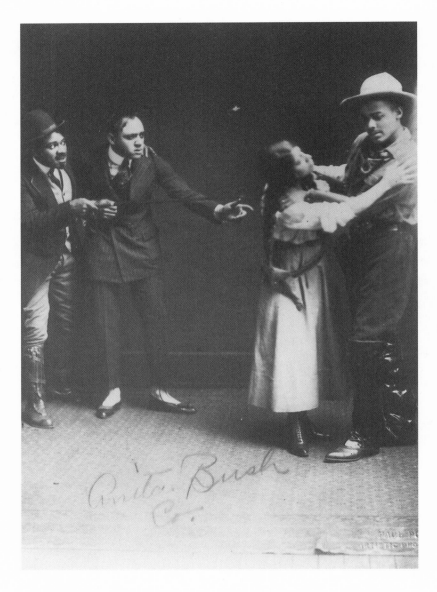

Anita Bush on stage at the Lincoln Theater with some members of her stock company, circa 1915. Courtesy of African Diaspora Images.

in the *New York Age,* on January 10, 1916: "Since the vogue of the Anita Bush Stock Company . . . , repeated demands have been made by members of the race that this popular dramatic organization present sketches dealing with Negro life. The chief criticism aimed at the offerings of the company has been that Negro characters and Negro environment are entirely ignored by those who are doing so much toward cultivating a taste among colored theatergoers for the dramatic. So in compliance with this insistent request," the company gave a condensed version of *The Octoroon* and offered a prize "for the best sixty-minute sketch dealing with Negro life." Walton noted, "Those previously fired with ambition to write

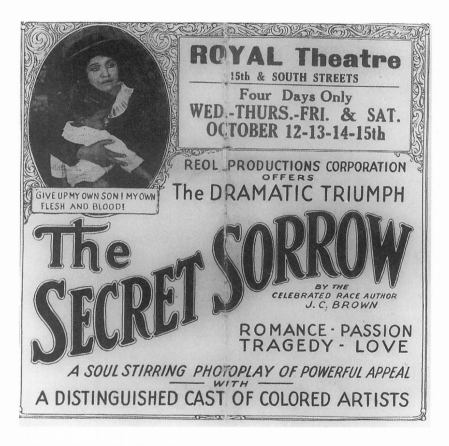

Handbill from the Royal Theatre, Philadelphia, for the Reol Production
Company's *The Secret Sorrow* (1921). Courtesy of the
George P. Johnson Negro Film Collection, Department of Special
Collections, Charles E. Young Research Library, UCLA.

Negro plays and sketches, but who deplored the fact that there was no demand for their offering, now find that conditions have suddenly taken a change for the better and there is a market for sketches of merit."

Several years later, the Reol Production Company attempted to capitalize on this dialogue by announcing to the press that it was seeking talented Negro writers on college campuses for its new film company.[21] Reol promoted its films to theaters by emphasizing that they were based on the stories and plays of Negro authors and starred the well-known performers of the Lafayette Players. Their first production, Paul Laurence Dunbar's *The Sport of the Gods* (1921), was touted as "The Most Remarkable Production Ever Filmed—Will Renew Race Pride in Every Breast—The Name of Paul Laurence Dunbar is Associated with the Highest Achievement of Our People."[22] *The Call of His People* was advertised as "from the famous story 'The Man Who Would Be White' by Aubrey Bowser," and *The Secret Sorrow* as by "the celebrated Race author, J. C. Brown." (Both films were also released in 1921.)

---

AT A TIME when the meanings and boundaries of American citizenship were being reinterpreted, Race pictures offered opportunities for both entrepreneurial and racial expression. This was in tune with Booker T. Washington's theories of self-help and the possibilities of Negro economic stability through the development of trade and entrepreneurial opportunities.[23] Washington's speech to the 1909 National Negro Business League reminded the conferees, "Competition [from whites] must be met not by sentiment nor by appeal to race prejudice, but by superior service, superior usefulness." He suggested planning a mammoth celebration of fifty years of freedom to display the progress of the Race. "In an increasing degree we must be an optimistic race. There is no hope for a despairing individual or a despairing race."[24]

Washington used film to advertise and raise money for Tuskegee Institute. The Broome Exhibition Company of Boston ("a group of Negro business men," with George W. Broome as manager, who thought it would be "a good thing, as well as a paying investment, to produce some pictures that would show colored people what colored people are doing") made films of "forty-three subjects." The company took footage of "the great

HIS SPECTATORS

Negro industrial school at Tuskegee in action," showing the buildings, students learning trades, working in the fields and the dairy, and "the body of 1600 students in motion, marching to chapel." This film was used at a New York fund-raiser, January 24, 1910, at Carnegie Hall.[25] The Broome films were also previewed to such leaders as Emmett J. Scott and Dr. Robert L. Park at the Crescent Theatre in Harlem and later played to the general public at the Temple Theater on Tremont Street in Boston.[26] Along with a film of "Congregations of the Colored Churches of Boston, leaving Church on a Sunday Morning," and "many other characteristic and interesting pictures . . . of the Negro," the Tuskegee footage also played in several churches in New York City, with special showings during the National Negro Business League's August 1910 meeting at the Palm Garden.[27] The Broome Exhibition Company notified the press of its plans to film Hampton Institute, Fisk University, and Shaw College, as well as the Tenth Cavalry, the crack Negro Regiment, then located at Fort Ethan Allen in Vermont.[28]

The Afro-American Film Company's moving pictures of the fourteenth meeting of the National Negro Business League in Philadelphia played, along with vaudeville acts, at the Lafayette Theatre for several days in the late summer of 1913. Although the *New York Age* criticized the quality of the photography, it praised the company for its "commendable" and "opportune" undertaking.[29] In 1914, this New York City company proposed recording the activities of notable Negroes such as Booker T. Washington, and the newly reorganized Haynes Photoplay Company subsequently did film newsreels of Washington and other well-known African Americans, the Odd Fellows Convention in Boston, the National Baptist Jubilee in Nashville, as well as popular prizefighters.[30]

In the spring of 1914, the *Chicago Defender* announced that Peter P. Jones, a former State Street still photographer, a member of the Association of Photographers who was also affiliated with the Victor Georg Galleries and with Moffet and the Matzene Studio, would be taking moving pictures of the Shriners convention. "Mr. Jones now heads a moving picture company made up of South American businessmen with a capital of $100,000 organized for the purpose of making pictures showing the progress of the Afro-American in the United States. This is the first moving picture ever taken of the Shriners and marks the beginning of a series

of our marching organizations and other features of race life that will encourage and uplift."[31] Jones had taken portraits of such well-known Race men as artist Henry O. Tanner and banker Jesse C. Binga, and athletes such as wrestler Illa Vincent. He also shot giveaway portraits of dancing school patrons and architectural views (the interior of St. Thomas Episcopal Church was described as a difficult feat by the *Defender*) and was championed by the paper as "our master photographer."[32]

The Peter P. Jones Film Company of Chicago exhibited five thousand feet of film from the 1915 Illinois National Half-Century Anniversary Exposition and the Lincoln Jubilee; scenes of the Eighth Regiment (a two-reeler, *Negro Soldiers Fighting for Uncle Sam*), which included a little drama about a colonel's daughter and her two military suitors; a comedy, *The Troubles of Sambo and Dinah;* and a three-reel compilation, *The Dawn of Truth,* billed both as the "Progress of the Negro: Facts from Farm, Factory and Fireside" and as "The Re-birth of a Nation." The film showed scenes of such places as Tuskegee Institute and Mound Bayou, Mississippi, "a Negro city built by a former slave." In a review of the program, the *Freeman* praised it for showing "the victories" of the Race, "an answer to that orgy of contempt . . . *[The] Birth of a Nation.*" These pictures "tell the story of the ascent from life's hovel to where the Negroes fused and became one with other people in the great melting pot of the nation. . . . The victories are the subject, leaving it to the dead past to bury its dead." The *Freeman* praised Jones for his expertise and held him up as an example of the artistic progress being made by Negroes in the moving picture business.[33]

William Foster, whom Henry T. Sampson credits as the first African American motion picture producer, screened his newsreel of a YMCA parade along with his first short comedy, the two-reel *The Railroad Porter* (1913).[34]

These early filmmakers were soon joined by other entrepreneurs who drew upon the discourses of Race progress and Race pride, and their productions were lauded in the press. On February 19, 1916, the *Chicago Defender*'s front page recounted the story of the formation of the Heart of America Film Corporation, a Kansas City, Missouri, firm. The founder of the company, A. A. Anderson, had written a scenario depicting the American Race man "from the earliest days, when he was a barbarian in Africa, down through American history, and a great dream of the future

HIS SPECTATORS

. . . [hoping] to show the advancement and development of the Negro and at the same time arouse in him an ambition for the future." The production planned to employ a cast of several hundred Negroes.

On October 21, 1916, the *Norfolk Journal and Guide,* in a front-page article titled "Race Progress in Movies," reported on the daily filming of the Raleigh, North Carolina, Negro State Fair: "The management has great pleasure in the announcement that arrangements have been completed by which [footage of] the coming great Negro Fair will be placed in the moving picture shows. This is something entirely new and must prove very attractive. The films will be made daily and will give life-sized views of the big show as it is going on from day to day. Exhibitors, exhibits, racing, midway scenes, the moving throng all will be shown. Be there and have your picture appear with others. These films will be largely used to advertise the next fair in all parts of the State and the pictures should be made as representative as is possible to make them. No charge, all free. Be sure and be there." The films were to show agricultural exhibits, parades, auto show, stock, motorcycle races, as well as practical demonstration in domestic science and household industry. "This year the midway will be crowded with high-class, clean amusements and there will be many free attractions. Altogether, Fair week this year will be a fare of opportunity for pleasure and profit. The prosperous condition of people, the high prices our farmers are receiving for their crops, the general good cheer everywhere apparent, should cause an attendance at the coming Fair unprecedented."

On June 23, 1916, the *St. Louis Argus,* under the heading "Story of Progress Will Be Told in Motion Pictures," reported the founding of the Allmon-Hudlin Film Company, a "new Negro enterprise," to produce and exhibit films. Organized by Charles Allmon, a "practical moving picture operator" who had been giving shows in St. Louis and the suburban towns for several years, and managed by Richard A. Hudlin, a news writer, actor, and dramatic manager, "the new film company has been engaged for several weeks photographing scenes of interest to the Colored people of St. Louis, which they will begin to exhibit next week to the public in a series of exhibitions. Among the attractive pictures that will be thrown on the screen will be pictures of the exterior and interior of the largest and finest Negro churches, showing the pastors and congregation

in action and the choirs in solemn processional." The company also shot footage of several of the largest public schools; the St. Louis Colored Orphan Home; the St. Louis Old Folks' Home; the annual public schools' field day, with drills, athletic events, and Maypole dances; the Masonic parade; and a baseball game between the St. Louis Giants and the Nashville Giants. "The promoters of the new enterprise believe they have discovered a new and fertile field worthy of all the brains and capital that can be put into it to develop its possibilities, in telling the true story of Negro American life in realistic motion pictures."

———

OSCAR MICHEAUX's candor about oppression and wrongdoing was rare in early Race pictures. More usual were self-congratulatory movies testifying to racial progress. Many early African American film businesses attempted to document places and events that would be a source of pride for, and of interest to, Black audiences—material which might otherwise go unnoticed. These films were opportunities for large groups of people to come together to articulate a pride in their heritage and racial identity, to demonstrate a sense of personal and historical agency. There was an impulse to document the culture and cultural experiences, to validate one's own self-perceptions and, at the same time, to counterbalance notions of "inferiority."

To see one's people displayed with dignity in public was in itself transgressive at a time when Black people were thought to have no group solidarity, no traditions, and no self-respect. A letter from a recent migrant to East Chicago, Indiana, to a friend down home in his "little city" of Union Springs, Alabama, serves to illustrate the point. After discussing working conditions and wages, he wrote, "I wish many time you could see our People up here as they are entirely in a different light. I witness Decoration Day on May 30th [1917], the line was 4 miles. (8) brass band[s]. All business houses was close. I tell you the people here are patriotic."[35]

Such filmed documents were being shown even into the early twenties, when feature-length dramatic films were becoming more available. *A Day in the Nation's Capital,* a Colored News Pictorial, showed a "colored fire fighting company, the Howard University Commencement, beautiful buildings in the nation's capital, race and business men, etc."[36] And

HIS SPECTATORS

the Pyramid Pictures Corporation of Chicago made *A Day in the Magic City,* about the Colored people of Birmingham, and *Youth, Pride and Achievement,* about the success of people of the Race in Atlanta.[37]

Edward L. Snyder of Chicago, addressing the National Negro Business League's annual meeting in Atlanta in 1921, told the participants: "[We want] to make motion pictures of colored people in many parts of the country. . . . What we want to do now is to get the message to the people. We are going to establish a news bureau here in Atlanta, so that we can . . . reach people all over in a short space of time giving them valuable information as to what the colored people are doing in Boston, New York, Cuba and other parts. It is our purpose to make a local motion picture revealing the Negro to himself and to the world."[38]

For many Black Americans, Marcus Garvey, with his assertive sense of dignity, optimistic faith in capitalism, and manly slogan, "Up, you mighty race," epitomized this resurgence of Race consciousness and gave it a direction. Like Booker T. Washington, Garvey used film to promote his ideas and to raise funds to support his enterprises. His use of uniforms, pageantry, and processions was recorded in a 1921 motion picture made by C. B. Campbell, the official photographer of the United Negro Improvement Association. The film showed the ships of the Black Star Line "steaming majestically up the Hudson with Black Captains and Crews," along with footage of "the mammoth success of the Negro; the Hon. Marcus Garvey and his cabinet in robes of state."[39]

During the Great War, many companies sold products that were expressions of Race pride: "Colored Man No Slacker," a mounted print "all ready for framing," was advertised as "The World War's Most Patriotic Picture—Should Be In Every Home . . . Where Race Pride Dwells." The Art Publishing Company of New York sold sixteen-by-twenty-inch pictures in "full life tone colors," called "Our Boys," and sets of postcards of colored troops. Charles A. Shaw in Atlanta offered a "beautifully illustrated sixty-four page booklet, two colors, embossed cover . . . of Colored Soldiers in France" for $1.25. And the Touissant Studios in New York City published inexpensive engravings selling for fifteen cents in stationery stores or through the mail. "Our First Heros in France," picturing Privates Henry Johnson and Needham Roberts, of the Fifteenth Infantry of New York, "the first Colored troops to reach the firing line in France and the

first two Race men to be awarded the French War Cross for bravery" was advertised as "The one picture that should be on the walls of every Colored Home in America. . . . It encourages the old, inspires the young and teaches the children that bravery shows no color." The company also advertised a series of pictures of "our first industrial heros," beginning with Charles Knight, "The World Champion Riveter[,] and His Crew."[40]

In 1918, the Touissant Motion Picture Exchange advertised its twelve-part series *Doing Their Bit,* showing the "military and economic part played by all the darker races in this WAR OF NATIONS, both 'OVER HERE' and 'OVER THERE.'" "Every Race man, woman, and child in America should see every chapter of this wonderful picture."[41] The Educational Film Company proposed to make films showing the progress of the Race. One of its first pictures was to be the Negro Regiment in Richmond, Virginia, the Fifteenth Infantry.[42] The *Indianapolis Star* reported that a local filmmaker, L. L. Alexander, had produced "an allegorical picture," *The Negro's End of a Perfect Day,* showing "the negro's part in all branches of military service and in war work."[43]

The *(Columbus, Ohio) Journal* reported a scenario submitted to the National Colored Soldiers Comfort Committee in 1918 and titled *The Loyalty of a Race,* "a three-reel film with a cast of all colored people. It will be a patriotic film. It is said that it abounds in pathos, humor, and thrilling climaxes, showing the colored men enlisting 'to make the world safe for democracy'; training in army cantonments, going 'over the top' in France, and fighting like demons against the foes of America. . . . The object of the film is to remind the American people of the loyalty, the valor and the advancement of the colored race."[44] The Foster Photo Play Company proposed photographing "the glorious send-off" of the Eighth Regiment, recording family members marching to the trains to bid their dear ones good-bye, bringing "comfort and cheer to our boys at the front." "Every man, woman and sweetheart who has loved ones 'over there' should aid in this great work and 'do their bit.' "[45]

Lincoln Pictures' very popular second film, the three-reel feature *Trooper of Troop K* (1916), was a fictional story centered on an actual incident concerning the Tenth Cavalry, a Black cavalry troop, during the battle at Carrizal, in Mexico, and its cast included former members of the Ninth and Tenth Cavalries. The company's ads said the picture "depicts in

HIS SPECTATORS

gripping scenes the unflinching bravery of Negro Troopers under fire and how they, greatly outnumbered, sacrificed their blood and life for their country."[46] In 1919, the company also distributed a one-reel "news pictorial" of "'American Colored Troops at the Front,' photographed by the Cinematographic Division of the French Army."

Juli Jones, Jr., writing in the *Half-Century Magazine* in June 1919, praised the social benefits of the soldier films: "The screening of the Colored men in this war has made friends for them, for us. A world that bows to the bravery of men, must think of the bravery and morality of that brave man's mother; must think of the loyalty of that man's wife and sister; and so thinking they will observe and learn." Jones continued: "There is a future for the race in the Motion Picture world actively and passively. Let every one so live and conduct himself as if he were to be caught on a 'close-up' or a 'long shot' he will be so acting and living that he will help the race he represents."

---

IN ADDITION to economic opportunities for Black soldiers and war workers, many saw the Great War as a chance to prove that they were worthy of citizenship. The *Chicago Defender,* for instance, featured a photo of a member of the Tenth Cavalry returning from battle, captioned "An American Citizen at Last." The *New York Age* wrote, "the Negro has a case in court upon which his life depends and which he cannot afford in any way to jeopardize.... To keep his case in court clean and to win, the Negro must continue to claim every right of citizenship and always be ready to perform any duty."[47]

Although today these discourses on favorable and credible images may seem to be politically limited, it would be a mistake to underestimate the power of such expressions of racial pride. These films and these critics gave credence to some of the contradictions and tensions that were a part of being Black and American in the early part of the last century. By bringing Black voices and visions to popular culture, by portraying identities more diverse and more complex than had previously been expressed in mainstream commercial culture, by declaring their own identity, they were writing their world into existence. Reenacting, through tales of heroism, the gestures that excluded them as citizens, these commercial

endeavors exploited the emotional impact that such images had for Black audiences by proclaiming forcibly that the invisible, the forgotten, cannot be forever deferred. This is important because the group gained a distinct identity not only from a shared material reality but also from a shared consciousness, that is, from the "image of their communion."[48] The soldier films, and other films of racial progress, were a strong counter-discourse that actively criticized those social discourses that so painfully disrupted the Race's sense of self. Lincoln Motion Picture Company's *Realization of a Negro's Ambition* was described in one review as "the business and social life of the Negro as it really is and not as our jealous contemporaries would have us appear."[49]

For many, the war provided the first real break in what Richard Wright called the "continuity of hopelessness," the opportunity for the Race to prove its loyalty, a way for Blacks to demand the rights and privileges they were denied in civil society. Adam Clayton Powell, Sr., told his congregation, "This is the psychological moment to say to the American white government . . . , 'Yes, we are loyal and patriotic.'" However, he went on to remind the administration: "We do not believe in fighting for the protection of commerce on the high seas until the powers that be give us at least some verbal assurance that the property and the lives of the members of our race are going to be protected from Maine to Mississippi. . . . It is infinitely more disgraceful and outrageous to hang and burn colored men and boys and women without a trial in times of peace than it is for Germans in times of war to blow up ships loaded with mules and molasses."[50]

James Weldon Johnson wrote of the honors given New York's Fifteenth Regiment by the French government and their triumphant return:

> The entire regiment was cited for exceptional valor in action during the Meuse-Argonne offensive, and its colors were decorated with the Croix de Guerre. The Fifteenth was under shell-fire 191 days, and held one trench ninety-one days without relief. At the declaration of the armistice, the French command gave it the honor of being the first of all the Allied forces to set foot on enemy territory; it went down as the advance guard of the French army of occupation. On this side, no single regiment in the A[merican] E[xpeditionary] F[orces] was more often heard of or better known than the Fifteenth.

The regiment, now the 369th Infantry, arrived back in New York on February 12, 1919. On February 17th they paraded up Fifth Avenue. New York had seen lots of soldiers marching off to the war, but this was its first sight of marching veterans. The beautiful victory arch erected by the city at Madison Square as a part of the welcome to the returning troops was just nearing completion, and the old Fifteenth was the first body of troops to pass under it. The parade had been given great publicity, and the city was anxious and curious to see soldiers back from the trenches. The newspapers had intimated that a good part of the celebration would be hearing the now famous Fifteenth band play jazz and seeing the Negro soldiers step to it. Those who looked for that sort of entertainment were disappointed. Lieutenant Jim Europe walked sedately ahead, and Bandmaster Eugene Mikell had the great band alternated between two noble French military marches. And on the part of the men, there was no prancing, no showing of teeth, no swank; they marched with a steady stride and from under their battered tin hats eyes that had looked straight at death were kept to the front.[51]

While the Fifteenth had been training the summer of 1917, there had been another parade. This time marching down Fifth Avenue from Harlem, ten thousand African Americans, children dressed in white, followed by women dressed in white, followed by men, silently marched to the sound of muffled drums. Their signs read: "Mother, do lynchers go to heaven?" "Give me a chance to live." "Treat us so that we may love our country." "Pray for the Lady Macbeths of East Saint Louis." "Mr. President, why not make America safe for Democracy." Expressing the community's outrage, they challenged the morality of white society. A banner, "Your Hands Are Full of Blood," preceded the flag of the United States. Black Boy Scouts passed out leaflets titled "Why We March," which called attention to lynchings and mob violence, segregation and disfranchisement: "We march because we want to make impossible a repetition of Waco, Memphis, and East Saint Louis, by rousing the conscience of the country and bringing the murderers of our brothers, sisters and innocent children to justice. We march because it is a crime to be silent in the face of such barbaric acts."[52]

Literature of the postwar period expressed that same anger. In Claude McKay's *Home to Harlem*, for example, Jake, who had been eager

to fight, enlisted to serve, but soon deserted: "I didn't run away because I was scared a them Germans. But I beat it away from Brest because they wouldn't give us a chance at them, but kept us in that rainy, slopply, Gawd-forsaken burg working like wops. They didn't seem to want us niggers foh no soldiers. We was jest a bunch a despised hod-carriers." And later, his friend Felice replies, "What right have niggers got to shoot down a whole lot of Germans for? Is they worse than Americans or any other nation a white people?"[53]

After the war, in the face of violent labor confrontations and escalating racial segregation and harassment, the Black soldier was still an important role model for many, a source of patriotic identity and a political tool, providing leverage in the fight for the rights of full citizenship. *Our Hell Fighter's Return,* a one-reeler from 1919, showed the return to New York of Colonel Haywood's 369th Regiment. Although the newsweeklies covered the event, this film showed "the entire proceedings from the time that they came up the bay until they dispersed at 145th Street and Lenox Avenue." The Frederick Douglass Film Company released *Heroic Negro Soldiers of the World War* in 1919, stating as its aim, "to present the better side of Negro life, and to use the screen as a means of bringing about better feelings between races." In articles on the film, the *New York Age* applauded the Frederick Douglass Film Company, "owned and controlled by Negroes" and the film for having played in "New York, New Jersey, Pennsylvania, Maryland, Virginia, North Carolina, Georgia, Michigan, Delaware and the District of Columbia."[54] Not only reporting on the film and the victory of the soldiers, the article also celebrated the successful enterprise as an accomplishment *for* the Race.

*From Harlem to the Rhine,* a post-Armistice show of five reels of newsreel footage and over fifty slides, depicted the Fifteenth Regiment in "its infancy when Bert Williams was a member," on the rifle range at their training grounds in Peekskill, and in battle in France and Germany; it played at the Layfayette Theatre in New York in 1920 as a benefit to raise money for a home for veterans. Music was provided by members of the old Fifteenth Regimental Band. The following week, the film showed in Brooklyn, the home base of one battalion.[55]

Oscar Micheaux's own first film, *The Homesteader,* premiered in Chicago, February 20, 1919, at the Eighth Regiment Armory, as the city

was celebrating the return of the troops from the war. By opening his first film (which was not about the war at all) in the armory, "a monument to the sacrifice and persistence of the military lover of the race,"[56] he was connecting himself with an enormously patriotic event. The auditorium, itself associated with the heroism of Illinois's Black regiments, provided seating for eight thousand spectators. The program included a short on the homecoming of the victorious Eighth: "We sent our camera man and director to [Camp] Grant where bright clear pictures of each Company and their officers were taken so you can see and recognize them. See therefore the REAL pictures of your heroes . . . in their own Armory."[57] Between March and April, *The Homesteader* played several theaters in Chicago, made a Midwest tour to cities in Missouri, Kansas, and Nebraska before heading South in May.[58]

His publicity for *The Homesteader* spoke to his audience in the context of the sociology and ideology of Race pride and Race betterment, as if his personal success story were fulfilling a collective destiny. "A powerful drama of the Great American Northwest, into which has been deftly interwoven the most subtle of all American problems—the race question," read the handbill for the Diamond Theatre. The story—his story—was also an adaptation of the sensational tropes already prevalent in the melodramas that dominated popular theater and pulp literature and, indeed, Micheaux's own novels: villainy, virtue, valor, scenes of assault and abduction, intercepted letters, false accusations, coincidences, and sudden reversals. It is the story of an individual both confirming, and confirmed by, the community. Micheaux was writing and filming for a specific, targeted audience, people who still felt hopeful about sharing the American dream of freedom and prosperity, and he felt that he knew what that audience wanted. (As an itinerant bookseller going door to door, he had, literally, met his public). His works were seldom vexed by moral ambiguity. And he was devoted to racial uplift through entrepreneurial achievement.

On May 29, 1920, the *Chicago Defender* quoted Micheaux's enthusiasm about "great activity in the building of new picture theaters by and for the Race in the East and South and the subsequent demand for more and better photoplays acted by Racial casts from stories concerning the lives of our people." On March 6 of that year, the *New York Age* ran an article

by Lester Walton titled "Colored Motion Pictures Are in Great Demand," which covered the opportunities Race movies offered—"Colored people throughout the country are clamoring for motion pictures dealing with Negro life"—and mentioned that "Oscar Micheaux . . . fairly exudes with optimism when discussing the outlook for colored photoplays." Six months later, on September 18, Walton wrote in the *Age* that the "unusual interest manifested by Harlemites in the presentation of the photo play *The Brute,* this week's attraction at the Lafayette Theatre, clearly points out the strong desire on the part of the Negro to see race plays both on the stage and screen. That the movies are destined to take the lead in catering to the present insistent demand for the production of plays written by Negroes and produced by Negroes is another fact being borne out." "The Editor" of one magazine extolled such advances: "In no two decades has the Negro made greater progress than during the past five years subsequent to the beginning of the great war; and in no line of new activity has he demonstrated his ability and enterprise more clearly and commendably than in the realm of 'motion pictures.' "[59] D. Ireland Thomas, in a 1923 appraisal of the future of Race movies, pronounced: "Twelve million people want to see themselves in the proper place on the screen."[60]

The *Chicago Defender,* in the beginning of 1920, mentioned "125,000 Race people in Chicago" as a substantial potential audience for Race films.[61] "Colored theatres are no longer an experiment," wrote the E. C. Brown Company at the end of 1920, trying to raise capital for the Douglass, a playhouse in Baltimore, and citing the success of the Dunbar Theater in Philadelphia and the Lafayette Theatre in New York. "In every city where a first class theatre has been erected, success has attended the venture."[62] Like the Lafayette and the Dunbar, the Douglass was soon showing films.

In the beginning of 1921, the trade paper the *Billboard* mentioned "800 houses catering to colored audiences."[63] Clarence E. Muse, also writing in the same paper on August 6 of that year, discussed more than a dozen production companies making Black-cast films (nine of which were capitalized by Negroes) and mentioned that there were over 600 theaters in the United States that catered to Colored people. In the same issue *Billboard* published a state-by-state tentative and ongoing tally (drawing from a variety of sources, including the 1920 census report, producers,

HIS SPECTATORS

exchanges, and theater owners) and declared that there were 178 colored theaters in the United States that played either motion pictures, or motion pictures and vaudeville.

At the time of their 1921 stock offering, the Micheaux Film Corporation said it had a distribution system in place that included eleven first-run houses that would pay rentals from $400 to $2,000, additional houses in Chicago, New York City, Philadelphia, Washington, D.C., and Baltimore, and numerous smaller theaters in the South and border states, that would net between $150 and $500 on each picture, as well as such alternative sites as schools and YMCAs.

Richard E. Norman, white, of Norman Film Manufacturing Company, which, like Micheaux's company at this time, handled its own distribution, wrote to the actress Anita Bush in 1921 to explain why he could not offer her a larger salary: "As our picture [*The Crimson Skull*] will be produced for colored theatres only, it will have a possible distribution in about 120 theatres; 85% of which have an average seating capacity of but 250. These figures are no comparison with the 22,000 white theatres in which our product will find no market."[64] (Norman might also have mentioned that many Southern theaters often had seasonal constraints, some closing in the summer because of heat and humidity and, from time to time, mosquitoes.)

The broad discrepancies in the figures would seem to indicate that some of the counts may have included theaters that reserved the balcony or another section for Blacks or had special days or hours set aside for Colored audiences. Some may have been vaudeville houses that played films only occasionally. Even though it would now be difficult to determine how many theaters showed Black films in the early twenties, it seems clear that the distribution network must have been extremely chaotic and decentralized. (The same year, the Comet Film Exchange, a white Philadelphia distribution company with offices in New York, Chicago, Altanta, and New Orleans, was setting up a "colored department" to handle Race films;[65] the Afro-American Film Exhibitors Company based in Kansas City, Missouri, advertised itself as "the largest independent releasers and distributors of Negro photoplays,"[66] and several regional exchanges were already operating.) But, perhaps more important, it is obvious from the amount of press generated that there was an enthusiasm for Race films

IN SEARCH OF AN AUDIENCE, PART II

and Race venues. The Clarence Muse article began, "At last the Colored Motion Picture game has been organized. The producing concerns have definite plans and are working on a schedule, releasing regularly. The distributing end of the industry is well prepared to market the products while the exhibitors are fully convinced that colored pictures for colored patrons are the best attractions they can secure."[67]

While the "industry" was probably never as organized as Muse imagined, there was enough product being offered and enough venues to show the films that by 1921 there seems to have been a legitimate reason for the excitment!

---

ACCORDING TO Henry T. Sampson, 1921–1922 was the height of silent Race film production. He estimated thirty films produced in 1921 and twenty-two films in 1922.[68] One of D. Ireland Thomas's 1922 columns, although not unusual, is notable for the amount of activity that he reported (in fifty-five lines): The banning of Jack Johnson's film, *For His Mother's Sake,* in Ohio; the lensing of *Shoot 'Em Up Sam* by the Black Western Film Company of Baltimore; the production plans of Leigh Whipper Films, which included a monthly Negro newsreel already in production, the near-future filming of *The Comeback,* starring Kid Nolan, and their next production, a "superfeature," *A Regeneration of Souls,* with Ellen Ray, Leon Williams, Victor Price, and Louise Fuller; an amateur with a story and a small amount of cash to invest; and Jacksonville, Florida's Nu-Art Motion Picture Company's stock offering.[69]

One of J. A. Jackson's 1921 columns in the *Billboard* announced the release of the Maurice Film Company's first picture, *Nobody's Children:* "This is the fifth absolutely colored concern to enter the field with pictures by Negro artists portraying a story of the race."[70] The Maurice company, of Detroit, went on to produce another feature in 1928, *Eleven P.M.*

However, many of the newly formed companies were unable to raise the money for a production or made only one picture. Oscar Micheaux's production volume was not typical. Reol, when organizing, announced its intention to put out a photoplay each month, and did produce seven or eight features but stayed in business less than four years. Richard Norman produced six features in nine years before discontinuing production. The

first six years George P. Johnson was working for the Lincoln Motion Picture Company, he could not afford to leave his job at the Omaha Post Office and his brother Noble did not draw a salary from his two and a half years of presidency and three starring roles.[71] The excitement in the press for Black filmmaking overlooked the fact that Race films still rested on a tenuous economic base.

In March 1919, before he left on *The Homesteader*'s southern booking trip, Micheaux sent out a promotional letter citing the success of the film in Chicago. He quoted O. C. Hammond, "owner of a string of Chicago theatres," on the large turnout at one of his theaters. "At 7 PM at our new Vendome theatre, seating 1500, a line had formed at our box office and from 2 PM to midnight 5700 paid admissions, at an advance in price of 10¢ over our regular admission had been recorded."[72] Ads for the New Orleans run of *The Homesteader* included the notice: "Exhibitors: As Negro Productions such as this are restricted as it were to Negro Theaters, and cannot be booked through regular exchanges on the usual basis, all bookings are to be made on a percentage plan, the admission price never to be under 25¢." However, by the time the film played the Globe Theatre, a 500-seat theater in Richmond (colored population, 50,000), September 18 and 19, 1919, Micheaux was accepting a flat rate of fifty dollars per day for a two-day run and the admission price was advertised as fifteen cents for children and twenty cents for adults.[73]

This elevated price, of course, was not unique to Micheaux's productions. When he was trying to book *The Brute* in the Diamond Theatre, Omaha, the booking agent wrote to the Micheaux company, "It has usually been their custom to double prices on colored feature attractions."[74] An ad for the opening of the new Loyal Theater in Omaha noted the regular adult admission was fifteen cents, and that is what the theater was charging for Mack Sennett's comedy feature *Tillie's Punctured Romance* (1914; starring Mable Normand and Charlie Chaplin); however, Lincoln Motion Picture's 1919 feature *A Man's Duty* was advertised at twenty-five cents for "this attraction only."[75]

In an announcement for the Knoxville showing of Micheaux's *The Symbol of the Unconquered,* the Gem Theater informed the public that it had gone to "enormous expense," and called for the people of Knoxville to "show their appreciation" with record attendance, in spite of the higher

ticket cost. The management suggested making price "a secondary proposition" for the one-day showing of this "great feature."[76]

———————

IN 1920 Lester A. Walton wrote:

> The large and increasing demand for colored motion pictures should mean much to the race from an economic stand point. There is no reason why all photo plays of this description should not be written, played and produced by Negroes. Here is a new and fertile field offering wonderful opportunities where we should be complete masters. If we lose our strangle hold it will be because we have failed to measure up and keep pace with the times.
>
> If the Micheaux, Douglass and other colored movie producing firms expect to remain leaders in their line they must be just as artistic in studio directorship, just as expert in photography and just as efficient in the matter of film distribution as the other fellow: for the day of expecting charitable consideration in business even of our own people just because we are Negro is past.[77]

With a larger number of Race pictures produced, gone were the days when the Lincoln Motion Picture Company could proclaim that it was "Owned and Operated by Negroes" and promise its exhibitors, "If you can count the Negro population, you can count your admissions."[78] By April 1, 1922, D. Ireland Thomas, who besides writing for the *Defender* also managed Race theaters, warned, "It used to be that when an exhibitor was playing a Race picture, all he had to do was to make it known that he was playing a Colored picture. This announcement was sufficient to fill his house. Now things are different. The people are not flocking to theaters any more just because it's a Race picture. They have to be shown that it is a good picture." A few weeks later, on May 27, he noted in his column that many managers had indicated that they "are disgusted with the class of Race productions" currently being produced "by the lately formed corporations." A 1922 ad announcing the new management of the Gilmor Theatre in Baltimore appealed to Race pride and the moviegoer's own responsibility in the quality of the programming: "If the shows at the Gilmor Theatre should not be quite as good as seen at some other theatre, why

every colored person should remember that Joshua Owens is one of your own people who is trying hard to make an honest living for himself and family and therefore he should receive the support and part of the patronage of every colored citizen in the city of Baltimore. Mr. Owens promises to get as good shows as the receipts of the attendance will procure."[79]

The dreams embodied in Race pictures, like the optimism of the migrants, eventually faded. Just as there had been a new self-consciousness about mobility, there had been a strong consciousness to speak as a people; not simply as Americans, but as Black Americans. Let us now look at some of Oscar Micheaux's films to see how they were perceived and what part they played in this period that saw, as Amiri Baraka put it, "[the] reinterpretation by the Negro of his role in this country."[80] We can try to imagine what it might be like to view these pictures as members of the audience and in the context of the time, in the comfort and familiarity of a community venue.

# Within Whose Gates?

**4** — The Symbolic and Political Complexity of Racial Discourses

---

The latest of the Micheaux productions, "Within Our Gates," will be seen for one week beginning on Monday January 12th at Hammond's Vendome Theater. . . . This is the picture that it required two solid months to get by the Censor Board and it is the claim of the author and producer that, while it is a bit radical, it is withal the biggest protest against Race prejudice, lynching and "concubinage" that was ever written or filmed and that there are more thrills and gripping holding moments than was ever seen in any individual production. The scenes are laid in the South where the outrages are most predominant, and the author has not minced words in presenting the facts as they really exist. . . . People interested in the welfare of the Race cannot afford to miss seeing this great production and, remember, it TELLS IT ALL.
—*Chicago Defender*, January 10, 1920

It is true that our people do not care—nor the other race for that matter, for propaganda as much as they do for all story. I discovered that the first night "The Gates" was shown.
—letter, Oscar Micheaux to George P. Johnson, August 14, 1920

If we must die—let it not be like hogs
Hunted and penned in an inglorious spot,
While round us bark the wild and hungry dogs,
Making their mock at our accursed lot.
—Claude McKay, "If We Must Die," 1919

---

BY OPENING his first film, *The Homesteader*, in 1919 at Chicago's Eighth Regiment Armory, a site symbolic of racial valor and accomplishment, Micheaux had made use of the climate of optimism and Race pride surrounding the homecoming of the victorious Eighth Regiment. The film itself was described as an achievement, "the greatest [photo]play yet

exhibited by members of the Race."[1] However, on February 22 of that year, the same issue of the *Chicago Defender* that carried the advertisement for the armory showing and pages of display ads welcoming the returning troops (with a special pictorial section featuring photos of the heroes) also contained an editorial with a harsh reminder of the job ahead: "The same fighting spirit which you displayed on the battlefields of Europe is needed in the titanic struggle for survival through which we are passing in this country today." Iterating the continuing racial violence and projecting a hopeful future, the paper called for radical defiance: "We are loath to believe that the spirit which 'took no prisoners' will tamely and meekly submit to a program of lynching, burning and social ostracism. . . . With your help and experience we shall look forward to a new tomorrow, not of subserviency, not of meek and humble obeisance to any class, but with a determination to demand what is our due at all times and in all places. . . . If you have been fighting for democracy, let it be a real democracy, a democracy in which the blacks can have equal hope, equal opportunities and equal rewards with the whites. Any other sort of democracy spells failure." Three months later, W.E.B. Du Bois, in the *Crisis* magazine, voiced a combative challenge to racism and demanded "a sterner, longer, more unbending battle against the forces of hell in our own land. We return. We return from fighting. We return fighting. Make way for democracy."

Many Negro servicemen's experience in Europe made them see U.S. racial relations as peculiar to America, "an *evil*, not . . . their eternal *lot*."[2] The frustration and just anger felt by the soldiers returning from the "white fo'kes war" to the same racist conditions they had left provoked profound disillusionment. Some exiled themselves in Europe, but many took a more militant stand in reaction to the open brutalities against the Race and the dashing of their hopes. Eight months after the armistice, during the "Red Summer" of 1919, there were uprisings in more than twenty cities: Washington, D.C.; Longview, Texas; Charleston, South Carolina; Omaha, Nebraska; Knoxville, Tennessee; Chicago, Illinois. . . . As the final lines in Claude McKay's sonnet avouched, "Like men they faced the murderous cowardly pack / Pressed to the wall, dying, but fighting back!"[3] In Chicago alone, over one thousand people were driven from their homes by fire.[4]

*[handwritten margin note: Black servicemen WW1]*

HIS TEXTS

"We are ignored by the President and the lawmakers," proclaimed *Challenge Magazine,* a popular monthly, in October of that year. "When we ask for a full man's share they cry 'insolent.' When we shoot down the mobist that would burn our properties and destroy our lives, they shout 'Bolshevist.' . . . We are abandoned, cast off, maligned, shackled, shoved down the hills toward Golgotha in 'The Land of the Free and the Home of the Brave.'" On December 13, the *Chicago Defender* called for a Day of Prayer for Our Assassinated, "a day of solemn prayer, in memory of the thousands of people in our group who have been wantonly assassinated at the hands of demon mobs, and murdered in cold blood for alleged crimes without due process of law, as guaranteed by the Constitution of the United States."

———————

*w/in our Gates controversial*

WHEREAS *The Homesteader* premiered in a moment of celebration and high hopes, Micheaux's second film, *Within Our Gates,* completed a few months after the bloody summer of 1919, opened in a climate of virulent racial confrontation. The Chicago censor board, which included at least one African American member, at first banned the entire movie because, according to the American Negro Press (ANP), "it was claimed the effects on the mind of the spectators would result in another 'race riot.'" The board once again consulted with members of the Black community. Opinion was divided: some of the people called in, including Alderman Louis B. Anderson, Assistant Corporation Counsel Edward H. Wright, and several members of the press, endorsed the film; some saw the film as dangerous because they feared further riots; others felt "the injustices of the times, the lynching and handicaps of ignorance, determined that the time is ripe to bring the lesson to the front." Eventually the film received a license. Nonetheless, those who objected organized in local churches to stop the screening of the movie. An interracial delegation from the Methodist Episcopal Ministers' Alliance visited the mayor and chief of police in an unsuccessful attempt to have the premiere canceled. The ANP proudly announced that "people are standing in the streets for hours waiting for an opportunity to get inside [the Vendome Theater]."[5]

The film, however, debuted with 1,200 feet cut. The original story had contained representations of peonage, rape, vigilantism, and lynching.

Willis N. Huggins, a Chicago schoolteacher, was one of the people who saw the film on the first day of the Vendome showing. For Huggins, *Within Our Gates* established a link to news stories of southern atrocities, a reference to "the Real." Moved to write to the editor of the *Chicago Defender*, he invoked current events in the South:

> The startling revelation now slowly coming to light that white men committed the murders in Arkansas for which men of our race are condemned to die are indeed fittingly coincident with the present run of the Micheaux picture which aims to expose just that sort of double dealing all over the south.
>
> I saw "Within Our Gates" Monday afternoon. Deleted as it is, it still constitutes a favorable argument against southern mobocracy, peonage and concubinage. The picture is a quivering tongue of fire, the burn of which will be felt in the far distant years. Even if it was in its original cast, it would only mildly portray southern treachery and villainy. The spirit of "Within Our Gates" is the spirit of Douglass, Nat Turner, Scarborough and Du Bois rolled in to one, but telling the story of the wrongs of our people better than Douglass did in his speeches, more dramatically transcendent than Du Bois in his souls of black folks [sic]. Had "Within Our Gates" been entirely barred, then should the press and pulpit of our group forever remain silent on oppression and injustice. "The Birth of a Nation" was written by oppressors to show that the oppressed were a burden and a drawback to the nation, that they had no real grievance, but on the other hand, they were as roving lions seeking whom they might devour. "Within Our Gates" is written by the oppressed and shows in a mild way the degree and kind of his oppression. That he is an asset to the nation in all phases of national life, aspiration and development. Nothing like it since "Uncle Tom's Cabin."[6]

As Huggins's letter eloquently illustrates, Micheaux's stories, themes, characters, and ideas resonated beyond the sounds and images of a specific film to other texts, such as news stories, magazine articles, oral tales, songs, sermons, and other films. These cumulative stories, bodies of knowledge, kinships, and expectations, directly or indirectly communicated, passed on privately and publicly, constituted a Grand Narrative, an important element in the shared experiences of Black Americans. Tales of opportunities, inventions, oppression, and insurrection were rooted

HIS TEXTS

in specific social and cultural encounters and traveled around the country. This Grand Narrative inflected cognitive and affective meanings as it was creating them anew, wakening into resonance collective, public, and personal histories.[7]

Huggins's awareness of peonage and violence in Arkansas appears to have informed his viewing experience. The *Chicago Defender*, in a series of articles between the fall of 1919 and the spring of 1920, had reported extensively on the efforts of tenant farmers in Phillips County, Arkansas, to organize a protective association and the subsequent confrontation that broke out when plantation owners tried to stop them. After two whites died, twelve African Americans were sentenced to die in the electric chair. The *Defender* coverage included articles by such commentators as Walter White and Ida B. Wells-Barnett about the lynching record for the state of Arkansas, about the technicalities of the law that condemned the men to death, and about the plantation system that kept tenant farmers and sharecroppers in ever-increasing debt. (One article compared the prices charged in plantation stores with the lower prices "in the open market," and another explained how farmers were cheated out of their share of the crop and held hostage on plantations until their debt was paid.)[8]

Specific stories of lynchings and sadistic torture were regularly reported in the Black weeklies, telling of burnings, mutilations, and body parts (including male genitals) being fought over or sold as souvenirs. On September 8, 1917, the *Chicago Defender* published a front-page photograph of a severed head, with ears, nose, and upper lip mutilated, under the headline "Not Belgium—America." This photo of Eli Person, who had been burned alive, had been reproduced and sold as a souvenir in Memphis, to whites only, for a quarter a copy.[9]

The *Chicago Whip*, on April 9, 1921, featured a front-page photo of Alexander Johnson, a Dallas man who had been abducted and branded on the forehead with the initials K.K.K. Under the headline "Who's Next?" the accompanying article gave details of Johnson's life, his alleged offense, his response to the charges, and a gruesome account of his seizure, flogging, and the painting of the letters on his forehead in silver nitrate. Two newspapermen had also been kidnapped to witness the whipping and mutilation "in order to insure ample publicity." On December 21, 1911, the *New York Age* told of Reverend William Tuner of Jackson, Georgia, being

hanged on the stage of the local opera house, instead of the jail yard, because the weather was "disagreeable" and "the Sheriff was fearful that the [ticket-holding] spectators would get wet."

Resistance and rebellion were also reported. On January 1, 1916, Robert H. McCray of Fort Worth, Texas, told the *Chicago Defender* of having witnessed seven hundred determined and armed men and women in Muskagee, Oklahoma, who had gathered to prevent the lynching of William Green and Matsias Foreman, charged with the murders of two white policemen. Later that year, on October 28, the *Defender* ran a boxed article on the front page telling of "a number of members of the Race" in Jackson, Tennessee, armed with Winchesters and revolvers, who had spent the night protecting Walter Elkins after he struck a white fellow workman on the head with an iron bar. "A mob of one hundred or more white people" were turned back when they were told "that a hot reception was awaiting them." "AROUND THE WORLD WILL LIVE THE DEED OF THIS SMALL NOBLE BODY OF MEN WHO BRAVELY DEFENDED ONE OF THEIR KIND AND REFUSED TO SEE HIM DIE LIKE A DOG."[10] The paper also told the story, on February 3, 1917, of a man in Athens, Georgia, who had opened fire on a group of white men, killing six, in revenge for the death of his wife—hanged by a mob for slapping a white boy who had been fighting with her young son.[11]

These kinds of stories in Black newspapers were full of details. They were not isolated or abstract acts of violence, unnamed places, and anonymous people. They were personalized stories of "facts": names, places, families, work lives, lodge affiliations, church membership, and graphic accounts of atrocities.[12] These served not only to identify and humanize the victims but also to build a collective consciousness. Richard Wright, reflecting on his youth in the South in the twenties, wrote: "The things that influenced my conduct as a Negro did not have to happen to me directly; I needed but to hear of them to feel their full effects in the deepest layers of my consciousness. Indeed, the white brutality that I had not seen was a more effective control of my behavior than that which I knew. . . . As long as it remained something terrible and yet remote, something whose horror and blood might descend upon me at any moment, I was compelled to give my entire imagination over to it."[13]

This manner of telling and retelling events in story form is a way of appropriating history and endowing it with a coherence;[14] a way of orga-

*[handwritten marginalia: Blacks Newspapers personalized black murders]*

HIS TEXTS

nizing experience that gives it meaning and value; a way to make it one's own. These stories often stretched beyond incontrovertible facts, becoming a part of the oratory of sermons, street corner speeches, and conversation, enabling people to come to terms with material that both reflected and illuminated their experience. These were some of the shared discourses of the Grand Narrative that would have influenced the spectator's reception of particular movie characters, places, and actions.

It is important to see Micheaux as a listener as well as storyteller, simultaneously participant and observer. Speaking to and about African American experiences and emotions, his films make reference to icons and artifacts of Black culture of the period. They are peppered with moments of actuality that help to establish place, character, and event, enhancing the "reality" of the film.

Micheaux's films contain a diversity of characters, many finely delineated. A Boston physician in *Within Our Gates,* for example, is first shown in his paneled office, seated at a rolltop desk, dressed in a fashionably tailored tweed suit. He picks up an issue of the *Literary Digest* with a cover illustration of Teddy Roosevelt. Roosevelt, at the time still a powerful icon to many in the African American community, had become symbolic of the Black soldiers' glory at the Battle of San Juan Hill, Cuba, in 1898.[15] The article the physician turns to is about campaigning for Negro education. This representation of an informed, professional, "Race man" is part of the diversity of people within the community, but seldom, if ever, seen on screen. It is the antithesis of any image African Americans would have seen in white-made movies playing in the same theaters.

In Micheaux's films of the late teens and early twenties, we see intelligent, honest, dignified people, with ambition, both middle-class professionals (e.g., doctors, educators, businessmen) and workers (e.g., sharecroppers, laborers, domestics, prospectors).[16] The modest home of Sister Martha Jane, a laundress, in *Body and Soul,* is sparsely furnished, and religious pictures share the wall with Booker T. Washington, Frederick Douglass, and Abraham Lincoln, proud symbols of freedom, hard work, and industry. At the beginning of the film, Sister Martha, a buxom woman in an apron, is seen ironing; the scene is intercut with a scene identified by the title card "The Negro in Business," of a bootlegger, dressed in a bowler hat, bow tie, suit, and flashy sweater-vest, making his "donation"

---

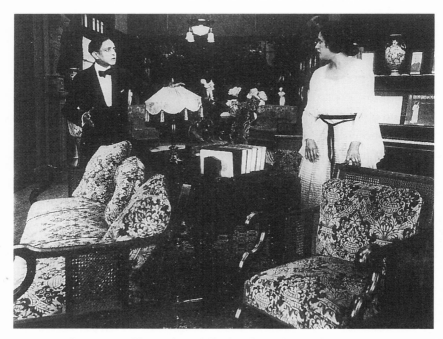

Lawrence Chenault and Evelyn Preer in a publicity still
from Oscar Micheaux's *The Brute* (1920), shot on location.
Courtesy of African Diaspora Images.

to the local preacher. The walls of a speakeasy set are decorated with illustrated stories from the *Police Gazette.* More than simply a contrast, these archetypal actions and spaces, familiar from the community's Grand Narrative, efficiently designate the morality of the characters.

As noted earlier, Micheaux often shot in people's homes, rather than studios. Stills from *The Brute,* for instance, show a well-appointed parlor cluttered with statuary, urns, vases of cut flowers, books, and ornaments. The chandelier, cushioned settee, tasseled table lamp, and piano adorned with sheet music and family photographs add an air of prosperity and sense of intimacy to the scene. These small details of characters' lives are not insignificant; they are referential and strategic, establishing the character and a sense of place. They are markers of "authenticity" that provide a comfort zone in this social space where Blacks can see credible images of themselves and their lives on the screen.

Julie Dash, interviewed in 1986, suggested that decades later, audiences continue to appreciate such details: "Every time we go on tour with

our films, at each film festival, with each screening, whether we are show-
ing in a church, community center, museum, or whatever, the audience
grows. They want to see more. Some people want to invest in our future
projects. Some come up with tears in their eyes. They just want to say hello
and tell you that they've had dreams or ideas just like what we've shown
them on film—and they've never seen these images on film before. It gets
very emotional at times."[17] Her film, *Daughters of the Dust* (1991), embeds
historical details in the most mundane images: hairstyles, dress, food, house-
hold objects. These culturally specific moments personalize and give
meaning to the fantasy and myths depicted in her narrative.[18] Toni Cade
Bambara has suggested that ticket buyers were drawn to "the respectful
attention Dash gives to our iconography—hair, cloth, jewelery, skin
tones, body language."[19]

Similarly, the small details in Micheaux's films became channels of
information, connecting spectators across geographic and generational
lines—redefining cultural boundaries. James Rundles, a retired jour-
nalist, remembered that the movies "brought the world to us, here in Mis-
sissippi, in Jackson, on Farish Street."[20] Many of the films incorporated
different lifestyles. For example, one sees well-to-do, sophisticated, ele-
gant, well-dressed, and well-coifed people and the homes in which they
live; one witnesses the professions that are open to Blacks in other com-
munities (the policeman and detective, for instance, in *Within Our Gates*).
One also learns about the inner mechanisms of African American insti-
tutions, as when the Reverend McCarthy is called before the Bishop and
the particulars of the church's infrastucture are revealed (in the novel
*The Homesteader,* and probably also in the film).[21] There are scenes from
various African American communities. In 1922, for example, Micheaux
announced in the press that he would be shooting "the Ferguson Hotel
and Theatre and some other views of the Negro district of Charleston,
West Virginia."[22] Later, in the sound films, the specialty numbers in
nightclub scenes acquainted audiences with elements of African Ameri-
can creativity in music and dance through fashionable entertainers and
the latest fads.

Although Micheaux wrote in 1924 of film as a "miniature replica of
life,"[23] it is best to think of his works as complex sign systems with both
real and imaginary referents, different cultural matrices interacting, a

heterogeneous ensemble. The lavish details are used to tell a story that is not unique but representative of people's broader experiences, familiar landscapes. Not that his story is a singular truth, but rather it speaks to people in a knowing way. Because the multiple lynchings and spontaneous acts of violence depicted in *Within Our Gates* were an essential reality for many and a significant part of the Grand Narrative, the horrors of the film were intensified. Indeed, Micheaux advertised the film as "full of details that will make you grit your teeth in silent indignation!"[24]

------------

AN UNDERSTANDING of this larger group of stories allows us to contextualize not only the films, but the audiences' experiences. The Grand Narrative, however, is not simply a context; it is a dynamic, simultaneously mobilizing and creating discourses. Any discussion of Micheaux's films, then, should include the social knowledge produced by his works in their time, not as a search for "authenticity," but as a way to understand his audiences as participants in their own cultural politics. It is interesting to ask: What were the frames of references African American spectators brought to *Within Our Gates*? What would those spectators have known that made Micheaux not feel the need to provide detailed exposition? What information did he elect to give and what did he assume could be left to the spectator's imagination and/or foreknowledge?

In particular, how would they have understood Sylvia Landry's backstory? Sylvia (played by Evelyn Preer) is the central character connecting all the film's stories. She is a genteel young woman, seen for the first time seated at a writing table surrounded by books. A title card describes her as "typical of the intelligent Negro of our times." It soon becomes clear, however, that Sylvia has a troubled past. When her fiancé, a prospector, arrives from Brazil, he sees her in what appears to be a compromising situation with a white man and, in a violent rage, rejects her.

For the first two-thirds of the film, Sylvia is represented as happily devoted to her job as a schoolteacher and to her service to the Race. Not until her cousin Alma reveals Sylvia's history to her new suitor, the Boston physician Dr. Vivian (played by Charles D. Lucas), do we learn of her traumatic past. The final third of the film is a flashback in which we learn that Sylvia's adoptive parents, sharecroppers, had been lynched and she

nearly raped by one of the mob. Jasper Landry had been falsely accused of killing Philip Gridlestone (played by Ralph Johnson), the plantation owner, in a dispute over monies due the sharecropper. The townspeople (including the actual murderer, a disgruntled white farmer), men, women, and children, ordinary citizens, gather in a festive picniclike atmosphere to hunt down the Landry family. Patrons from the local ice cream parlor, a boy on a bicycle with a baseball bat, a man in a butcher's apron, a woman in a gingham dress armed with a rifle quickly become a lawless mob.

The crowd seeks vengeance not only against the accused man but against the entire Landry family. However, Sylvia had separated from the other family members to look for provisions and, during a moment when the mob is distracted, Landry's young son, Emil, manages to escape on horseback. A still photograph of a scene from the film (which does not appear in the extant print)[25] shows the boy, distraught, in a sheriff's office, where two white men with badges have expressions of disinterest on their faces.

After a week of pursuit, the restless crowd, poised to shoot at anything that moves, mistakenly kills one of their own. When the shooters turn the body over to further vent their anger with their rifle butts, the face of the disgruntled white farmer is revealed; a title card announces, "Divine justice punishes the real killer." The mob finally finds, captures, and hangs Sylvia's parents.

At the same time that the mob is setting fire to the bodies of her parents, Armand Gridlestone (played by Grant Gorman), brother of the murdered plantation owner, discovers Sylvia in a nearby house and attempts to rape her. Scenes of the bonfire are intercut with her struggle to resist her attacker. It is only when Gridlestone discovers a birthmark on her chest that he realizes he is molesting his own offspring. "Remember," enticed the film's press releases, "it TELLS IT ALL."

By crosscutting the defilement of the Black woman and the lynching of the Black male for reasons that have nothing to do with crimes against white women, Micheaux demystifies pervasive racist myths. In this rape, it is the white man who is the sexual violator, not the Negro; and the "promiscuous Black female" is not a willing participant but vigorously fights back. The lynching is not to protect white womanhood but a response to the sharecropper trying to free himself from economic bondage.[26]

The image of the Black man as savage brute, and the equally falli-
ble myth of the sanctity of white womanhood, were powerful weapons
used by white men to reassert control over Black labor in the postslavery
era. The character Jasper Landry (played by William Stark), a civil, mild-
mannered, hardworking tenant farmer, is portrayed in the local newspaper,
shown in an insert shot, as a drunken, fiendish killer, and Philip Gridle-
stone, whom an intertitle described earlier as "a modern Nero" feared
by Blacks and whites alike, is portrayed in the paper as a kindly aristo-
crat. This fiction is used to fuel the mob's hatred. Needing to set itself off
against the Other, the fantasy of whiteness is absolutely dependent on that
which it seeks to suppress.

The linking of rape with lynching associates the two as instruments
of terror, part of the systematic dehumanization of Black Americans and
a direct attack on the African American family. The intercutting is also
an indictment of white perfidy and hypocrisy. Indeed, Armand Gridlestone
(and probably others in the mob) is kin to his victim; bloodlines are so
tangled that race is less a matter of biology than politics.[27]

The revelation of Sylvia's progenitor in the middle of the attack
raises questions about her natural mother's relation to this man. Had she
also been raped by Gridlestone? While the intertitle in the film currently
in distribution, translated from a Spanish print repatriated in 1988,
describes Sylvia as the product of a "legitimate marriage" (*legítimo matri-
monio*), ads and descriptive material in the press, although not using the
words "incest" or "rape," do refer frequently to concubinage. Although
Huggins refers to it in his letter, concubinage is not represented in the
existing print; but even if it was not depicted, the reference to concubi-
nage in the promotional material and a knowledge of how endemic con-
cubinage was within the sharecropping system would have been enough
to suggest this as a likely backstory for Sylvia's mother. The Spanish inter-
title seems dubious; perhaps it is a concession to local mores, or censors,
or a misinterpretation.[28]

Micheaux revisits the subject of concubinage and paternity in his 1924
adaptation of T. S. Stribling's *Birthright,* a story about bigotry, narrow-
mindedness, and deception in a small southern town. Captain Renfrew,
the town's most prominent white citizen, is suggested to be African
American Peter Siner's unacknowledged father. When Peter's mother, Car-

oline Siner, falls ill, she asks him to contact Captain Renfrew. Upon hearing the news about her condition from Peter, Renfrew arranges for a doctor and comes to her home. After her death, the captain invites Peter to move into his home and work as his secretary. "When I'm dead, you will receive a certain portion of my estate, because I have no other heirs. I am the last of the race of the Renfrews, Peter, the last."[29]

In *Within Our Gates,* there may also have been a more overt representation of white paternity. According to one review, "You see the white man [presumably Armand Gridlestone] who claims the black child laid at his doorstep by the mother because it is his own and he later gives the mother some money."[30] Neither this scene nor, indeed, any mention of the natural mother or the circumstances of Sylvia's conception is in the existing print. This suggests that these scenes may have offended some censor boards, theater owners, or archivists. Given the prevalence of rape, abduction, and concubinage in the South, and the power of white men, through coercion or suasion, to demand sexual favors, it is interesting to speculate about how Black audiences of the time would have interpreted Sylvia's mother's backstory, whether the footage existed or not. The reviewer quoted above suggests, "There is nothing in the picture but what is true and lawfully legitimate." Micheaux often promoted the film as "8000 Feet of Sensational Realism."

There were some connotations in Sylvia's story that the audience didn't need to have spelled out for them. If these scenes were not in the film, Micheaux must have been confident that he could use a backstory that is not fully explained and the audience would understand it from their experience of the Grand Narrative. Stories of the vulnerability of slave women or household servants were commonplace.

The *Independent* magazine, for example, ran an article in which a southern woman, employed as a cook, tells about how she refused to let her employer's husband kiss her.

> A colored woman's virtue in this part of the country has no protection. I at once went home, and told my husband about it. When my husband went to the man who had insulted me, the man cursed him, and slapped him, and—had him arrested! The police judge fined my husband $25.00. I was present at the hearing and testified on oath to the insult offered me. The white man,

of course, denied the charge. The old judge looked up and said
. . . "This court will never take the word of a nigger against the
word of a white man." Many and many a time since I have heard
similar stories repeated again and again by my friends. I believe
nearly all white men take, and expect to take, undue liberties
with the colored female servants—not only the fathers, but in
many cases, the sons also. Those servants who rebel against
such familiarity must either leave or expect a mighty hard time,
if they stay. By comparison, those who tamely submit to these
improper relations live in clover. They always have a little
"spending change," wear better clothes, and are able to get off
from work at least once a week—and sometimes oftener. This
moral debasement is not at all times unknown to the white
woman in these homes. I know of more than one colored
woman who was openly importuned by white women to
become the mistresses of their white husbands, on the ground
that they, the white wives, were afraid that if their husbands did
not associate with colored women, they would do so with out-
side white women, and the white wives, for reasons which
ought to be perfectly obvious, preferred to have their husbands
do wrong with colored women in order to keep their husbands
*straight*! And again, I know at least fifty places in my small town
where white men are positively raising two families—a white
family in the "Big House," and a colored family in a "Little House"
in the back yard.[31]

Such indignities were woven into the racial caste system of southern
society. During slavery, Black women were viewed as property and often
forced to bear their white master's progeny. Some white men considered
free and uninhibited access to female slaves their prerogative and after
Emancipation the violation of Black women persisted.[32] Micheaux was
not exposing what was unknown; its radical potential lies precisely in the
revelation that the secret is no secret at all. In the Black community, mis-
cegenation, as James Kinney puts it, is "less a taboo than a common fact
of life."[33]

---

HOWEVER, it is probably best not to separate the flashback about the Landry
family, at the end of the film, from the rest of the narrative, the opening
two-thirds of which shows Sylvia as a teacher, trying to raise money for her

HIS TEXTS

school. The two sections are interrelated and interconnected. When added together, they take on a force larger than either of the individual parts, and most important, larger than the sum of the parts. By seeing the lynching and rape story as separate from the rest of the narrative, we lose much of the force of Micheaux's argument.[34] Joining the two, the film changes from simply self-affirmation to a call for assertive action.

Like Mildred in Micheaux's second novel, *The Forged Note* (1915), Sylvia Landry is a model single woman, resisting the allure of city life, dedicating herself to social service. And like Mildred, Sylvia is trying to prevail over a mysterious past, and it is through unselfish service to the Race that she is renewed. Both a teacher and an activist, Sylvia has devoted her life to the education of her people. Teaching, at the time, was a highly regarded profession for Black women and was looked upon as making a major contribution to the betterment of the Race. It is because of her education and role as a teacher that Sylvia is able to raise money from the wealthy white Bostonian woman who befriends her. Her cause is seen as an instrument to help build bridges across the divide between the races. The character may have been inspired by Booker T. Washington's representation of Miss Olivia A. Davidson (soon to become Washington's wife) in *Up from Slavery* and the Tuskegee Institute being saved in the nick of time by a large donation that she secured from two ladies in Boston. Interestingly, in the film the head of the Piney Wood school does propose to Sylvia.[35]

Education is a major theme in the picture. For African Americans, education offered the possibility of empowerment. By the time of Emancipation, every southern state had laws forbidding the education of slaves and, in many instances, free Blacks as well. After Emancipation, education was seen as a tool for self-improvement and Race progress. Nonetheless, sixty years later, in 1922, $12 per year was being spent on the education of white children, and only $2.20 on African American children (who were also sometimes restricted to attending school only after the planting and harvesting were completed).[36]

The Piney Woods School, where Sylvia teaches, was an actual school, founded in 1909 in Braxton, Mississippi, to provide industrial education for rural Blacks. When it is established that Landry has earned a small profit, Sylvia wants to enroll Emil, her little brother, in the school. There

is a scene in the film in which a poor farmer arrives at Piney Woods, after having walked a great distance, and, having no money, offers his labor so his children can get an education and "be useful to society."[37] Emil and these children are symbols of hope and aspirations, projecting the story into the future.[38]

*Edu. is the future for Black kids*

The system of peonage that replaced slave labor gave the wealthy planter near-total control over the exploitation of cheap labor for his land as well as for the Big House. In *Within Our Gates,* Micheaux alludes to the coercive conditions under which the racist regime had been maintained and enforced: the planter's tactics of intimidation, including cheating, disenfranchisement, sexual exploitation, physical brutality, and psychological terror. Sylvia's adoptive parents, the Landrys, have been able to gain some control over their labor through their daughter's education. She helps them keep a record of their crop for the season and calculate what is due them. Education provides a tool to challenge the system of tenant farming and, as such, poses a threat to the security of the planter's way of life. Gridlestone, waving his fists at Landry, is incensed by the farmer's "uppityness" (Landry "trying to act like a white man": educating his children and daring to present him with a bill) and angered precisely because his power over Landry is weakened.

An important aspect of the film's lynching story, then, is economic. And when the lynching story is added to the theme of education, a larger story emerges concerning the threat that education, high ambitions, and achievements posed to the status quo. Education could open new opportunities for Blacks but could also bring retribution. As A. B. Smith, from Abbeville, South Carolina (most certainly a white racist), warned readers of the *New York Age,* "The best medicine for a nigger that has the social equality bugs working in his head is a good dose of hemp rope."[39]

The *New York Age* coverage of the 1921 report from the Georgia State Governor's office highlighted the case of a Negro farmer with 140 acres, five mules, a horse, a cow, and thirty-five hogs. Three of his daughters were educated:

> During the war with Germany, this Negro family bought approximately $1000 worth of Liberty Bonds and thrift stamps. The Negro headed an organization of Negroes, who raised between

HIS TEXTS

$10,000 and $11,000 for Liberty Bonds. His work was highly praised by the newspapers at the time.

A white man, who can neither read nor write, owns a farm adjoining the farm of the Negro. When the articles praising the man for his war work appeared, the white man remarked: "– – – – – – –'s getting too damned prosperous and biggity for a nigger."

The paper went on to itemize a series of attacks on the Negro farmer and his family culminating in the confinement of the father in a chain gang and the family being driven out of the county with the threat of lynching if any of them ever returned to their home. The report's final line, "The education of his children and the success of his thrift seem to be the sole offense of the Negro," was elaborated by one of the *Age*'s contributing editors, James Weldon Johnson: "It is absolute folly to believe that the Negro or anyone else can protect his material and property rights unless he has all the other common rights of citizenship."[40]

As Frederick Douglass, in an address that was still being quoted in Black newspapers in the midteens, remarked: "The resistance we now meet is the proof of our progress. The resistance is not to the colored man as a slave, a servant or menial. It is aimed at the Negro as a man and a scholar. The Negro in ignorance and rags, meets no resistance. He is rather liked. He is thought to be in his place. It is only when he acquires education, property and influence, only when he attempts to rise and be a man among men, that he invites repression."[41]

By coupling the "uplift melodrama" with the lynching and rape story, Micheaux makes very clear that the threat to white supremacy is not Black sexuality, but Black autonomy and self-determination.

*———— Threat to white supremacy*

MICHEAUX RETURNS again to the theme of education in *Birthright*. In this picture, Peter Siner, the young hero, returns from Harvard with plans to open a school for Negroes to better the conditions of his people; however, his plans are thwarted when whites defraud him on a land deal. The educational advancement of the town's Black population is posited as a threat to the continuation of the caste system on which white privilege rests. Self-improvement or individual initiative would undermine white

"supremacy." Peter's "white man's" education and sophistication have left him overconfident and robbed him of the basic wariness that governed Blacks' understanding of racial relations in the South. Bereft of the shrewdness that marks the pragmatic scrappers of his community, Peter falls for the real estate operator's scheme and purchases land that has a restrictive covenant. When he finds out that the deed contains "negro stoppers" and questions the legality of such a clause, a streetwise friend replies, "Legal—hell—anything a white man wants to put over on a nigger is legal."[42]

Stribling's novel ends with Peter and his girlfriend heading North for more equitable opportunities. However, in the sound version of the film, and very likely the silent one, the couple receive a telegram that notifies Peter that he has inherited money from Captain Renfrew, and it is implied that he will finally be able to build a school of higher education for Negroes, an ending more typical of Micheaux's narrative resolutions.[43]

In Micheaux's consistent commitment to progress, in his conviction that anyone with boldness, enterprise, and a willingness to work could succeed, he seems to have chosen a narrative strategy of optimistic closure. He writes in *The Conquest* about a couple of trips to the theater and describes his pleasure in the Joseph Medill Patterson play *The Fourth Estate.* Comparing it to one recommended by friends, *Madame X,* a "pathetic drama" by a "tragedian," Micheaux lays out his preferences in both narrative structure and character: "Instead of weakness and an unhappy ending, [*The Fourth Estate*] was one of strength of character and a happy finale." His description of the play makes it seem like part muckraking manifesto and part romantic melodrama: A newspaperman, "with the bigness to hand out the truth regardless of the threats of the big advertisers," falls in love with the daughter of a corrupt judge "whose 'rotten' decisions had but sufficed to help 'big business' without regard to their effect upon the poor." The young woman at first rejects his investigation of her father, but when she accidentally overhears the judge verbally assaulting the newspaperman and condoning his own dishonesty, she changes her opinion. At the end, the reporter gets the support—and hand in marriage—of the judge's daughter and, as Micheaux put it, "all's well that ends well."[44]

In his 1925 film adaptation of C. W. Chesnutt's *The House Behind the Cedars,* Micheaux changed the heroine's fate from a tragic death (which

Anyone that works hard can succeed Micheaux

in the novel is portrayed, in the nineteenth-century tradition, as an instrument of spiritual redemption, the supreme heroic act) to a more promising ending. After attempting to pass for white, Rena finally sees Frank, her industrious Negro neighbor who has been "unselfish and devoted" to her throughout, as "the wonderful man that he really was" and lives to marry him.[45]

In a revealing letter to Chesnutt, Micheaux explains his reasons for wanting to change the ending: "Colored people whom we must depend upon as a bulwark for our business, as I view them, are at this time very much incapable of appreciating immortality, which the ending of this story is a wonderful version of. I have been trying to visualize just how they would leave the theater after the close of a performance. You have created a wonderful heroine in Rena—but for her to die in the end of the story as therein detailed, I have grave doubts as to the outcome." Convinced that a happy ending would pay off at the box office, "[as] far as our people are concerned, send them out of the theatre with this story lingering in their minds, with a feeling that all good must triumph in the end, and with the words 'Oh! Want that just wonderful!' instead of a gloomy muttering and a possible knocking with their invisible hammers, would result much more profitably from a financial point of view."[46]

Micheaux was not trying to tame his contentious material with melodrama; he was bound by his concept of what would be satisfying to his audiences and therefore profitable. He spoke in the idiom of the popular, adding urgent political concerns to familiar forms.

The ending of *Within Our Gates* is not simply the romantic union of the central characters, Sylvia Landry and Dr. Vivian; it also includes a reiteration of heroic moments of the Race: Dr. Vivian recalls Cuba, the Battle of Carrizal in Mexico, and the war in Europe, "from Bruges to Chateau Thierry." Be proud that you are an American! Take strength in the past history, the soldier's demonstration of loyalty, heroism, valor, and citizenship. You are not pitiful but powerful! What is interesting here is that Micheaux presents a resolution—the healing—not from individual experience, but from the group's experience. Sylvia's "cure" is found in the social; the healing takes place within the group, within our gates. The image of soldiers in past wars reminds us that in struggle there is the chance for glory. As McKay wrote, "If we must die, O let us nobly die / So that

our precious blood may not be shed / In vain; then even the monsters we defy / Shall be constrained to honor us though dead!"

Dr. Vivian is instructing Sylvia to use the heroic qualities of the Race to overcome her past wounds. By calling up discourses on Race pride, Micheaux lets the sociological text take over. The gauntlet of social justice is being tossed to Sylvia, and, with the added support of Dr. Vivian's oath of love, she is a means through which bright prospects can be realized. In the final shot, the camera captures the companions-in-struggle, Sylvia dressed in bridal white, embracing in front of a window, looking toward the future.[47]

Authorial intrusions such as the list of heroic battles mentioned in *Within Our Gates,* or, in other films, a character's declamation against gambling, sloth, or immorality, moments when the author seems to be preaching, lecturing, or educating, disrupt the fictional flow of the melodrama. These passages of propagandistic rhetoric interrupt the forward thrust of the narrative and invite the audience to pause and reflect on aspects of life outside the theater. Yet despite this intrusion of seemingly extraneous material, because of his commitment to "story," Micheaux's fictional universe is ultimately ordered by a tidy resolution. Disharmony (greed, racism, etc.) is eventually discredited, overridden, and/or replaced by the triumph of the noble over the wicked.

In *The Forged Note,* for example, to save her father from the chain gang, Mildred had been forced into a sexual relationship with the white man who held proof of her father's crime. In exchange for her father's freedom, she was stripped of her personal dignity. This "secret," this blight on her character, haunts her throughout the story, and, like Sylvia, she feels unworthy of her true love.[48] "When you rob a woman of her purity, you have destroyed her womanhood" (p. 507).

On his deathbed, the man who had held power over her leaves Mildred $25,000, to ease his guilt. By the end of the novel, she has decided to give this money, "the price of her virtue," anonymously to help build a colored YMCA. Convinced that this would save the downtrodden, "she . . . came to feel that her sacrifice might be a blessing in disguise" (pp. 510–511).[49] By this service, she overcomes her past history, the "barrier" is removed, order is restored, and she is able to marry the man she loves (p. 50).

HIS TEXTS

*[margin handwritten notes:]* Disruption of fictional flow allows audience to reflect on issues outside of the Theater

At the trial in the ending of *The Homesteader,* the hero, found innocent in the death of his wife and father-in-law, is reunited with his first love. After spending most of the novel looking for an acceptable wife, he discovers that his original love, the strong, hardworking daughter of a neighboring homesteader, is a woman of color after all, so he can be true to his Race and marry her. In a rewrite of this novel, *The Wind from Nowhere* (1943), the hero not only marries his true love but is able to realize some of his utopian dreams when they divide up part of his land to distribute to the poor of the cities.

Micheaux's silent films and early novels have a political agenda that is both corrective and transformative. His formal project, the aesthetic strategies he uses, cannot be severed from his moral project. These works should be seen within a cultural tradition of expression that rejects the modern Western and commercial separation of ethics and aesthetics, culture and politics. As W.E.B. Du Bois put it in 1921, "We insist that our Art and Propaganda be one."[50]

CONVINCED THAT the immediacy of life and the urgency of the social condition could be marketable, Micheaux called *Within Our Gates* "the greatest preachment against race prejudice and the glaring injustices practiced upon our people." The social pathologies, both intra- and intergroup, he dealt with in the early films often brought him into confrontation with censor boards and others who might influence public exhibition. *Within Our Gates* was not the first of his works to provoke strong opposition. Several clergymen had tried to stop the theatrical release of his previous film, *The Homesteader,* and Micheaux had also exploited this in his advertisements. He developed and cultivated an image of himself as a controversial filmmaker. From his earliest correspondence with the Lincoln Motion Picture Company, while the company was trying to negotiate the rights to the novel *The Homesteader,* Micheaux insisted that the theme of interracial marriage, which Lincoln felt was "too advanced," could be a very good selling device.[51]

But from where did the objections come? Who voiced them? And what were the sensibilities and class interests of these individuals? Were Black Americans even asked for their opinion? Micheaux himself had posed this

challenge to the Virginia State Board of Censors in 1925 when they called together a committee of citizens to screen *The House Behind the Cedars*.[52] But who would the white censoring board have elected to include from the Black community? In Chicago, for example, Reverend Alonzo J. Bowling, a Harvard-educated African Methodist Episcopal minister, sat on that city's board for seven years before being replaced by another African American in 1921.[53] What were the interests of the "representatives" chosen by the board? The community was certainly not homogeneous in class, education, or political ideology. Can we assume that an African American professional serving on a censor board or advising the censors had the same views as other audience members? We have to be careful to look at censorship without flattening out the complexity and diversity of the reasons for censoring, censuring, removing footage, or banning.[54] Responses differed according to particular individual and community experiences, needs, desires, and attitudes.

In Chicago in 1920, it was once again a group of ministers that influenced the censor board to ban *Within Our Gates,* perhaps because of the lynching, or the suggestions of rape and miscegenation, but perhaps also because of the way the church and the ministry were represented. Although we have seen no primary documentation explaining exactly why *Within Our Gates* was censored in Chicago, the State of Illinois had recently passed a new law prohibiting "the exhibition of any film that shows a lynching or unlawful hanging." The *Chicago Tribune* had said that the bill (known as the Jackson Bill, after Major Robert R. Jackson, one of two Negro representatives from Chicago in the state legislature) "was based on the theory that presentations of such pictures tends to raise hatred and rioting." This law, which was enacted to stop *The Birth of a Nation,* could, ironically, have been invoked against *Within Our Gates* as well. The subject of miscegenation alone would have made the film difficult to play in states with antimiscegenation statutes or where custom forbade it. The full version of Micheaux's *A Son of Satan* (1924), for example, was rejected by the Virginia censor board, "for reasons of discretion," because it dealt with miscegenation. And in the 1925 report on *The House Behind the Cedars,* the same censor board seemed particularly concerned with the representation of the white suitor's lust for the young woman who had been passing for white: "Even after the woman has severed her relations

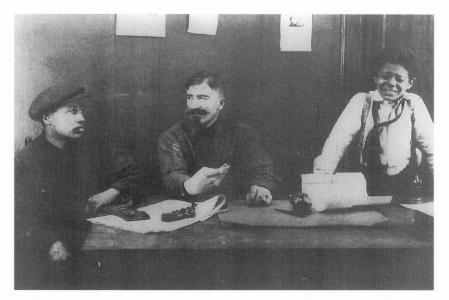

Still from Oscar Micheaux's *Within Our Gates* (1920). This scene is not in the print currently in circulation. Courtesy of African Diaspora Images.

with the man he is pictured as still seeking her society; nor does his quest end until she has become the wife of a dark-skinned suitor."[55]

But there certainly was other contentious material in *Within Our Gates*! The missing scene of the frightened boy reporting the mob's attack on his parents to the law officers is one example. Any representation of the authorities being unresponsive, unfair, or ineffectual would have invited censure.

In New Orleans, it was a police captain who instructed the manager of the Temple Theatre, "which is conducted for negro patrons only," to discontinue showing *Within Our Gates* "owing to the race conditions as they exist at this time."[56] The Star Theatre in Shreveport, Louisiana, refused to book the film because Charles F. Gordon, the manager, didn't like the subject matter: "Regarding *Within Our Gates*, Mr. Micheaux's agent was here, but on account of the nasty story, we too refused to book it and won't consider it."[57] William Hammond, a white Louisiana theater manager, referred (seemingly by mistake, exaggeration, and/or denial) to the film's representation of the treatment of Negroes during slavery and the execution by hanging of "approximately nine for absolutely

no cause," and felt that it was "a very dangerous picture to show in the South."[58]

For the second run of *Within Our Gates* in Omaha, it was the opinion of George P. Johnson, the booker, on the salability of the film that persuaded Micheaux to make cuts. Johnson was convinced that "Race propaganda" wouldn't appeal to ticket buyers. He wrote to Micheaux requesting a trailer immediately by special delivery and "kindly eliminate from the second reel all the objectionable lynchings scenes such as has caused trouble in other communities. It was in the film that [was] shown here in Omaha before, but caused quite a bit of feeling that could better be avoided without effecting [sic] receipts by eliminating that portion of the film."[59] The reference to the lynching scenes being in the second reel makes one wonder if the film was, at one point, arranged in chronological order. Perhaps the placement of the lynching story at the end of the film, as a flashback, was an attempt to keep audiences from leaving the theater in the beginning? Or maybe there had been other lynchings in the second reel.

The advertisement for the return engagement at the Loyal Theatre in Omaha, "the first and only colored theatre in Nebraska," actually noted, "All objectionable scenes that caused feeling when exhibited here before have been deleted." But in spite of the deletions, heavy promotion—including posters, advertising heralds and slides, newspaper ads, as well as a sign on an automobile that toured the neighborhood—and fine weather, the results of that two-day run at the Loyal "were far from satisfactory." Johnson suggested several reasons in a letter to Micheaux: "One, we had heavy competition; another was film repeated too soon as you say; another was that . . . [y]ou did not take enough of the second reel out and . . . the public does not like the picture. Quite a few walked out." In a letter accompanying a check for Micheaux's share of the receipts a few days later, Johnson again emphasized the controversial subject matter: "[*Within our Gates*] failed to pull the crowd. No excuse other than Public does not like the Race propaganda regarding lynching, especially here, as it is too realistic of what happened here in the city last year."[60]

The film was banned in toto by the Ohio state censors,[61] but may have played unlicensed and unadvertised in single-day bookings. Perhaps in these venues, it played whole and uncut. But there is the possibility, in

any exhibition, that a theater owner or projectionist may have independently removed "offensive" scenes or title cards. It is difficult to know whether cut passages were returned to their original positions or put back at all. Perhaps William Hammond was right, there *had* been more lynchings in the film!

The character Eph, Philip Gridlestone's manservant, may have been as controversial for some Black spectators as the lynching scenes.[62] Promotional material for the film described Eph as "the 'tattle-tale' whom the blacks called a 'white fo'kes nigger,' a pest, making no effort towards his own betterment, but who made it his business to 'spread news.' "[63] His costuming, makeup, and antics, reminiscent of minstrelsy and vaudeville, may seem somewhat comic. But as a character who buttresses the painful stereotype preferred by whites, he is no longer laughable.

Eph's obsequious behavior and posture are a part of the expected demeanor of a servant; he "knows his place." Wearing the mask and performing well, Eph deludes himself into believing he is secure. When the master is out, he feels free to prop his feet up on the boss's desk and down a few shots of his liquor. He imagines his position in the Gridlestone household gives him "status" above the field hands. In an attempt to secure his "privileges" in the Big House, he betrays Jasper Landry, the earnest sharecropper, who has worked hard to educate his family. Not only are Landry's efforts to improve himself and become independent an affront to the plantation owner and a threat to his economic livelihood, they are also a threat to the social hierarchy that gives Eph his imagined status. By commenting on the house servant's "trading" of civility and deference for certain comforts and perquisites, Micheaux also criticizes Eph for being content to imitate the boss, rather than striving to uplift himself.

In Micheaux's synopsis of the film, Eph tells Gridlestone how Landry has learned to keep track of his accounts, "owned a mule," is "buyin' land," "eddicatin" his children and, therefore, "gittin' sma't." "Now dey am keepin' books and when he comes to settle, ain' gwine to take yo' figgers, but will bring a bill!"[64] As Landry comes to present his bill, Eph peeps through a window to see "what mischief he has wrought." When Eph turns his head toward the camera to giggle, a shot rings out. Not seeing a poor and disgruntled white farmer with a rifle at another window, Eph mistakenly thinks that Landry fired the fatal shot and runs off to inform the

town that Landry has murdered Gridlestone. The townspeople immediately form a lynch mob.

So Eph is more than a malicious gossip; he is a betrayer. By assuming Landry's guilt and publicly announcing that a fellow Negro murdered a white man, he poses a threat to the entire community.

While Landry and his family are in hiding, Eph becomes a part of the lynching bee. As confidant and informer, he thinks he has endeared himself to the whites and won their favor and protection. "There's no doubt that the whites love me." "Here I am among them while the other Blacks are hidin' in the woods."[65] But as he is gloating, the impatient mob turns on him. In a moment of fear—or perhaps revelation—Eph loses his mask and, in a superimposed shot, sees himself hanged. As the embodiment of the stereotype—the obsequious loyal servant—Eph is so unaware of himself as a Black man that he's unable to see his own fate until it is too late. His servility and deference to whites represent his way of negotiating racism; however, in a climate of hatred, it is clear that the shield is precarious. In the end, he is just another "nigger."

By his act of betrayal, Eph alienates himself from the community. In the existing print, he is only seen in white-dominated spaces, and he is never in the same space or frame with another Black person. "Old Ned," the minister, on the other hand, is represented as an integral part of the Black community. He is first shown preaching to his congregation. The particularity of naming the sermon ("Abraham and the Fatted Calf"), the intensity of worship, the ecstasy of shouting and conversion, and the preacher's oratorical style and delivery are all elements of "the real," cultural codes of the Black church. By enhancing his fiction with the "truth" of daily experience, Micheaux placed his story in a context that heightened its credibility. These moments of the familiar have a rhetorical function; they suggest that this is not about a specific minister or an individual fictional character, but that "Old Ned," like Eph, is plural, one of a social type.

The intertitles call the preacher both Old Ned and Uncle Ned, but never give him the respect of the honorific Reverend, or even a surname. Indeed, it is possible that Ned is not the character's Christian name at all, but a generic reference to the sentimental plantation "darky," "Old Uncle Ned,"[66] a "respected" elderly man, a reassuring image of Black docility.

In the congregation, Micheaux implanted two elders, in obviously fake

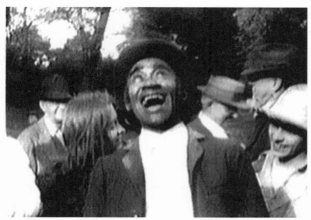

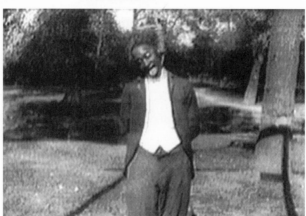

Eph (E. G. Tatum), the tattle, at his moment of realization,
in *Within Our Gates* (1920).

wigs and beards, returning money they had pilfered from the collection plate. One parishioner, deliberately overdrawn, is snoring with his mouth open; a woman struck by the holy spirit knocks her glasses askew. There is an element of caustic wit in the scene as well as amusement, an example of what Mel Watkins calls the "insistent impious thrust" of African American humor, a humor that is neither playful diversion nor innocuous entertainment, but relates to pertinent real-life situations. "Following the 'libelist' tradition of the African source from which it was partially derived, most African American humor . . . is bitingly satirical." Sterling Brown described Bert Williams's popular sketch of Elder Eatmore as "folk-satire near to the real thing."[67]

Yet, Micheaux is not attacking the institution of the church, or even the emotional catharsis of the Black folk sermon, but condemning those who, under the guise of moral authority, lead the group astray.[68] For Micheaux, Ned is an implement to point to a manner of thinking, feeling, and acting that obstructs Racial progress.[69] The Black folk church in *Within Our Gates* is the backdrop for a story of betrayal. In this film, the charismatic rural church plays a conservative and inhibiting role: teaching resignation and preaching submission to authority and deliverance in heaven as release from earthly bondage.

Even before the censorship of *The Homesteader* and *Within Our Gates*, Micheaux had strong views on the clergy and the faithful. In his first novel, *The Conquest* (1913), he wrote of a "fire eating" colored evangelist who possessed "great converting powers and unusual eloquence":

> Coincident with the commencement of Rev. McIntyre's soul stirring sermons a big revival was inaugurated, and although the little church was filled nightly to its capacity, the aisles were kept clear in order to give those that were "steeping in Hell's fire" (as the evangelists characterized those who were not members of some church) an open road to enter into the field of the righteous; also to give the mourners sufficient room in which to exhaust their emotions when the spirit struck them—and it is needless to say that they were used. At times they virtually converted the entire floor into an active gymnasium, regardless of the rights of other persons or of the chairs they occupied. I had seen and heard people shout at long intervals in church, but here, after a few soul stirring sermons, they began to run out-

side where there was more room to give vent to the hallucination and this wandering of the mind. It could be called nothing else, for after the first few sermons the evangelist would hardly be started before some mourner would begin to "come through." This revival warmed up to such proportions that preaching and shouting began in the afternoon instead of evening. Men working in the yards of the foundry two blocks away could hear the shouting above the roaring furnaces and the deadening noise of machinery of a great car manufacturing concern. . . . At the evening services the sisters would gather around a mourner that showed signs of weakening and sing and babble until he or she became so befuddled they would jump up, throw their arms wildly into the air, kick, strike, then cry out like a dying soul, fall limp and exhausted into the many arms outstretched to catch them. This was conclusive evidence of a contrite heart and a thoroughly penitent soul. Far into the night this performance would continue, and when the mourners' bench became empty the audience would be searched for sinners. I would sit through it all quite unemotional, and nightly I would be approached with "Aren't you ready?"     (pp. 18–20)

For Micheaux, the church, as ideological practice and as a repository of African American culture and expression, is both powerful and repressive. His main criticism in *Within Our Gates*, however, was not of specific denominations or individual spirituality but of the power of the minister over the congregation. Five years later, he elaborated on this theme in *Body and Soul* (1925), where the respect the congregation accords its preacher, and the congregation's complicity in the unconditional allegiance that gives the minister power, are sexualized and criticized even more strongly. The preacher's symbolic significance as the group's spokesperson and as exemplary figure within the community made Micheaux's representations of members of the clergy highly controversial.

There is an interesting parallel between Eph's servility before whites and the minister's when the latter makes his rounds, hat in hand, on Monday morning to collect his weekly "contribution" from whites. The two white men are reading a newspaper article about the Black vote and ask Uncle Ned's opinion; he assures them that he has "always preached that this is a country for whites and Blacks should stay in their place." (His sermon to the congregation in the preceding scene had demonstrated his

commitment to both the existing order and the hegemony of the here-after: "the majority of whites with all their education, wealth, and vices will end up in the fiery inferno" and "Blacks, without these vices and with purer souls, will ascend to Heaven! Hallelujah!") In exchange for his support of the status quo, Ned extracts a small donation.

A southern white dowager, advising a Boston philanthropist, had earlier underscored this point that the preacher could be bought for a small amount of money: "It is ridiculous to pay $5000 to [Piney Woods School], when $100 to Old Ned . . . will contribute more to keeping them in their place than all the schools put together."[70] In contrast to the fundamentally conservative preacher, Sylvia is committed to social change; her appeal for funds from the northern white philanthropist is in the service of Race progress.

However, Ned becomes more complicated at the end of this scene. After he is "playfully" kicked in the butt by his "benefactors" (one of the gestures that clustered around the "Tom" character in minstrelsy), he leaves the office, drops his mask for a moment, and we see in the closer shot of his facial expression, the shame and anger beneath his submissive grin,[71] the "pain swallowed in a smile" that Langston Hughes wrote about a few years later.[72] Micheaux forces Ned out of his "acceptable role" and shows us that in allowing himself to be demeaned, he has betrayed himself and his Race, selling his "birthright" for a miserable "mess of pottage."[73] The character performs the stereotype *and* comments on it. Using the stereotype and the stock vaudeville and minstrel gesture in a complex process of adaptation and transformation, Micheaux exposes the contradictions in a world where the expression of desire and ambition are constrained by social custom and law. By allowing whites to define them, both Eph and Ned reinforce the very system that denies their humanity and by playing to southern racial "arrangements," both characters collude in their own emasculation.

These characterizations of Old Ned and Eph are caricatures readily recognizable from other texts—films, vaudeville, minstrelsy, and African American literature and journalism—and carry meanings that dance beyond the images on screen.[74] The character Eph is immediately readable (via body language, costume, and acting style). Even before he becomes the betrayer, he is recognizable as a character to be ridiculed,

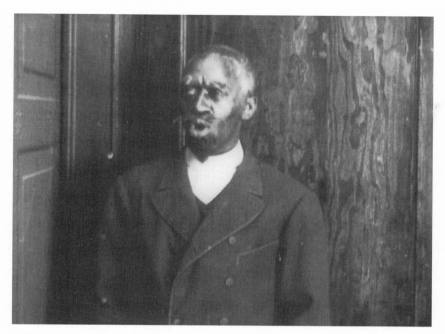

Old Uncle Ned (Leigh Whipper) after being kicked, in *Within Our Gates* (1920). Photo by Charles Musser. Courtesy of the Museum of Modern Art/Film Stills Archive.

and perhaps even pitied. He is the dependent "childlike" incompetent, bloated with self-importance, greed, jealousy, and cowardice. In another context, as a Black character in a white story, such a buffoon might have been comic relief.

The performance style of the actors who play Ned and Eph (seasoned players Leigh Whipper and E. G. Tatum, respectively) differs from the rest of the cast. Their constant body movements, broad gestures, and exaggerated facial expressions draw from their vaudeville training. Uncle Ned, on his Monday visit, is hunched over, his head bowed, clasping his hands in front of him. It is an economical style, resonant with meanings from other contexts.

Racial stereotypes are usually analyzed in the context of racist motivations or effects: to justify and maintain white domination, aggression, and privilege.[75] However, if we look at Eph and Old Ned as discourses from within the Black community, as part of the Grand Narrative, and examine the social voices speaking through these characters, we see that

*racial stereo-types*

Micheaux's strategic use of the stereotypes was not meant to dehuman-
ize or subordinate but to posit moral instruction, as examples of misplaced
values and low self-worth.

In the scenes in which Eph sees himself lynched and "Old Ned"
reflects on his humiliation, Micheaux endows the characters with sub-
jectivity, a racial consciousness which is at odds with stereotypical repre-
sentations. Both of these scenes are shot in medium close-up, some of the
closest shots of the film, emphasizing the characters' facial expressions:
Eph's terror; Ned's anger and self-loathing. Micheaux has constructed
the characters on the level of gesture, makeup, dress, and performance
style as stereotypes but has deliberately given them a narrative function
that subverts the stereotype,[76] so that kowtowing to whites becomes not
simply servility but an act of betrayal. Appropriating these stereotypes for
a knowing audience, Micheaux redefined them not only to expose them,
but also, in a remedial effort, to raise the consciousness of the audience
in order to motivate change. He was mapping out the boundaries of accept-
able behavior, insisting on impermeable boundaries, whereas they are really
much more fluid: the betrayer among us, or even within us, is not so easy
to discern. His provocative representations invite you to think, and,
almost like a parable, they are certainly meant as moral guidance (per-
haps the moral guidance expected of a minister). The *Chicago Defender*
commented on the effectiveness of Micheaux's moralism, proclaiming that
"the interest manifested by the audience shows that the great lessons taught
by the splendid picture [are] being properly driven home."[77]

Stereotypes do not usually change or develop through the course of
the narrative,[78] nor do they generally have any individuality or interior-
ity. In *Within Our Gates,* Micheaux turns objects into subjects: active,
thinking, feeling agents. Audiences may have been—indeed, may still be—
uncomfortable with Micheaux's version of these stereotypes because the
same stereotypes have provided much of the humor in minstrel and
vaudeville shows and films made by whites. One of the most novel aspects
of *Within Our Gates* is its use of stereotypes for sentiments other than simply
comic—to demonstrate that stereotypes can be serious and eloquent.[79]
Reclaiming the stereotypes in the service of revising the narratives fash-
ioned by members of the dominant group, Micheaux gives these characters
back their humanity, permitting them to break out of what Alice Walker

HIS TEXTS

calls the "prisons of image."[80] They are no longer relegated to the margins, and the lies of stereotypical behavior become the opportunity to "voice" long-suppressed truths (part of what Thelma Golden recently called the ongoing reevaluation of "the real" in Black life).[81] By exposing the power relations beneath the surface of Black-white relations, the traumatic pain and anguish that are the consequence of white domination, Micheaux tactically and self-consciously rent the surface of the implicit narrative of mainstream representation.

As an expression of creative power, *Within Our Gates* is an important resistance to a system that would prefer opposition to be voiceless; but it is as an address to the African American community of the twenties that it is most meaningful. It is within these gates that the symbolic and political complexity of the discourses on religion, education, voting, service, miscegenation, peonage, and lynching are formed.

# The Symbol of the Unconquered
# 5 and the Terror of the Other

The Symbol of the Unconquered, the latest and the best of the Micheaux productions, will open a six day showing at the Vendome Theater on Monday January 10th. This feature has been creating a wonderful amount of comment all over the East and is one which should be seen by everybody. The story is a clean-cut one and the action is full of speed, interesting and exciting. It tells of the struggles of a young man to retain possession of a piece of valuable oil land against tremendous odds, which includes [sic] everything from intimidation at the hand of his neighbors to a narrow escape from death for him at the hands of the Ku Klux Klan. A love story of beautiful texture lends added interest and some red-blooded scrapping and hard, hard riding furnishes the picture with the amount of exciting action required to make the blood tingle through your veins at high speed.

—*Chicago Defender*, January 8, 1921

My color shrouds me in . . .                    —Countee Cullen

OSCAR MICHEAUX's fourth film, *The Symbol of the Unconquered*, "A Stirring Tale of Love and Adventure in the Great Northwest," is a wilderness story like *The Homesteader*. Press releases for the film alluded to the characteristic elements of the popular Westerns, both serials and features, playing in theaters across the country: hard riding and red-blooded scrapping. The frontier, for Micheaux, was the mythic space of moral drama and the site of golden opportunities (seemingly free of the social arrangements and racial antagonisms of the rural South and the urban metropolis), where the characteristic model of economic expansion is entrepreneurship. His first novel, *The Conquest*, set in Gregory County, South Dakota, had celebrated the enterprising individuals: homesteaders, merchants,

156

bankers, and real estate dealers involved in commercial clubs, land booms, and speculation about the route of the railroad. The hero of *The Symbol of the Unconquered,* Hugh Van Allen, a man of the frontier, self-willed and self-motivated, is another articulation of Oscar Micheaux's "biographical legend." Accumulating wealth through hard work and self-denial, he is almost a metaphor for the spirit of individualism.

In a 1910 article in the *Chicago Defender,* Micheaux quoted Horace Greeley, "Go west young man and grow up with the country," and although he wrote about openings for doctors, lawyers, laborers, and mechanics, he posited the future of the West with agricultural possibilities, calling farmlands "the bosses of wealth." For Micheaux, the land openings along the frontier provided the opportune moment for the Negro to "do something for himself." Detailing the participation of the Race in agriculture, he wrote of fewer than "300 Negro farmers in the ten states of the Northwest" and "more opportunities than young men to grasp them."[1] Although such an image made him seem unique, enlarging his legend as a "Negro pioneer," Micheaux was, in fact, one of many thousands of African Americans, since Emancipation, who were drawn to the frontier as a place where one could realize one's own destiny.[2]

The appeal of the West spoke strongly to many Americans as both a symbolic and actual place offering an unspoiled environment in "the hollow of God's hand"[3] for individuals to fill with their own virtue: a place where social conventions and distinctions prove less important than natural ability, inner goodness, and individual achievement. Real estate promoters, railroad advertisements, news stories, dime novels, traveling shows, and movies mythologized the frontier as the site of freedom, abundance, and independence, capturing the imagination of a multitude of African Americans determined to put the residues of slavery and racial barriers behind them. In *The Symbol of the Unconquered,* Hugh Van Allen, a gentlemanly frontiersman riding in a buckboard, embodied the Western hero, self-sufficient and calmly rugged.

Race theaters, not unlike white houses, regularly featured Westerns as part of the programming in the late teens and twenties; Dustin Farnum's *A Man in the Open,* "A Thrilling Romance of the Great Northwest," played at the Vendome the day before *The Homesteader* opened. Edward Henry, an African American projectionist in a neighborhood theater in Jackson,

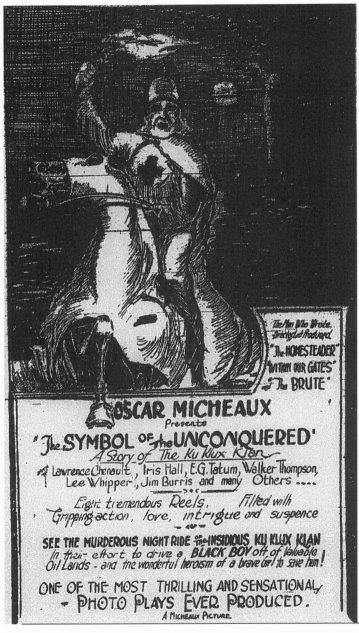

Advertisment in *The New York Age* (December 25, 1920)
for *The Symbol of the Unconquered* (Oscar Micheaux, 1920).

Mississippi, throughout the twenties recalled: "When you go back, William S. Hart was one of the big men. . . . All you had to do was just put his name out there; [you] didn't have to put any pictures or anything, just William S. Hart, Wednesday, and they'd be coming. . . . William S. Hart, Tom Mix . . . as I say, just open the door and stand back. The crowds'll come in."[4]

The great antagonist in *The Symbol of the Unconquered,* however, was not hostile elements, menacing outlaws, or "savage" Indians, as in most white Westerns, but the Ku Klux Klan. And Micheaux capitalized on that. Despite a climate of racial violence and intimidation, he advertised the picture's premiere in Detroit as "SEE THE KU KLUX KLAN IN ACTION AND THEIR ANNIHILATION!" When it played in Baltimore, the *Afro-American* ad exhorted, "SEE THE MURDEROUS RIDE OF THE INSIDIOUS KU KLUX KLAN in their effort to drive a BLACK BOY off of valuable Oil Lands—and the wonderful heroism of a traveler to save him!" Another reference to the KKK (apparently quoting from Micheaux's press release) appears in the *Chicago Whip:* "Night riders rode down upon [the hero] like ghosts with firey torches intent upon revenge." And the *New York Age* review headlined, "KKK Put to Rout in PhotoPlay to be Shown at the Lafayette," called attention to the "viciousness and un-Americanism of the Ku-Klux-Klan which . . . is beginning to manifest itself again in certain parts of the United States. . . . [The film] is regarded as quite timely in view of the present attempt to organize night riders in this country for the express purpose of holding back the advancement of the Negro." The *Competitor* magazine singled out the same part and saw a similar significance: "One of the most thrilling and realistic scenes is that of the Ku-Klux Klanners, who ride forth 'on the stroke of twelve' to pursue their orgy of destruction and terror. Coming at this time when there is an attempt to revive this post–civil war force of ignominy and barbarism denounced by the leading people of both races, in speech and editorials, North and South, the effect of disgust and determination are heightened."[5]

Promotion for *The Symbol of the Unconquered* addressed the Black spectator and underscored the protest nature of the film.[6] However, to think of the Klan as the singular antagonist is to reduce the complexity of Micheaux's representation. Homesteader Hugh Van Allen (played by Walker Thompson) is echoed by Driscoll (played by Lawrence Chenault), the villain who is also out to improve his lot. Both characters

are speculators who have migrated to the Northwest in pursuit of bigger and better opportunities. Although Driscoll is motivated by the same drives as the hero (indeed, as Micheaux himself), he acts in unscrupulous ways. He advances his standing, not by hard work and self-denial, but through coercion and deception. Through Driscoll and his cohorts, Micheaux exposes the economic origins of white-capping: Driscoll, a light-skinned man passing for white, is the leader of a gang of greedy misfits plotting to intimidate Van Allen and drive him off his valuable oil lands. It is Driscoll's participation in the Klan, his use of the same forces of intimidation that he would experience if his true racial identity were known, that disturbs the equilibrium of any clear-cut binary opposition.

Why does Micheaux superimpose the image of the KKK on an interracial band of thieves, swindlers, and connivers (including a former clergyman)? Is Driscoll the resurrected Eph from *Within Our Gates,* a betrayer, albeit in a more complex form? Driscoll's racial ambiguity enables him to pass, but the darker-complexioned Eph must rely on a charade of obsequious behavior to gain white acceptance. Eph's wearing of the servile mask and his loyalty to his master are his ways of negotiating racism. Driscoll, on the other hand, not only wants to be white but, in order to achieve whiteness, assumes the posture of the oppressor; to ward off the terror of the Other, Driscoll himself becomes a terrorist. He counters racism with hatred, turns that hatred on the Race and, by extension, on himself. Both Eph and Driscoll deny their solidarity with the group. Eph, in trying to secure his own "privileged" position among the whites in the Big House, separates himself from, and betrays, a fellow Negro. Driscoll, by internalizing negative perceptions of blackness, isolates himself and betrays the Race.[7] Micheaux condemns the social behavior of both characters, and both get their just deserts.

Van Allen's triumph over hatred is even sweeter because he has overcome Driscoll's self-hate, as well as the night riders, the symbol of racial oppression and intimidation. The unmasking of hatred is as much a part of the film as the violence perpetrated in the name of that hatred.

---

WE THINK of Van Allen as Micheaux's surrogate, and in the character of Van Allen, Micheaux was dreaming and redreaming his own ambitions

HIS TEXTS

Eve Mason (Iris Hall) and Hugh Van Allen (Walker Thompson)
in *The Symbol of the Unconquered.* Photo by Charles Musser.
Courtesy of the Museum of Modern Art/Film Stills Archive.

and desires. In the epilogue, Van Allen's good deeds are rewarded: he becomes prosperous from the oil on his land and discovers that neighboring homesteader Eve (or Evon, as she is called in some notices) Mason (played by Iris Hall) is, despite her light skin, really a Black woman and thus a suitable wife. In *The Conquest,* Micheaux writes of his experiences homesteading and falling in love with his neighbor's daughter, an unnamed young Scottish woman of strong character and "anxious to improve her mind," attributes he clearly admired.[8] One of the least verifiable episodes in the author's life, this interracial romance is a recurring theme and rhetorical trope in his films and novels. Micheaux replays this love, or the possibility of it, in many of his works. In *The Conquest,* although he never acts on his feelings (self-control and self-denial were guiding principles of conduct in Micheaux's biographical legend), he conveys a sense of anxiety about even considering it: to pursue an interracial relationship would call into question his loyalty to the Race.

This type of titillation—and concession to popular mores—is more developed in his novel *The Homesteader*. The main character, the Negro pioneer Jean Baptiste, discusses his selection of a wife, interrupting the narrative with an excessive and problematic digression on "physical morality" that attempts to explain the mixed blood of the African American people:

> The masters had so often the slave women, lustful by disposition, as concubine. He had, in so doing of course, mixed the races, Jean Baptiste knew, until not more than one half of the entire race in America are without some trait of Caucasian blood. There had been no defense then, and for some time after. There was no law that exacted punishment for a master's cohabitation with slave women, so it had grown into a custom and was practiced in the South in a measure still.
>
> So with freedom his race had not gotten away from these loose practices. . . . In his business procedure of choosing a wife, one thing over all else was unalterable, she must be chaste and of high morals.[9]

What is unsaid, blocked, or submerged in this outrageous dissertation on miscegenation is sexual relations between white women and black men. Embedded here is a displacement of the hero's forbidden affection for Agnes, the daughter of a white neighbor. Jean Baptiste (whose goodness and morality are part of his narrative function) offers a tale that is the obverse racial dynamic from the one he is contemplating, one that has historically invoked severe repercussions. The myth of the lascivious character of women of the Race covers up for the myth he cannot speak; what is silent, and so taken for granted that it need not be spoken, is the myth of the purity of the white woman and by extension, the purity of the "white" race.

Is Jean Baptiste resurrecting the myth of the licentious Black woman in order to avoid confronting his own forbidden desires? Or is widespread racial mixing a rationale for his defiant romantic involvement? Is his attack on the women of the Race a compensation for the inability of Black men to protect their families in slavery? Perhaps even in "freedom"?[10]

Jean Baptiste, deciding not to marry the woman he loves (whom he believes to be Caucasian), cites "*The Custom Of The Country, and its law,*" and goes on to note that such a marriage "would be the most unpopu-

HIS TEXTS

lar thing he could do . . . he would be condemned, he would be despised by the race that was his" (p. 147; Micheaux's italics and capitalization). In *The Conquest,* Oscar Devereaux exclaims, "I would have given half my life to have had her possess just a least bit of negro blood" (p. 168), and in subsequent films and novels, Micheaux provides exactly such an ending: the hero discovers that his love has a nonwhite ancestor, a parent of "Ethiopian extraction," and marriage becomes possible. Georgia Hurston Jones wrote of the "compensations" in Micheaux's first four films: "Mr. Micheaux has not overlooked the sheer joy of 'living and loving,' and though some ugly conditions are set forth (to the end that they might be improved), yet his pictures leaves one with the comfortable feeling that 'all's well that ends well.' "[11]

---

CLUES TO the true racial identity of the woman, who seems to be an inappropriate love interest for the hero, emerge in different ways in his later films and novels. In *The Exile* (1931), for example, the heroine is described as a white woman by another character early in the movie. The audience gets essential narrative information at the same time as the heroine does: we share her curiosity when she examines her physical appearance before a mirror, but do not know for certain that she is Black until she does, in a final scene. On the other hand, the audience knows more than the characters do in *The Betrayal* (1948), the film version of Micheaux's 1943 novel *The Wind from Nowhere* (another reworking of his biographical legend). The picture opens with a scene of an elderly Black man explaining his granddaughter's lineage; however, the heroine is not present in that scene and does not know that the gentleman is her grandfather.[12] By carefully tracing the character's origins, Micheaux informs the audience that the heroine herself is unaware of her true racial identity and therefore is neither deceitful nor disloyal. In *The Symbol of the Unconquered,* a fragment of a scene at the opening of the film shows Eve at the deathbed of her grandfather, a dark-skinned man with a large white mustache. Both the heroine and the audience, from the very beginning of the narrative, are aware of her racial identity, despite her fair skin.

Consistently in all these works, it is the Micheaux-like male hero who struggles for much of the story with the political and moral dilemmas of

such a marriage.[13] *His* is the noble fight. In *Thirty Years Later* (1928), it is the man who is unaware of his ancestry; however, he also fights the noble fight: when he learns about his origins, the hero becomes proud of the Race and marries his love.[14]

Micheaux's treatment of miscegenation in such films as *The Homesteader, Within Our Gates, The Symbol of the Unconquered, A Son of Satan, The House Behind the Cedars, Thirty Years Later, Birthright, The Exile, Veiled Aristocrats, God's Stepchildren, The Betrayal,* and all seven of his novels, is an ambitious reworking of the conventions of melodrama from a point of view within the Black community—a resourceful reconfiguration of the genre. By centering the African American experience, he offered a bold critique of American society. To understand the scope and complexity of this critique, we must see it, as Jane Tompkins wrote of the sentimental novel, as a political enterprise that both codified the values of the time and attempted to mold them.[15]

Although mistaken identity was a common convention of nineteenth- and early twentieth-century melodrama—the ill-suited lover who turns out not to be ill-suited after all (that is, not a sibling, a pauper, a moral indigent, etc.)—the reversals in Micheaux's stories more often involve the potential transgression of the social taboos and legal prohibitions against miscegenation. Because of confusions over lines of race difference and the subsequent fear of not being able to distinguish who is Black and who is white, legislators in some states imposed legal definitions of race. The fetishization of "black blood," as Toni Morrison puts it, "is especially useful in evoking erotic fears or desires and establishing fixed and major difference where difference does not exist or is minimal. . . . Fetishization is a strategy often used to assert the categorical absolutism of civilization and savagery."[16]

Micheaux's use of mistaken identity and the potential for miscegenation that ensues opens up the question of the problematic ambiguity of those boundaries. Such racial mixing threatens definitions of race, challenging the idea that racial identity might be "knowable." By blurring the dichotomy on which whiteness depends, miscegenation throws into disarray the basis of white supremacy. Morrison points out that it is by imagining blackness that whiteness "knows itself as not enslaved, but free, not repulsive, but desirable, not helpless, but licensed and powerful."[17]

In *The Symbol of the Unconquered* (as in much of his other early work), Micheaux worked within the hardened conventions and presuppositions of "the Negro problem" text, melding plots and conventions from the sentimental melodrama with Western settings and characters. Rather than suggesting a radical new way of seeing or attempting to create a new narrative space for representation, he was "crafting a voice out of tight places," as Houston Baker wrote of Booker T. Washington's use of minstrelsy.[18] Often invoking the novel *Uncle Tom's Cabin* in his promotional material (print ads and trailers), Micheaux seems to have admired not only the enormous social impact (and commercial success) of Harriet Beecher Stowe's work, but also its evangelical piety and moral commitment.[19]

———————

REPRESENTING sociological and moral forces rather than psychologically individuated people,[20] many of his characters function as models to illustrate what could be accomplished through hard work and industry. The character Van Allen in *The Symbol of the Unconquered,* and the film's title, are expressions of Oscar Micheaux's optimism for the Race. Like Micheaux's biographical legend, Van Allen is the adventurous entrepreneur, an achiever, loyal to the Race, persistent and brave in the face of adversities. Today, however, Van Allen is one of the least provocative characters. Driscoll, on the other hand, is so overdrawn that he borders on the horrific—almost uncanny. "Uncanny" because he is at once so evil and so familiar. Although passing is not uncommon or automatically condemned by the Black community, it is Driscoll's attitude of superiority, seeing Blacks as subhuman and taking pleasure in their misfortune, that is wicked—both a betrayal and a surrender.

Driscoll refuses Abraham, a Black traveling salesman (played by E. G. Tatum, who lends a comic irony to the melodrama), a room in his hotel and leads him to the barn. When Eve arrives at the hotel later, hungry and exhausted from a long journey, Driscoll at first thinks she is white; but, as she is about to register, he looks into her eyes and "sees" her true identity. His initially genial behavior turns to hatred; he denies her a bed in his hotel, sending her to the hayloft. During the night, Eve is awakened by a storm and is frightened upon discovering that there is someone else in the barn. She falls from the loft and runs out into a driving rain. Driscoll,

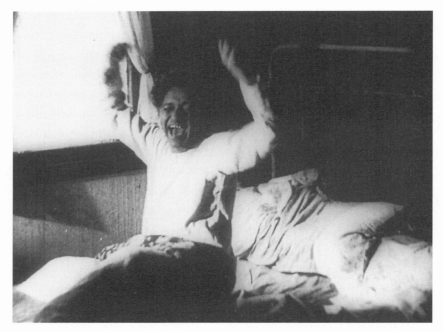

Driscoll (Lawrence Chenault) raising his arms in triumph,
in *The Symbol of the Unconquered*. Photo by Charles Musser.
Courtesy of the Museum of Modern Art/Film Stills Archive.

watching from his bedroom window as she struggles in the storm, takes sinister joy in her suffering. Surrounded by an aura of shimmering whiteness (in white nightshirt and sheets, lit as if he were aglow), he thrashes his arms in triumph.

What is so disturbing about Driscoll is his assumption of the posture of the oppressor *and* his terror of discovery. In Eve's pale face, he sees both his true identity and the possibility of being unmasked. In *The Conquest,* invoking a story from his experiences as a homesteader in South Dakota, Micheaux wrote about the children in a wealthy mixed-race family who were passing for white and living in fear of other members of the Race, dreading "that moment of racial recognition" (pp. 160–162). Driscoll's own racial identity is exposed early in the picture when he is greeted by his mother, a darker-skinned lady, as he is proposing to a white woman.[21] In this scene, the terror of racial recognition and the odiousness of racial terror come together as Driscoll attacks his own mother because she is Black.

HIS TEXTS

Later, in a barroom scene, there is a fistfight between Van Allen and Driscoll, supposedly over a horse deal turned sour. The fight scene is introduced by a close shot of both Driscoll and Van Allen framed in a mirror. Driscoll looks up and recognizes Van Allen. Does he see Van Allen as the horse-trade victim he has been mocking? Or is this that moment of racial recognition? Perhaps Driscoll sees his despised self, his own blackness, in Van Allen. Driscoll's whiteness is dependent upon a racial Other against which to define itself. And yet the fear of recognition and his self-hate puts him in terror of that very Other.

Driscoll pulls a gun and threatens Van Allen, but Van Allen wrestles the gun away from him and they "duke it out." After being beaten by Van Allen and declaring, "I'll get my revenge!" Driscoll is thrown out of the bar with a swift kick in the butt by the same traveling salesman whom he had refused to serve in his hotel. Is this a matter of a Black man getting

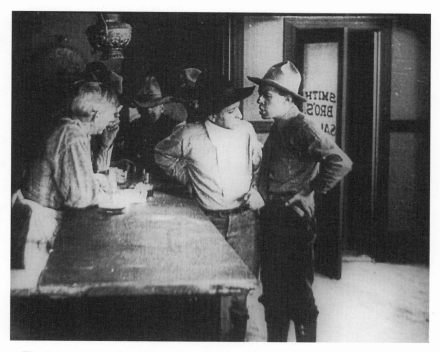

The bar scene, where Van Allen (Walker Thompson) confronts Driscoll
(Lawrence Chenault), in *The Symbol of the Unconquered*.
Photo by Charles Musser. Courtesy of the
Museum of Modern Art/Film Stills Archive.

THE TERROR OF THE OTHER

the better of a "white" man,[22] or is it intraracial censure? To the spectators in the bar who are unaware of his racial identity, this is a "reversal" of the standard prank: it is a "white" man, not the dark-skinned black, who is the butt of the joke and object of ridicule.

Lawrence Chenault's appearance and performance style throughout the film—his chalky makeup; his outlined eyes and arched eyebrows; his tense, often flailing, arms and hunched shoulders; the rigidity of his body and the vehemence of his gestures—express a man driven by fear. Driscoll's self-loathing and terror of discovery provoke his attack on Van Allen; having failed, he uses the Klan as a personal instrument of revenge. It is because his identity is so tenuous that he is so vicious. Reflecting on the South Dakota mixed-race family, Micheaux wrote, "What worried me most, however, even frightened me, was that after marriage and when their children had grown to manhood and womanhood, they . . . had a terror of their race" (*The Conquest,* p. 162). They looked upon other Blacks with a dread of discovery that would expose not only their racial identity but also a life of deception, threatening social and psychological upheaval. For Driscoll, Race is the unspeakable, the stranger entering the gate, menacing his whiteness. Identity, to borrow from James Baldwin, "would seem to be the garment with which [he] covers the nakedness of the self."[23]

The *Competitor* magazine praised *The Symbol of the Unconquered* as making a significant thrust at the "more than 500,000 people" in the United States who are "passing for white." With urbanization, migration, and the relative anonymity of city life, fair-skinned people with African ancestry found it easier to cross the color line. The *Daily Ohio State Journal* in 1909 wrote of thousands of people passing in Washington, D.C., alone: "Those who just occasionally pass for white, simply to secure just recognition, and the privileges the laws vouchsafe an American citizen, should not be censured harshly. An unjust discrimination, a forced and ungodly segregation drives them to practice deception. . . . But it is an awful experience to pass for white. At all times fear—the fear of detection—haunts one. . . . Those who turn their backs upon their own color, own race and own relatives to live a life of fear, of dread, and almost isolation just to pass for white seven days in the week, while regarded with utter contempt by their colored race, really ought to be pitied, when it is known how heavy is the burden they carry, and how much they suffer in silence."[24]

MICHEAUX exploited these concerns in the script for his 1938 film, *God's Stepchildren*. Andrew, the white husband of the young woman who is passing, upon discovering his wife's "streak," says, "You aren't the first to try this, Naomi. No, it has been tried since the days of slavery and even before that; but they can't get away with it, so you see you can't get away with it, for sooner or later, somewhere, some time after a life of fear and exemption you will be found out, and when you are they'll turn on you, loath you, despise you, even spit in your face and call you by your right name—Naomi, Negress."[25]

The Black press often covered both well-known interracial marriages and court cases of people attempting to prove that they were Negro in order to counter charges of miscegenation.[26] Stories of whites being unable to discern what is obvious to a Black person were part of the popular discourses of the time. It was thought quite funny that for whites, race was not so much a matter of color and appearance as mannerisms and deportment. Helen M. Chesnutt, in her biography of her father, tells of the family entering a restaurant while traveling and, after being seated, seeing the manager "bearing down" upon their table. They immediately began speaking French . . . and the man retreated.[27]

Lester A. Walton, in a *New York Age* article titled "When Is a Negro a Negro to a Caucasian?" asked, "by what standard do they differentiate as to when is a Negro a Negro?" and laughed about vaudevillian John Hodges ("Any colored person can tell what John Hodges is") trying to eat at a restaurant and getting served after telling the waiter that he is not a Negro but an English Jew. In another article, Walton tells the story of the white manager and cashier at the Fifty-ninth Street Theatre in New York who were discharged because "they mistook a young lady of color to be of the white race and proceeded to speak disrespectfully of their ebony-hued employer [William Mack Felton]." Walton mused, "One of the amusing features of the so-called Negro problem is the inability of the white people to recognize hundreds and hundreds of colored people who have gone on the other side of the color line. To us there is nothing so ludicrous as to observe one known as a violent Negro hater walking arm-in-arm or sitting at a table eating with a person of color, the radical Caucasian indulging in an erratic outburst of abuse on the Negro to the unconcealed delight of the colored person."[28]

In 1925, the trial of wealthy, white New York socialite Leonard "Kip" Rhinelander and his wife made the front pages of the Black weeklies. Rhinelander had taken his new wife, Alice Jones Rhinelander, to court to dissolve their marriage because he said that he had just found out that she had "Negro ancestry and that she had concealed the fact from him during their courtship."[29] Mrs. Rhinelander denied any deception, insisting that anyone could tell she was a Negro. Micheaux used the notoriety of the Rhinelander case in his promotion for *The House Behind the Cedars,* his 1925 adaptation of C. W. Chesnutt's story of passing.[30] But even if he had not mentioned it in his ads, such popular discourses on crossing the "color line" certainly would have influenced the way audiences understood the film. Press coverage, folk sayings, blues songs, verbal exchanges are all part of the spectator experience. As Tony Bennett and Janet Woollacott put it, "A text . . . is never 'there' except in forms in which it is also and always other than 'just itself,' always-already humming with reading possibilities which derive from outside its covers."[31]

However, in what appears to be a contradiction in many of Micheaux's works, the Black romantic lead, in order to meet the demands of melodrama, must be blind to the race of his beloved until the moment of utopian revelation. In its review of *The Symbol of the Unconquered* on January 1, 1921, the *New York Age* commented, "As in nine cases out of ten Negroes instinctively recognize one of their own, some are apt to wonder why [Van Allen] did not learn the truth sooner. However, the raising of such a point does not in any way detract from the general excellence of the picture."

Because Driscoll's true racial identity is established early in the film, audiences watch his vileness while knowing he is Black. Wearing his mask, he so vehmently rejects blackness that, turning his anger on the Race, he also assaults the audience. The defeat of the vengeful character at the end of the film must have given the spectator a moment of relief and joy—a blow against the oppressor. Likewise, the scene in the bar where he is kicked in the butt by the traveling salesman allows the spectator to take vicarious pleasure in his humiliation. Driscoll's downfall and the apocalyptic renewal of the ending are victories not only for Van Allen but for the spectator as well, putting to rest notions of Black "inferiority." What visions of their own radical anger and omnipotence might the audience have experienced watching their hero![32]

HIS TEXTS

The character Driscoll is both a vehicle for exploring interracial relations and, as a person of mixed blood (the product of historical miscegenation), an expression of those relations. The question of color is a recurring interest for Micheaux. However, his is not a simple "infatuation with color," nor is it simply a narrative contrivance—that is, the melodramatic trope of someone being other than what he or she seems. It is far more complex. Although he was sometimes accused of casting by color,[33] he criticized the color-caste system within the community as destructive social behavior. And although he created a star system of many fair-skinned performers (Iris Hall, Shingzie Howard, Evelyn Preer, Lawrence Chenault, Andrew Bishop, Carman Newsome, Lorenzo Tucker, etc.) chosen for their "look" and potential appeal to audiences,[34] he didn't necessarily associate these "looks" with certain qualities, such as "goodness." In *Body and Soul,* Paul Robeson plays both the hero and the villain with no difference in makeup, and the scoundrel, "Yellow Curley," is played by Lawrence Chenault (who also plays villains in other films where the shade of one's skin is not part of the story).[35] In *The Symbol of the Unconquered,* Walker Thompson, playing the rugged outdoorsman hero, acquires his swarthy complexion with dark makeup. Carl Mahon, who did not think of himself as an actor, felt that Micheaux cast him in romantic leads because of his "exotic looks," the combination of dark skin and straight hair.[36] In several of his films—*The Symbol of the Unconquered, The House Behind the Cedars,* and *God's Stepchildren,* for example—we would argue that Micheaux is not reproducing "color prejudice" but rebuking it.

For Micheaux, the problem of miscegenation is not the mixing of the races but the denial of racial identity and disloyalty that comes from trying to hide one's Race. In *Within Our Gates,* Sylvia, the offspring of the plantation owner's brother, is adopted by Black sharecroppers and raised as one of their own. She sees herself as a Black woman. As a person of mixed blood, Sylvia is not automatically an outsider, someone different, a point of division.[37] In a medium-long shot of her family around a table, there are a variety of skin tones. The story line is not "about" skin color per se; it is "about" the rape of Black women by white men.

Although much of Eve's backstory in the surviving print of *The Symbol of the Unconquered* seems to be missing,[38] Eve, like Sylvia, is comfortable with who she is and is not trying to pass. In an interview around the time

of the film's release, Micheaux said, "There is one thing aside from [making] the story interesting, that . . . I strive to demonstrate in all my pictures and that is, it makes no difference what may be a person's color, or from where a person comes, if the heart is right, that's what counts, and success is sure."[39] Eve is not only a Black woman but a Race woman. It is through a letter commending her for her service to the Race that Van Allen discovers her true identity.

*Gve*

In *The Betrayal,* Martin Eden (the character's name, like Eve's, associates him with a pastoral innocence)[40] tells the story of the children of a mixed-race family in South Dakota who would pass their father off as an "old colored servant who helped to raise them" when visitors came to call. One of the brothers was dark. Drafted into the army and assigned to a colored unit, unhappy with being unable to serve in a white regiment, "he stood before a mirror in his tent one night, took a German Luger that he had acquired—and blew his brains out."[41]

Although some contemporary critics have accused Micheaux of "Race hatred,"[42] it might be more fruitful to look at his work as criticizing certain attitudes, behavior, and conduct as detrimental to the future of the Race. Among the great diversity of characters criticized are gamblers, womanizers, people without ambition, blind followers of the faith, and those who project their self-hate outward upon other Blacks. As bell hooks put it, he "was not concerned with the simple reduction of black representation to a 'positive' image."[43] Micheaux proclaimed, in a letter to the *Pittsburgh Courier* on December 13, 1924: "It is only by presenting those portions of the race portrayed in my pictures, in the light and background of their true state, that I can raise our people to greater heights. I am too much imbued with the spirit of Booker T. Washington to engraft false virtues upon ourselves, to make ourselves that which we are not. Nothing would be a greater blow to our progress." In his 1946 novel, *The Story of Dorothy Stanfield,* he described his surrogate, the book publisher and motion picture producer Sidney Wyeth, as "an intense race man; and while he can and does criticize the Negro in his books, he is for his people at all times, regardless the circumstances."[44] Among Micheaux's characters, there *are* those who hate the Race—Driscoll in *The Symbol of the Unconquered* and Naomi in *God's Stepchildren,* for example.

Naomi, a fair-skinned infant, was abandoned at the home of Mrs. Saunders, a good, proper, and loving Negro woman. In a scene that does not appear in the extant print of the film, a neighbor tells Mrs. Saunders that the baby is white, "Look at it, its face is as white as snow," and advises her to turn the child over to the police. But Mrs. Saunders suggests that they move to the window and examine the baby more closely. "Yes, I see it now. She's colored alright, you see it in her eyes. Over there in the shadows, they seem to be blue; but here in the daylight they're brown. That's the Negro in her. Yes, she's colored alright."[45]

This "look into the eyes" is a frequent recognition device in Micheaux's work. This is how Driscoll knows Eve's race. Agnes, in the novel, *The Homesteader,* described as a young woman with unusually long, thick and heavy "flaxen" hair, had eyes that "were a mystery—baffling. Sometimes when they were observed by others they were called blue, but upon second notice they might be taken for brown. Few really knew their

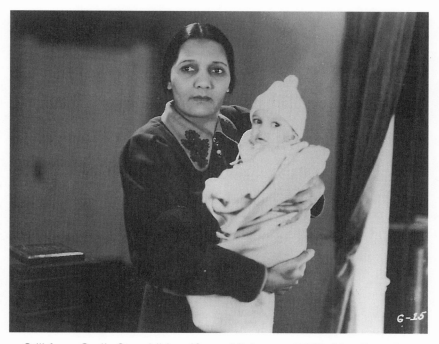

Still from *God's Stepchildren* (Oscar Micheaux, 1938); Mrs. Saunders (Alice B. Russell) is holding an abandoned baby as her neighbor exclaims, "It's a white child. You should call the police."
Courtesy of African Diaspora Images.

THE TERROR OF THE OTHER

exact color, and to most they were a puzzle" (p. 14).[46] Later, in *God's Stepchildren*, Naomi's white husband, suspecting she is Negro, says: "Let me look straight into your eyes. That's where I've been seeing something that I could never understand."[47]

A handbill advertising *God's Stepchildren* announced: "At an early age . . . , Naomi develops peculiarities. She doesn't want to be colored."[48] In school, in a confrontation with her teacher, she yells, "I hate you because you're black and I hate all the children because they're black, too. . . . I won't stay here and be black like the rest of you, I won't, I won't, I won't. . . . I am not colored and nobody is going to make me colored." When the teacher responds that we are all God's children, Naomi answers back, "Yes, God's Step Children and he don't know anything about them."[49]

Naomi refuses to accept the arbitrariness of the social restrictions that dictate her identity and confine her to a segregated world. As a young woman returning from a convent, where she had been sent because she acted out her hatred of blackness, she sees her hope in the ambitious, morally upright, and light-skinned Jimmy, her foster brother. But her family sees her love as forbidden, and Jimmy is already pledged to another. They prefer to see her married to Clyde, the industrious, successful, unsophisticated, darker farmer, whom Naomi finds "funny looking" and "ugly." "Oh, mami I don't want anybody who looks like that!" To please her family, she marries Clyde, has a child, but decides "to go over to the other side."

As she was betrayed when her mother abandoned her, she betrays her own child by abandoning him to Mrs. Saunders, the same virtuous woman who had cared for her. "I've left Clyde and I am leaving the Negro race. . . . I have tried; heaven knows I have; but I can stand it no longer. . . . As to my baby, that is the hard part. . . . Do you suppose I don't love my child? Oh, God, forgive me, forgive me. . . . I came to leave my baby with you. I know you will give it a mother's care, and if I ever decide to turn back, I know where to find it. . . . [If] I take my baby, I'll be branded. . . . Please try to forgive me, mother, and don't hate me anymore than you can help." Romanticizing the world beyond the narrow confines of "Colored town" where she feels separate and different, Naomi assumes she will be happier there. However, the audience recognizes the folly of

HIS TEXTS

her actions. Because she has contempt for her own blackness and has given up her child, she brands herself. Her choice to pass is doomed. It is her pained reaction upon seeing her small son on the street that gives her away.[50]

The scene of discovery is once again a scene of maternal devotion; however, contrary to Driscoll's, Naomi's is a scene of love not hate. Driscoll has no loving ties to anyone.[51] Naomi is defeated by both her love and her self-loathing. Rejected by her white husband, she returns to her family's home and looks in on a warm, idyllic scene. We see a close shot of her face framed through the window, confined, once again, by a void. Condemned by her betrayal, Naomi quietly sinks into the murky river to end her suffering. In the film's final shot, the words, "As ye sow, so shall ye reap," are superimposed over her hat floating on the surface of the water.

Driscoll's identity as a "white" man depends on Blacks being less than human. The appearance of his mother, drawn to her son and taken in by Eve, makes clear how much his self-hatred has cost him. Her presence is a constant reminder that his hate has destroyed him and he doesn't even know it. Like Naomi, Driscoll is the moral instrument through which Micheaux offers direction on social aspirations.

*The Symbol of the Unconquered* sets up an oppositional imperative between individual attitudes and behavior (such as the denial of racial identity in order to assert personal power and privilege) and the well-being of the group. Van Allen is both a stand-in for Oscar Micheaux and a means through which Micheaux builds his biographical legend, his legend of success. In the epilogue, not only is Van Allen prosperous, but the traveling salesman is, as well. Micheaux seems to be reading his own success as both a benefit and a catalyst for the entire community. The film might be seen as an intragroup morality play. The working title of *The Symbol of the Unconquered* was *The Wilderness Trail*.[52] The name change is both affirming and challenging, a call to collective consciousness—very much like the title and long patriotic speech at the end of *Within Our Gates*. These films are a part of a continuous recoding and reshaping of racial identity, African American solidarity, and the individual.

# 6  *Body and Soul* and the Burden of Representation

Paul Robeson, the world's greatest actor of the race . . . makes his debut as a screen star . . . [in] an Oscar Micheaux production, entitled *Body and Soul.* . . . Mr. Robeson plays a dual role, that of Rev. Jenkins, a rascal masquerading as a minister of the Gospel, and that of his twin brother, a hard working conscientious lad. During the course of the story, complications arise out of which develop one of the most tragic, yet sympathetic stories yet filmed. . . . In nine great reels, here is melodrama to the nth degree, a story guaranteed to hold one speechless to the very end, beautifully photographed, extraordinarily original and acted by a cast of the race's greatest artists, including other than Robeson, Julia Theresa Russell, Tom Fletcher, Madame Robinson, Mercedes Gilbert, Walter Cornick and a coterie of others [too] numerous to mention.              —*New York Age*, November 14, 1925

What excuse can a man of our Race make when he paints us as rapists of our own women? Must we sit and look at a production that refers to us as niggers?
              —William Henry, a moviegoer from Richmond, Virginia,
              *Chicago Defender*, January 22, 1927

IN A SCATHING REVIEW of *The Brute* (1920), critic Sylvester Russell, writing in the *Freeman,* voiced his distaste for the barroom scenes, dancing the shimmy at 3 A.M., a woman shooting dice, a woman smoking cigarettes, and the suggestion of physical violence: a battered wife with a black eye and her aunt coming to her defense with a pistol. The "story was not elevating. . . . All of us well reared people sighed. Some departed. . . . good moral philosophy is lost. . . . Hoodlums took it for granted that the verse which read: 'The only way to make a woman love you is to knock her down.' was true." Russell ended by rhetorically addressing the filmmaker: "No,

Mr. Micheaux, society wants a real story of high moral aim that can appeal to the upbuilding of your race and society." Lester A. Walton, an amusement columnist for the *New York Age,* agreed. Posing his objections more concisely, he wrote that the film was not "any too pleasing to those of us who desire the better side of Negro life to be portrayed," adding ruefully, "As I looked at the picture I was reminded of the attitude of the daily press, which magnifies our vices and minimizes our virtues."[1]

Not all members of the audience for Oscar Micheaux's silent films were open to his representations of African American life. While some people applauded the pictures' "realistic" representations of particular aspects of community life and portraits of situations that needed to be addressed, others objected to seeing the seamier side of their experiences displayed on the screen. What appeared genuine to one segment of the population was repugnant to the idealism of another.

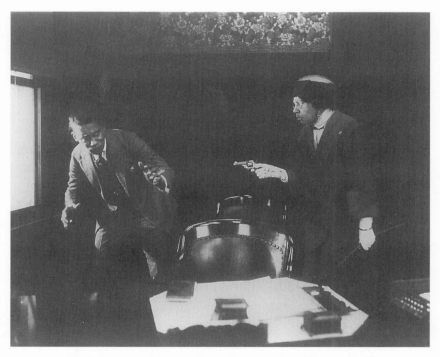

"And the next time you lay a finger on her I'll use this!"
A. B. De Comathiere and Suzie Sutton in a still used to promote
the forthcoming film *The Brute* (Oscar Micheaux, 1920).
Courtesy of African Diaspora Images.

THE  BURDEN  OF  REPRESENTATION

Randolph Edmunds, in "Some Reflections on the Theater," suggests that the Black theater of the time was also thought to be guilty of too much haranguing about oppression. "We see dark portrayals of human misery silhouetted against a black sky-line of woes. [These plays] reveal earthly suffering at its blackest—men and women with skins of night struggling in the anguish and agony of situations that doom them to failure and despair from the very opening of the curtain. . . . This piling up of insurmountable obstacles with their overtones of inferiority is very unsatisfactory to those who see something deeper and finer and more dramatic in Negro life and envisage in it a real contribution to the American theater."[2]

The constraints imposed on particular images by some members of the African American community were self-imposed gestures of discretion made in the name of prudence, social responsibility, and racial solidarity. In a highly racialized and race-conscious society, the desire for assimilation and acceptance often carried with it a special burden on representation. Too much emphasis on images of the downtrodden, the oppressed, and social embarassments had the appearance of disloyalty.

Those who denounced Micheaux for his unflattering representations would have preferred him to substitute a mask of rosy perfection. One audience member, William Lewis, wrote to the *(Baltimore) Afro-American*, "I have had the pleasure of observing several of Mr. Oscar Micheaux's productions and am forced to ask (with no offense to Mr. Micheaux whatever) why they are so suggestive of immoral and degraded habits of the human race? In several instances I have taken particular notice that only the worse condition of our race are shown and the very worse language is used with no attempt whatever to portray the higher Negro as he really is."[3]

D. Ireland Thomas, a columnist for the *Chicago Defender* and, at the time, also the manager of the Lincoln Theater in Charleston, South Carolina, took a more pragmatic view, qualifying his praise of Micheaux's *A Son of Satan* (1924). In his column of January 31, 1925, he wrote: "Some may not like the production because it shows up some of our Race in their true colors. They might also protest against the language used. I would not endorse this particular part of the film myself, but I must admit that it is true to nature, yes, I guess, too true. We've got to hand it to Oscar Micheaux when it comes to giving us the real stuff." He went on to say:

HIS TEXTS

"Like Sylvester Russell, I do not want to see my Race in saloons or at crap tables. But it is not what we want, that gets the money. It is what the public clamors for that makes the coin jingle." Indeed, the headline of Russell's article announced that *The Brute* drew thousands to the Chicago showing at the Vendome Theater,[4] and when the picture opened in New York City and Philadelphia, the Micheaux Film Corporation boasted of having made approximately $3,000 dollars in the first four days.[5]

Some felt that Negro photoplays should not contain contentious material. Reviewing Lincoln Motion Picture Company's *By Right of Birth* (1921), the *Los Angeles Daily Herald* described the film as "typically racial in appeal, yet free from racial propaganda such as has been characteristic in several similar productions attempted by other concerns."[6] One wonders if this was not a backhanded slap at Micheaux. Appearing six months after the release of Micheaux's *The Symbol of the Unconquered, By Right of Birth* was also a love story in which oil is discovered and virtue triumphs; however, it took place in a bourgeois setting, and, although

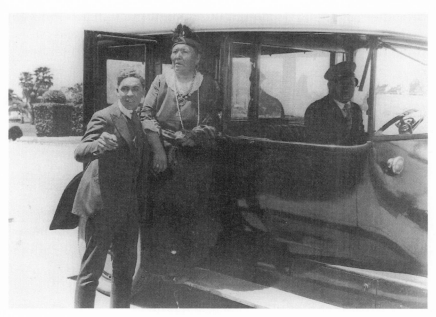

Clarence Brooks and Minnie Provost ("an Osage Indian") in a still from Lincoln Motion Picture Company's *By Right of Birth* (1921). Courtesy of the George P. Johnson Negro Film Collection, Department of Special Collections, Charles E. Young Research Library, UCLA.

THE  BURDEN  OF  REPRESENTATION

reviews referred to an interracial cast,[7] it was without racial antagonism, racial violence, or immoral Negro characters. (The villain was "an un- scrupulous Mexican-American stockbroker.")[8] The hero secured his for- tune, not by battling the KKK (as in *The Symbol of the Unconquered*), but by rescuing the boss's daughter from a runaway horse. To remove themselves as far as possible from even the "whisper of inferiority," the Lincoln Company scrupulously avoided treating either the downtrodden or racial conflict.[9] But Lincoln was not alone. Charles McClane, an African Ameri- can billed as the "road manager" for *A Prince of His Race* (1926), the first film released by the white-owned Colored Players Film Corporation of Philadelphia, declared, "Our aim is to give plays that are free from all race propaganda."[10]

---

WITH THE GROWTH of "Race pictures" and their increasing popularity both in the United States and abroad, Lester Walton posed a responsibility:

> It is incumbent upon colored producers to set a high standard not only from the standpoint of photography and technical stage direction, but a determined effort must be made so that in the thematic construction of plays the Negro is given high ideals and types which he can emulate and of which he can feel justly proud.
>
> The screen not only is functioning as a great entertainer, but a great educator as well. As at no other time in the history of motion pictures have white producers sought to present the Negro in a complimentary light, it therefore is the duty of our race producers to gladden our hearts and inspire us by present- ing characters typifying the better element of Negroes.[11]

William Henry, the moviegoer from Richmond cited in the epigraph at the beginning of this chapter, felt that a film producer had the moral obligation to work for the good of the Race because "there is no greater influence than the pulpit and screen."[12] Both preachers and motion pic- ture producers, masters of illusion, were under pressure to tell empower- ing stories. By describing, extending, and revising the nature of reality, they created tales central to the ways in which self-definitions were pro- duced and reproduced. Many believed that only the most optimistic plots and exemplary accounts would be of lasting service to their audiences.

In 1927, Wallace Thurman accused American Negroes of having been misinterpreted and caricatured for so long that they have "an inferiority complex to camouflage" and "feel certain that they must always appear in public butter side up." Thurman added, "Once a Negro gains the ear of the public he [feels he] should expend his spiritual energy feeding the public honeyed manna on a silver spoon."[13]

The same year, Langston Hughes wrote: "I understand these 'best' colored folks when they say that little has been written about them. I am sorry and I wish someone would put them into a nice story or a nice novel. But I fear for them if ever a really powerful work is done about their lives. Such a story would show not only their excellences but their pseudo-culture as well, their slavish devotion to Nordic standards, their snobbishness, their detachment from the Negro masses and their vast sense of importance to themselves. A book like that from a Negro writer, even though true and beautiful, would be more thoroughly disliked than the stories of low-class Negroes now being written."[14]

Writing in the magazine *Opportunity* about the audiences of literary and dramatic works, Sterling Brown complained about their rejection of crime, squalor, and ugliness, and their fear of exposing themselves to the possibility of adverse criticism: "We look upon books regardless of the author's intention as representative of all Negroes, i.e., as sociological documents. We insist that Negro books must be idealistic, optimistic tracts for race advertisement. We are afraid of truth telling, of satire. We criticize from the point of view of... racial apologists.... We are cowed: We have become typically bourgeois. Natural though such an evolution is, if we are *all* content with evasion of life, with personal complacency, we as a group are doomed."[15]

Micheaux's silent films deflated the pretensions of an expanding middle-class culture; they provided images of victimization and poverty too reminiscent of racist portrayals that were supposedly defining characteristics of the Race and the essence of the African American condition. Many of his critics were successful professionals of "respectable" taste and manners who wanted their own self-image to be heard, seen, and understood. They wished to distance themselves not only from the drunken, dice-throwing lore that black skin (as some would have it) signaled to the world, but also from the newly arrived migrants and working poor

(although many were themselves not more than a generation or two removed from the same conditions and aspirations). The social urgency of the times led some members of the Black bourgeoisie to the delusion that positive representations of cultural vitality and achievement could demonstrate the Negro's basic humanity to the world and win the rights of full citizenship. This acceptability, however precarious, depended on setting themselves apart from, or denying, the socially abject. By attempting to prove that they were modern and not so different from the American mainstream, they were sacrificing their autonomy and the particularity of their experience and vision,[16] and denying the social reality of racism.

The critical considerations and discourses surrounding Oscar Micheaux's *Body and Soul* (1925) and other early works offer valuable sites to examine some of the competing cultural value judgments that inflected the politics of racial identity and the quest for racial unity in the period between the end of the Great War and the Great Depression, a period when the class structure within the African American community was becoming more stratified.

---

AFTER UNFAVORABLE criticism of *Birthright* (his 1924 adaptation of the popular novel about the social order dictating relations between Blacks and whites in a small southern town by the white southerner T. S. Stribling), Micheaux attempted to garner support for his work. He wrote to both the *Pittsburgh Courier* and the *Afro-American* to draw attention to production practices in the Race pictures field and to plead for an understanding of the films as an opportunity to expose the truth, no matter how uncomfortable that might be. "The mastery . . . of the art of production, for indeed it is an art, is no small attainment, and success can only be assured by the most active encouragement and financial backing. The colored producer has dared to step into a world which has hitherto remained closed to him. His entrance into this unexplored field, is for him, terribly difficult. He is limited in his themes, in obtaining casts that present genuine ability, and in his financial resources. He requires encouragement and assistance. He is the new-born babe who must be fondled until he can stand on his own feet, and if the race has any pride in presenting its own achievements in this field, it behooves it to inter-

est itself, and morally encourage such efforts." Laying out what he thought of as his personal charge and personal aesthetic, his own form of social realism, he went on to say: "I have always tried to make my photo-plays present the truth, to lay before the race a cross section of its own life, to view the colored heart from close range. My results might have been narrow at times, due perhaps to certain limited situations which I endeavored to portray, but in those limited situations, the truth was the predominant characteristic."[17]

Similar discourses on truth—almost a personal theology or cultural mission for Micheaux—appear in his earliest works. In *The Conquest*, he vaguely disguises his family name and actual places, writes in the first person, draws on his own experiences, and declares, "This is a true story of a negro."[18] In his second novel, *The Forged Note*, the hero's mission is described as "seeking out the truth of our people."[19] These novels weave strands of sociohistorical detail (the descriptions of the Negro quarters of Effingham [Birmingham] in *The Forged Note*, for instance) and moral preachment (against, for example, playing the numbers) with passages of romance, melodramatic coincidence, and intrigue.

Micheaux's "cross section" of Negro life brought a diversity of characters to the Race picture phenomenon. In addition to the professional class, he depicted other segments of Black society, including a critical look at the exploiters, the takers, those who prey on others for their livelihood (the policy runner, the bootlegger, the fast-talking city slicker, the jack-leg preacher), and at times brought depth, solidity, and rootedness to the working poor and the jobs they performed to earn a living. Sister Martha Jane, one of the central characters in *Body and Soul*, for example, is a laundress. She is shown actually working: carrying laundry in a large basket on her head, ironing in her home as her daughter, Isabelle, brings her beau to ask permission to marry. The respect paid to her labor includes close shots of her working hands, attention to the details of her trade, and her pride in her accumulated savings.

By contrast, the Lincoln Motion Picture Company's genteel stories pictured larger-than-life, exceptional individuals. A review of *Realization of a Negro's Ambition* (1916) described it as set among "Los Angeles' Colored '400'."[20] The press release for *Trooper of Troop K* (also 1916) describes the young working-class hero as "shiftless" and "careless," but "kind"

and "humane." He falls in love with a high school girl of "good family." She doesn't take him seriously until he goes off to war with the Tenth Cavalry and returns from the Battle of Carrizal decorated for having saved the life of his white captain.[21] It is by happenstance or an act of fate that he becomes a hero and it is that "accomplishment," his act of valor, that is lauded, rather than hard work and industry.

But were Micheaux's characters and situations always in the interests of picturing a cross section of the Race? Or was it sometimes a matter of employing the sensational to lure audiences? After all, he did advertise *Deceit* (1923) by enticing audiences with a fight between two sisters: "O Mamma, come and see the hair fly."[22] And *The Brute,* which Sylvester Russell found so offensive, tempted spectators with "a beautiful and tender girl in the toils of a shrewd gambler and boss of the underworld, Bull M'Gee, whose creed is: 'TO MAKE A WOMAN LOVE YOU, KNOCK HER DOWN.' "[23] Surely the filmmaker's use of the sensational was not simply a response to what he felt his audiences wanted; it was, in addition, a way of building expectations in his customers and developing a following that expected the sensational.[24] His business depended not only on creating films for Black audiences, but also on creating a public for his films. Capitalizing on the Rhinelander divorce trial in his advertisements is just one example of his utilization of controversy to attract ticket buyers.

To stir up interest and excitement, Micheaux even exploited his critics. In a statement distributed at the time of the release of *Birthright* in Cleveland, he wrote:

> I am told almost daily by super-sensitive members of my race that in producing Colored motion pictures, I should show nothing bad; that I should not picture us speaking in dialect, shooting craps, boot-legging, drinking liquor, fighting, stealing or going to jail; that I should, in effect, portray the better side of our lives—and they have promptly gone to sleep on such pictures when offered.
>
> This story, as told by an old Negro living in a little town on the banks of the Tennessee River, at a point where the state lines of Georgia, Alabama, and Tennessee intersect, is a true story; and to have attempted transposing it to the screen without having him do any of the things objected to would have destroyed the origin of theme and story.

HIS TEXTS

> Because of these views, however, I have heard many criticisms of the book; I expect some criticism of the picture. But to those willing to look deeper into the position of the educated young Colored man, for instance, returning south with his degree and thought and vision, ambitious of lifting his race to a higher plane of thought and action:—and of the beautiful but helpless Colored girl, trying to be nice in a small southern town like "Hooker's Bend," tempted, because of poverty and lack of protection, on one side, by designing men of the opposite race; on the other, by low-bred and immoral men of her own race, ready to sink her lower and lower into the squalor of the "Niggertown" of our story, this picture is especially dedicated.[25]

Such claims to truth—and their implication of the authoritative—were certainly tied to the scarcity of film representations by African Americans. With so few examples, each treatment seemed to take on a monumental responsibility to respond to the needs of the community, and "the authentic" became a crucial political concept for both Micheaux and his critics.

In *Body and Soul,* without sidestepping painful issues and once again risking offense, Micheaux challenges the authority of the minister, an important figure in the community, and implies the congregation's complicity in his abuse of authority. Carefully couching the critique in the bogus (a title card and a shot of a newspaper article at the very beginning of the film describe the preacher as an ex-convict wanted in England), Micheaux strips the minister to expose the weakness of the flesh.[26] Raising a topic shunned in polite society—the pastor's sexual exploits in his female-dominated congregation—Micheaux again draws an unflattering portrait of the community. However, this is not simply a prurient interest; he implies the possibility that these sorts of relations may be an inevitable part of a ministry where the congregation's unquestioning faith makes them vulnerable and the preacher's power is unsupervised and unchecked. He implies that the minister's behavior—his drunkenness, womanizing, and thievery—is "endorsed" by the "blind faith" of the matrons of the church and the collusion of the deacons who witness it (and perhaps participate). Micheaux also implies the possibility that these transgressions nurture and compound hypocrisy and threaten the moral fabric of the community.

Paul Robeson, the son and brother of ministers, plays the Right Reverend Isaiah T. Jenkins, alias "Jeremiah, The Deliverer," a small-town Georgia preacher, thief, drunkard, and rapist, and, in a secondary role, his morally upright, industrious brother, the unassuming inventor Sylvester.[27] The film is not a theological critique but a weighted attack on the way the ministry functions in the community and may have had deep roots in Micheaux's personal memory. In *The Conquest,* Oscar Devereaux recalls his teenage years: "When we lived in the country we fed so many of the Elders, with their long tailed coats and assuming and authoritative airs, that I grew to almost dislike the sight of a colored man in a Prince Albert coat and clerical vest. At sixteen I was fairly disgusted with it all and took no pains to keep my disgust concealed" (pp. 16–17).

In *The Homesteader,* Jean Baptiste, the Micheaux-like hero, looks back upon his childhood and a traumatic incident when he was five. He went hunting with his older brothers and bagged quails, rabbits, and partridges. The game was prepared for a group of visiting preachers, "big men

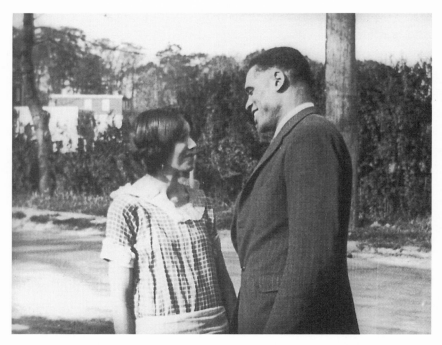

The young lovers, Isabelle (Julia Theresa Russell) and Sylvester (Paul Robeson), in Oscar Micheaux's *Body and Soul* (1925).

HIS TEXTS

with no time or care to waste with little boys." He watched them eat, seeing the quail disappear one by one, as he got hungrier and hungrier. When one of the other guests, a teacher, noticed him and invited him onto her lap to taste some of the quail on her plate, he was reprimanded by one of the preachers, taken aside by his mother, and severely beaten with a switch. He later recognized the Reverend Newton Justine McCarthy, father of his bride, Orlean, as the same preacher who had scolded him and provoked the whipping.[28]

The fictional jackleg preacher, McCarthy, is a man of extreme vanity, used to being flattered, and a "debaser of women" (p. 518). He raised his two daughters to be subservient to his will, to praise and coddle him, and demanded their absolute loyalty. Orlean and her sister, Ethel, vie for his affection. Their mother, who is portrayed as a shell of a woman, beaten down by her husband and depersonalized, projects a sorry future for the two young women. The minister betrays the trust that his family has in him by manipulating their loyalty and affection. After a year of marriage, Orlean loses her infant in childbirth, and her father persuades her to leave Jean Baptiste and return with him to Chicago. Torn between allegiance to her father and her duty to her husband, she eventually goes mad.

Part of Micheaux's story seems to have had a parallel in his personal life. Although it is difficult to confirm that all the personality traits of the fictional N. J. McCarthy were shared by Micheaux's actual father-in-law, Chicago's Reverend N. J. McCracken, Micheaux's wife did leave the South Dakota homestead sometime prior to April 29, 1911. On that date, the *Chicago Defender* reported that Oscar Micheaux had been seen, accompanied by a doctor, trying to visit his estranged wife at her father's home in Chicago. Turned away at the door, he retreated to his hotel.

Using his personal experience and elaborating on it, Micheaux fashioned several stories about this incident. In *The Conquest,* after his father-in-law (here called Reverend N. J. McCraline) takes his distraught daughter to Chicago to recover, Oscar Devereaux brings a doctor to their home, but is denied admittance. "When I called up the house later Ethel came to the phone, and said 'How dare you bring a nigger doctor to our house? Why, papa has never had a negro doctor in his house. Dr. Bryant is our doctor'" (pp. 277–278). Another version of the same scene appears in *The Homesteader:* "For when he knocked at the door with a doctor at his

side, they were forbade admittance. Thereupon Baptiste was embarrassed and greatly humiliated at the same time. Ethel had a good laugh over it when they had left and cried: 'He had his nerve, anyhow. Walking up here with a nigger doctor, the idea! I wish papa had been home, he'd have fixed him proper! Papa has never had one of those in his house, indeed not. No nigger doctor has ever attended any of us, and never will as long as papa has anything to do with it!'" (p. 314).

In these narratives, Micheaux demonized his father-in-law and used the preacher's hubris for dramatic conflict. The reverend is one pin on which the author's biographical legend turns. The character embodies a tangled web of familial displacements, generic conventions, and narrative functions—to the point that Micheaux's real life, and his own vulnerability, are virtually irrecoverable.

In a clearly fictionalized passage, reminiscent of Charles Dickens, the Reverend McCarthy experiences a guilt-ridden "trance" in which he is revisited by his past and all his miserable wicked deeds parade before his eyes (including a mistress and their two children). Having succeeded in taking his daughter away from Jean Baptiste, he sees how he had "let his evil fall upon [his] own daughter" and ruined her life (p. 370). In a moment of either self-pity or repentance, he regrets his role in the unfolding tragedy of Orlean and Jean Baptiste. This passage opens up the character a bit, making him more psychologically complex; interestingly, in his film adaptation of *The Homesteader,* Micheaux had for a while considered playing the part of the "evil N. Justine McCarthy" himself.[29]

Jean Baptiste wants to punish his father-in-law for his vanity and the extremes to which he goes to satisfy his ego; however, he checks his anger, and, eventually, the minister gets his comeuppance when the bishop reprimands him for his part in destroying Baptiste's marriage and reputation. At the annual church conference, the preacher is publicly "demoted" to a "less dignified" charge, a poor isolated parish (pp. 480–481). But Orlean, in a state of mental anguish, vengefully stabs her father in the heart and then "raise[s] the knife and [sinks] it into her own breast" (p. 522). Having made a poor choice in marriage, Micheaux fictionally destroys not only his nemesis—his father-in-law—but his wife as well.[30]

Variations on the malevolent clergyman also appear in other Micheaux works. In *The Forged Note,* for example, an ambitious man of the cloth

counterfeits a promissory note in order to cover the money he stole from his church to campaign for promotion to bishop. When his forgery is discovered, his daughter, Mildred Latham, is blackmailed into becoming the mistress of her father's accuser, a white man, in order to save her father from the chain gang (p. 506). And one of the Klansmen in *The Symbol of the Unconquered*, Augustus Barr, is described in the title cards as a former minister. The character's shady background is developed more fully in *The Homesteader*, where Barr is pictured as an unscrupulous infidel who demands another man's wife as payment for securing the man's freedom from a penal colony (p. 49; p. 530).

In *Body and Soul*, Reverend Jenkins, besides being a faker and womanizer, takes a payoff from the proprietor of the Autumn Leaf Social Club (played by Marshall Rodgers) to refrain from condemning the speakeasy from the pulpit. He uses his position as spiritual leader of the congregation to get free liquor from the bootlegger as well as cash for gambling. Although Jenkins and his cohort from prison, "Yellow Curley" Hinds (played by Lawrence Chenault), are the only ones actually shown carousing, it is implied that the club has the patronage of some church members and the minister has the power to mold the thought and behavior of his congregation.

In *Within Our Gates*, Micheaux exposed the preacher as an obstacle to the progress of the Race, who uses his powers of persuasion, "prophesying," and "speechifying" to maintain subservience and the status quo. In *Body and Soul*, he modeled a clergyman who professes to have been called by the Spirit, but is no more than a con artist and exploiter who preys on the vulnerability of the congregation. Inherent in Micheaux's stories (both personal and fictitious) is his challenge—perhaps with some envy—to the leadership and the privileged position historically held by the minister in the community.

The church, historically the cultural backbone of many African American communities, occupied an important social and political position in the early part of the twentieth century. The social cohesion and independence of Black churches gave the minister a certain amount of authority and power. Expressing admiration for the Negro preacher, W.E.B. Du Bois portrayed him as a "leader, a politician, an orator, a 'boss,' an intriguer, an idealist." Praising him as "the most unique personality developed by

the Negro on American soil," he describes the preacher's skills—a "combination of a certain adroitness with deep-seated earnestness, of tact with consummate ability." Du Bois felt that these attributes both gave the preacher his preeminence and helped him maintain it.[31]

For James Weldon Johnson, the church was "an arena for the exercise of one's capabilities and powers, a world in which one may achieve [the] self-realization and preferment" that are "so curtailed [for the Negro] in the world at large." Besides the spiritual benefits derived, the church functioned as a social center: "Going to church means being dressed in one's best clothes, forgetting for the time about work, having the chance to acquit oneself with credit before one's fellows, and having the opportunity of meeting, talking, and laughing with friends and of casting an appraising and approving eye upon the opposite sex." More recently, bell hooks looked back at the church as a refuge of dignity and respect for African American women: "Despite the sexism of the Black church, it was also a place where many Black women found they could drop the mask that was worn all day at Miss Anne's house. . . . Church was a place you could be and say, 'Father I stretch my hands to thee,' and you could let go. In a sense you could drop the layers of daily existence and get to the core of yourself." And Henry Louis Gates, Jr., described celebrants finding "hope and its concomitant, courage," in church, "hope and an affirmation of their spiritual and cultural selves, a collective act of worship and celebration that glorified both God and human will."[32]

The appeal of the church attracted many to the profession. The clergy, with its promise of power and independence, was especially attractive to those who were denied the normative masculine role in every other area of American social life. Some had the benefit of seminary education; others were home taught. On occasion, they were opportunists. James Weldon Johnson remonstrated against the many "parasitical fakers, even downright scoundrels, who count themselves successful when they have under the guise of religion got enough hardworking women together to ensure them an easy living."[33] In *The Forged Note*, Micheaux wrote that there were so many "unordained" preachers in one Florida city that he was unable to obtain from the secretary of the board of trade a list of clergy to whom to forward information about his books (p. 70).

HIS TEXTS

Writing in the *New York Age* on March 23, 1931, Cyril A. Wilson accused even formally educated ministers of assuming a false appearance of virtue, "an amusing gesture," preaching against racketeers and rackets, "It would be unfair to classify all our ministers in the same group, but I'm afraid that a great majority of the so-called spiritual leaders of today are racketeers themselves. Their methods of obtaining a living are nothing short of high-handedness under the cloak of religion. They preach nothing and practice less. The educated ones are a disgrace to their education, and the ignorant shame their followers."

Sensational stories about wayward ministers and their transgressive behavior were frequently featured in the popular press. The *New York Age,* for example, on February 9, 1924, had a front-page headline, "Charge Ministers Are Muzzled by the Bootlegging Crowd" and, the following week, "Bethel Pastor Denies Inebriation in Pulpit"; later that year, on July 12, the headline read, "Ministers and Churchmen Are Alleged to be Addicts to the 'Numbers' Gambling." The *Chicago Defender*'s front page announced, "Bare Scandal in Divorce Case: Clergyman and Wife in Hot Tilt," and the *Afro-American* carried a story about a fake preacher who fleeced several local Baptist churches, headlined "Tobacco Chewing Parson Wanted in Jersey City."[34] Bert Williams's famous sketch of Elder Eatmore lampooned the Elder not only for having a voracious appetite but also—playing with stereotypes prevalent in white minstrelsy and vaudeville—for stealing chickens, excessive drinking, and gambling.[35] According to Arlene A. Elder, false religion and unchristian Christians were often targets of scorn in late ninteenth-century Black novels.[36] And historian Lawrence W. Levine writes about the proliferation of jokes about ministers and the messages and efficacy of religion that freedmen and their descendants told one another.[37]

*Body and Soul* assaults hypocrisy—in particular, the pretense of virtue and piety—not only in the ministry but in the congregation as well. Along with betrayal, hypocrisy was a major theme in Micheaux's work, and there is a strong continuity in the way he treats the minister. A blurb on *The Homesteader*'s book jacket promotes the book as a story of "a courageous Negro youth in the toils of a hypocritical minister of the gospel." In *Deceit,* a group of preachers try to ban the hero's first film, titled *The Hypocrite.* In *Body and Soul,* the guise of the ministry allows the con artist

to hone and deploy his deceptions. Sister Martha Jane's inability to judge the character of her minister completes the moral economy of this tale of manipulation, transgression, hypocrisy, and betrayal.

*Roseanne,* "a play of Negro life in the South, having to do with a transgressing preacher and his, finally, avenging congregation," by Nan Bagby Stephens (a white woman from Georgia), seems to have been an uncredited source for *Body and Soul.*[38] The three-act drama, "with spirituals," was first produced at the end of 1923 at the Greenwich Village Theatre in New York City with a white cast in blackface; then, after a week, it moved to a short run on Broadway. The appropriateness of a white cast was debated in both the Black and the white press,[39] and an "all-star colored cast" production was presented for a week at the Shubert-Riviera Theatre at 97th Street. Rose McClendon and Charles S. Gilpin played the principal roles as Roseanne, a middle-aged woman bringing up her younger sister Leola, and Cicero Brown, her pastor. Although an advertisement in the *New York Age* announced that seats could "be secured in any part of the [Shubert-Riviera] Theatre," a review in *Variety* mentioned that, while the lower floor was sparsely settled, the balcony was "crowded with colored folk," implying both little patronage from the white community and segregated seating.[40] When the Negro cast production did not move back downtown to Broadway as expected, and was instead scheduled at the Lafayette Theatre in Harlem, Paul Robeson replaced Gilpin in the role of the preacher.[41]

Roseanne and Sister Martha Jane are central in the play and the film, and both have feelings for their minister. Rarely in Micheaux's silent films and early novels does he deal with a female character in such depth. Although still a sociological type, Sister Martha (played by Mercedes Gilbert) is psychologically individuated; the film is focalized through her, and all the other characters revolve around her.

There are, however, significant differences between the play and Micheaux's film. In the film nearly all of the story is a dream, "only the night-mare of a tortured soul!" Approximately fifteen minutes into the film, after proposing that her daughter Isabelle (played by Julia Theresa Russell) marry the minister, Sister Martha strikes her daughter for calling him "a drunkard and a sinner" and tearfully collapses in her Morris chair.[42] It is only at the end of the photoplay, when she awakens seated

in the same armchair wearing the same gingham dress, that we realize that almost the entire film had been her nightmare. This dream structure not only allows *Body and Soul* to have a happy ending, but also permits a more trenchant critique of the preacher and of his relationship to the women in the church. The sisters of the church, particularly Martha Jane, blinded by their faith in the paramount goodness of their spiritual leader, pamper, flatter, and indulge him, coyly currying his favor.

In an important scene at Sister Martha Jane's house, Reverend Jenkins comes to visit while two other matrons of the church, Sisters Ca'line and Lucy (played by Lillian Johnson and Madame Robinson) are also calling. The ladies flirtatiously fluff their ruffles and, with exaggerated gestures, adjust their hats, smooth down their dresses, and primp for their pastor. Sister Martha dusts off the Morris chair (the only cushioned furniture in her modest home, the symbol of maternal comfort, the center of the home, of the family, and, by extension in this scene, of the church and community) with her apron. When he sits down, she falls to her knees and wipes off his shoes. As they fawn over him, the ladies' adoration of their minister seems more than simply respectful.

In church, during one of the collections, a young, stylishly dressed woman reaches over and places a donation directly into the preacher's hand. A matted close shot shows their entangled hands; as she slowly withdraws hers, he sensuously fingers the folded bills in his palm. A second shot shows him grinning as he looks at the money and then a title card appears: "God bless my—these women, God bless 'm!" The highly sexual nature of the close-up suggests an unspoken intimacy and implies the offer of other favors as well.

It is intimated that all the women give their pastor food, money, or other kindnesses; they cater to his daily necessities, and he is always welcome in their homes. They bestow their affection on their minister through the largess of their gifts and sacrifices. In a near symbiotic relationship, he is their spiritual guide, taking care of their souls, and they, in turn, care for his earthly needs. Both dominant and dependent, he is a father figure and one who needs mothering, nurturing, and protection. The Latin root of the word "pastor" is *pascere,* to feed; the Turkish, to protect. Given Micheaux's complex, even contradictory, description of the preacher, the women's adulation takes on connotations beyond spiritual

salvation. The matrons' devotion to their pastor is a mix of love and awe. In the practical world, the minister is a "good catch."

————————

WHEREAS MALE AND FEMALE sexuality are repressed and replaced by mental and spiritual kinship in *The Symbol of the Unconquered* and *Within Our Gates, Body and Soul* is bursting with sexual energy. However, for a film that is supposed to teem with sexuality, in *Body and Soul* the Black body is neither eroticized nor on display as spectacle. Paul Robeson was an athlete whose physique was well known, who posed nude for photographer Nickolas Muray and sculptor Antonio Salemmé, and whose sex appeal would later be exploited in such films as *Borderline* (1930) and *Emperor Jones* (1933). Nevertheless, in this film, unlike in the white-made films, he was not turned into a sexual object, exotic innocent, or savage primitive. Because of Robeson's superior acting (in this his first screen role), his prepossessing physique, and the resonance surrounding his persona in the African American community, the minister takes on a monumental presence in the film.[43]

As with Reverend McCarthy in *The Homesteader* and the Reverend Latham in *The Forged Note,* dishonesty and greed are the driving forces of Reverend Jenkins's autocratic desires and a young woman is irreparably harmed by his selfish arrogance. Not only does he exploit the emotions of the women of his congregation, he proceeds as if ordinary ideas of morality and propriety do not apply to the powerful and the grand, as if his ambitions were more important than moral doctrine.

He forces Isabelle to steal her mother's savings, which are hidden in the family Bible. A close shot shows his hands stroking the money (similar to the matted shot of folded bills in his palm). A series of dissolves superimposes close-ups of Jenkins's hands with the wad of cash over close shots of Sister Martha's hands working, picking cotton, dampening clothes, and ironing, representing years of toil to earn the money that she had saved. The camera captures him caressing the bills in a prayerlike gesture before thrusting them into his pocket. Such close-ups are unusual in Micheaux's silent films; the emphasis on the hands makes them both synecdochic—standing in for the whole being—and metaphorical—signifying an ethos of work. Neither the "blood money" stolen from Sister

HIS TEXTS

Martha Jane nor the "donation" from the church woman is recompense for work or merit.[44]

At the beginning of the film, as the characters are being developed, Sister Martha Jane takes out the Holy Bible to count her savings at the end of a hard day's work; this image is intercut with her pastor returning to his home drunk.[45] The Bible is Sister Martha's place of safekeeping. "Ah keeps mah money in de bible 'cause ah feels dat de wustes sinnuh wouldn't dauh touch hit in dis sacred place." Micheaux's use of the Holy Book was significant on many levels.[46] It established a level of credibility for the African American audience. The Bible was a common presence in many Black homes, housing the precious records of births, deaths, marriages, the history of the family's lineage—a written adjunct to the family historian. Sister Martha Jane's large ornate Victorian Bible with raised wood-paneled covers, shown in a close shot, is metonymically linked to her faith, almost a mystical object of goodness. It extends the glory and security of the church into the home. Until the utopian ending, it is the only book pictured in Sister Martha's otherwise spartan home.

In the church scenes, Micheaux articulates the passion of testimony and worship, the call and response in the vernacular of Black religion. Drawing on the familiar sermon, "Dry Bones in the Valley" in the title card, he portrays members of the congregation experiencing the liberating and transforming power of the Spirit in their midst. The stylization of performances, makeup, and costuming poses an opportunity for Micheaux to forge a knowing kinship with members of the audience.

The church was an environment in which African Americans could express themselves as freely and as emotionally as desired. The Holy Spirit's presence in the assembly elicited what W.E.B. Du Bois called the "frenzy of shouting" among the devout. "It varied in expression from the silent rapt countenance or the low murmur and moan to the mad abandon of physical fervor,—the stamping, shrieking, and shouting, the rushing to and fro and wild waving of arms, the weeping, and laughing, the vision and the trance. All this is nothing new in the world, but old as religion, as Delphi and Endor. And so firm a hold did it have on the Negro, that many generations firmly believed that without this visible manifestation of the God there could be no true communion with the Invisible."[47]

Micheaux described his own mother as a "shouting Methodist." He wrote of his experiences in Metropolis, Illinois, a small river town, where the "social life centered in the two churches where praying, singing and shouting on Sundays, to back-biting, stealing, fighting and getting drunk during the week was common among the men. They remained members in good standing at the churches, however, as long as they paid their dues, contributed to the numerous rallies, or helped along in camp meetings and festivals. Others were regularly turned out, mostly for not paying their dues, only to warm up at the next revival on the mourners bench and come through converted and be again accepted into the church and, for a while at least, live a near-righteous life" (*The Conquest*, p. 16).

He also wrote of the revival meeting of a visiting "fire-eating evangelist": "The church stood on a corner where two streets, or avenues, intersected and for a block in either direction the influence of fanaticism became so intense that the converts began running around like wild creatures, tearing their hair and uttering prayers and supplications in discordant tones." The city council served notice on the church declaring that "so many converts every afternoon and night was disturbing the white neighborhood's rest as well as their nerves" (*The Conquest*, pp. 18–21).

Micheaux carries this critique further in *Body and Soul* and implies that the charisma of the preacher extends beyond the emotionalism of the sermon; religious devotion is, at times, even associated with sexual fantasy. For Sister Martha Jane, at least, the delicate balance between respectful admiration for her minister and carnal desire totters. Feelings she cannot admit to are transformed and displaced onto her daughter with devastating results; the young woman is violated by the minister: when they find refuge in an isolated cabin during a driving rainstorm, he rapes her.

Before her dream, Sister Martha had expressed a wish that her daughter marry the minister—a form of sexual displacement, too—but the rape represents a nightmare of the minister's powers. The rape becomes an extension not only of Sister Martha's unconscious feelings for her minister but also, on the social level, the spiraling consequences of all the favors freely given by the women of the church—the pampering, flattery, money, and the choicest morsels at the dinner table, no matter how meager the victuals. It is as if it were the logical conclusion of his abuse of power and his betrayal of the trust that the women have in him.[48]

In the scene where Reverend Jenkins comes calling at Sister Martha's home and she and Sisters Ca'line and Lucy vie for his attention, Isabelle returns home and her mother, as the intertitle indicates, presents her to their minister as an "offering." In the double sense of both a sacrifice and a contribution, Sister Martha Jane "gives" the minister her gently and lovingly reared daughter. With a quick pinch to her arm, the mother nudges her toward the man who has come to "save her soul." Jenkins dismisses the three matrons so he can be alone with Isabelle. He twists her arm, and the scene fades to black. Returning later, Sister Martha Jane asks submissively, "'Scuse me Elduh; but has I retuhned too soon?" He replies with confidence, "It was a great struggle, Sister Martha; but the Lord's Will be done. He won. And now I must carry his work into the byways for other sinners. I'll be moseying along."

The matted insert of the pinch resembles an earlier scene outside the church when Sister Martha, wishing to walk with the minister, urges Isabelle to accept the arm of a stranger, "Yellow Curley." Isabelle is a demure, obedient, and dutiful daughter; her innocence is portrayed in her lack of forwardness. It would have been out of character for her to respond to a stranger. The irony in the close-up of the pinch encourages us to question the nature of Sister Martha Jane's feelings for her pastor early in the film. Whereas her motherly devotion is treated very seriously throughout the movie, it becomes clear that her devotion to the minister may be blinding her to the welfare of her daughter.

After stealing her mother's money, Jenkins, reminding Isabelle that her mother would take his word over hers ("Do you suppose that she would believe you?" he says with a smirk on his face), gives her some bills and advises her to flee to Atlanta. Thinking that Isabelle has stolen the money, Sister Martha seeks her out in Atlanta to forgive her, and Isabelle discloses the preacher's act of infamy.

In a flashback scene (not in the play), one of the most cinematic of the film, we see Isabelle and Reverend Jenkins, forced to seek shelter from a sudden downpour, enter a deserted cabin. At his suggestion and under the pretense of concern, the preacher leaves the room so that Isabelle can remove her garments to dry in front of the fire. A series of brief point-of-view shots, marked by both discretion and suggestiveness, heighten the tension of the scene. Beginning with a menacing shot of the bottom of

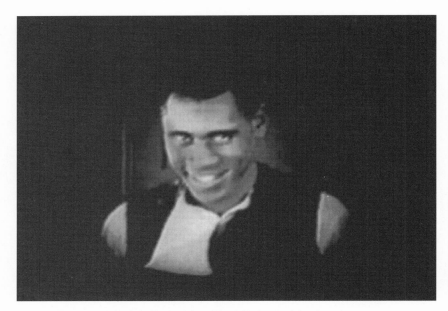

Reverend Isaiah T. Jenkins (Paul Robeson) in the rape scene
from *Body and Soul.*

the door slowly opening, the film cuts to a close shot of Isabelle's head
and bare shoulders, and then back to the door and the feet of the
preacher entering the room. Her attempt to hide her nakedness and pro-
tect herself is intercut with a head shot of Jenkins's leering smile, his cler-
ical vestments open at the collar. We see the frightened, defenseless, and
shamed young woman backed into a corner of the room, followed by an
intertitle simply announcing the passage of time, "a half hour later." This
is immediately followed by a close-up of his feet leaving the room. This
economy of language—the fragmented shots and the elliptical editing—
create a chilling moment of innocence under siege.[49]

   After confessing the painful details of the rape, Isabelle dies. A criti-
cal moment in which both brutalization and idealization come together,
her passing is informed by various cultural and literary traditions: the
biblical legacy of purification and redemption in innocence, the melo-
dramatic legacy of dying for the sins of others, and death as the ultimate
self-denial. Although her demise is not unexpected, it is still moving; its
power lies in the veneration it arouses in her mother. To Sister Martha,
Isabelle is still Mama's little girl. (Reunited with her daughter, Martha lifts

Isabelle (Julia Theresa Russell) in the rape scene
from *Body and Soul*.

her up and rocks her like a baby.) Moments later, now dressed in white
as she was in the rape scene, Isabelle, before dying, asks her mother to
read from the Bible. The overdrawn innocence of the daughter has a dra-
matic function: competitive signs (the innocence of a child versus vicious,
rampant sexuality) in open conflict. Likewise, the storm setting of the rape
accentuates her innocence and inflates the minister's villainy, an excess
that makes the signs unambiguous and even more impressive.[50]

Following her daughter's death, Sister Martha returns to her church
to confront the minister. In the play, author Nan Bagby Stephens uses
the apparition of Roseanne's dead sister to help Roseanne exact her
vengeance: Leola's spirit returns as the preacher's accuser, standing by
as the minister is reduced to a frightened, cowering figure.[51] In *Body and
Soul,* in a similar scene and with the same gestures, Sister Martha Jane,
as the "angel of truth," enters from the back of the church, stands erect,
with a raised arm and pointed finger, and publicly denounces the min-
ister in his pulpit. But rather than depending upon the presence of an
apparition, Sister Martha confronts the congregation directly with the

Sister Martha (Mercedes Gilbert), the avenging angel, accusing her pastor in *Body and Soul*. Photo by Charles Musser.
Courtesy of the Museum of Modern Art/Film Stills Archive.

story of the minister's immoral behavior as her weapon. Micheaux is not as interested in the spiritual as he is in the social—in particular, the enormous influence that the minister has over his parishioners and the community.[52] Such settings and gestures bear the weight of this impassioned critique. The riled congregation drives the minister out of the church, as in Peter Brooks's description of the final act of nineteenth-century stage melodrama, a physical acting-out of "virtue's liberation from the oppressive efforts of evil."[53]

Trying to escape the wrath of his avenging flock, Jenkins returns to Sister Martha's home, a site resonant with meaning as the scene of both his tender care and his betrayal. Reverend Jenkins slips into her house, stooped, with his clothing disheveled, and falls to his knees in front of Sister Martha Jane. In a reversal of the earlier scene in which Sister Martha was at the preacher's feet dusting off his shoes, he is now at her feet as a supplicant, and Sister Martha is in the position of power, a dramatic shift in social relations. But then Jenkins accuses the women of the church for his downfall. Their pampering and indulgences spoiled

him! Employing the ultimate chicanery, he seeks to avoid his own culpability by inverting the blame.

Acknowledging the weakness of the preacher and her own guilt, the good Christian Sister Martha conceals his presence from the pursuers.[54] There is a consistency in the way the rogue minister behaves throughout Sister Martha's nightmare: the character is never unaware of his ability to bend the women of the church to his will. He is unredeemed.

The subtle relation between the resolution of narrative order and the perception of social order established by the end of *The Symbol of the Unconquered* and *Within Our Gates* is not so easily achieved in *Body and Soul*. Only the dream structure relieves the tensions. But in the absence of cinematic cues to indicate a nightmare (camera work, lighting, etc.), it is only retroactively understood as dream. Resurrecting Isabelle (she is neither dead nor raped) also eradicates the heinous behavior of the preacher. *Body and Soul*'s final scene may be reassuring, but, as melodrama, it is not convincing. Virtue never gets the opportunity to triumph over evil. Although Isabelle's innocence is recovered, the minister's character remains unresolved. In

The pastor begs for leniency at Sister Martha's feet,
in *Body and Soul*.

fact there is no mention of him at all, as if he never really existed, as if the absence could obliterate the last image we had of the preacher, running from Sister Martha's home and brutally bludgeoning a young boy of the congregation who was pursuing him.

However, the nightmare does shatter Sister Martha's vision of herself: she recognizes the errors in her past judgments. With her new awareness, she accepts Sylvester as her daughter's husband, gives the young couple her blessings and savings (still in the Bible), and, in the utopian epilogue, the three are seen living together—the family reunited—ostensibly prosperous. Sister Martha, no longer in her apron, is enjoying her new-found leisure time reading a magazine (there are also several books on the table). In the final moment of the film, the newlyweds have returned home from their honeymoon and the family is shown gathered around a piano in the parlor. It is doubly felicitous: not only was the nightmare just a dream, but Sylvester's invention has been sold for a large amount of money and their new home seems to have all the accoutrements of bourgeois life. No longer the selfless, sacrificing character we were introduced to at the beginning of the film, Sister Martha seems to be enjoying the benefits of her hard-earned savings.

Micheaux's happy endings were likely motivated by more than box office considerations; they also had a strong remedial impact. By making the good brother, Sylvester, a successful inventor, Micheaux was celebrating achievements seldom acknowledged as a part of American culture.[55] According to Roi Ottley and William J. Weatherby, when the U.S. Patent Office, preparing to participate in the Paris Exposition of 1900, communicated with patent attorneys requesting data concerning Negro inventions, "many brows wrinkled at this request. Negro inventors? . . . Negro inventors were unknown, but definitely. Henry E. Baker, Patent Office examiner who received the replies, reports the amazement of most of the attorneys: 'Negro inventors—ridiculous!' cried some; 'I never heard of a Negro inventor,' wrote an Alabaman; 'There'll never be a Negro inventor,' replied a Georgian."[56] Yet, by the turn of the century (thirty-five years after emancipation gave all Negroes the right to secure patents) there were "fully four hundred" patents granted to such men as Granville T. Woods, Elijah McCoy, Jan E. Matzeliger, and Louis Howard Latimer.[57]

Micheaux's happy endings were also contrary to the plight of the pathetic and tragic Black characters of white drama and white-authored Negro folk plays—such as *Roseanne*—where the final curtain drops with the Black man dead or grimly defeated. "A serious drama about Negroes simply cannot end happily," Langston Hughes observed.[58]

*Roseanne,* a sentimentalized folk drama made for liberal white patrons enchanted by the jubilance of Negro spirituals,[59] nourished both the envy and the apprehension of the exuberance and seeming lack of inhibition— the inspired abandon—that was supposedly a prime component of the "primitive" American Negro personality and a mainstay of many white musicals and comedies.[60] The play's list of characters designates them by name, age, and singing voice. The church scene, an entr'acte between the second and third acts, constitutes nearly one-third of the play. White critics were fascinated with the exotic aspects of the scene and the "Negro emotionalism." Kenneth McGowan, for example, in *Theatre Arts Monthly,* felt the best scene was "a colored church during a revivalist sermon," and "Mr. Hornblow" in *Theatre Magazine* exalted "the primitive members of the flock . . . wrought up into a religious frenzy by the preacher's exhortation."[61] Alexander Woollcott described the church scene as "made fascinating by the singing of rich spirituals and the hypnotic madness of a revival meeting."[62] A romantic interpretation of southern Black religiosity that was at once ennobling and debasing, *Roseanne*'s spectacle of religious ecstasy, superstition, and quaint dialect was clearly paternalistic and condescending.[63] Juxtaposed to the political unrest in the streets, this image of African Americans was comforting to white folks, conducive to a late supper and a good night's sleep.

But what white critics deemed acceptable—even praiseworthy—in burnt cork, did not seem to offer the same enjoyment when Gilpin and McClendon played the parts on upper Broadway. The *Variety* reviewer suggested that "whites refused to accept the proposition seriously."[64] The presence of accomplished Black performers on stage in dramatic roles and a theatergoing population relegated to the balcony must have posed a very different vision of "colored people" from the Clement Wood definition presented in the program notes of the Greenwich Village Theatre production: "What are colored people? The Southern colored, due to the inner sunshine of their nature and the bitter cup handed every slave race,

THE BURDEN OF REPRESENTATION

developed the gentlest flowering of the spirit yet seen on American soil. The old-fashioned descendant of slave parents—and his children have not forgotten it—learned from his imposed lot, a rooted courtesy, a child-like faith in a sky-great father, an interchange of fidelity for affection and care with their 'white folks.'" The final line was marked by a telling candor: "Reinterpreted in the harsher light of today, this spiritual blossoming is one of the wholesome gifts to a land sorely in need of wholesomeness."[65] In a review highly critical of the Black-cast production, *Variety* suggested that "with a little stronger playing for the comedy than there was in the script the negro players should have been able to put it over."[66] Woollcott denounced Gilpin's performance for being marked by a "gentle melancholy that suggested a struggling inner ambition to have a go at *Hamlet* one of these days."[67] With the infusion of Gilpin's dramatic overtones, this was no longer amusing folk culture.

Nonetheless, it was the opinion of some Black critics that both the play *Roseanne* and the novel *Birthright* contained elements of "truth." Theophilus Lewis, in the the *Messenger,* called *Roseanne* a "faithful portraiture of life" and, suggesting the play's verisimilitude for African American audiences, added that the main character "smells as sweaty under the arms as the woman next door."[68] J. A. Jackson, after seeing the Greenwich Village performance, wrote in the *Afro-American* that the play was "a well told story of a condition that has been only too familiar to us." He described the church service as paradoxically "evok[ing] considerable amusement from white patrons and command[ing] respect for its fidelity from the colored ones."[69] Jackson praised the sensitivity of Nan Bagby Stephens and the production: "the writer has a most intimate knowledge of the Negro; and the producing authorities have attained just about perfection in the matter of little details that create the atmosphere and stamp it as a most accurate picturization [sic] of Negro life in a small town." Although he felt that "every one of the 24 characters are true, and each faithfully represents a well known type," he criticized the sacrilege of the service scene, in particular, the use of a sermon and the noisy assembling of the congregation: "Church is the one place that the race does not make a noise, except in reverence."

Perhaps Lewis and Jackson were so tolerant because they were hoping to pave the way for African American artists to dramatize their own

HIS TEXTS

version of the play. Jackson did suggest a recasting with Evelyn Preer in the title role, Ida Anderson or Evelyn Ellis as Leola, Richard Harrison, Sidney Kirkpatrick, or Charles Gilpin as the minister, and the Elkins Folk Song Singers as the choir, "and, ye Gods, no audience could withstand the appeal."[70]

When the play was cast with Black performers, Lester Walton commended Gilpin's interpretation: "He knows Negro life and faithfully depicts it." Walton also approved of the music: "The colored actors are heard in Negro Spirituals as they only can be sung by members of the race. This ability to sing so soulfully and feelingly is the price paid by the Negro for untold suffering." But he had some hesitation: "Several encores were taken and at one time it looked as if the performance would develop into a singing rather than a dramatic entertainment." Clearly valuing drama, he ended the review, "Whether or not *Roseanne* will make its way back to Broadway with a Negro cast, the present producers will find in it a strong road attraction; and those interested in the development of Negro drama will find much comfort in the thought that the present experiment has fully demonstrated the advisability of giving preference to a competent colored cast when Negro life is to be portrayed."[71]

In the same issue of the *Afro-American* in which he reviewed *Roseanne,* Jackson wrote of Micheaux's adapation of *Birthright* and described the novel as "not a nice story in many of its aspects, but if the truth it reveals can be carried to the country at large, it will have served a most useful purpose." He also lauded the truthfulness of the movie version: "Every school teacher, every Negro who has purchased property in the south, all who have ever had contact with the police and sheriffs or constables in southern states, every returned soldier, and every pretty colored woman who has or does live in a southern state will find some big truth that a personal experience or observation can confirm."[72]

Walley Peele's review of the film talked about both the praise and condemnation that *Birthright* received in Philadelphia. Voicing his own view, Peele criticized several intertitles and "the broad use of the word 'nigger.'" But he, too, summoned up the notion of truthfulness: "Conditions as presented in this picture are not at all overdrawn, and exist at this very moment in places too numerous to mention in the Southland. If we are to help our own to a higher place, then we must know the truth; the best way to

THE BURDEN OF REPRESENTATION

make the truth impressive is to have it reflected upon the mind through sight." He went on to say that it is often "the truth which stings us most."[73]

Perhaps these "sophisticated" urban critics could embrace *Roseanne* and *Birthright* precisely because the characters and incidents portrayed were thought to be confined to the small town or rural South. Although *Roseanne* was not set in the past, J. A. Jackson felt obliged to reassure his readers that "its duplication is hardly possible today because of the very thoro organization of the colored denominations into conferences, and . . . because of the long process of education required of the minister. . . . The whole group is a sad arrangement of a lack of education that makes it possible for a mountebank to assume such importance in the life of any community."[74]

In contrast to what Alexander Woollcott called Stephens's "amused and affectionate knowledge of negro life," Micheaux directs his attention to a more serious self-criticism and moral instruction.[75] *Body and Soul*'s dream structure imposes contradictions and complications upon his characters, moving the story beyond spectacle to explore a social world usually hidden from the gaze of the camera. Sister Martha Jane's nightmare is the pivotal trope in Oscar Micheaux's critique of community. Her loving concern for the welfare of her child and her unawakened desires for the man she has proposed as her future son-in-law destroy her treasured child as well as her revered pastor.

In *Roseanne* the situation of two sisters vying for the affection of their preacher doesn't suggest the same incestuous conflict of Micheaux's mother-daughter relationship, nor is there the complication of the immorality of his drinking and gambling. Instead, *Roseanne*'s characters are trapped in layers of superstition and emotionalism. All speak the same stage dialect. Although it would be difficult to argue that Micheaux's use of speech in these intertitles or in his novels was particularly sensitive to the cadences, imagery, and expressiveness of the folk idiom, his dialect was meant to indicate social status and education level, defining characters in terms of their life experiences and their ability to assimilate.[76] In *Body and Soul*, Isabelle speaks so-called standard English, without any trace of Sister Martha's vernacular. Isabelle corrects her mother when she uses the term "niggah." "It's vulgar," she says. Dialect in *Body and Soul* represents an aspect of culture; in *Roseanne,* it constitutes it. For the play's

HIS TEXTS

white patrons, the dialect and the spirituals must have evoked "the authentic primitive folk," an essentializing attempt to account for tensions between the traditional and the modern: an authentic folk as custodians of an invariant, everlasting notion of blackness, a universal Negro of disingenuous simplicity.[77] The *Afro-American* described some members of the *Body and Soul*'s Baltimore audience as "talking out loud to the picture tearfully and wrathfully."[78] It is hard to imagine such a response to *Roseanne*.

Even while minimizing racial distinctions and proclaiming that, given equal opportunity, all citizens enjoy the same freedom of movement to participate in this economic democracy, Micheaux was telling stories that pointed to an existential difference—a difference that was distasteful to those Blacks who did not want to be reminded of shortcomings or oppressions. William Henry's letter to the editor of the *Chicago Defender* asked readers, "Which screen production [*The Birth of a Nation* or *Body and Soul*] does our people the most harm?" One would expect a white screenwriter "to fan the flame of hatred." But what can we say when a Black man portrays our people in the same manner?[79] But Maybelle Chew, a vaudeville columnist for the *Afro-American*, expressed less faith in consensus and took a more ironic view: The "picture is the 'thing' at the Royal. Oh, boy! If some of the Reverends could see how Micheaux pictures the harm done by that Jack-leg Preacher, but of course, they wouldn't go near that den of iniquity, a theater. And, of course, in Baltimore the women don't buy the Reverend suits, feed them on chicken dinners, hang on their slightest word and force their daughters on their attentions. Oh! No. . . . If in the end it had not proved to be a dream I know the audience couldn't have stood it."[80]

Micheaux's discourses of truth (indeed, as Wahneema Lubiano has pointed out, any claims to truth) laid the ground for their own deconstruction: someone else's notion of truth, one's own "authenticity."[81] With so many distortions and dismissals from the dominant culture, many African Americans insisted on countertruths and the need for images that would provoke solidarity. But although Black Americans shared the realities of an oppressive racism, there were significant differences and internal divisions among members of the population along lines of class, color, region, gender, and education. As the few responses cited here indicate, in this period of ideological and cultural contestation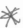

THE BURDEN OF REPRESENTATION

between an emerging Black bourgeoisie and an urban Black working class,[82] *Body and Soul* spoke to different groups and different audience members in different ways. For William Henry, only the depiction of a socially acceptable moral order would be congenial to a positive racial identity. For Maybelle Chew, Oscar Micheaux's film was an affirmation of identity not trapped in the affirmative.

HIS TEXTS

# Epilogue

They went to the Negro Picture Theater and held each other's hand, gazing in raptures at the crude pictures. It was odd that all these cinematic pictures about blacks were a broad burlesque of their home and love life. These colored screen actors were all dressed up in expensive evening clothes, with automobiles, and menials, to imitate white society people. They laughed at themselves in such rôles and the laughter was good on the screen. They pranced and grinned like good-nigger servants, who know that "mas'r" and "missus," intent on being amused, are watching their antics from an upper window. It was quite funny and the audience enjoyed it. Maybe that was the stuff the Black Belt wanted.

—Claude McKay, *Home to Harlem*, 1928

OSCAR MICHEAUX survived, but could he prevail?

In the beginning of 1925, D. Ireland Thomas's column in the *Chicago Defender* suggested that "the principal reason there is a slump in the manufacture of movies of our race" is that the theater owners were not willing to pay the increased costs to book a Race film. "They want it as cheap as a regular production of a white corporation and they know that this is impossible, as the producer of Race pictures is forced to get his profit out of a few Race theaters, while the white productions encircle the globe. Mary Pickford is just as popular in China as she is in America, etc. All Race movies make money regardless of their merit, yet the manager of a theater will try to tell you that his patrons do not like Race pictures. He will not place a Race picture because he can exploit a big western picture

and fool our people into his theater and make a big profit." The following month, responding to the request for information from a traveling showman, Thomas insisted that he could not make any money showing the two pictures the showman suggested because "they have been exhibited in almost every theater of consequence in the United States catering to Race patronage. . . . Good Race features are very hard to get. Almost impossible." "The day is gone," wrote the *Afro-American*, "when people will pay to see a colored picture simply because it is a colored picture."[1]

At the same time, the press was vocal in its praise of the progress Negroes were making in Hollywood and mainstream theater. Two weeks after Thomas was complaining about the lack of good Race pictures, the *Defender* ran an article describing two players, Edna Morton and Arthur Bryson, leaving in a private railway car with "a dozen well-known and popular white screen stars" to take part in "a great motion picture now in the making." The article praised the Vitagraph production: "The two members of our group are playing excellent parts in the picture. They appear throughout not in a manner of burlesque, but in prominent parts where intelligence, poise and acting is required." Later that year, the paper had a feature article about Evelyn Preer signing with stage impresario David Belasco, with no mention at all of her work in Race films. J. A. Jackson's report in the *Billboard* on Peter P. Jones's move from making independent shorts to working for a major studio as a still photographer was headlined "Peter Jones Follows the Rainbow." And Lester Walton, in a 1929 *New York World* article, announced that pioneer William Foster had finally gotten a break. "Fortune Smiles on Negro in Hollywood." Pathé had purchased several scenarios and given him a contract to assist in the direction of the films.[2]

Large ads in newspapers that had once boasted of Micheaux's block-booking or regional schemes for short runs at different theaters in nearby towns or cities were replaced by smaller announcements of one- or two-day bookings in single theaters, often appearing only in the exhibitor's strip of weekly listings. Perhaps as a result of less investment in advertising, there was also less coverage of his films in the Black weeklies. Or perhaps the press was deserting Race pictures for the more costly, better-made Hollywood films where Blacks were beginning to find roles.[3] On December 23, 1925, Romeo L. Dougherty's column in the *New York Amsterdam News* criticized Micheaux's films as "passé" because they

were inept compared to the Hollywood product with "studios fully equipped and with high paid writers furnishing scenarios." When *Body and Soul* opened in New York City in the fall of 1925, the *New York Amsterdam News* devoted more than four times the space to the review of Douglas Fairbanks's *Don Q, Son of Zorro.*

-------------------

IN 1925, some twenty thousand moving picture theaters were operating in the United States. Three-quarters of them were smaller houses in rural towns and urban neighborhoods. However, with less seating capacity and generally lower ticket prices, they brought in less than a quarter of the dollars spent on movies.[4] The rest went to the larger, more luxurious, picture palaces in the cities. But those houses seldom screened Race movies. By the end of 1928, most of the larger theaters in the United States were wired for sound and they were almost guaranteed even greater profits with the new "talkies." But what about smaller Colored houses in rural towns and neighborhoods? Could the independent exhibitors afford the expenditure?[5] Were they forced out of business?[6] As automobiles and paved roads were becoming more common, the more affluent moviegoers in small towns and rural areas were able to drive to the nearest city to enjoy sound films. Many smaller theaters were swallowed up by theater chains. By the late twenties, the major circuits were beginning to expand into the Stroll.[7] How did these exhibitors respond to Micheaux's films and business practices?

How Oscar Micheaux must have been hurt by the changeover to sound! It certainly would have become more difficult for him to book his stock of silent pictures.[8] Not only was it much more expensive for Race-picture manufacturers to produce sound films, it was more difficult to book talent as Negroes sought newly created jobs in Hollywood sound films: there now were Black-cast musical shorts, glamorous musical features with small parts for Black entertainers, and soon Hollywood was producing Black-cast sound features (MGM's *Hallelujah!* and Fox's *Hearts in Dixie* were both released in 1929).

In 1928, while still producing silent films, Micheaux went into voluntary bankruptcy.[9] However, in late 1929, despite the collapse of the stock market, he reemerged as Micheaux Pictures, and later as the Micheaux

Picture Corporation, with some of the films "presented" by A. (that is, Alice) Burton Russell, his wife.[10] Much research needs to be done on his work during this period. We know that in the beginning of 1930, Micheaux Pictures released *Daughter of the Congo*. Although billed as a "talking, singing and dancing" picture and hailed by the *New York Age*, on April 5 of that year, as the first venture into the talkie field by a Negro concern, the sound sequence, according to one reviewer, was confined to "one short and unnecessary scene."[11]

In 1931 he reincorporated again with new capital provided by Frank Schiffman (a white entrepreneur who operated several theaters in Harlem), with Micheaux as president, Schiffman as vice president and secretary, and Leo Brecher (a white theater owner and associate of Schiffman) as treasurer, to make *The Exile*.[12] Although parts of the picture were filmed silent (and even included some intertitles), *The Exile* was billed as "The First All-Negro Talking Picture."[13] However, by 1931 the spectators and the press coverage Micheaux had enjoyed during his silent period were already declining.

With his "talking pictures," Micheaux repeated and revised many of the themes of his earlier work. He made sound versions of his silent films with different casts (*Birthright*, 1924, was made again in 1939; *House Behind the Cedars*, 1925, was remade as *Veiled Aristocrats*, 1932; *The Gunsaulus Mystery*, 1921, became *Lem Hawkins' Confession* in 1935;[14] *The Spider's Web*, 1926, was turned into *The Girl from Chicago* in 1932; and the story of *The Homesteader* was reworked, with a slight alteration in the plot, into *The Exile* in 1931, and, again, in 1948, into *The Betrayal*).

Unable to compete with Hollywood's well-mounted musicals, Micheaux responded to his audience's cravings for "all singing, all dancing" talking pictures with his own short, *Darktown Revue* (1931), and used the nightclub setting as part of the plot in such features as *Ten Minutes to Live* (1932), *Lying Lips* (1939), and *The Notorious Elinor Lee* (1940). These films featured acts well known from such Harlem nightspots as the Cotton Club and Connie's Inn. There appears to have been at least one singing, dancing, or comic act inserted in almost every film. The trailer for *Temptation* (1936), after showing several club routines, proclaimed, "Hot cabaret sequences running the gamut of the picture—a melodrama with music!" *Underworld* (released the same year) used the same nightclub set, the same

OSCAR MICHEAUX

extras in the club scenes, and some of the same cabaret performers in different routines. In *Veiled Aristocrats,* the maids in the wealthy brother's home wear tap shoes! The story of *Swing* (1938) revolved around a musical theater production. Even *The Exile,* which once again drew on Micheaux's biographical legend, included a framing story of a Chicago "supper club" with several specialty numbers.

Although one might imagine that the clash over such films as *Within Our Gates, Birthright,* and *Body and Soul* influenced Micheaux's decision to make more commercial films afterward, neither censorship nor controversy had previously inhibited him. When he remade *Birthright* as a sound film, he was again truthful to the story and dialect of the novel. *The Exile* opens with a discussion of white-flight from newly integrated neighborhoods, and *God's Stepchildren* (1938) revisited many of the controversial issues of the early silent films. Even though much of this later part of his career seems to have been driven more by market demands than by social concerns, Micheaux still managed to express his views on race and the world around him.

It may be more helpful to look into the competition from Hollywood and the technological, distribution, and market changes that were connected to Race movies' entry into the sound era. An investigation into when and why Micheaux stopped distributing his own films might prove insightful as well. How much of his profits did he have to share? Did his new distributors have a say in decisions about what was to be produced? What revelations might there be in an examination of the Black films distributed by such white firms as Sack Amusement Enterprises, Toddy Pictures, and International Road Shows? What kinds of films from Micheaux and other directors did they choose to distribute and/or fund? One might also explore further the dynamic relationship between Micheaux and the Black press. What aspects of his work appealed to their sensibilities and class interests? How did their diminished support affect his work? There was, even in the sound films, a certain consistency of themes and opinions. How did Micheaux's success stories—stories of hard work, sobriety, and individual achievement—read to audiences during the Great Depression and in the post-Depression period?

Such questions demand a broader analysis of Race pictures so that his work is seen in the context of a larger culture and a competitive market.

And if, as we have tried to do in this book, critical attention is focused on the ideological and icongraphic forces that functioned intraracially (to which Race films inescapably and subtly responded), Micheaux's films of the thirties and forties might be seen to have had different possibilities open to them, precisely because they served different social purposes than Hollywood movies and circulated in a different sort of cultural economy. The films, then, would be seen as part of a complex multilevel dynamic of social, cultural, political, and discursive forces. The questions raised above are meant to chart out some avenues of investigation that might illminate the decline of Race film production and Micheaux's final years as a producer.

Applying such a framework to Micheaux's later career, one would have to wrestle with many contradictions in his struggles for power and autonomy, and the complex psychological dynamic of being both entrepreneurial and oppositional at the same time. A reexamination of Oscar Micheaux's total output, from his first writings in 1910 to his death on the road selling his books in 1951, would have to look at the tensions and challenges of being a Black businessman in America, unacknowledged by the dominant society and literary and filmmaking establishment, and publicly expressing attitudes—a particular angle of vision and worldview—that were not always well accepted in Black or white communities.

———————

IN THE EARLY FORTIES, Oscar Micheaux had left filmmaking behind temporarily and returned to writing, publishing, and peddling his novels. Sidney Wyeth, his surrogate from *The Forged Note* and *The Gunsaulus Mystery,* appears again as the bookseller and writer and former motion picture producer in two of his 1940s fictions, *The Story of Dorothy Stanfield* and *The Case of Mrs. Wingate.*[15] Although no longer the homesteader story (these are updated stories of intrigue with Nazi spies and Communists), the plots continue to incorporate and promote his own biographical legend. In *The Story of Dorothy Stanfield,* another character, in a long discussion that praises Wyeth for making photoplays "true to Negro life," explains why he gave up filmmaking. Suggesting it was difficult to make a profit with only a few hundred houses catering to the "colored trade,"

several pages later he also tells of difficulty raising money and dealing with the partners that higher budgets necessitated (pp. 197–200). "Except for pictures made years ago, and which the theatres for colored people here in Memphis have played over and over again until, to me, they have long since become monotonous, we never see any Negro pictures in Memphis any more" (p. 197).

The book's list of characters includes Frank Knight, "a Negro author, who married a white woman," a thinly veiled allusion to Richard Wright. Three characters compare Sidney Wyeth and Frank Knight. First they praise Wyeth's *The Homesteader,* a "corking good story," and the book's discussion of Booker T. Washington, who "insisted our people actually do something and not just getting an education—then talking about it" (p. 72). One character finds Frank Knight's books, *Nature's Child* and *Black Narcissus,* "very interesting." "I don't altogether like his pattern, but I suppose that it was, to some degree, laid out by his publishers. Sidney Wyeth seems to be the only Negro engaged in writing fiction, who is free and independent in what he writes. . . . He is about the only Negro author who writes about us colored people as we are living and thinking today; about the only writer who puts the love and the romance of our lives in his stories" (p. 73). Considering how white readers liked Knight's fiction, one replies, "It is so easy for white people to picture a Negro as unfortunate and hard up. It seems to be the condition they expect to find the Negro submerged in—poverty and misery" (p. 81). Another notes that publishers and the reviewers "have the race couched in a groove and seek to keep him in that groove as much as they can" (p. 74).

Calling Frank Knight the "best known and most read of Negro writers" and, discussing his Communist past, they mention that he married a "Jewess" and went "into voluntary exile as almost every Negro does when he marries a white woman." They note that Wyeth is "married to a girl of our own race. They live in Harlem and go around among Negroes," and "Knight is *never* seen in Harlem" (pp. 84–85; emphasis in original). Including Wyeth in a list with Joe Louis and Paul Robeson, "our better folk," Micheaux writes of him as rising above the masses, and helping others by being an inspiration to the Race (pp. 86–87). Later in the novel, the question of what white people might think of Wyeth's novels is raised and

then dismissed: "He has developed and owns his own publishing outlet you know, so makes far more money from the sale of same, than he would if some of the big white publishers were distributing for him on a royalty basis" (pp. 198–199).

Micheaux's extended comparison of Wyeth with Knight (fifteen pages) points to the envy he must have felt over Richard Wright's success and the disappointment he must have experienced with his own lack of recognition and status. Interviewed in the *New York Amsterdam News* in the mid-1940s, Micheaux claimed to have made a good living, selling over 125,000 books during his thirty-year career.[16] But these numbers could not compare with Wright's success. Wright's radical racial protest literature appealed to a liberal white readership. His book *Native Son,* which became a Book-of-the-Month Club selection and enjoyed high sales (more than 200,000 copies in less than three weeks),[17] symbolized the critical commercial success that Micheaux had been unable to achieve after more than three decades as a self-published writer.

Whether piqued by falling sales and/or the lack of critical attention to his novels, or merely wanting to promote the controversial aspects of his work, Micheaux felt the need to include a publisher's preface in *The Story of Dorothy Stanfield.* In this preface he claims that his previous novel, *The Case of Mrs. Wingate,* was ignored because he "dared reverse the old order, and recited in his book the case, based on fact, of a wealthy and aristocratic, but passionate, white girl who fell in love with a Negro youth." He goes on to claim that in the past few years "especially since the rise of Communism in America, there has been an increased amount of race-mixing, mostly between white women and colored men." Furthermore: "The publisher" asserts that "Race-mixing is *not* the theme of Mr. Micheaux's novels by any means, notwithstanding that here and there and now and then it happens to occupy a part in the development of his plots. The practice, as stated, is going on all over the North and is the subject of conversation and debate among Negroes the country over. So why does the great American press condemn Mr. Micheaux's books just because he chooses the facts to some degree and they exist? This is democracy and 'freedom of speech'—with a penalty!" Proud of writing commercial books for a popular market, he then lamented the lack of literary respect they were accorded.

BUT IF MICHEAUX was combative, he was not dispirited. In the spring of 1947, seeing that his book business was declining, after a seven-year hiatus from film work, and despite severe arthritis, he was back making movies and once again at work on a "big picture," *The Betrayal* (1948), a three-hour epic that dealt with many of the potentially contentious themes of the more inflammatory early films.[18] The film was an adaptation of his 1943 novel, *The Wind from Nowhere,* a reworking of *The Homesteader* story, a trace of his past, many years removed.[19] Reasserting his biographical legend, he returned to his first majestic concerns: his life had become his life's work.[20] Instead of attacking discrimination directly, as Richard Wright, for example, had, Micheaux was once again constructing an enabling fiction, where good is beneficently rewarded. A Washingtonian morality continued to drive his stories. Was this the result of his being unable to integrate the changes around him? Or was it employed for

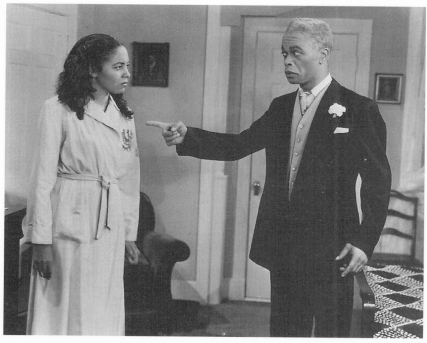

Publicity still from Oscar Micheaux's *The Betrayal* (1948).
Courtesy of African Diaspora Images.

commercial reasons? Or was it a reflection of the way he saw his life—as a teleological journey, unfolding toward a progressive goal?

In New York City, *The Betrayal* played at the Mansfield Theatre on Broadway, the house known for having hosted the successful theatrical productions *Green Pastures* and *Anna Lucasta*. It played for only a few days. In its review of July 3, 1948, the *New York Amsterdam News* found the film embarrassing: "The film from beginning to end was bad; the acting is worse than amateurish; the dialogue is ridiculous; the story downright stupid." Playing to mixed audiences, the film had been reviewed on June 26 by the *New York Times*. The *Times* reviewer, too, had cited technical imperfections. But the reviewer also seemed to have been nettled by the representation of interracial relations, "The film . . . contemplates at some considerable length the relations between Negroes and whites . . . as partners in marriage."[21] Could it be that Micheaux was right, the press was not ready for a story of a Black man and white woman?

The business stationery the Micheaux Film Corporation was using back in 1926 announced his plans to film Zora Neale Hurston's "Vanity."

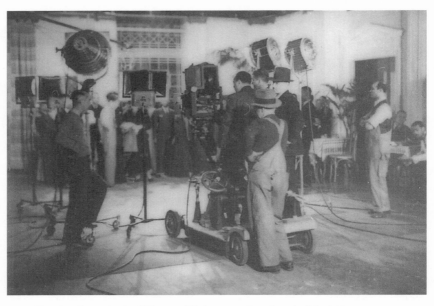

Production shot of Oscar Micheaux standing behind the camera on the set of his final film, *The Betrayal*, in Fort Lee, New Jersey.
Courtesy of African Diaspora Images.

Although there is no record of him having made the film, and it is difficult to determine positively what story he might have been planning to use,[22] her play, *Color Struck,* which won an *Opportunity* award in 1925 and was published in *Fire!!* the following year, employs several of the themes that interested Micheaux during those years. It is the story of a dark-skinned woman in Jacksonville, Florida, who "so despises her own skin that she can't believe any one else could love it." She rejects the love of a "light brown-skinned man" who she supposes prefers a "yaller face." When her beloved daughter (by a white man) gets ill, the mother refuses to let a black doctor treat her and the child dies before the white physician arrives.

The question of what might have been the appeal of Hurston to Micheaux, though elusive, is important. Perhaps it was her early image of herself as a confident self-made success, her resistance to the cry of prejudice, "the tragedy of being Negro."[23] In contrast to Wright's victimized, hunted characters, defeated and humiliated, Hurston celebrated Black life; her characters lead vigorous, textured, and lyrical lives, unaware of being "a problem."[24]

Although Micheaux also avoided the agony of social alienation in his work, there is an underlying longing for a real and—at times mythical—home. His nostalgia for the Rosebud reservation infused even his final film, testifying to the romanticism of the frontier, even while narrating its loss. The title of this film, *The Betrayal,* like that of his earlier adaptation of *The Homesteader, The Exile,* is significant. It marks not a return to a utopian past, but its erosion.

---

TODAY, the work of one man's imagination has become a chronicle of history for the citizens of Gregory, South Dakota (population 1,375). In the summer of 1996, they inaugurated what they hoped would become an annual Oscar Micheaux Film Festival. Governor William J. Janklow issued a proclamation that publicly declared the event "in honor of a remarkably talented South Dakota pioneer and the lesson of hard work overcoming obstacles and leading to success that he taught by example and through his films and books." The governor urged all South Dakotans to avail themselves of the opportunity to learn more about the early days of

South Dakota statehood and an outstanding pioneer by attending the events of the Oscar Micheaux Film Festival.[25]

Nowadays Gregory appears much like a typical Midwest town. Looking down Main Street, a wide thoroughfare running through the town, you can imagine the throngs of people who descended upon this area hoping to acquire a piece of land. Or close your eyes and fast-forward a few more years and witness, as Micheaux must have, the bustling activities of a frontier town: men on horseback herding livestock onto boxcars waiting not far from the edge of town; wagons carrying supplies (lumber, furniture, fuel) to the ranches and farms spread across the prairie landscape.

Main Street is still the center of commerce with shops on either side of the street. An empty wood-frame building next door to the small movie theater and town hall once housed the land office where prospective homesteaders first registered to enter the lottery. This was the place thousands who had come by rail and then by wagon, from as far away as Boston and New York, headed to draw a number hoping to lay claim to one of the mere 450 homesteads available.

The festival's two energetic organizers (Francie Johnson, a member of the South Dakota Board of Tourism, and Richard Papousek, vice president of the Gregory County Historical Society and a contractor), along with the South Dakota Humanities Council, pulled together the support of local businesses, the high school, town library, and a small army of individual volunteers to host the event. They planned a screening of Micheaux's *Within Our Gates,* the earliest of his extant films, a roundtable discussion with local historians and invited scholars, as well as an informal "living history" in which the discussion was opened up for audience members to share stories about their own families' experiences. The Gregory town library and the shops along Main Street advertised the three-day event with memorabilia highlighting Micheaux as author and filmmaker. Special exhibits of local history were on view in the library and in nearby Burke, the Gregory County registrar of deeds displayed land abstracts, survey maps of homestead allotments, and other records relating to Micheaux for scholars to study.

Feelings about Oscar Micheaux run high in Gregory. The high school history teacher uses *The Conquest* in his classroom. David Strain,

On Route 90, a sign indicating the site of Oscar Micheaux's first homestead. Courtesy of African Diaspora Images.

a historian and writer, put up $500 as seed money so that the University of Nebraska could reprint *The Conquest* and Micheaux's later book, *The Homesteader*.[26] From Micheaux's description in *The Conquest*, Richard Papousek re-created a sod house, barn, and outhouse at Micheaux's original 160-acre-homestead site. Early editions of Oscar Micheaux's two books that concern his homesteading experiences, *The Conquest* and *The Homesteader*, are still in the town library. Some of the local families brought their own copies to the festival. One family had a book in which a grandmother had noted the original names of the characters and the towns. Another had a notation by a local lawyer who claimed to have helped edit *The Conquest* (and also written pages 48–53). At the second-year festival, one of the early editions was sold for $150.

Many of the names on the map of homesteading parcels are the surnames of people who live in Gregory County today, many still on farms and ranches. But not Micheaux's. None of his descendants are in the area. Harley Robinson, a cousin from California, has been an invited guest at the festival. Often the only African American there with ties to South

Dakota history is Ted Blakey, a historian from Yankton, a hundred miles away. His family were homesteaders in the early years of the twentieth century. His is often a dissident voice challenging Micheaux's notion of being the only African American in the area.[27] A Black Air Force family also came once, all the way from Rapid City. But it's still a predominantly white town. Most Native Americans live on reservations separated from the white community.

On the last day of the festival each year, which always falls on a Sunday, there is a sunrise church service and pancake breakfast under a tent at the homestead site. The "minister" is a local actor, dressed in a black frock coat and crowned hat. He reads from the Bible, and the group is led in song. Among the songs chosen to fit the occasion are "Amazing Grace" and "We Shall Overcome."

After the second year, the South Dakota Humanities Council went to Washington to accept an award from the Federation of State Humanities Councils for its support of the festival. During the third year of the festival, in addition to the regular screening of Micheaux films, one of the invited scholars brought Alexander Dovzhenko's *Earth* (1930) to show. Some of the residents of Gregory are of Ukranian origin.

————————

MICHEAUX'S NAME now appears on a bronze star on Hollywood Boulevard, the Director's Guild of America has given him a lifetime achievement award, and, every year since 1974, the Black Filmmaker's Hall of Fame has honored "some of the black pioneers in cinema" with an "Oscar Micheaux Award."[28] Oscar Micheaux used his life as a catalyst for his imagination, dramatizing his experiences and envisioning himself as a model for other African Americans. His self-image as a pioneer, on the land, in his novels, and in his filmmaking, was a charmed space he could return to and manipulate over and over again. This space embodied his dreams and ambitions as he struggled within the limits he set for himself and in defiance of those imposed by others.

# Notes

## Preface

1. We use the terms "Black" and "African American" interchangeably in this book. The currently outmoded terms "Negro" and "Colored" are sometimes used when it seems appropriate to the historical context. We capitalize "Black" because it refers not to skin pigmentation but to a specific social identity and heritage, akin to other ethnic identities, and lowercase "white" because it refers not to a specific ethnic group or ethnic identity, but to many. This is also the form of capitalization that was employed by most of the Negro press in the late teens and twenties.

2. Hayden White, *The Content of the Form: Narrative Discourse and Historical Imagination* (Baltimore: John Hopkins University Press, 1989), p. ix.

3. The only known copy of *Within Our Gates* had been returned to the United States in 1988 from the National Film Archive of Spain (La Filmoteca Nacional de España) with Spanish intertitles, and a print of *The Symbol of the Unconquered* was repatriated in 1992 from the Belgium national film archives (Cinémathèque Royale/Koninklijk Filmarchief) with French and Flemish titles.

4. Letter, Swan Micheaux, general manager, Micheaux Film Corporation, to George P. Johnson, general booking manager of the Lincoln Motion Picture Company, 9/7/20, George P. Johnson Negro Film Collection, Department of Special Collections, Charles E. Young Research Library, University of California, Los Angeles.

5. The title under which *Within Our Gates* appeared in Spain, *La Negra* (The Black Woman), suggests some clues to its appeal. The renaming reduced Micheaux's complex story and rich title to simply race and gender. Come and see *La Negra:* the Negress, the exotic Other on display! What fears and desires, projections and compensations, contributed to such attractions? What ideological factors contributed to the distinctions perceived between the races, particularly surrounding gender and sexual behavior?

Although the opening title of the Belgium archive's print of *The Symbol of the Unconquered* is missing from the repatriated film, title slates on two reels were marked *La Chevaucée Infernale* (The Infernal Ride). Once again Micheaux's uplifting title was changed, this time to call attention to the more spectacular and controversial aspects of the picture. While we know very little thus far, a future study of the reception of these features in Europe might help us to move

beyond the mythology of open-armed acceptance to better understand the European fascination with race in America and African American culture.

6. *Black History: Lost, Stolen or Strayed* (Matthew Henson and David Hale Williams, 1967, narrated by Bill Cosby).

7. Five of the nine prints of *The Brute* were in distribution in the South. Letter, Swan Micheaux to George P. Johnson, 10/27/20, Johnson Collection, UCLA. According to Henry T. Sampson, the film was released in Sweden under the title *Mr. Bull McGee* (*Blacks in Black and White: A Source Book on Black Films*, 2nd ed. [Metuchen, N.J.: Scarecrow Press, 1995], p. 579).

8. See, for example, J. Ronald Green's "Micheaux v. Griffith," *Griffithiana* 60/61 (1997): 32–49; and "Lift Every Voice" from the six-part documentary series *I'll Make Me a World* (Sam Pollard, 1999).

## Chapter 1   Writing Himself into History

1. See Oscar Micheaux, *The Conquest: The Story of a Negro Pioneer* (Lincoln, Nebraska: The Woodruff Press, 1913), p. 147. Subsequent page references to this work are given in the text.

2. Land in the Rosebud Reservation became available in 1903. Richard Slotkin (in *The Fatal Environment: The Myth of the Frontier in the Age of Industrialization, 1800–1890* [New York: Atheneum, 1985], pp. 284–285) suggests that the Homestead legislation that divided Indian lands into homestead-type allotments was planned as both a safety valve for urban discontent and a way to integrate Native Americans into "civilized society" by making them into yeoman farmers. However, "unlike homesteading in the well-watered and forested Middle West, plains farming required considerable investment of capital and a larger scale of operations to make it profitable. . . . Indeed, the greatest beneficiaries of the Homestead legislation were railroad, banking, and landholding corporations; and thirty years after the first Homestead Act, land ownership in the Great Plains states was being steadily consolidated in fewer and fewer hands." Micheaux himself seldom mentions the Native American population or the appropriation of their land. But in a short passage in *The Conquest* he does refer to the Indians as "easily flattered" and, rather than developing their allotments, selling them and spending their money as quickly as possible, "buying fine horses, buggies, whiskey, and what-not" (p. 178). His pragmatic self-deception was consonant with the vision of degraded Indians, free land, and progress that held the popular imagination of most of the rest of the nonnative population.

3. The term "biographical legend" is Boris Tomasevskij's [Tomashevsky]. He writes: "Thus the biography that is useful for the literary historian is not the author's curriculum vitae or the investigator's account of his life. What the literary historian really needs is the biographical legend created by the author himself." See "Literature and Biography," in *Readings in Russian Poetics: Formalist and Structuralist Views,* ed. Ladislav Matejka and Krystyna Pomorska (Ann Arbor: University of Michigan Press, 1978), p. 55.

4. A previous film, *Daughter of the Congo* (1930), was billed by Micheaux as a "talking, singing and dancing" picture; however, there was only one short sound sequence.

5. W.E.B. Du Bois, *The Souls of Black Folk* (1903; reprint, New York: Signet Classic, 1969), p. 52.

6. His mother's name is also sometimes spelled Belle.

7. Of the 18,437 Colored employed men listed in the 1910 Chicago census, the largest category of work was railway porters (3,828 men); there were also 3,136 servants and waiters; 2,500, general laborers; 1,841 artisans (barbers, butchers, carpenters, masons, etc.); 1,358 janitors, as well as many who had jobs in

transportation and professional service. ("Colored Chicago," *Crisis*, September 1915.)

8. Carter G. Woodson, *A Century of Negro Migration* (1918) excerpted in *Up South: Stories, Studies and Letters of This Century's African American Migrations*, ed. Malaika Adero (New York: New Press, 1993), p. 9.

9. He also tells of signing on again in another district, after drawing too high a number in his first attempt in the land lottery. "Ofttimes porters who had been discharged went to another city, changed their names, furnished a different set of references and got back to work for the same company. Now if they happened to be on a car that took them into the district from which they were discharged, and before the same officials, who of course recognized them, they were promptly reported and again discharged." Micheaux "pondered the situation" and decided to keep his own name, "assume that I had never been discharged," and went to the St. Louis office with the same references he had used before and was hired (pp. 58–59).

10. *Chicago Defender*, 10/28/11. In *The Conquest* (p. 147) he wrote of having sent articles to several Black newspapers on the opportunities for settlement.

11. Many members of the family spelled their name without the "e." His grandmother's given name is also sometimes spelled Malverna.

12. A woman was qualified to file on a claim only if she were single, deserted by her husband, or a widow. See "3,000 Homesteads Free . . . Beat the Foreigner to This Land," *Chicago Defender*, 9/23/11. In *The Homesteader* (Sioux City, Iowa: Western Book Supply Company, 1917), Micheaux writes of "his business procedure of choosing a wife" (p. 161). Oscar Micheaux married Orlean McCracken in Chicago on April 20, 1910 (*Chicago Defender*, 4/23/10).

13. The railroad ultimately selected a different route, bypassing Micheaux's claims in both Gregory and Tripp Counties.

14. Micheaux, *The Homesteader*, p. 407. Subsequent page references to this work are given in the text.

15. The name Jean Baptiste may have been an homage to Jean-Baptiste Point Du Sable, the Haitian creole explorer who founded Chicago.

16. Gregory County Register of Deeds, Burke, South Dakota.

17. There were severe droughts in the area in 1910 and 1911. See Herbert S. Schell, *History of South Dakota* (Lincoln: University of Nebraska Press, 1975), p. 257.

18. In *The Conquest*, his wife leaves him after her son is stillborn (pp. 262–272). In *The Homesteader*, the child had to be aborted in order to save Orlean's life (pp. 257–258). In *The Wind from Nowhere*, his 1943 reworking of the homestead story, the son lives and his mother takes him to Chicago; after her death, the child is returned to his father and to Rosebud (p. 422). No record of a Micheaux child's birth exists in the Gregory or Tripp County records.

19. Oscar Micheaux, *The Forged Note* (Lincoln, Nebraska: Western Book Supply Company, 1915), p. 541. In the frontispiece he writes of eighteen months in "Dixie land," which he refused to call by the romantic traditional name because Rosebud Country was "the only place that is dear" to him. Subsequent page references to this work are given in the text.

20. Letter, George P. Johnson to Western Book Supply Company, 5/7/18, George P. Johnson Negro Film Collection, Department of Special Collections, Charles E. Young Research Library, University of California, Los Angeles. Lincoln Motion Picture Company was founded in 1916 and incorporated in 1917.

21. Letter, Noble Johnson to George P. Johnson, no date (probably the end of May 1918, immediately before George P. Johnson's letter to Micheaux of 5/31/18), in ibid. The handwritten letter goes on to say "and as I said before I for myself will not make [indistinguishable] my/any living/thing catering to our people." (Noble did not take any salary from the Lincoln Company.)

22. See, for example, letters from Oscar Micheaux to George P. Johnson, 5/13/18, 5/15/18, 5/31/18, and 6/25/18, in ibid.
23. In a letter from Oscar Micheaux to the Lincoln Motion Picture Company, 6/25/18, in ibid.; capitalization and punctuation as in original. Micheaux certainly was cognizant of the public attention brought to the interracial marriage of the champion boxer Jack Johnson and the government's attempt to legally entrap him.
24. Letter, Oscar Micheaux to Clarence A. Brooks, 8/11/18, in ibid. During this period, Chicago was known as a site for African American actors and musicians. In the 1910 census, there were more Black actors listed than clergymen (78 vs. 76), as well as 216 musicians and 30 showmen ("Colored Chicago").
25. See Frederick James Smith's "The Cost of a Five-reel Photoplay" (*Dramatic Mirror*, 7/7/17) and Jay Edwards's "Hustling for the 'Movie Fan'" (*Motion Picture Classic*, July 1917).
26. Letter, Oscar Micheaux to Clarence A. Brooks, 8/13/18, Johnson Collection, UCLA.
27. *Chicago Defender*, 2/22/19.
28. The two *Chicago Defender* articles by Micheaux are "Where the Negro Fails," 3/19/10 and "Colored Americans Too Slow to Take Advantage of Great Land Opportunities Given Free by the Government," 10/28/11.
29. This promotional piece was a booklet consisting of the first four chapters (42 pp.) of the novel and a letter to his reader; no date, Johnson Collection, UCLA. The page with the advertising appeal also included a portrait of the author and a photo of the book cover.
30. *Chicago Defender*, 3/1/19.
31. Ibid.
32. Oscar Micheaux, "The Negro and the Photoplay," *Half-Century Magazine*, May 1919. The *Half-Century Magazine* was founded in August 1916 by Katherine E. Williams, "for the masses," and promised "not to become a 'literary gem' to suit the fancy of highbrows." The monthly's title commemorates a half-century of emancipation.
33. Howard Phelps, "Negro Life in Chicago," in ibid.
34. Frank, a Jewish man convicted of the rape and murder of a young white woman, was lynched by a mob in Marietta, Georgia, in 1915. Although prerelease advertisements for *The Gunsaulus Mystery* mention that the film was based on the Leo M. Frank case, the ads for the premiere in April and later showings in May do not mention Leo Frank at all. In the extant sound version *Lem Hawkin's Confession* (1935), which seems to be very close to descriptions of the silent film in the press (see, for example, *New York Age*, 4/23/21), there is no mention of the Frank case. Building his plot, Micheaux has manipulated the Frank story, heightening the mystery, and placing the shared guilt in the death of the young white woman on two white men, her boss and a jealous boyfriend. In altering the facts of the Frank case, Micheaux also omitted the anti-Semitism and lynching and emphasized the success of a West Indian author and door-to-door book salesman-turned-lawyer, the central character, who proves the innocence of a Negro night watchman and wins the affection of the watchman's sister. By using the tag, "Was Leo M. Frank Guilty?" and by claiming to have been in the courtroom during "this most sensational of all trials," Micheaux was speaking to a readership who was certainly aware of the case. The Black press covered the trial extensively, partly because a Black witness was allowed to testify against a white. (See Joel Williamson, *The Crucible of Race: Black-White Relations in the American South Since Emancipation* [New York: Oxford University Press, 1984], pp. 168–172.)

35. Letter, Theodore A. Ray, captain, to Frank T. Monney, superintendent of police, 3/19/20, Johnson Collection, UCLA.
36. The censor board rejected the film on 2/4/30; see Commonwealth of Virginia, Department of Law, Division of Motion Picture Censorship, list of films rejected in toto since 8/1/22, Virginia State Library and Archives, Richmond. In his 1925 review of *The House Behind the Cedars,* the board's chair, Evan Chesterman, wrote that the film "contravenes the spirit of the recently enacted anti-miscegination law which has put Virginia in the forefront as a pioneer in legislation aimed to preserve the integrity of the white race."
37. Letter, Oscar Micheaux to Virginia State Board of Censors, 10/14/24, Virginia Division of Motion Picture Censorship, Virginia State Library and Archives.
38. "Race Problem Play Comes to Omaha," no date, clipping file, Johnson Collection, UCLA. The film was to play at the Loyal Theater beginning 8/9/20. This article seems to be based on Micheaux's promotional material; the same wording appeared in an article in the *Chicago Defender* for the January run of the film at the Vendome Theater.
39. *Chicago Defender,* 1/31/20.
40. Ibid., 2/21/20.
41. Although Micheaux had completed *Deceit* by mid-August 1921 and was planning to release it that October, we have yet to find any mention of a commercial showing before 1923. (See letter, Ira McGowan to George P. Johnson, 8/17/21, Johnson Collection, UCLA.)
42. See correspondence in Virginia and New York, for examples. A license from the censors was necessary to show a film legally; without a license the film risked confiscation. With limited prints in circulation, Micheaux could not afford to have a print seized.
43. T. S. Stribling, *Birthright* (New York: Century, 1922); the Black press noted how close the film followed the book. See, for example, *New York Age,* 1/19/24: "In adapting the story for the screen, Mr. Micheaux followed the book very closely, even using in the [intertitles] the identical language contained therein." See also D. Ireland Thomas, who wrote in the *Chicago Defender,* 10/24/24: "Mr. Micheaux is not the author of *Birthright.* He is not responsible for the bad language used in the production. He filmed the production as the author wrote it." Micheaux made a sound version of the film in 1939.
44. Maryland State Board of Motion Picture Censors, List of Eliminated Films, Week ending 1/26/24; letter, Oscar Micheaux to Virginia State Board of Censors, 10/14/24, both in the Virginia Division of Motion Picture Censorship, Virginia State Library and Archives.
45. "Correspondence Regarding Controversial Pictures, 1924–1965," in ibid.
46. See, for example, letter, E. R. Chesterman, Virginia State Board of Censors, to C. C. Collmus, Jr., of Norfolk, 2/28/24, in ibid.
47. Letter, Virginia State Board of Censors to the Auditor of Public Accounts, 11/10/24, in ibid.
48. Letter, Oscar Micheaux to Virginia State Board of Censors, 10/14/24, in ibid.
49. Letter, Virginia State Board of Censors to the auditor of public accounts, 11/10/24, in ibid. Micheaux was fined twenty-five dollars, for a "first offense," and given the same fine in 1932 for showing *Veiled Aristocrats* without a license at the Dixie Theatre in Newport News. See letter from the censor board to the attorney general of Virginia, 4/22/32, in ibid.
50. Julius Lester, *Black Folktales* (New York: Grove Press, 1970), p. 93. Lester's italics.
51. Letter, Oscar Micheaux to the Virginia State Board of Motion Picture Censors, 3/13/25, Virginia Division of Motion Picture Censorship, Virginia State Library and Archives.

52. The apt description of Lawson as a "bruised speculator," is Richard Hofstadter's in *The Age of Reform* (New York: Vintage Books, 1955), p. 195. Micheaux praised Lawson's 1906 book in *The Conquest,* p. 142.

53. Micheaux, *The Conquest,* p. 145. Micheaux repeated this line eleven years latter in letters to the *Pittsburgh Courier,* 12/13/24, and the *Afro-American,* 12/27/24.

54. Booker T. Washington, *My Larger Education* (Garden City, N.Y.: Doubleday, 1911), p. 107.

55. Micheaux, *The Conquest,* pp. 252–253. Although Micheaux referred to Washington often in *The Conquest,* he did not mention Du Bois by name. However, in *The Forged Note,* using the pseudonyms Derwin ("a man who used to be professor of sociology in one of [Atlanta's] colleges") and *The Climax* ("the only magazine edited by, and in the interest of this race"), he praised Du Bois and the *Crisis* magazine (pp. 68–69). And he did give the name Alfred Du Bois to a Micheaux-like character, the filmmaker, in his 1923 film *Deceit.*

56. Letter, Oscar Micheaux to C. W. Chesnutt, 1/18/21, Charles W. Chesnutt Papers, Western Reserve Historical Society, Cleveland, Ohio; the extant version of the sound remake, *Veiled Aristocrats,* suggests that Micheaux, in the sound version at least, did make the changes in the character.

57. Clipping, *Chicago Bee,* no date, courtesy Grace Smith.

58. This edition of *The Forged Note* is in the Schomburg Center for Research in Black Culture, New York, N.Y.

59. See, for example, Garland L. Thompson's article on the Commentary page of the *Baltimore Sun,* 4/13/91, discussing *New Jack City* and *The Five Heartbeats* in the context of Micheaux's career, and Carl Franklin's homage to Micheaux in *Devil in a Blue Dress* (see *New York Times,* 9/24/95). There was also a lively debate on Micheaux's life and films during a panel discussion on "Mainstreaming Independent Film" at the February 1990 annual conference of the College Art Association among filmmakers Isaac Julien and Arthur Rogbodiyan (Arthur Jafa), and *(New York) City Sun* critic Armond White.

60. Chesnutt's daughter Ethel, after seeing the film, wrote of Micheax's rewriting to her father dated 4/25/32: "It was not artistic like the story" and "your beautiful English" was "lacking"; quoted in Thomas Cripps, "'Race Movies' as Voices of the Black Bourgeoisie: The Scar of Shame," *American History/American Film,* ed. John E. O'Connor and Martin Jackson (New York: Ungar, 1979), p. 48.

61. Letter, Oscar Micheaux to *Pittsburgh Courier,* 12/13/24. In Micheaux's idealized world, however, race would be a less defining characteristic. Frank also tells Rena: "It seems it would all be so much happier if they would be just willing to meet us half way. But life is like that. If people could all see alike and feel alike, there would be no politics, no race prejudice."

62. Booker T. Washington, *Up from Slavery: An Autobiography* (1901; reprint, Garden City, N.Y.: Doubleday, 1963), p. 77. Whereas Washington found hope in the South, Micheaux, who did not seem to share Washington's acceptance of the social separation of the races, saw fresher prospects in the northern Great Plains. Washington, however, was troubled by the economic and political status of the Negro in the Northwest. He felt that the sparseness of the Colored population in any one community accounted for a lack of business opportunities, a lonesomeness and lack of racial solidarity, and, although they voted freely, the inability to wield the ballot effectively. (See his letter to *New York Age,* 3/20/13.)

63. Joseph A. Young argues in *Black Novelist as White Racist: The Myth of Black Inferiority in the Novels of Oscar Micheaux* ([Westport, Conn.: Greenwood Press,

1989], p. 1 et passim) that Micheaux's novels express an assimilationist world-view and an acceptance of white cultural values. Arguing from Young, Jane Gaines sees Micheaux as typical of the Black bourgeoisie, viewing Black culture through the eyes of whites ("Fire and Desire: Race, Melodrama and Oscar Micheaux," in *Black Cinema: History, Theory, Criticism* ed. Manthia Diawara [New York: Routledge and Chapman, Hall/American Film Institute, 1993], p. 66). However, it might be more profitable to look at this contrast between the city and the wilderness, an opposition that Slotkin sees as common in the frontier myth, with the hero leaving the metropolis to rid himself of the corrupting "civilized" values, as a necessary part of Micheaux's biographical legend, the building of an identity in opposition to those he saw as having a detrimental effect on Race progress.

64. Oscar Micheaux, *The Wind from Nowhere* (New York: Book Supply Company, 1943), pp. 422–423.

65. See *New York Age*, 5/28/38. Micheaux met with the Young Communist League and, according to Angelo Herndon, agreed to cut sections of the film. Apparently, the YCL did not see the film as criticizing the fair-skinned woman's actions: "We made it clear that this picture creates a false splitting of Negroes into light and dark groups. White employers have . . . tried . . . this very tactic. This is a weapon that is used by whites to make dark Negroes feel that light Negroes are their superiors." The film was also protested in Boston. (See *New York Amsterdam News*, 12/9/39.)

66. Langston Hughes, "The Negro Artist and the Racial Mountain," *Nation*, 6/23/26; Alain Locke, *The New Negro: An Interpretation* (New York: A. and C. Boni, 1925), p. 12.

67. The first quote by Micheaux appeared in "The Negro and the Photoplay," *Half-Century Magazine*, May 1919; the second, in the *Chicago Defender*, 1/31/20. The final quote was published in both the *Pittsburgh Courier*, 12/13/24, and the *Afro-American*, 1/24/25.

68. Micheaux Book and Film Company, Inc., open letter to exhibitors, March 1919, Johnson Collection, UCLA.

69. *Chicago Defender*, 5/31/19. Besides a wide readership in Chicago, the paper was influential in the South, distributed along the route of the Illinois Central Railroad System and other lines passing through the nation's rail hub, with railroad personnel often acting as publicists and distributors of the paper. See James R. Grossman, *Land of Hope: Chicago, Black Southerners, and the Great Migration* (Chicago: University of Chicago Press, 1989) pp. 66–81.

70. Micheaux's second film, *Within Our Gates*, was booked at the following theaters for the first three months of 1920: 1/20, Rex Theatre, Durham, N.C.; 1/21, Reidsville, N.C.; 1/21–22, Auditorium Theater, Atlanta, Ga.; 1/21–22, Atlas Theatre, Spartanburg, S.C.; 1/23–24, Community Center, Charlotte, N.C.; 1/27–28, Star Theatre, Asheville, N.C.; 1/29, Dixie Theatre, Greenwood, S.C.; 1/30–31, Lincoln Theatre, Columbia, S.C.; 2/3, Palmetto Theatre, Orangeburg, S.C.; 2/4, Globe Theatre, Wilson, N.C.; 2/6, Rex Theatre, Goldsboro, N.C.; 2/9, Globe Theatre, New Bern, N.C.; 2/10, Victoria Theatre, Washington, N.C.; 2/11, Palace Theatre, Kingston, N.C.; 2/17–18, Pekin Theatre, Brunswick, Ga.; 2/20, Crystal Theatre, Dublin, Ga.; 2/23–24, Dixie Theatre, Sandersville, Ga.; 2/26, Lennox Theatre, Augusta, Ga.; 2/28, 81 Theatre, Atlanta, Ga.; 3/1, Morton Star Theatre, Athens, Ga.; 3/2, Douglas Theatre #2, Macon, Ga.; 3/12, Liberty Theatre, Greenville, S.C.; 3/14, Dream Theatre, Columbus, Ga.; 3/15, Gem Theatre, Fort Valley, Ga.; 3/16, Elite Theatre, Cordele, Ga.; 3/17, Opera House, Americus, Ga.; 3/19–20, Star Theatre, Waycross, Ga. While the film netted $150 in a one-day rental in Atlanta, the firm took in only $35.90 for two days in Sandersville

(ledger, African Diaspora Images, Brooklyn, N.Y.). Later that year, five of the nine prints of *The Brute* were "working" in the South two months after the film's debut. (Letter, Swan Micheaux, general manager, Micheaux Film Corporation, to George P. Johnson, 10/27/20, Johnson Collection, UCLA.)

71. George P. Johnson, who booked the return engagement of *The Homesteader* into the Loyal Theater in Omaha, Nebraska, sent the Micheaux Book and Film Company $90.76, representing 50% of net receipts from the two-day showing (8/2 and 8/3 of 1920). He reported spending $15.00 on newspaper advertising and $3.50 for printing heralds; the competition was heavy, the weather was fine, and attendence was "Better than expected for this time of year." (Letter, George P. Johnson to Oscar Micheaux, 8/4/20, Johnson Collection, UCLA.) Both Johnson and Micheaux considered these results very good, actually more than they had expected.

72. Vaudette Theatre, Detroit premiere, 1/26/20, and the Loyal Theater's return engagement in Omaha, 8/9 and 8/10 of that year (*Chicago Defender,* 1/24/20, and unidentified clipping, Johnson Collection, UCLA, respectively).

73. See, for example, "Noted Motion Picture Producer Soon Sails for Europe," *Chicago Defender,* 1/31/20.

74. Letter, Swan Micheaux to George P. Johnson, 9/7/20, Johnson Collection, UCLA.

75. Micheaux Book and Film Company, Inc., 1921 stock offering, in ibid.

76. Undated document, most likely compiled at the time of the stock offering, in ibid.

77. Announcement of *The Brotherhood,* 10/6/20, in ibid.

78. Micheaux Book and Film Company, Inc., 1921 stock offering, in ibid.

79. See, for example, the ad in the *Pittsburgh Courier,* clipping, no date, in ibid.

80. See, for example, "Producer Returns: Busy Making New Productions That Will Appear Soon," *Chicago Defender,* 5/29/20, and "Micheaux to Sail," the *Afro-American,* 12/12/25.

81. Letter, Oscar Micheaux to George P. Johnson, 8/14/20, Johnson Collection, UCLA. Besides filming *The House Behind the Cedars,* he later also adapted *The Conjure Woman* and remade *The House Behind the Cedars* as a sound film titled *Veiled Aristocrats* (1932). In an interesting foreword to his novel *The Masquerade* (New York: Book Supply Company, 1947), a retelling of the story in *The House Behind the Cedars,* Micheaux throws some light on his attitude toward the reuse of material: "After deciding to do an historical novel as my next publication, I went back to my old file of motion picture scenarios and found one that just fitted my purposes: a scenario from a novel by Chas. W. Chesnutt, published almost fifty years ago. I had filmed the novel twice. First as a silent film in the early twenties, and as a talking picture in the early thirties." While never naming the Chesnutt novel or discussing the question of permission or collaboration, he goes on to express his gratefulness: "I am very happy, in the meanwhile, for the privilege of having known Mr. Chas. W. Chesnutt, who died in 1932, and acknowledge with gratitude, the assistance provided by his book of that period which I have drawn upon in the rounding out and completion of this novel."

82. See letters: Charles W. Chesnutt to Oscar Micheaux, 1/20/21, and Charles W. Chesnutt to his publishers, Houghton Mifflin, 1/27/21, Charles W. Chesnutt Papers, Western Reserve Historical Society, Cleveland, Ohio. According to Alice Dunbar-Nelson's diary, she was interested in writing scenarios for Micheaux, in particular adapting her story "The Goodness of Saint Rocque" for the screen. She also mentioned, however, that she didn't find his language very refined (*Give Us Each Day: The Diary of Alice Dunbar-Nelson,* ed. Gloria T. Hull [New York: Norton, 1984], pp. 75–77, 95).

83. See, for example, the letters to "Dear Friend Brooks" dated 8/11/18 and 9/13/18, Johnson Collection, UCLA.

84. Letter, Oscar Micheaux to George P. Johnson, 6/25/18. Later, to keep track of what Micheaux was doing, George P. Johnson placed moles in Micheaux's office: his wife's sister's husband, Ira McGowan, and the former Lincoln agent Homer Goins.

85. George P. Johnson, however, was reluctant to leave the security of his full-time position at the Omaha, Nebraska, Post Office, explaining, "I . . . would not desire to sacrifice a sure permanent job, losing my seniority; without entering a position equally as well or better and with some assurance of a term contract" (letter, 9/22/20, Johnson Collection, UCLA). Noble Johnson, star of Lincoln's first three films, one released in 1916 and two in 1917, had been receiving pressure from the Universal Picture Corporation to work exclusively for them, according to Henry T. Sampson (*Blacks in Black and White: A Source Book on Black Films* 2nd ed. [Metuchen, N.J.: Scarecrow Press, 1995], pp. 133–136), and resigned from the Lincoln Motion Picture Company at their board meeting of 9/3/18. However, Lincoln did make two other films, *A Man's Duty* (1919) and *By Right of Birth* (1921), with Clarence Brooks as the male lead in both. By 1923 the company had ceased operations.

86. See, for example, letters, Oscar Micheaux to Charles W. Chesnutt, 6/17/21 and 10/30/21, Chesnutt Papers, Western Reserve Historical Association.

87. Many of those new companies, however, produced only one film, and some of them never released a product; J. A. Jackson, writing in 1922, estimated that 68% of the firms failed (*Afro-American*, 6/23/22). Some of these ventures are discussed in chapter 3.

Ira McGowan, writing to his brother-in-law, George P. Johnson, in August of 1921, complained of the "hard pickings" and competition from white producers who were cutting prices when they found the market hard to penetrate ("they can afford to do so because they have the cash laid aside to make 5 or 10 pictures") and from Colored producers of inferior films who were "letting the exhibitors set the price on their pictures" (8/17/21, Johnson Collection, UCLA).

88. In 1923 a print of Micheaux's film *Deceit* was siezed by the sheriff for moneys owed, in Knoxville, Tennessee (*Chicago Defender,* 12/29/23).

89. Reported in the *Billboard,* 1/28/22, and discussed in letter, Oscar Micheaux to Charles W. Chesnutt, 1/15/22; however, according to another letter to Chesnutt, he found Jacksonville too racist and did not want "to subject our ladies to possible insult which we are most likely to encounter" there (Oscar Micheaux to Charles W. Chesnutt, 2/28/22, Charles W. Chesnutt Papers, Western Reserve Historical Society).

90. The Mrs. Sewell who appeared in *The Conjure Woman* is most likely the Alma Sewall [sic] listed in Sampson's *Blacks in Black and White* and the American Film Institute's catalogue, *Within Our Gates: Ethnicity in American Feature Films, 1911–1960* (ed. Alan Gevinson [Berkeley: University of California Press, 1997]) as having a small role in *Birthright* and may also have been the Olivia Sewall listed as having appeared in *A Son of Satan.* All were filmed in Roanoke. Mrs. Sewell also claimed to have appeared in *The House Behind the Cedars* and *Uncle Jasper's Will.* (See the *Roanoke World-News,* 10/29/42, for Mrs. Sewell's reminiscences. Aukram Burton draws on this article in his report on Roanoke in *Oscar Micheaux Society Newsletter,* vol. 7, summer 1998.)

91. Theresa Dawkins Holmes, interview by the authors, 6/27/94, Roanoke, Va.

92. Verna Crow (Micheaux's niece), interviewed by Pearl Bowser, 1/29/91, Los Angeles, Calif., for the film *Midnight Ramble: Oscar Micheaux and the Story of Race Movies* (Bester Cram and Pearl Bowser, 1994).

93. The quote is from an interview with Elcora "Shingzie" Howard, 7/18/88,

Steelton, Pa., by Pearl Bowser, in the collection of the American Museum of the Moving Image. See also interviews in the same collection with Elton Fax and Carlton Moss.

94. Howard interview, 7/18/88; although Howard did not remember which film was being shot, it may have been *The Virgin of Seminole, A Son of Satan* (working title *The Ghost of Tolston Manor*), or *The House Behind the Cedars,* all of which had scenes shot in Roanoke.

95. Toni Cade Bambara, interviewed in the film *Midnight Ramble.* George P. Johnson, in a 1970 interview, also mentioned Micheaux's ability to talk ("George P. Johnson: Collector of Negro Film History," Oral History Program, University of California, Los Angeles [1967 and 1968], interviewed by Elizabeth I. Dixon and Adelaide G. Tusler, pp. 159–160).

96. *Pittsburgh Courier,* 5/10/20.

97. *Philadelphia Tribune,* 12/13/24.

98. Statement by the Producer to our Patrons, 12/29/23, Chesnutt Papers, Western Reserve Historical Society; these appearances must have also been an attempt to raise capital. Swan came to the company in 1920, around the time that Oscar moved to New York City; he left the firm in the beginnng of 1927. According to Henry T. Sampson, Oscar and Swan may have had a falling out over financial matters (*Blacks in Black and White,* p. 160). Sampson notes that the plot summary of *The Wages of Sin* (1928) parallels the personal story of the Micheaux brothers (a filmmaker gives his younger brother a job in the company; "the younger brother proceeds to spend money on fast women and night life and almost bankrupts the company").

99. *The Autobiography of an Ex-Colored Man* was not revealed as fiction until 1927. See Donald C. Goellnicht, "Passing as Autobiography: James Weldon Johnson's *The Autobiography of an Ex-Coloured Man,*" *African American Review* 30:1 (spring 1996): 18.

100. *Chicago Defender,* 3/19/10.

101. Fred and Blanche Crayton, Oscar Micheaux's brother-in-law and sister-in-law, interviewed by Pearl Bowser, 8/10/75, Chicago; Edna Mae Harris, interview, 1/8/91, for the film *Midnight Ramble.*

102. Letter, Oscar Micheaux to Clarence A. Brooks, 9/13/18, Johnson Collection, UCLA.

103. Letter, Oscar Micheaux to George P. Johnson, 8/14/20, in ibid.

104. Letter, Oscar Micheaux to Charles W. Chesnutt, 1/18/21, Charles W. Chesnutt Papers, Western Reserve Historical Society.

105. "Shingzie" Howard, interview, 9/14/91, for the film *Midnight Ramble.* This method of acquiring footage must certainly have inflected Micheaux's editing practice. J. Hoberman finds his "mismatched" shots "surreal," akin to the avant garde ("A Forgotten Black Cinema Resurfaces," *Village Voice,* 11/17/75).

106. Howard interview, 7/18/88: "Now I didn't have a wardrobe and he didn't have any money to buy me a wardrobe. . . . He saw the coat which represented elegance and he wanted that."

107. George Heller, interview by the authors, 6/27/94, Roanoke, Va.

108. Evelyn Preer appeared in the following films: *The Homesteader, Within Our Gates, The Brute, The Gunsaulus Mystery, Deceit, Birthright, The Devil's Disciple, The Conjure Woman,* and *The Spider's Web.*

109. *Afro-American,* 1/29/27.

110. Henry T. Sampson's listing of credits in *The Ghost Walks: A Chronological History of Blacks in Show Business, 1865–1910* (Metuchen, N.J.: Scarecrow Press, 1988) illustrates how easily many professional performers moved between drama, comedy, vaudeville, and minstrelsy during the early part of the past century.

111. Tucker, for example, in an interview on Julius Lester's *Free Time* (PBS, 11/18/71), told stories of getting an advance from Micheaux to get his suit out of hock. See also Richard Grupenhoff's *The Black Valentino: The Stage and Screen Career of Lorenzo Tucker* (Metutchen, N.J.: Scarecrow Press, 1988), p. 64.

112. The ads for *The Brute* appeared in the *Chicago Defender,* 6/12, 6/19, 6/26, and 7/10, all in 1920.

113. Unidentified clipping, no date, Johnson Collection, UCLA; clipping, *Chicago Bee,* no date, in ibid.

114. Letter, Oscar Micheaux to George P. Johnson, 8/14/20, Johnson Collection, UCLA. The Layfayette Players advertised as being in *The Brute* were Evelyn Preer, A. B. De Comathiere, Susie Sutton, Lawrence Chenault, and Alice Gorgas.

115. Carl Mahon, interviewed on Julius Lester's *Free Time* (PBS, 11/18/71).

116. Claude McKay, *Home to Harlem* (1928; reprint, Boston: Northeastern University Press, 1987), p. 315.

## Chapter 2    In Search of an Audience, Part I

1. John R. Grossman, *Land of Hope: Chicago, Black Southerners, and the Great Migration* (Chicago: University of Chicago Press, 1989), p. 30.

2. Charles S. Johnson, *The Negro in American Civilization: A Study of Negro Life and Race Relations in the Light of Social Research* (New York: Henry Holt and Company, 1930), p. 19. Between 1910 and 1920, New York City's Black population grew from, 91,709 to 152,467; Chicago's from 44,103 to 109,458; Detroit's from 5,741 to 40,838.

3. Oscar Micheaux, *The Conquest: The Story of a Negro Pioneer* (Lincoln, Nebraska: Western Book Supply Company, 1913), p. 10.

4. *Chicago Defender,* 4/1/22. The article quotes Moorefield Storey, a director of the National Association for the Advancement of Colored People, about American citizens "who ought to be protected against hostile legislation in any state by the 14th amendment. Yet all over the country their rights are ignored and they are subjected to indignities of every kind simply because they are Negroes."

5. This incident took place in January 1921. The paper disguised the man's name and the exact locale.

6. This quote, from former governor Hugh Dorsey, is in W.E.B. Du Bois's "Propaganda and World War," from *Dusk of Dawn* (1940), p. 748, in *W.E.B. Du Bois Writings,* ed. Nathan Huggins (New York: The Library of America, 1986).

7. Grossman, *Land of Hope,* p. 79. Grossman estimates the circulation rose from 33,000 copies in early 1916 to 230,000 in 1919. He writes that "Abbott's first issue set the tone, denouncing 'WHITE GENTLEMEN FROM GEORGIA' who had condoned a white man's murder of three blacks for committing the crime of refusing to work overtime" (p. 75).

8. LeRoi Jones (Amiri Baraka), *Blues People* (New York: William Morrow, 1963), p. 96.

9. Letter, 1917, Emmett J. Scott, "Additional Letters Negro Migrants of 1916–1918," *Journal of Negro History* 4 (October 1919): 452.

10. "A Piece of Doggerel from the Cotton Fields," quoted in Grossman, *Land of Hope,* p. 29 from George E. Haynes, "Negroes Move North, I," *Survey* 40 (5/4/18): 118.

11. The Mississippian is quoted in Grossman, *Land of Hope,* p. 18; the letter from the Chicago carpenter is in Scott, "Additional Letters Negro Migrants," p. 459.

12. Emmett J. Scott, "Letters Negro Migrants of 1916–1918," *Journal of Negro History* 4 (July 1919): 302.

13. Rudolph Fisher, "The City of Refuge," in *The Short Fiction of Rudolph Fisher,* ed. and intro. Margaret Perry (Westport, Conn.: Greenwood Press, 1987), p. 28. The story was first published in the *Atlantic Monthly* 135, 1925.

14. Jones, *Blues People*, p. 96; emphasis in original.
15. "By What Name Shall the Race Be Known," *Half-Century Magazine*, November 1919.
16. Clipping, no date, probably 1917, Tuskegee Institute newspaper clipping files.
17. See Stuart Hall's essay "The Rediscovery of 'Ideology': Return of the Repressed in Media Studies" (in *Culture, Society, and the Media*, ed. M. Gurevitch, T. Bennett, J. Curran, and J. Woollacott [London: Methuen, 1982], pp. 78–79) for a discussion of the different inflections of the derogatory "black" and the valued "Black."
18. Jones, *Blues People*, p. 106.
19. The endorsement of the Negro dolls is in the *Afro-American Ledger*, 11/7/08. Berry and Ross Company advertised its stock offering in the *Atlanta Independent*, 4/19/19 and 5/3/19. The firm accepted money orders or Liberty Bonds.
20. Advertisements appeared in the *New York Age*, 1/5/11; the *Chicago Defender*, February 1917; and the *Afro-American*, 5/12/22, respectively.
21. M. S. Stuart, *An Economic Detour: A History of Insurance in the Lives of American Negroes* (College Park, Md.: McGrath, 1940), p. xxiii.
22. Grossman, *Land of Hope*, p. 8.
23. The Chicago firm's ad appeared in the *Chicago Defender*, 5/23/19; for Pace's Black Swan Records, see, for example, ads in the *New York Age* during January 1922, and the *Chicago Defender*, 6/4/21 and 12/16/22. In 1924, after declaring bankruptcy, Pace sold the Black Swan label to Paramount Records. (See Eileen Southern's *The Music of Black Americans: A History*, 3rd ed. [New York: Norton, 1997], pp. 370–371.)
24. William Holman remembered his mother walking into town with a white woman from the neighboring farm, and sitting on different sides of the aisle when they entered the small-town Arkansas theater. (Interview by the authors, 6/22/93, Memphis, Tennessee.)
25. *(Baltimore) Afro-American Ledger*, 2/5/10.
26. Chicago Commission of Race Relations, *The Negro in Chicago* (Chicago: University of Chicago Press, 1922), p. 319.
27. The article on the Apollo Theater appeared in the *New York Age*, 10/10/25; the Tivoli case was reported in *Variety*, 2/18/25.
28. As reported in the the *Afro-American Ledger*, 2/5/10.
29. *Atlanta Independent*, 11/29/19, 12/6/19, 12/13/19.
30. According to George C. Wright, *Life Behind a Veil: Blacks in Louisville, Kentucky 1865–1930* ([Baton Rouge: Louisiana State University Press, 1985], p. 200), the theater did change its policy to allow colored patrons to enter from the main street and be accommodated in the first balcony. Cited in Gregory A. Waller's *Main Street Amusements: Movies and Commercial Entertainment in a Southern City, 1896–1930* (Washington D.C.: Smithsonian Institution Press, 1995), p. 311.
31. The promotional material, which appeared in the *Lexington Leader*, 11/7/07, is cited in Waller, *Main Street Amusements*, p. 166. The *Indianapolis World* article was reprinted in the *Chicago Defender*, 7/20/12, and the quote from Thomas's *Defender* column appeared 6/6/25.
32. *New York Age*, 7/11/12. See also the announcement of a new theater in Norfolk, Va., 7/5/19; and two theaters in Petersburg, Va., 10/25/19.
33. *Lexington Leader*, 11/30/07, cited in Waller, *Main Street Amusements*, p. 169.
34. *Afro-American Ledger*, 12/11/09.
35. Proceedings of the Seventeenth Annual Convention of the National Negro Business League, 1916, p. 162.
36. *(Indianapolis) Freeman*, 3/31/17.
37. *New York Age*, 3/7/12.

38. See Oscar Handlin's "The Goals of Integration," *Daedalus* 95 (winter 1966): 284, quoted in David Gordon Nielson, *Black Ethos: Northern Urban Life and Thought, 1890–1930* (Westport, Conn.: Greenwood Press, 1977), pp. 112–113.

39. Bureau of Labor Statistics, cited in Lizabeth Cohen, "Encountering Mass Culture at the Grassroots: The Experience of Chicago Workers in the 1920s," *American Quarterly* 41:1 (March 1989): 13.

40. *Louisville News,* 4/7/17.

41. Mary Carbine, "'The Finest Outside the Loop' . . . Motion Picture Exhibition in Chicago's Black Metropolis, 1905–1928," *Camera Obscura* 23 (May 1990): 15.

42. *Norfolk Journal and Guide,* 9/8/23; see Waller, *Main Street Amusements,* pp. 161–175 for a discussion of the white films playing in Colored theatres in Lexington, Ky., 1907–1916.

43. William H. Jones, *Recreation and Amusement Among Negroes in Washington, D.C.: A Sociological Analysis of the Negro in an Urban Environment* (1927; reprint, New York: Negro Universities Press, 1970), p. 114.

44. *Chicago Defender,* 1/24/25.

45. *Norfolk Journal and Guide,* 1/19/24. As early as 1917, S. H. Dudley called for managers to set aside one night a week for Race films, but lamented that there was not enough product (*Chicago Defender,* 12/15/17). In 1927, he suggested that patrons "demand Race pictures at the theater where you spend your money," but he proposed, less optimistically, "at least once a month" (*Chicago Defender,* 7/9/27).

46. *Chicago Defender,* 1/19/1918; the ad read that Johnson was "supported by Eddie Polo"! The following year (10/11/19), the *Chicago Whip* announced that Johnson was "still starring with Eddie Polo in their great serials" and went on to explain that "Johnson is a fair actor and while generally given many heavy parts, is never shown to be at a disadvantage. Johnson's light complexion fools many people who follow the screen light but he is colored all right, and we trust he some day will·be allowed to play a stellar role."

47. The right side also touted "Clarence Jones' Wonder Orchestra, the best music in the world" (10/20/23).

48. *Chicago Defender,* 6/6/25.

49. *Half-Century Magazine,* June 1919; Jean Voltaire Smith, "Our Need for More Films," *Half-Century Magazine,* April 1922.

50. See advertisement in *New York Age,* 1/5/11.

51. Waller, *Main Street Amusements,* pp. 52, 166.

52. *Chicago Defender,* 3/14/17; "Some Facts Concerning the Lincoln Motion Picture Company, Inc. and Its Productions," George P. Johnson Negro Film Collection, Department of Special Collections, Charles E. Young Research Library, University of California, Los Angeles.

53. Wilson continued through the early sound era, traveling in a trailer with sound equipment and adding Georgia and Florida to his itinerary. (Versie Lee Lawrence, *Deep South Showman* [New York: Carlton Press, 1962].)

54. *Chicago Defender,* 2/18/20; *Billboard,* 5/22/20.

55. *Chicago Defender,* 5/6/22. Thomas regularly discouraged people from opening a Race theater in a town with too small a Colored population to support the enterprise. He advised the writer from a small town in Mississippi that the white theater in his town, catering to people of both races, only operated three days a week. Although the Black man who wished to open a theater was sure the Race would patronize a theater with better accommodations, Thomas insisted that the population was not large enough to support a separate theater (*Chicago Defender,* 6/6/25).

56. See ibid., 12/1/23 and 3/15/24.

57. Ibid., 3/15/24.
58. Ibid., 2/14/25, 6/6/25, and 3/28/25.
59. Ibid., 2/14/25.
60. Frederick Detweiler, *The Negro Press in the United States* (Chicago: University of Chicago Press, 1922), pp. 2–3. The fact that in the early twenties Chicago, alone, had four Black weeklies—the *Defender,* the *Whip,* the *Chicago Bee,* and the *Broad Ax*—points not only to the variety of coverage, but also to the diversity of the African American community. Monthly magazines, such as the *Half-Century,* the *Champion Magazine,* and the *Competitor,* also covered popular amusements.
61. Cited in Paul K. Edwards's *The Southern Urban Negro as a Consumer* (1932; reprint, New York: Negro Universities Press, 1969), p. 171.
62. The 12/2/16 advertisement for the film in the *Chicago Defender* also declared it "the only five reel picture ever produced and acted by Colored People."
63. *Billboard,* 4/1/22.
64. Letter, Romeo L. Dougherty to C. Wells in Philadelphia, 8/16/17, Johnson Collection, UCLA.
65. Although it had been a common practice, today we might see a conflict of interest in some of the coverage; for instance, in his *New York Age* article of 2/22/20, Lester A. Walton emphasized the huge crowds at the Lafayette Theatre's showing of the 1920 documentary *From Harlem to the Rhine,* which might have helped persuade theater owners to book the film; as the film's distributor, Walton stood to personally profit from subsequent bookings. Walton was co-manager of the Lafayette Theatre from 1914 to 1916 and returned again to the Lafayette in 1919. Active in the Democratic Party, he served as U.S. envoy to Liberia from 1933 to 1946.
66. "Some Facts Concerning the Lincoln Motion Picture Company, Inc. and Its Productions," Johnson Collection, UCLA.
67. Letter, George P. Johnson to Oscar Micheaux, 5/15/18, in ibid.
68. Letter, Tony Langston to George P. Johnson, 8/10/16 (in ibid.) on Foster stationery; *Chicago Defender,* 3/13/20.
69. *Chicago Defender,* 11/6/20.
70. Perry was Johnson's middle name. After Lincoln ceased production in 1923, Johnson, under the name George Perry, wrote about film and performers for the Pacific Coast News Bureau.
71. For instance, *Motion Picture Magazine, Motion Picture Classic,* and *Photoplay.* For more information on fan magazines in the late teens and early twenties, see Kathryn H. Fuller's *At the Picture Show: Small-Town Audiences and the Creation of Movie Fan Culture* (Washington, D.C.: Smithsonian Institution Press, 1996).
72. These advertisements appeared in *Chicago Whip,* 10/22/21; *New York Amsterdam News,* 12/9/25; *Chicago Whip,* 5/7/21; and *Chicago Defender,* 1/3/20, 9/9/22.
73. *Chicago Defender,* 5/19/17.
74. Ibid., 4/22/22.
75. The article mentions, as an added inducement, that the director would be Sam T. Jacks, a well-known vaudevillian (*Chicago Defender,* 9/22/23). A similar enterprise was announce by the Capital Motion Picture Corporation of Washington, D.C. in 1920 (*Billboard,* 12/25/20).
76. *Chicago Defender,* 5/27/22; *Variety,* 12/3/24 (see also articles in the *Afro-American,* 12/13/24, and the *Pittsburgh Courier,* same date); *Afro-American,* 12/20/24.
77. *Afro-American Ledger,* 4/11/09. The Amazon Amusement Company was, at the time, the proprietors of the Home Theatre in Baltimore, a "success[ful] . . . Negro moving picture house."
78. *Chicago Defender,* 8/11/17, capitalization as in original; Lincoln's ads also appeared in the trade papers.

79. *Afro-American,* 12/31/20. *The Birth of a Race*'s 1917 stock offering entreated, "This is your Photoplay, for you are a part of it. It will picture the true story of Negro Progess." The advertisement also mentioned that shares were being sold to white investors with a limited number "reserved for Colored people." "This master photoplay will appeal to all classes—to all races—for it deals with real understanding and betterment" (*Chicago Defender,* 3/3/17). Although the film was originally planned by the NAACP and other African American activists as a challenge to D. W. Griffith's *The Birth of a Nation* (1915), showing the progress of Black America since emancipation, the compromises that came about with the U.S. entry into World War I, the input of Hollywood funders, and the loss of influence of the original Black activists turned the film into a story of mankind emphasizing what historian Thomas Cripps has called a "neutrally shaded universal 'progress.' " By the time the film played theaters along "the Stroll" in Chicago, ads mentioned that it was "dedicated to all the races of the world" (*Chicago Defender,* 8/30/19). For a detailed history of the production, see Thomas Cripps's "The Making of *The Birth of a Race:* The Emerging Politics of Identity in Silent Movies" in *The Birth of Whiteness: Race and the Emergence of United States Cinema,* ed. Daniel Bernardi (New Brunswick, N.J.: Rutgers University Press, 1996). The quote is on p. 45.

80. The announcements of stock offerings appeared in the *Chicago Whip,* 5/21/21, and the *(Wilmington, Del.) Advocate,* 5/8/20. The quote by D. Ireland Thomas is from the *Chicago Defender,* 11/30/22; see also the *Afro-American,* 12/1/22.

81. Oscar Micheaux, "The Negro and the Photoplay," *Half-Century Magazine,* May 1919; Smith, "Our Need for More Films."

82. See ads in the *New York Age* during October 1908, on 7/6/11, and during November 1912. Admission at Young's Casino was between fifteen and thirty-five cents, depending where you got a seat, a table, or a box.

83. See ads for the skating rink in the *Chicago Defender,* April 1910, and the *Defender* article of 3/18/11.

84. C. H. Douglass, Proceedings of the Sixteenth Annual Convention of the National Negro Business League, 1915, p. 186; by 1920, Douglass owned two theaters and numerous other enterprises in Macon, and was talking about erecting a third theater. See *Chicago Defender,* 6/19/20.

85. *New York Age,* 7/11/12.

86. Ibid., 8/21/13.

87. *Chicago Defender,* 11/21/25; "Chicago Stage Notes," *New York Age,* 1/30/13; *New York Age,* 3/25/14; *(Indianapolis) Freeman,* 12/23/11; and *New York Age,* 12/12/12.

88. The sources for these ads are as follows: unidentified clipping, no date, Johnson Collection, UCLA; *Afro-American,* 5/26/22; *Chicago Defender,* 3/18/11; *Lexington Leader,* 11/30/07, and *Lexington Herald,* 12/11/07, cited in Waller, *Main Street Amusements,* pp. 169 and 167, respectively; *Norfolk Journal and Guide,* 1/20/23 and 3/14/25. The campaign by the Hippodrome does not seem to have worked; six months later, citing little support from Black patrons, the theater instituted a "whites-only" policy.

89. For the ads, see unidentified clipping, no date, Johnson Collection, UCLA; *Atlanta Independent,* 3/1/19. For the essay contest, see clipping, no date, Tuskegee Institute newspaper clipping files.

90. *Chicago Defender,* 6/13/25.

91. *Afro-American,* 3/9/23.

92. Lawrence, *Deep South Showman,* p. 92.

93. *Afro-American,* 8/25/22.

94. Clarence Muse and David Arlen, *Way Down South* (Hollywood, Calif.: David Graham Fischer, 1932), pp. 49–50.

95. Ibid., p. 61. The theater was owned by Wiley Bailey (white), a political boss and shareholder of the L & N Railroad. On special occasions, a theater might change its seating policy. For example, at a 1917 showing of Lincoln Motion Picture Company's *Trooper of Troop K* in New Orleans, Blacks were allowed to sit anywhere they wished "until a certain hour in the evening" (unidentified clipping, no date, Johnson Collection, UCLA). In 1918, for the two-day showing of the film at the Plaza theater in downtown Denver, the *Chicago Defender* reported a "new policy" by which "members of the Race were admitted to buy any seat in the house" (*Chicago Defender,* 4/20/18).

96. *Chicago Whip,* 12/2/22.

97. Ethel Waters, who began her singing career in 1917, tells of misunderstanding the restrained response of audiences when she first began to perform in the North, in "big time vaudeville" theaters, in the twenties. Thinking their applause was a rebuff, "Nobody stomped as they always do in colored theaters when I finish my act. Nobody screamed or jumped up and down. Nobody howled with joy" (Ethel Waters [with Charles Samuels], *His Eye Is on the Sparrow: An Autobiography* [Garden City, N.Y.: Doubleday, 1951], pp. 174–175).

98. *New York Age,* 12/13/19.

99. Ibid., 11/14/12.

100. Jones, *Recreation and Amusement Among Negroes in Washington, D.C.,* p. 116.

101. Edwards, *The Southern Urban Negro as a Consumer,* p. 184.

102. See Cohen's "Encountering Mass Culture at the Grassroots" (p. 14) for a discussion of yelling and jeering in other ethnic theaters in Chicago in the twenties. Roy Rosenzweig, writing about the conduct of working-class patrons in Worcester, Massachusetts, suggests that it grew out of a tradition of "public recreational behavior based on sociability, conviviality, communality, and informality" (*Eight Hours for What We Will: Workers and Leisure in an Industrial City, 1870–1920* [New York: Cambridge University Press, 1983], p. 203).

103. Edwards, *The Southern Urban Negro as a Consumer,* p. 184.

104. See, for example, *Chicago Defender,* 8/9/24 and 4/11/25; also 7/25/27.

105. An article in the *News and Courier,* a white Charleston newspaper, also sheds some light on his operating practices: Thomas reassured readers that before being shown at the Lincoln Theatre, where he was manager, "films are 'edited' to insure that they contain nothing which would agitate racial differences." Clipping, no date (c. 1939), courtesy of Pearl W. Thomas. D. Ireland Thomas told the journalist that his motto was "Work hard, mind your own business and work hard."

106. Lawrence, *Deep South Showman,* p. 14.

107. *Afro-American,* 9/11/26; *New York Age,* 9/18/20; *Pittsburgh Courier,* 6/11/27. For a moving discussion of back talk, see bell hooks's "Talking Back" in *Discourse* 8 (fall–winter 1986–1987): 123–128.

108. Waller, *Main Street Amusements,* pp. 168–170; *Chicago Defender,* 8/30/24.

109. *Chicago Defender,* 6/13/11.

110. *New York Age,* 1/1/21.

111. *Billboard,* 7/16/21; *(Los Angeles) Examiner,* 6/23/21.

112. *Chicago Defender,* 12/27/24.

113. Pearl W. Thomas, interview by Louise Spence, 4/14/95, Charleston, S.C.

114. *New York Age,* 12/15/10.

115. Powell's phrase, in ibid.

116. *Chicago Defender,* 4/3/20.

117. *New York Age,* 3/3/10.

118. Smith, "Our Need for More Films," April 1922; *Freeman,* 4/1/16.

1. *Norfolk Journal and Guide,* 10/2/15; *Afro-American,* 2/3/17; *Chicago Whip,* 9/15/20; *Chicago Defender,* 11/13/20; *New York Age,* 9/17/21; *Champion Magazine,* September 1916.
2. Unidentified clippings, no dates, George P. Johnson Negro Film Collection, Department of Special Collections, Charles E. Young Research Library, University of California, Los Angeles.
3. *Tuskegee Student,* 7/17/17; *Chicago Defender,* 8/18/17. *Trooper of Troop K* was also known as *Trooper of Company K.*
4. Johnson Collection, UCLA.
5. Letter, George P. Johnson to Oscar Micheaux, 5/15/18, in ibid.
6. Unidentified clipping, no date, in ibid.
7. See Henry T. Sampson, *Blacks in Black and White: A Source Book on Black Films,* 2nd ed. (Metuchen, N.J.: Scarecrow Press, 1995), pp. 200–201; and Ebony Film Corporation's ad in *Motion Picture World,* 4/20/18.
8. The ad appeared in *Motion Picture World* on 8/10/18, and may have been written by Ebony's distributor, the General Film Company of New York. The *Morning Telegram* commented, "The fact that the pictures feature negroes will attract the attention of exhibitors who are looking for something new and different to present to their audiences and they will find that the films can be advantageously used as a novelty which will draw and at the same time give satisfaction. In theatres catering to audiences of dusky hue the Ebony comedies should prove very popular" (clipping, no date, Johnson Collection, UCLA).
9. The letter and Tony Langston's reply are in the *Chicago Defender,* 7/1/16; the letter writer referred specifically to *Aladdin Jones, Money Talks in Darktown,* and *Two Knights of Vaudeville,* films that, according to Henry T. Sampson, along with *A Natural Born Shooter,* were actually produced by the Historical Feature Film Company, also of Chicago, and released under the Ebony banner before they began to make their own films in 1918 (*Blacks in Black and White,* p. 207).
10. Letter, George P. Johnson to Committee on Public Information, 8/12/18, Johnson Collection, UCLA. By the time the committee received his letter, it had already signed a contract with the Downing Film Company of New York to produce a two-reel picture, *Our Colored Fighters,* showing "the important place the American negro fighters are taking in the world war . . . the enlistment and training of the colored soldiers in the cantonments and . . . their work overseas." (See *Billboard,* 11/2/18; *New York Dramatic Mirror,* 11/9/18; and *Moving Picture World,* 11/9/18. The similarity of wording in all three papers' reporting of *Our Colored Fighters* suggests that they were guided by the company's press release or a wire service report and point to the close ties between critical and promotional discourses during this period.)
11. See John S. Wright, "A Scintillating Send-off for Fallen Stars: The Black Renaissance Reconsidered," in *A Stronger Soul Within a Finer Frame: Portraying African-Americans in the Black Renaissance* (Minneapolis: University [of Minnesota] Art Museum, 1990), p. 15; Anna Julia Cooper, *A Voice from the South by a Black Woman of the South* (1892; reprint, New York: Negro Universities Press, 1969), p. 28, quoted in Wright's essay on p. 16; Victoria Earle Mathews, "The Value of a Race Literature," reprinted in the *Massachusetts Review* 27:2 (summer 1986) and quoted in Wright's essay on p. 16; and M. A. Majors, "Why We Should Read Books Written by Negroes," *Half-Century Magazine,* June 1919.
12. The article by Alex Rogers appeared in the *New York Age,* 12/24/08; the *Freeman* quote is from an undated clipping, probably 1917, Tuskegee Institute newspaper clipping files.

13. Langston Hughes, *Crisis*, December 1925.
14. *Freeman*, 4/1/16. Clarence Muse's announcement was reported in the *Chicago Whip*, 9/18/20; he estimated the cost of the film to be $90,000. (The following year, Muse described what he thought of as the most important requirements of the Race movie: "The story must be clean, entertaining, devoid of odorous propaganda and above all a Negro tale, with Negro heroes and heroines in a natural atmosphere" [*Billboard*, 8/6/21].) For Leigh Whipper's announcement, see the *Billboard*, 4/15/22.
15. Letter, George P. Johnson to Oscar Micheaux, 5/15/18, Johnson Collection, UCLA.
16. The screenwriter was Mrs. M. M. Webb, wife of the Unique Film Company's president, Miles M. Webb. The Chicago-based company, organized in 1915, claimed that the film was "the first and only three reel feature drama ever produced exclusively by colored people in the history of the moving picture world" (promotional material, no date, Johnson Collection, UCLA).
17. *Chicago Defender*, 2/22/19.
18. Oscar Micheaux, "The Negro and the Photoplay," *Half-Century Magazine*, May 1919.
19. Micheaux's speech to the American Negro Press, quoted in the *Competitor*, January–February 1921, p. 61.
20. Micheaux, "The Negro and the Photoplay."
21. *Afro-American*, 1/26/23.
22. *Chicago Defender*, 5/24/21. The *Defender* noted that Dunbar works had "universal recognition." The company, founded by a white man, Robert Levy, former owner and manager of the Lafayette Players, produced at least seven dramatic features from 1921 to 1924, also made a feature-length comedy, *Easy Money*, starring Sherman H. Dudley in 1922, as well as a comic short.
23. The free Negroes of the eighteenth and early ninteenth century laid the foundation for the African American entrepreneurial tradition.
24. Booker T. Washington, quoted in the *New York Age*, 8/19/09.
25. *New York Age*, 1/10/10 and 1/27/10.
26. Ibid., 1/10/10, and *Chicago Defender*, 12/31/10.
27. *New York Age*, 2/3/10 and 8/11/10.
28. Ibid., 1/10/10, and 1/27/10.
29. Ibid., 9/4/13.
30. *Freeman*, 3/13/15.
31. *Chicago Defender*, 5/23/14. See also the *Freeman*, 4/1/16.
32. *Chicago Defender*, 1/20/12; Jones seems to have had a certain standing in the community: as an independent candidate for alderman of the Second Ward in 1912, he garnered the support of the *Defender*, and was one of the organizers of the Negro Business League's State Street Carnival that same year.
33. See the ad for this program that was playing at the Lincoln Theater in Cincinnati 4/2 and 4/3/16, in the *Freeman*, 4/1/16, and the same day's review of the program playing the Washington Theater in Indianapolis.
34. Sampson, *Blacks in Black and White*, p. 2. Foster had some previous experience in theatrical circles and was the proprietor of the William Foster Music Company of Chicago. Besides sheet music (and later records and piano rolls) and picture postcards of Chicago buildings, the company sold "the Fad of the day," Jack Johnson buttons for ten cents each (*New York Age*, 5/26/10). The postcards' photos of churches and Negro businesses were taken by photographer Peter P. Jones, a few years before he began making films himself (*Chicago Defender*, 8/5/11).
35. Emmett J. Scott, "Additional Letters Negro Migrants of 1916–1918," *Journal of Negro History* 4 (October 1919): 464.

36. *Chicago Whip*, 11/13/20.
37. Ibid., 7/16/21; *Georgian*, 6/4/21.
38. Edward L. Snyder's remarks are from the report of the National Negro Business League Proceedings of the Twenty-second Annual Meeting, pp. 96–97.
39. The film was probably used as an organizing tool, playing at halls where it might have invited more discussion than it would have on a mixed bill in a theater. It was shown, for example, at such venues as the Emery Auditorium in Cincinnati and the Morning Star Baptist Church in Chicago. See the *(Cincinnati) Union*, 5/21/21, and *Chicago Whip*, 4/9/21.
40. These ads appeared in the *Chicago Defender*, 5/7/18; the *Atlanta Independent*, 6/21/19; and the *Chicago Defender*, 6/15/18, respectively.
41. *Chicago Defender*, 6/15/18.
42. *Richmond Plane*, 3/10/17.
43. *Indianapolis Star*, 9/4/18.
44. *(Columbus, Ohio) Journal*, 1/25/18. Footage was taken at Camp Meade, showing the soldiers in their daily activities, including hiking and parading, and at the Baltimore Colored YMCA *(Bee*, 4/10/18).
45. *Chicago Defender*, 4/27/18.
46. The ads for *Trooper of Troop K* are in the Johnson Collection, UCLA.
47. *Chicago Defender*, 7/15/16; *New York Age*, 2/17/17. In 1940, as W.E.B. Du Bois looked back at World War I, he wrote a poignant essay, which is worth quoting from at length:

> Then came the refusal to allow colored soldiers to volunteer into the army; but we consoled ourselves there by saying, 'Why should we want to fight for America or American's friends; and how sure could we be that America's enemies were our enemies?' With the actual declaration of war in April, 1917, and the forced draft May 18th, the pattern of racial segregation which our organization had been fighting from the beginning was written into law and custom. The races by law must be mustered and trained separately. Eighty-three thousand Negro draftees, raised at the first call, had to go into separate units and so far as possible, separate encampments. Hundreds of colored unfortunates found themselves called with no place prepared where they could be legally received. Colored militia units already enrolled in the North were sent South to be insulted and kicked in Southern cantonments, while thousands of draftees were engulfed in a hell of prejudice and discrimination. Not only that, but hundred of Negroes were drafted regardless of their home duties and physical health. The government had to dismiss the Draft Board of Atlanta in a body for flagrant and open race discrimination. When sent to camp, a concerted effort was made to train Negro draftees as laborers and not as soldiers. There have been few periods in the history of the American Negro when he has been more discouraged and exasperated.
> ("Propaganda and World War," from *Dusk of Dawn* [1940], in *W.E.B. Du Bois Writings*, ed. Nathan Huggins [New York: The Library of America, 1986], pp. 734–735.)

48. Benedict Anderson points out that "members of even the smallest nation will never know most of their fellow-members . . . , yet in the midst of each lives the image of their communion." It is "the style in which they are imagined" that distinuishes communities. *Imagined Communities: Reflections on the Origin and Spread of Nationalism* (London: Verso, 1983) p. 6.
49. Unidentified clipping, no date, Johnson Collection, UCLA.
50. Quoted in Adam Clayton Powell, Sr., *Patriotism and the Negro* (New York: Behive Printing Company, 1918), unpaginated. Hubert H. Harrison described the war

as a catalyst: "The great World War, by virtue of its great advertising campaign for democracy and the promises which were held out to all subject peoples, fertilized the Race Consciousness of the Negro people into the stage of conflict with the dominant white idea of the Color Line" (*When Africa Awakes: The "Inside Story" of the Stirrings and Strivings of the New Negro of the Western World* [New York: Porro Press, 1920], p. 78).

51. James Weldon Johnson, *Black Manhattan* (1930; reprint, New York: Atheneum, 1972), pp. 235–236.

52. Ibid., p. 237. The march took place on 7/27/17.

53. Claude McKay, *Home to Harlem* (1928; reprint, Boston: Northeastern University Press, 1987), pp. 331–332.

54. The quotes in this paragraph appeared in *Variety*, 3/7/19; *New York Age*, 5/24/19, 3/29/19, and 5/24/19, respectively.

55. *New York Age*, 2/22/20.

56. Howard A. Phelps, "Negro Life in Chicago," *Half-Century Magazine*, May 1919. The Eighth Regiment Armory was at 35th Street and Forest Avenue. Erected when Colonel Franklin A. Denison was in charge of the regiment, it was one of the largest gathering places in the community.

57. *Chicago Defender*, 2/22/19.

58. In Chicago, *The Homesteader* played at the Vendome, Atlas, and States; the Midwest tour with tenor George R. Garner, Jr., stopped at Kansas City, Mo. (twice); Wichita, Kan.; St. Joseph, Mo., Topeka, Kan.; Omaha, Neb., later in March. It then had a return engagement in Chicago from the end of March to the beginning of May before the "Great Southern Tour" in May, June, and July. The film continued to play engagements throughout the fall (in Richmond, Va., Washington, D.C., and Baltimore, Md., for example, and in October, the film had another two-day showing at the Roosevelt Theater in Chicago) and it appears as if the company continued to get bookings for the next few years. In 1922, Micheaux applied for a seal for the film from the newly established New York State censorship board (Motion Picture Commission, State of New York, New York State Archives, Albany).

59. Unknown magazine, probably April 1921, Tuskegee Institute newspaper clipping files.

60. *Chicago Defender*, 10/27/23.

61. Ibid., 1/17/20.

62. *Afro-American*, 12/31/20. When the Douglass Theater opened in the winter of 1922 as the city's only nonsegregated legitimate theater, the *Afro-American*, on 2/10/22, declared it "an epoch in the history of Baltimore. . . . The promoters of this gigantic enterprise involving nearly a half million dollars, deserve great credit in putting over this wonderful monument to Negro genius and advancement, and I miss my guess if the colored people of Baltimore do not show by their support and hearty cooperation that their efforts are appreciated."

63. *Billboard*, 1/15/21.

64. Letter, Richard E. Norman to Anita Bush, 8/31/21, Richard E. Norman Collection, Black Film Center/Archive, Libby Library of Rare Books and Manuscripts, Indiana State University. Although Norman was using this information to try to negotiate a fee with Bush, it seems unlikely he would have deflated the figure, as he was also trying to impress her with his knowledge of the field and the professionalism of his approach. The Norman Film Manufacturing Company was a white-owned and -managed company with a studio near Jacksonville, Florida, that made seven films between 1920 and 1928: *The Love Bug*, a short, *The Green-Eyed Monster*, *The Crimson Skull*, *The Bull-Dogger*, *Regeneration*, *The Flying Ace*, and *Black Gold*. They also distributed films made by other companies

(North State Film Company's *A Giant of His Race,* for example). For more information on Norman and the company, see Gloria Gibson-Hudson, "The Norman Film Manufacturing Company," in *Black Film Review* 7:4 (1992): 16–20, and Matthew Bernstein and Dana F. White, "'Scratching Around' in a 'Fit of Insanity': The Norman Film Manufacturing Company and the Race Film Business in the 1920s," *Griffithiana* 21: 62/63 (May 1998): 81–127.

65. Promotional letter, 6/8/21, Johnson Collection, UCLA.
66. *Billboard,* 1/21/22.
67. Ibid., 8/6/21.
68. Sampson, *Blacks in Black and White,* pp. 6–7.
69. *Chicago Defender,* 4/22/22.
70. *Billboard,* 1/8/21. The Maurice Film Company was founded by actor Richard Maurice, who starred in the films.
71. For a more detailed discussion of Lincoln's financial situation, see Thomas Cripps, *Slow Fade to Black: The Negro in American Film, 1900–1942* (New York: Oxford University Press, 1977), pp. 75–89.
72. Open letter to exhibitors, March 1919, Johnson Collection, UCLA.
73. Sampson, *Blacks in Black and White,* p. 24; population figure from the *Billboard,* 8/6/21.
74. Letter, George P. Johnson to Swan Micheaux, 9/15/20. The letter goes on to note that, "At a 20% commission with a 60% gross coming to you, you are therefore only paying 10¢ commission on the usual 50% returns; which is at a less cost than you could have afforded to pay salary and transportation for a special representative." (Johnson Collection, UCLA.)
75. Unidentified clipping, no date, in ibid.
76. *Chicago Defender,* 2/5/21.
77. *New York Age,* 3/6/20.
78. *Freeman,* 7/1/16; *Motion Picture World,* 7/1/16.
79. The *Afro-American,* 3/17/22.
80. LeRoi Jones (Amiri Baraka), *Blues People* (New York: William Morrow, 1963), p. 96.

## Chapter 4   Within Whose Gates?: The Symbolic and the Political Complexity of Racial Discourses

1. *Chicago Defender,* 3/1/19.
2. LeRoi Jones (Amiri Baraka), *Blues People* (New York: William Morrow, 1963), p. 113; emphasis in the original.
3. Claude McKay's poem, "If We Must Die," appeared in Max Eastman's *Liberator* and A. Philip Randolph and Chandler Owen's *The Messenger,* July 1919 and September 1919, respectively. It was also included in McKay's book of poetry, *Harlem Shadows* (New York: Harcourt, Brace, and World, 1922).
4. St. Clair Drake and Horace R. Cayton. *Black Metropolis: A Study of Negro Life in a Northern City* (New York: Harcourt, Brace, and Company, 1945), p. 65.
5. All quotes in this paragraph are from 1/20/20, and are clippings in the files of the George P. Johnson Negro Film Collection, Department of Special Collections, Charles E. Young Research Library, University of California, Los Angeles.
6. *Chicago Defender,* 1/17/20.
7. Our use of the term "Grand Narrative" differs from Jean-François Lyotard's *grands récits* in that these unifying tales are not necessarily of emancipation and enlightenment. See Lyotard's *The Postmodern Condition: A Report on Knowledge,* trans. Geoff Bennington and Brian Massumi (Minneapolis: University of Minnesota Press, 1984), pp. xxiii–xxiv.

8. See, for example, *Chicago Defender,* 11/1/19, 12/20/19, 12/27/19, 3/20/20, 4/3/20, 5/15/20.

9. James Weldon Johnson, in his role as field secretary for the National Association for the Advancement of Colored People, while investigating Mr. Person's death, heard of the mob, "men and women, women with babies in their arms and women with babies in their wombs," scrambling for bones while the ashes were still hot. In his autobiography, he wrote, "I tried to balance the sufferings of the miserable victim against the moral degradation of Memphis, and the truth flashed over me that in large measure the race question involves the saving of black America's body and white America's soul" (*Along This Way: The Autobiography of James Weldon Johnson* [1933; reprint, New York: Viking Press, 1945], pp. 317–318).

10. Capitalization as in original.

11. The man's name was withheld because he had escaped. For more on the struggles against lynching, see Ida B. Wells, "Southern Horrors: Lynch Law and all its Phases," in *The Selected Works of Ida B. Wells Barnett,* ed. Trudier Harris (New York: Oxford University Press, 1991).

12. See, for example, "A High Mason is Branded by KKK," *Chicago Defender,* 4/1/22, detailing the story of two men beaten and branded in Phoenix.

13. Richard Wright, *Black Boy* (1945; reprint, New York: HarperCollins, 1993), p. 203.

14. Hayden White, *The Content of the Form: Narrative Discourse and Historical Imagination* (Baltimore: Johns Hopkins University Press, 1989), p. ix.

15. Roosevelt's following in the Negro community, however, was not uncontested after his 1906 dismissal, without honor, of the veteran soldiers of the Twenty-fifth Infantry Regiment accused of involvement in the disorders in Brownsville, Texas. (See Joel Williamson, *The Crucible of Race: Black-White Relations in the American South Since Emancipation* [New York: Oxford University Press, 1984], pp. 354–355.) Micheaux writes of one of his brothers dying of pneumonia while in the army in Cuba, in *The Conquest: The Story of a Negro Pioneer* (Lincoln, Nebraska: Woodruff Press, 1913), p. 13.

16. The Lincoln Motion Picture Company during this period also depicted middle-class acheivers but seldom gave much attention to the working class.

17. Kwasi Harris, "New Images: An Interview with Julie Dash and Alile Sharon Larkin," *Independent,* December 1986.

18. Dash described the hand signals two men exchange as "a refererence to the non-verbal styles of communication of ancient African secret societies which have been passed down across thousands of years and through hundreds of generations. Today these forms are expressed in the secrets of fraternities and in the hand signals of youth gangs." (Julie Dash, "Making Daughters of the Dust" in *Daughters of the Dust: The Making of an African American Woman's Film* [New York: New Press, 1992], p. 6.)

19. "Preface," ibid., p. xv.

20. James Rundles, interview by the authors, 6/16/93, Jackson, Miss.

21. Oscar Micheaux, "The Bishop's Inquisition" and "The Bishop Acts," in *The Home-steader* (Sioux City, Iowa: Western Book Supply Company, 1917), pp. 464–481.

22. *Afro-American,* 12/22/22. The new hotel and theater got quite a bit of press when they opened in March of that year (see, for example, the *Afro-American,* 3/31/22).

23. Letter to the *Pittsburgh Courier,* 12/13/24.

24. See, for example, the advertisements in the *Chicago Defender* for the Vaudette Theatre in Detroit (1/24/20) and for Hammond's Vendome Theatre's premiere in Chicago (1/10/20).

25. The print in circulation, the print repatriated from La Filmoteca Nacional de España, the National Film Archive of Spain, in 1988, currently in the collection of the Library of Congress, is a little over six thousand feet, approximately 75 percent of the advertised length.

26. For an elaboration on the politics of this crosscutting based on a comparison with D. W. Griffith, see Jane Gaines's "Fire and Desire: Race, Melodrama and Oscar Micheaux," in *Black Cinema: History, Theory, Criticism,* ed. Manthia Diawara (New York: Routledge and Chapman, Hall/American Film Institute, 1993), pp. 55–59.

27. This discussion of rape is indebted to Hazel Carby's consideration of Pauline Hopkins's *Contending Forces* in "On the Threshold of Woman's Era: Lynching, Empire, and Sexuality in Black Feminist Theory," in *"Race," Writing, and Difference,* ed. Henry Louis Gates, Jr. (Chicago: University of Chicago Press, 1986).

28. Jane Gaines, on the other hand, argues, in "Mixed Blood Marriage in Early 'Race' Cinema," that the title card, "legitimate marriage," is in keeping with "history, literature, and legend," and that the interracial marriage is a device Micheaux used to offer an "alternative story" to the "prevailing mythology about illicit interracial sexuality." See *Oscar Micheaux and His Circle: The Silent Era,* ed. Pearl Bowser, Jane Gaines, and Charles Musser (forthcoming).

29. These lines are taken from the fragment of the 1939 sound remake in the Library of Congress. The silent version of *Birthright* does not seem to exist any longer. However, there is evidence from several comments in the Black press (see, for instance, *New York Age,* 1/19/24, and *Chicago Defender,* 10/24/24) that the silent film was very similar to the novel; the dialogue and actions in the fragment of the sound version is indeed almost identical to the book (with the important difference of the ending, which is discussed in more detail later in this chapter); therefore, we are assuming that the two Micheaux films were closely aligned.

30. Quoted in Henry T. Sampson's *Blacks in Black and White: A Source Book on Black Films,* 2nd ed. (Metuchen, N.J.: Scarecrow Press, 1995), p. 152. Note the review mentions the film playing at the Pickford Theater (perhaps in Chicago, 1/29 through 1/31/20); however, Sampson does not cite the source or date.

31. "A Southern Domestic Worker Speaks," *Independent,* 1/25/12, pp. 196–200; reprinted in Herbert Aptheker's *A Documentary History of the Negro People in the United States, 1910–1932* (New York: Citadel Press, 1973), pp. 48–50.

32. As Deborah Grey White (*Ar'n't I a Woman: Female Slaves in the Plantation South* [New York: Norton, 1985]) has pointed out, in the first two-thirds of the twentieth century, no white man had ever been convicted for the rape of a Black woman. Cited in Leith Mullings's "Images, Ideology, and Women of Color," in *Women of Color in U.S. Society,* ed. Maxine Bava Zinn and Bonnie Thornton Dill (Philadelphia: Temple University Press, 1994), p. 271.

33. James Kinney, *Amalgamation! Race, Sex, and Rhetoric in the Nineteenth-Century American Novel* (Westport, Conn.: Greenwood Press, 1985), p. 211.

34. See, for example, Patricia Mellencamp, *A Fine Romance: Five Ages of Film Feminism* (Philadelphia: Temple University Press, 1995), pp. 229–232, and Gaines, "Fire and Desire," pp. 49–70.

35. Booker T. Washington, *Up from Slavery: An Autobiography* (1901; reprint, Garden City, N.Y.: Doubleday, 1963), pp. 102–104.

36. These figures were often quoted during this period. See, for example, W.E.B. Du Bois interview, *Chicago Defender,* 5/15/22; Du Bois called for national aid distributed to states in proportion to the size of their illiterate population. In the film, the fictional head of the Piney Woods school, Reverend Jacobs, probably quoting older figures, says that the state pays only $1.49 per Negro student.

37. This is an English translation of the Spanish version. We mention the translation because it is important to note that the original may well have more closely approximated the language of an illiterate sharecropper. Micheaux often wrote in an invented dialect in an attempt to indicate the different economic and educational status of characters.

38. In *The Homesteader,* Micheaux wrote that "[Jean Baptiste] had confidence in education uplifting people; it made them more observing. It helped them morally. And with him this meant much" (p. 160).

39. A. B. Smith, "The Soul of a Lyncher (By Himself)," *New York Age,* 1/11/19. As Anna Julia Cooper pointed out, however, it was not social equality that Blacks were demanding but social justice. Cited in Carby, "On the Threshold of Woman's Era," pp. 305–306.

40. *New York Age,* 5/7/21.

41. *Commonwealth,* 7/24/15.

42. New York State censorship records, Motion Picture Commission of the State of New York, New York State Archives, Albany, New York; the board demanded that this titlecard be eliminated. The line was in Stribling's novel and also appears in the fragment of the sound version in the Library of Congress. Censorship problems did not seem to keep Micheaux from including the line in his remake!

43. In some of his works that appeared after the Great Depression, Micheaux takes a more cynical stand on education; *The Exile, Murder in Harlem,* and *The Betrayal,* for example, all mention people with a lot of education who are starving.

44. Oscar Micheaux, *The Conquest: The Story of a Negro Pioneer* (Lincoln, Neb.: The Woodruff Press, 1913), pp. 229–230. Subsequent page references to this work are given in the text.

45. Letter, Oscar Micheaux to C. W. Chesnutt, 1/18/21, Charles W. Chesnutt Papers, Western Reserve Historical Society, Cleveland, Ohio.

46. Ibid. Notes in the files of the Virgina State Board of Censors, Richmond, indicate that Micheaux did make the changes he suggested. In the film Micheaux presented to the Board, the heroine did live and married her "dark-skinned suitor" (3/18/25).

47. This formulation of marriage as a partnership in Race work recalls Dr. Latimer and Iola Leroy in Frances Ellen Watkins Harper's 1892 novel *Iola Leroy.*

48. Oscar Micheaux, *The Forged Note* (Lincoln, Nebraska: Western Book Supply Company, 1915), p. 50. Subsequent page references to this work are given in the text.

49. In *Within Our Gates,* like *The Forged Note,* the white man salves his guilt with money. Although Sylvia is unaware of it, he has paid for her education.

50. *Crisis* 22, June 1921. The more conservative James Weldon Johnson, however, in the preface to his poetry anthology, *Book of American Negro Poetry* (1931; reprint, New York: Harcourt, Brace, and World, 1959), calls for the Black artist to escape "race" and the "propagandic" [sic].

51. In a letter from Micheaux to the Lincoln Motion Picture Company, 6/25/18, Johnson Collection, UCLA.

52. Letter, Oscar Micheaux to the Virginia State Board of Motion Picture Censors, 3/13/25, Virginia State Library and Archives.

53. *Billboard,* 8/20/21. For information on Bowling, see Charlene Regester's "Black Films, White Censors: Oscar Micheaux Confronts Censorship in New York, Virginia, and Chicago," in *Movie Censorship and American Culture,* ed. Francis G. Couvares (Washington, D.C.: Smithsonian Institution Press, 1996), p. 170.

54. Gaines, for example, in "Fire and Desire" assumes it is the lynching and burning that drew ire (pp. 49–55). For a brief history of the relation of race and cen-

sorship in America and a listing of specific cuts requested by the Chicago, New York, and Virginia boards, see Regester's "Black Films, White Censors," pp. 159–186.

55. The *Chicago Tribune* quote appeared in the *Chicago Defender,* 4/24/17. See Commonwealth of Virginia, Department of Law, Division of Motion Picture Censorship, list of films rejected in toto since 8/1/22 (2/4/30), Virginia State Library and Archives.

56. Letter, Theodore A. Ray, captain, to Frank T. Monney, superintendent of police, 3/10/20, Johnson Collection, UCLA.

57. Letter, Charles F. Gordon to D. Ireland Thomas, 3/19/20, Johnson Collection, UCLA. Although he doesn't say that it influenced his decision, Gordon seems to have also received a note from Superintendent of Police Monney of New Orleans.

58. Letter, Ray to Monney.

59. Letter, George P. Johnson to Oscar Micheaux, 8/4/20, Johnson Collection, UCLA.

60. Letters, George P. Johnson to Oscar Micheaux, 8/10/20 and 8/13/20, in ibid. Micheaux's 50 percent share of the 8/9–10/20 receipts was $50.28.

61. Film censorship records, State Board of Education, Ohio Historical Society, Columbus, Ohio.

62. The 1/20/20 clipping from the American Negro Press mentioned that the film presented "types of both races," and the *Chicago Defender,* 1/17/20, reported that a "committee of the protestors" attending the Vendome and seeing the film for the first time expressed the opinion that it showed up "a certain class of both the white and our Race."

63. See, for example, the handbill for the film's showing at Loyal Theater in Omaha, in Johnson Collection, UCLA.

64. Advertising cut, National Poster and Printing Company, Chicago, in ibid.

65. Our translation of the Spanish intertitles; our thanks to Kathleen Newman and Kate Levin for their help. In the recent print from the Library of Congress the intertitles have been translated into English; however, there are differences between the "Black/misspoken English" of those titles and lines attributed to Eph as we have found them in Micheaux's publicity material.

66. See Stephen Foster's song.

67. Mel Watkins, *On the Real Side: Laughing, Lying, and Signifying—The Underground Tradition of African American Humor That Transformed American Culture from Slavery to Richard Pryor* (New York: Simon and Schuster, 1994), p. 476; Sterling Brown, *Negro Poetry and Drama and the Negro in American Fiction* (1937; reprint, New York: Atheneum, 1969), p. 112.

68. Micheaux does express some faith in the clergy. Reverend Wilson Jacobs in *Within Our Gates,* the fictional head of the Piney Woods School, offers an alternative pastoral mission to Ned. In Reverend Jacobs, Micheaux advances the secular rewards of education and community self-help. (Interestingly, the tireless fundraiser for the "Y" in *The Forged Note* is also named Reverend Wilson Jacobs.) A fictional bishop rebukes the hypocritical minister in the novel *The Homesteader.* Micheaux's ads for *The Homesteader* quoted Chicago Bishop S. T. Fallows, who objected to the censoring of the film and noted the presence of a certain amount of hypocrisy in the church.

69. Landry is a heroic figure, a hardworking honest man who wants to improve his lot and that of his children; in contrast, the preacher, one of the few members of the African American community who has traditionally been permitted by the politically powerful white community to have a measure of success and self-determination, is not heroic at all.

70. A character in *The Forged Note,* referring to a pastor of an "old style religion" church, says, "White fo'kes 'll give any nigga plenty money, when he says what they want him too [sic]" (p. 76). In his book *The Delta Ministry* (New York: Macmillan, 1969), Bruce Hilton quoted a former Mississippian, an A.M.E. minister in Denver, who, after graduating from the seminary, returned to Mississippi: "They gave me a plantation church out near Leland. The second day I was there, the boss-man called me in. He handed me a ten-dollar bill and said, 'Your job is to keep my niggers happy. Do that, and I'll keep you happy.'" The young man packed up and left Mississippi the next day. Hilton pointed out that many of the pastors at the time still solicited white businessmen for contributions, "a practice that has its effect on the militancy a pastor can be expected to show" (pp. 183–184).

71. Note there is a similar scene in the 1935 film *Murder in Harlem* (also known as *Lem Hawkins' Confession*), and perhaps the silent version of the story, *The Gunsaulus Mystery* (1921), where the janitor thanks the white factory owner for giving him $250 for helping to cover up a young white woman's murder. When the owner leaves the room, the janitor turns to the camera and says, "This white man's got somepin' up his sleeve. He ain't givin' me all this here money for nufin'."

72. Langston Hughes, "The Negro Artist and the Racial Mountain," *Nation,* June 23, 1926.

73. These same words appear as the final line of James Weldon Johnson's *The Autobiography of an Ex-Colored Man* (1912; reprint, New York: Penguin, 1990), as the nameless protagonist contemplates the part he might have taken in "making history and a race" (p. 154).

74. See, for example, the front-page story in the *Chicago Defender,* 7/3/20, about a man who received a monetary reward after turning over a "member of the Race" to a white mob with the headline: "Give Purse to Race Betrayer: 'Uncle Tom,' Who Led Innocent Man to Mob, Rewarded by Lynchers."

75. Albert Memmi, *Dominated Man* (Boston: Beacon Press, 1968), p. 186.

76. Richard Dyer, *A Matter of Images: Essays on Representation* (London: Routledge, 1993), pp. 15–16.

77. *Chicago Defender,* 1/17/20.

78. Dyer, *A Matter of Images,* p. 13.

79. Leslie Catherine Sanders uses this language in her discussion of the use of dialect in Willis Richard's plays in *The Development of Black Theater in America: From Shadows to Selves* (Baton Rouge: Louisiana State University Press, 1988), pp. 31–32.

80. Alice Walker is cited in Ella Shohat and Robert Stam, *Unthinking Eurocentrism* (New York: Routledge, 1994), p. 198.

81. Thelma Golden, ed., *Black Male: Representations of Masculinity in Contemporary American Art* (New York: Whitney Museum of American Art, 1994), p. 42.

### Chapter 5  *The Symbol of the Unconquered and the Terror of the Other*

1. Oscar Micheaux, "Where the Negro Fails," *Chicago Defender,* 3/19/10.

2. Nell Irvin Painter's *Exodusters: Black Migration to Kansas after Reconstruction* (New York: Norton, 1992) is a study of one such group of homesteaders. Micheaux's own family had migrated West from Kentucky and southern Illinois to Kansas and, later, Colorado and California. Even before Oscar Micheaux left home, his uncles A. J. Michaux and William P. Michaux were homesteading in the township of North Seward in Stafford County, Kansas, and his paternal Aunt Harriet married a farmer, Napoleon Robinson, from the same township. (We are indebted to Martin Keenan for this information.)

3. Micheaux used this phrase in *The Homesteader* (Sioux City, Iowa: Western Book Supply Company, 1917), p. 25 and, again, in *The Wind from Nowhere* (New York: Book Supply Company, 1943), p. 133.

4. Edward Henry, interview by the authors, 6/18/93, Jackson, Miss. Mr. Henry, well-respected in the Farish Street community, worked at Race theaters in Jackson from 1919 to 1977 and trained several other African American operators. Westerns continued to play regularly in "Colored theaters" into the 1940s and Black-cast Westerns from Norman Pictures, Jed Buell's Hollywood Productions, and others were popular. Singer Herb Jefferies, although he had fair skin and had to wear dark makeup, enjoyed a substantial career.

5. *Chicago Defender,* 11/20/20 (headline for the Detroit premiere); *Afro-American,* 12/31/20; *Chicago Whip,* 1/15/21; unsigned review, *New York Age,* 12/25/20; and *Competitor,* January–February 1921, p. 61.

6. The film did play to a "general patronage" at the Temple Theater in Cleveland at the end of January 1921. J. A. Jackson, a prominent trade critic, noted, "Mixed audiences saw the picture and both races seemed to be equally interested" (*Billboard,* 1/29/21).

7. This behavior constrasts with that of the mulattoes in C. W. Chesnutt's works, whose characters continue to have ties to the community (for example, the title story in *The Wife of His Youth and Other Stories of the Color Line* [Boston: Houghton Mifflin, 1899]), or who have affection for and the support of their family, even though they are bitterly missed, as in *The House Behind the Cedars* (Boston: Houghton Mifflin, 1900).

8. Oscar Micheaux, *The Conquest: The Story of a Negro Pioneer* (Lincoln, Nebraska: Woodruff Press, 1913), pp. 153–154. Subsequent page references to this work are given in the text.

9. Micheaux, *The Homesteader,* pp. 160–161. Subsequent page references to this work are given in the text.

10. Interestingly, this condemnation of "loose practices" conflicts with the alternative visions of forced miscegination he creates with the attempted rape of Sylvia in *Within Our Gates,* the coerced concubinage of Mildred in *The Forged Note,* and threat of imprisonment Cissie faces unless she agrees to bestow sexual favors on her boss's son, in *Birthright.*

11. Unidentified magazine clipping, probably spring 1921, Tuskegee Institute newspaper clipping files.

12. Script, Motion Picture Commission of the State of New York, New York State Archives, Albany.

13. South Dakota did not have an anti-miscegination law until 1909.

14. Bernard L. Peterson, Jr., *Early Black American Playwrights and Dramatic Writers: A Biographical Directory and Catalogue of Plays, Films, and Broadcasting Scripts* (Westport, Conn.: Greenwood Press, 1990), p. 139. According to Peterson, the story is based on *The Racial Tangle* by Henry Francis Downing. Henry T. Sampson, on the other hand, says that it is based on "the original stage drama, 'The Tangle.'" (No playwright is given.) See *Blacks in Black and White: A Source Book on Black Films,* 2nd ed. (Metuchen, N.J.: Scarecrow Press, 1995), p. 621.

15. See Jane P. Tompkins's "Sentimental Power: Uncle Tom's Cabin and the Politics of Literary History," in *The New Feminist Criticism: Essays on Women, Literature and Theory,* ed. Elaine Showalter (New York: Pantheon, 1985), pp. 84–85.

16. Toni Morrison, *Playing in the Dark: Whiteness and the Literary Imagination* (Cambridge, Mass.: Harvard University Press, 1992), p. 68. Morrison is elaborating linguistic categories from James A. Snead's *Figures of Division: William Faulkner's Major Novels* (New York: Methuen, 1986), pp. x–xi.

17. Morrison, *Playing in the Dark,* p. 52.

18. Houston A. Baker, Jr., *Modernism and the Harlem Renaissance* (Chicago: University of Chicago Press, 1987), p. 33.

19. *Within Our Gates,* for example, was advertised as "the most sensational story of the race question since *Uncle Tom's Cabin.*" He described *Birthright* as "a grim, gripping story of Negro life in the South today, more crowded with action, thrills, romance, comedy and suspense than any story on this subject since *Uncle Tom's Cabin.*" His novelization of *Veiled Aristocrats* and *The House Behind the Cedars, The Masquerade* (New York: Book Supply Company, 1947), opens with a reference to Stowe's book.

20. More recently, Spike Lee uses characters in a similar way in such films as *School Daze* (1988) and *Do the Right Thing* (1989). As Manthia Diawara has recently pointed out, Lee also reclaims stereotypes and redeploys them in subversive ways; see Diawara's *In Search of Africa* (Cambridge, Mass.: Harvard University Press, 1999), p. 260.

21. The role of the white woman is played by a fair-skinned African American woman. It was not uncommon to avoid interaction between Black male performers and white female performers. Vaudevillian Bert Williams, wishing to quash potential trouble, added a clause to his contract with Florenz Ziegfield stipulating that he would never be onstage with any of the white women in the Follies troupe. See Ann Douglas, *Terrible Honesty: Mongrel Manhattan in the 1920s* (New York: Farrar, Straus and Giroux, 1995), p. 328.

22. This social taboo was so entrenched that when boxer Jack Johnson defeated his white opponent, films of his bouts were banned from interstate commerce. See Dan Streible's "A History of the Boxing Film, 1894–1915: Social Control and Social Reform in the Progressive Era," *Film History* 3:3 (1989): 235–257.

23. James Baldwin, *The Devil Finds Work* (New York: Dell, 1976), p. 93.

24. *Competitor,* January–February 1921; *Daily Ohio State Journal,* quoted in the *New York Age,* 10/16/09.

25. New York State Archives; script copyrighted 1937. The author's preface to the script declares that "all the characters appearing herein, regardless how bright in color they may seem, are members of the Negro Race." In a film that deals with the sensitive subject of an interracial marriage, Micheaux seems to be assuring the censors, and perhaps even his distributors, that the cast is all Black. There exists no record of the determination of the Motion Picture Commission of the State of New York; however, this scene does not appear in the print currently in circulation.

26. See, for one example, the front page of *New York Age,* 8/21/13. In one article, "Can't Tell Who's Who: Denver Authorities Think Woman Married to Coal Black Negro is White," Mrs. Nora Harrington Frazier offers samples of her blood to prove that she is Black. The article also discusses several tests that the woman submitted to in order to persuade the marriage license bureau clerk to give her a license, including looking for dark blotches at the root of her hair and pressing her fingernails. Just below that notice is a piece "Gives Up All for Negro: Pretty Daughter of Wealthy White Farmer Marries Samuel De Frees Against the Wishes of Her Parents" about a couple in Ringwood, N.J.

27. Helen M. Chesnutt, *Charles Waddell Chesnutt: Pioneer of the Color Line* (Chapel Hill: University of North Carolina Press, 1952), p. 274.

28. *New York Age,* 4/22/09, 5/1/13. The theater, near a neighborhood known as San Juan Hill, catered to the residents of the vicinity, both Black and white.

29. *Norfolk Journal and Guide,* 11/28/25. During the proceedings, Mrs. Rhinelander was asked to bare her back to the jury, so that they could tell how dark her skin was.

30. See, for example, "The Parallel of the Rhinelander Case" (*New York Amsterdam News*, 3/4/25) and the "Amazing Parallel to the Famous Rhinelander Case" (*Afro-American*, 3/14/25).

31. Tony Bennett and Janet Woolacott, *Bond and Beyond: The Political Career of a Popular Hero* (London: Methuen, 1987), pp. 90–91.

32. Contemporary critic Mark Reid, in *Redefining Black Film* (Berkeley: University of California Press, 1993), sees Van Allen's "retaliatory violence against the Klan" as anticipating the Black-oriented Hollywood films of the early seventies: Van Allen is "an ancestor of such heroes . . . as Sweetback, who appears in Melvin Van Peebles's *Sweet Sweetback's Baadasssss Song* (1971)" (p. 14).

33. See Theophilus Lewis, *New York Age*, 4/16/30, for example. Speaking of *Daughter of the Congo*, Lewis accused Micheaux of associating "nobility with lightness and villainy with blackness." More recently, Charlene Regester has revived this discussion in "Oscar Micheaux's Multifaceted Portrayals of the African American Male: The *Good*, The *Bad*, and The *Ugly*," in *Me Jane: Masculinity, Movies, and Women*, ed. Pat Kirkham and Janet Thumin (New York: St. Martin's Press, 1995), pp. 166–183. The practice of individual performers using makeup that lightened their skin was well established on stage and may have carried over to early film where many performers also made themselves up. As early as 1911 Sherman H. Dudley admonished the female members of the Smart Set Company's chorus not to use light "paint and powder." Lester A. Walton in *New York Age* (9/28/11) reprinted part of Dudley's speech and elaborated on it, condemning the practice of making up "brown-skinned girls light and the bright girls lighter" and praising Aida Overton Walker as a performer who "has never shown a disposition to be other than a 'brownie,' and it cannot be said that she has suffered any for using such good judgment." Bert Williams commented frequently on both the shallowness of his material and the bitter irony of African American comics being obliged to work under cork. He described this eloquently as "lynching one's soul in blackface twaddle" (quoted in the *Negro World*, 4/21/23).

34. Although Charles D. Lucas was finally hired to play Jean Baptiste in *The Homesteader*, Micheaux's description of his casting opinions is worth citing at length: "[I have] tentatively engaged E. Bismarck Slaughter, whom I regard as an extraordinry type for the part. He is intelligent, 6 feet, 200 pounds, good face—bright complexion with good hair and my kind of chin—we will boil him into the part. A Miss [Iris] Hall, sweet, tender, vivacious and clever—yet possessing all that which I have desired to play the sort of Agnes—can pass for white and is just the size. She has been with Lafayette Stock Players for three years and has worked in movies as a maid with Pauline Frederick and can make up fine" (letter, Micheaux to C. Brooks, 9/13/18, George P. Johnson Negro Film-Collection, Department of Special Collections, Charles E. Young Research Library, University of California, Los Angeles). Micheaux seems to be working with a sense of authenticity in Slaughter's size, weight, and chin; however, Micheaux himself did not have a "bright" complexion.

35. Richard Grupenhoff, in *The Black Valentino: The Stage and Screen Career of Lorenzo Tucker* (Metuchen, N.J.: Scarecrow Press, 1988), pp. 61–81, discusses Tucker playing both romantic leads and gangsters in Micheaux's later films.

36. Carl Mahon, interview , 11/18/71, in Julius Lester's *Free Time* (PBS). Mahon was a New York City schoolteacher with good diction, but little acting experience.

37. Most African Americans are familiar with a wide variety of skin colors in the community and their own families. For example, painter and illustrator Elton Fax commented, "We all knew there were light-skinned Blacks who were our cousins, our brothers and sisters, so there was nothing new in that. To white people, this might have been new but it wasn't to us" (Pearl Bowser's interview

with Elton Fax, 1/7/91, New York City, for the film *Midnight Ramble: Oscar Micheaux and the Story of Race Movies* [Bester Cram and Pearl Bowser, 1994]).

38. Since the only known print (the Museum of Modern Art print) is 3,852 feet, a little more than half of the seven reels advertised in 1920, it is difficult to determine exactly how Micheaux developed much of the story, characters, and themes. A good part of the Klan attack toward the end of the film is also missing.

39. Quoted in the *Competitor,* January–February 1921, p. 61. Micheaux's thoughts here are similar to Booker T. Washington's: "Every persecuted individual and race should get much consolation out of the great human law, which is universal and eternal, that merit, no matter under what skin found, is in the long run, recognized and rewarded" (*Up from Slavery: An Autobiography* [1901; reprint, Garden City, N.Y.: Doubleday, 1963], p. 29).

40. The name seems to have been borrowed from or an homage to Jack London's 1909 semi-autobiography, *Martin Eden.* Micheaux was an admirer of Jack London's writing (he mentions having read *Martin Eden* in *The Homesteader,* p. 405). Micheaux also used the title of Gertrude Sanborn's 1923 novel, *Veiled Aristocrats,* as the name of his sound remake of C. W. Chesnutt's *The House Behind the Cedars.*

41. Script, New York State Archives, Albany.

42. See, for example, Joseph A. Young's *Black Novelist as White Racist: The Myth of Black Inferiority in the Novels of Oscar Micheaux* (Westport, Conn.: Greenwood Press, 1989). J. Ronald Green and Horace Neal, Jr., in "Oscar Micheaux and Racial Slur: A Response to 'The Rediscovery of Oscar Micheaux,'" *Journal of Film and Video* 40:4 (fall 1988): 66–71, raise questions about how Micheaux used racial stereotypes and "slurs" and their effects. Jane Gaines discusses the debate over Micheaux's class position and Race hatred in "Fire and Desire: Race, Melodrama, and Oscar Micheaux," in *Black Cinema: History, Theory, Criticism,* ed. Manthia Diawara (New York: Routledge and Chapman, Hall/American Film Institute, 1993).

43. bell hooks, "Micheaux: Celebrating Blackness," in *Black Looks: Race and Representation* (Boston: South End Press, 1992), p. 133.

44. Oscar Micheaux, *The Story of Dorothy Stanfield* (New York: Book Supply Company, 1946), p. 85.

45. Micheaux's 1937 script submitted to the New York State Board of Censors, New York State Archives, Albany. Although this scene and a scene where the husband looks into Naomi's eyes is not in the print currently in distribution, they are in one of the film's trailers. Unfortunately, it is not possible to tell from existing records if these scenes were ordered eliminated in New York State. It is interesting that Micheaux used the controversial out-takes for the trailer. Was this a question of economy? Or did it reflect his practice of using controversy to promote his films? Or could it have been a way to give his audience important information that was not going to make it to the film?

46. A similar scene also exists in *The Exile.*

47. Micheaux's 1937 script submitted to the New York State Board of Censors, New York State Archives, Albany; the scene does not appear in the extant film.

48. From a cut for a handbill, Schomburg Center for Research in Black Culture, New York, N.Y.

49. Micheaux's 1937 script submitted to the New York State Board of Censors, New York State Archives, Albany; capitalization thus in original. In the film currently in circulation, the part of the dialogue dealing specifically with race is omitted. The film cuts directly from Naomi saying "I don't like any of the children and I'm here only because my Mama made me come," to an awkwardly matched face-on medium-close shot of Naomi puckering up to spit at the teacher.

50. The script submitted to the New York State Board of Censors indicates that when Andrew, her white husband, sees her reaction and grabs her, Naomi begs him not to hit her again. This kind of confrontational material between the races would certainly have provoked censorship.

51. The woman he had been proposing to is never seen again. "The maternal heart of poor mother Driscoll" pulls her toward her son, but, although she is welcomed by Eve, in the existing print mother and son have no further encounters. (Intertitle; our translation from the French.)

52. Letter, Swan Micheaux to George P. Johnson, 10/27/20, Johnson Collection, UCLA. A Tom Mix film, *The Wilderness Trail*, had opened in July of 1919.

## Chapter 6 *Body and Soul* and the Burden of Representation

1. Sylvester Russell's review of *The Brute* appeared in the *Freeman*, 8/28/20. The quote by Lester A. Walton is from the *New York Age*, 9/18/20.

2. Randolph Edmunds, "Some Reflections on the Theater," *Opportunity*, October 1930, pp. 303–305.

3. William Lewis's letter appeared in the *Afro-American*, 9/11/26; note he goes on to praise *A Prince of His Race* (Colored Players Film Corporation, 1926).

4. *Freeman*, 8/28/20.

5. Letter, Swan Micheaux to George P. Johnson, 9/17/20, George P. Johnson Negro Film Collection, Department of Special Collections, Charles E. Young Research Library, University of California, Los Angeles.

6. *Los Angeles Daily Herald*, 6/18/21. The *Billboard* (10/29/21) gave the film a positive review, noting, "The story is one that has many openings to inject all kinds of propaganda, but the company evaded every chance to allow anything to appear on the screen that would cause any feeling or create any race prejudice whatever, much to their credit. Other companies producing Negro pictures might try the same thing."

7. Besides the *Daily Herald* review cited earlier in the paragraph, see the *(San Antonio, Tex.) Sentinel*, 7/9/21.

8. Scenario, Johnson Collection, UCLA.

9. The "whisper of inferiority" is Claude Steele's phrase. See Ethan Watters, "Claude Steele Has Scores to Settle," *New York Times Magazine*, 9/27/95. George P. Johnson's 1967–68 oral history mentions having been brought up by a Negro domestic in the servant quarters of a wealthy white home in Colorado Springs, Colorado, playing with white youngsters his own age, and never having heard the word "Negro" while growing up. A fair-skinned man, he reports, "I've been raised, trained, all my habits were white. I talk that, I act that, I was trained that" (p. 20; George P. Johnson, "Collector of Negro Film History," Oral History Program, University of California, Los Angeles, interviewed by Elizabeth I. Dixon and Adelaide G. Tusler).

10. *Afro-American*, 8/7/26. McClane, also a theater manager in Philadelphia (and earlier in Charleston and Baltimore), would soon become the husband of the film's star, Shingzie Howard.

11. *New York Age*, 9/18/20.

12. Letter to the editor, *Chicago Defender*, 1/22/27.

13. Wallace Thurman, "Negro Artists and the Negro," *New Republic*, 8/31/27, p. 38.

14. Langston Hughes, "These Bad New Negroes: A Critic on Critics, Pt. I," *Pittsburgh Courier*, 4/9/27; pt. II, 4/16/27.

15. Sterling Brown, "Our Literary Audiences," *Opportunity*, February 1930, pp. 42–46.

16. James Baldwin, looking back, noted, "Our good will, from which we yet expect such power to transform us, is thin, passionless, strident: its roots, examined,

lead us back to our forebears, whose assumption it was that the black man, to become truly human and acceptable, must first become like us. This assumption once accepted, the Negro in America can only acquiesce in the obliteration of his own personality, the distortion and debasement of his own experience, surrendering to those forces which reduce the person to anonymity and which make themselves manifest daily all over the darkening world" ("Many Thousands Gone," *Partisan Review,* November–December 1951; reprinted in *Notes of a Native Son* [New York: Beacon Press, 1955], p. 45).

17. "Oscar Micheaux Writes on Growth of Race in Movie Field," *Pittsburgh Courier,* 12/13/24; "Micheaux Answers His Philly Critics," *Afro-American,* 12/27/24.

18. Oscar Micheaux, introduction to *The Conquest: The Story of a Negro Pioneer* (Lincoln, Nebraska: Woodruff Press, 1913), p. 6; he barely alters the names of places and people again in *The Homesteader,* for instance, calling Cairo (Ill.) "Egypt" on p. 163. Subsequent page references to *The Conquest* are given in the text.

19. Oscar Micheaux, *The Forged Note* (Lincoln, Nebraska: Western Book Supply Company, 1915). Later, the book jacket copy for *The Story of Dorothy Stanfield* (New York: Book Supply Company, 1946), another self-published novel, touches on "race-mixing" and asks, "Why does the great American press condemn Mr. Micheaux's books just because he chooses to portray the facts to some degree as they exist?"

20. Unidentified clippings, Johnson Collection, UCLA.

21. Johnson Collection, UCLA.

22. *Afro-American,* 4/11/24.

23. *Chicago Defender,* 9/4/20. Capitalization as in original.

24. Stories of murder and mayhem, raided love nests, and morally unfit preachers regularly spiced the news in the Negro press of the twenties.

25. "Statement by the Producer to Our Patrons," 12/29/23, Charles W. Chesnutt Papers, Western Reserve Historical Society, Cleveland, Ohio.

26. Records of the New York State censorship board suggest that Micheaux may have added an insert shot of the news article showing the minister to be an escaped ex-con wanted abroad and the title ". . . posing as a 'man of God' " to accommodate the censors. (See appeal from Micheaux to the Motion Picture Commission, State of New York, 11/9/25, New York State Archives, Albany.) This would explain why, in the existing print, the good brother, Sylvester, does not expose his brother as a fake. For a provocative, but differing view of this puzzling element of the narrative, see Charles Musser's "Troubled Relations: Paul Robeson, Eugene O"Neill, and Oscar Micheaux," in *Paul Robeson: Artist and Citizen,* ed. Jeffrey C. Stewart (New Brunswick, N.J.: Rutgers University Press, 1998), pp. 81–102. Thomas Cripps, in his pioneering book on the Negro in American film, *Slow Fade to Black* (New York: Oxford University Press, 1977), offers another interpretation of the film's "garbled plot." Basing his explanation on the "balance demanded by the censor board," he suggests that Micheaux may have added the good brother as a concession to the board's complaints (pp. 191–193). Micheaux had submitted 9,000 feet to the New York State censors (he also advertised the film at 9,000 feet); agreed to cut it to 5,000 feet for the 11/25 New York City showing; George Eastman House's 35 mm print, from which the 16mm prints circulating today were struck, is approximately 7,750 feet.

27. Micheaux's press releases promptly declared Robeson "the world's greatest actor of the race," an accolade, at the time, generally reserved for Charles S. Gilpin. According to Eslanda Goode Robeson's diaries, Robeson was to receive 3% of the gross after the first $40,000 in receipts from *Body and Soul* and a salary of $100 per week for three weeks of shooting (cited in Martin Bauml Duberman's *Paul Robeson* [New York: Alfred A. Knopf, 1988], p. 77). The double role cer-

tainly gave Robeson an opportunity to display his acting talent. It also makes more complex the representation of masculinity in the film. See Charlene Regester's discussion in "Oscar Micheaux's Multifaceted Portrayals of the African American Male: The *Good*, The *Bad*, and The *Ugly*," in *Me Jane: Masculinity, Movies, and Women,* ed. Pat Kirkham and Janet Thumin (New York: St. Martin's Press, 1995).

28. Oscar Micheaux, *The Homesteader* (Sioux City, Iowa: Western Book Supply Company, 1917), pp. 164–169. Subsequent page references to this work are given in the text.

29. Letter, Oscar Micheaux to George P. Johnson, 6/3/18, Johnson Collection, UCLA. In a later letter to Johnson (9/7/20), Swan Micheaux informs him that it is the company's policy not to exhibit films in churches; the 1921 stock offering, however, mentions that they did show their pictures at schools and YMCAs (Johnson Collection, UCLA).

30. Orlean McCracken Micheaux died in Chicago, in 1917, in an accident. The *Chicago Defender*'s front page headline announced, "Pastor's Daughter Killed by Runaway Horse," 8/18/17.

31. W.E.B. Du Bois, *The Souls of Black Folk* (1903; reprint, New York: Signet Classic, 1969), p. 211.

32. James Weldon Johnson, *Black Manhattan* (1930; reprint, New York: Atheneum, 1972), p. 165; bell hooks and Cornel West, *Breaking Bread: Insurgent Black Intellectual Life* (Boston: South End Press, 1991), p. 79; and Henry Louis Gates, Jr., in preface to Thomas Roma's *Come Sunday: Photographs by Thomas Roma* (New York: Museum of Modern Art, 1996).

33. Johnson, *Black Manhattan*, p. 164.

34. *Chicago Defender,* 7/18/25; *Afro-American,* 6/30/22.

35. See the *Afro-American,* 1/13/22. Elder Eatmore's sermons were available on Columbia Records and advertised widely in the Black weeklies in the early 1920s.

36. Arlene A. Elder, *The "Hindered Hand": Cultural Implications of Early African American Fiction* (Westport, Conn.: Greenwood Press, 1978), p. 46.

37. Lawrence W. Levine, *Black Culture and Black Consciousness: Afro-American Folk Thought from Slavery to Freedom* (New York: Oxford University Press, 1977), pp. 326–330.

38. Johnson, *Black Manhattan*, p. 192; note both Johnson and Martin Duberman, in *Paul Robeson,* spell the playwright's name "Stevens." An early description of the film on a piece of promotional material in the files of the Virginia State Board of Censors lists "two big releases for 1925," *The House Behind the Cedars,* "adapted from the immortal novel by Chas. W. Chesnutt," and *Body and Soul.* Although the synopsis does not mention Stephens's name at all, it uses the same names for the characters as in the play. This must have been a preproduction blurb because Evelyn Preer is listed as starring in the film and Paul Robeson is not. (Commonwealth of Virginia, Department of Law, Division of Motion Picture Censorship, Virginia State Library and Archives, Richmond.)

39. See, for example, *New York Age,* 1/25/24 and *New York Herald,* 12/31/23.

40. See *New York Age,* 3/8/24 and *Variety,* 3/19/24. Interestingly, although it doesn't seem to have happened, early announcements of this production mentioned the possibility that the play would be renamed "The Hypocrite," the title of the film within the film of Micheaux's *Deceit* (1923).

41. *New York Age,* 3/22/24; the play also ran in Philadelphia at the Dunbar for another week with Robeson in the lead.

42. Julia Theresa Russell was the sister of Alice B. Russell who soon after became Micheaux's wife. A Morris chair also had a central presence on the set of *Roseanne.*

43. Paul Robeson had become something of a folk hero in the Black community. He was an athlete and a scholar, a gifted singer, and, by the time the film was released in the fall of 1925, he was enjoying newfound celebrity after his triumph in Eugene O'Neill's *All God's Chillum Got Wings* at the Provincetown Playhouse. His professional engagements, both in the U.S. and abroad, were proudly reported in the Black press. Although there was certainly a critical interest in Robeson on the part of whites, because of the white press's indifference to "Race pictures," the critics did not seem to have noticed his appearance in *Body and Soul*. In a review of Dudley Murphy's 1933 film version of O'Neill's *The Emperor Jones*, for example, Herman Weinberg states, "Since *Borderline* [1930] was never shown in America (its theme of miscegenation was taboo here), *The Emperor Jones* served to introduce Paul Robeson as a screen player" (*Close Up*, December 1933, p. 351).

44. Old Uncle Ned, the minister in *Within Our Gates*, receives money as well, but the moment is not given the special attention of a close-up. It is not Ned's work ethic that is being censured, but rather his acquiescence to the racial "arrangements" of the South.

45. Robeson playing the double role makes the dissolute preacher's contrast to his brother's industriousness and sincerity even stronger.

46. In *Roseanne,* an unnamed book in the top drawer of the bureau is the place of safekeeping. But in *Glory,* Stephens's 1932 novelization of the play, the book is, as in *Body and Soul,* specifically a Bible and Roseanne says, "Nobody would steal it out of the Good Book" ([New York: John Day, 1932], p. 53).

47. Du Bois, *The Souls of Black Folk,* p. 212.

48. Interestingly, *Roseanne* has no explicit mention of rape (although a sexual relationship between Leola and the preacher might be implied: the minister suggests the possibility of marriage in Atlanta and after she runs off, Roseanne likens Leola to that "Magdaleny 'oman").

49. Censorship records suggest that this scene was changed in the print that was released in New York City in the fall of 1925, so that "Yellow Curley" became the villain. Letter Oscar Micheaux to New York State censorship board, 11/11/25, New York State Archives, Albany.

50. According to Peter Brooks, this clarity is a primordial concern of melodrama. *The Melodramatic Imagination: Balzac, Henry James, Melodrama, and the Mode of Excess* (New Haven: Yale University Press, 1976), p. 48.

51. Unpublished manuscript, Hatch-Billops Collection; no stage directions were included to designate whether projections were used in this scene or how it was mounted.

52. He also avoided the stereotype of Blacks' fear of ghosts and "haints" that predominated in the minds of white Americans.

53. See Brooks, *The Melodramatic Imagination,* p. 32.

54. In Stephens's play, the men of the congregation, acting like a mob in the tradition of "southern justice," pursue Cicero Brown with the church's bell rope. After he proclaims that he wants to make his peace with Leola before he dies, Roseanne hides him; however, as he leaves to escape, shots ring out off stage. The crowd drags him back into Roseanne's cabin and he dies with his head "cradled on her breast."

55. Sylvester, the inventor, is Micheaux's character. In *Roseanne,* Leola's boyfriend Rodney is younger and plays a smaller role. He is a kindly youngster, but is not represented as an achiever.

56. Roi Ottley and William J. Weatherby, *The Negro in New York: An Informal Social History* (New York: New York Public Library, 1967), p. 143.

57. Ibid.

58. Langston Hughes, quoted in Leslie Catherine Sanders, *The Development of Black Theater in America: From Shadows to Selves* (Baton Rouge: Louisiana State University Press. 1988), pp. 20–21.

59. It was customary for such popular concert soloists as tenor Roland Hayes, baritone Jules Bledsoe, and later Robeson himself to end their recitals with several spirituals.

60. The vestige of this folkloric tradition continued, often on behalf of a progressive social agenda, in such productions as MGM's *Hallelujah!* (1929) and the Federal Theater Project's *Mississippi Rainbow* (1937).

61. *Theatre Arts Monthly,* February 1924; *Theatre Magazine,* March 1924. "Mr. Hornblow" was Arthur Hornblow, editor of *Theatre Magazine.*

62. *New York Herald,* 12/31/23.

63. Even the pastor's name, "Cicero," is a throwback to the slave owners' custom of giving their slaves pretentious classical Greek and Roman names.

64. *Variety,* 3/19/24.

65. Billy Rose Theatre Collection, New York Public Library at Lincoln Center.

66. Ibid.

67. *New York Herald,* 3/11/24.

68. *Messenger,* March 1924; Lewis was reviewing the white-cast production.

69. *Afro-American,* 1/25/24.

70. Ibid.

71. *New York Age,* 3/15/24. However, Walton's evaluation was not simply due to the fact that Gilpin was Black; Walton found the white actress who played Roseanne downtown, Chrystal Herne, "more convincing" than the less experienced Rose McClendon. And he admired Evelyn Ellis's performance as Leola: "Miss Ellis is not a clever colored actress; she is a clever actress." He summarized, "After all points pro and con are totaled, the colored cast strikes a higher average. Some of its members are not nearly the polished actors and possessing skill of their white predecessors; nevertheless the very fact of their being genuine Negroes adds much to realism. Formerly one always kept in mind that the white actors were not the real thing but an imitation." The *New York Times* critic, John Corbin, had also written that the Greenwich Village Theatre's blackface performance was not convincing (12/31/23).

72. *Afro-American,* 1/25/24. The *Norfolk Journal and Guide* wrote: "Those of the theater going public who have seen any of Micheaux productions know how well they depict the true aspect of the race. Mr. Micheaux is the only moving picture producer in America who has made a success with colored pictures, and it is because every Micheaux picture has been a winner. Mr. Micheaux is an author as well as a producer and his productions have been true to Negro life because he understands all of the circumstances which have attended the uphill climb of the race since Emancipation, and it is his true characterization of these things that make his pictures have a peculiar appeal to all reel loving people. His pictures have had a telling effect in portraying the true history of the race and in imparting inspiration to lovers of good drama" (1/26/24).

73. *Philadelphia Tribune,* 11/29/24. The term "nigger" so offended the community that when the play *Justice* was performed at the Lafayette Theatre in Harlem at the end of 1920, the author Butler Davenport felt it necessary to address the audience before the curtain was raised: "It would be impossible to give the play a setting true to Altanta without using the word [nigger]" (cited in the *Competitor,* January–February 1921, p. 47)

74. *Afro-American,* 1/25/24.

75. *New York Herald,* 12/31/23.

76. Micheaux's use of dialect in the title cards of *Birthright* was widely criticized, but defended by D. Ireland Thomas and others as true to the Stribling novel. The Black press noted how close the film followed the book. See, for example, *New York Age*, 1/19/24: "In adapting the story for the screen, Mr. Micheaux followed the book very closely, even using in the headlines [intertitles] the identical language contained therein." D. Ireland Thomas wrote in the *Chicago Defender*, 10/24/24: "Mr. Micheaux is not the author of *Birthright*. He is not responsible for the bad language used in the production. He filmed the production as the author wrote it." (He went on to say that he felt that the story was "true—too true" and liked the movie better than the novel.) Note, however, that the synopsis of the film in Thomas's 3/15/24 column, which seems to be taken directly from the company's press release, changes the word "Niggertown" to "the village" and the description of Persimmon from "a white fo'kes nigger" to "a white folk's man." Interestingly, in his inclusion of the comic routines in such sound films as *Ten Minutes to Live* and *Darktown Review*, Micheaux "inadvertently" captured moments of characteristically expressive speech, which contrast greatly with the dialect he wrote in his early novels and silent film title cards.
77. See Paul Gilroy's "Jewels Brought from Bondage: Black Music and the Politics of Authenticity," *Black Atlantic* (Cambridge, Mass.: Harvard University Press, 1993), p. 91.
78. *Afro-American*, 9/11/26.
79. *Chicago Defender*, 1/22/27.
80. A few weeks later (10/2/26), the *Afro-American* announced that the faith-healing "'Right Reverend Bishop' Grace," founder of Houses of Prayer in "scattered communities throughout the United States," had been arrested for deserting his family: "He and his several deaconesses drove about the city . . . riding in a large automobile . . . , the gift, he said, of the saints in Baltimore." The followers of Sweet Daddy Grace, as he was called, "showered him with riches," according to a recent profile in the *New York Times* (12/17/95), "stuffing 'love offerings' of cash into his hands as he paraded into the churches surrounded by a bevy of female attendants who waved large fans as he took his place on a red throne."
81. Wahneema Lubiano, "But Compared to What?: Reading Realism, Representation, and Essentialism in *School Daze, Do the Right Thing*, and the Spike Lee Discourse," in *Representing Blackness: Issues in Film and Video*, ed. Valerie Smith (New Brunswick, N.J.: Rutgers University Press, 1997), p. 105.
82. See Hazel Carby's "Policing the Black Woman's Body in an Urban Context," *Critical Inquiry* 18 (summer 1992): 754.

## Epilogue

1. *Chicago Defender*, 1/10/25; *Afro-American*, 12/20/24.
2. *Chicago Defender*, 2/28/25, 9/12/25; *Billboard*, 4/1/22; *New York World*, 6/16/29. The *New York World* article also mentions that the dialogue in some of the stories would have to be changed as "the sentiment expressed would not be well received in the South."
3. See, for example, an article in the *Afro-American* on 12/20/24 that celebrated the increased demand for Negro performers in Hollywood that year.
4. See Douglas Gomery, *Shared Pleasures: A History of Movie Presentation in the United States* (Madison: University of Wisconsin Press, 1992), p. 216. Although Micheaux's films were booked throughout the South, he generally got only one- and two-day runs in the smaller towns and slightly longer (four days in Birmingham, five in Atlanta) in the cities. An undated document in the George P.

Johnson Negro Film Collection (Department of Special Collections, Charles E. Young Research Library, University of California, Los Angeles), most likely from 1921, shows the Micheaux Film Corporation earning $805 from eighteen days' receipts in twelve sites in Alabama, $525 from fourteen days' receipts in ten venues in Arkansas, and $1000 in receipts from nine days in Chicago and $1,600 from twelve days' receipts in New York City (the number of theaters in the individual cities is not indicated). Whereas he was averaging a little over $100 per day in the cities, he often only drew only $20–$40 in the smaller towns.

5. Even if banks were willing to float loans to independent movie theaters, because of sound installers' agreements with the major chains, smaller houses were generally last in line for conversions.

6. Paul K. Edwards, in the study of the southern Negro as consumer cited in chapter 2, pointed out that by the late twenties or early thirties in some southern cities (Atlanta, Birmingham, Nashville, and Richmond, for example), the number of Colored theaters and their seating capacities were inadequate for the population. (*The Southern Urban Negro as a Consumer* [1932; reprint, New York: Negro Universities Press, 1969], p. 184.)

7. Mary Carbine, "'The Finest Outside the Loop' . . . Motion Picture Exhibition in Chicago's Black Metropolis, 1905–1928," *Camera Obscura* 23 (May 1990): 16; more regional studies such as Carbine's, Waller's on Lexington (Ky.), Robert C. Allen's on Durham (N.C.), and Matthew Bernstein and Dana F. White's work-in-progress on Atlanta would bring us closer to answering these kinds of questions.

8. Micheaux's stock of films was his major asset. The 1920 film *The Brute,* for example, was still being booked in 1925 (*Afro-American,* 1/3/25) and *Deceit* (1923) was playing in Chicago in 1927 (*Variety,* 7/6/27).

9. *Variety,* 2/15/28 and 3/14/28. Micheaux's corporation listed its assets at $1,400 and liabilities as $7,837.

10. Oscar Micheaux married the actress Alice B. Russell, 3/20/26. It is possible that he was involved in another marriage after Orlean McCracken Micheaux died. In a letter to George P. Johnson, dated 6/9/18, he mentioned sending his wife to her home for an extended visit while he traveled. (Johnson Collection, UCLA.)

11. John Mack Brown, *Norfolk Journal and Guide,* 4/12/30.

12. *Negro World,* 1/17/31. Schiffman later sued Micheaux, charging him with misappropriation of funds and demanding an accounting of the company's financial state (*New York Amsterdam News,* 5/18/32).

13. *Pittsburgh Courier,* 5/23/31.

14. *Lem Hawkins' Confession* was rereleased as *Murder in Harlem* the following year.

15. Oscar Micheaux, *The Case of Mrs. Wingate* (New York: Book Supply Company, 1945); Oscar Micheaux, *The Story of Dorothy Stanfield* (New York: Book Supply Company, 1946). Page references to the latter book are given in the text.

16. Quoted in Henry T. Sampson, *Blacks in Black and White: A Source Book on Black Films,* 2nd ed. (Metuchen, N.J.: Scarecrow Press, 1995), p. 166.

17. Michel Fabre, *The Unfinished Quest of Richard Wright* (New York: William Morrow, 1973), p. 180.

18. Mrs. Oscar Micheaux (Alice B. Russell) described *The Betrayal* as a "big picture" in a letter to Micheaux's sister, Ethel, 1/7/48; she is quoted in Richard Grupenhoff, "The Rediscovery of Oscar Micheaux, Black Film Pioneer," *Journal of Film and Video* 40:1 (winter 1988): 40–48. When the film premiered in New York City, it ran 183 minutes, shortened from 195 minutes, or 3 1/4 hours (*Variety,* 6/30/48).

19. See the script on the Rutgers University Press Web page: http://rutgerspress.rutgers.edu.

20. "Your next book should be an autobiography," Deborah, the love interest, tells the hero, "Martin Eden, young Negro man of Conquest, who built an agricultural empire in the Dakota wilderness" (dialogue sheet, New York State Archives, Albany).

21. This review was signed T. M. P. [Thomas M. Pryor], 6/26/48. The film ran into censorship problems when Micheaux tried to distribute it in Ohio and Maryland. In Maryland, the board made him cut a sequence in the beginning where Martin Eden discusses the suicide of a mixed-race army draftee (*Within Our Gates: Ethnicity in American Feature Films, 1911–1960*, ed. Alan Gevinson [Berkeley: University of California Press, 1997], p. 87).

22. There is no record of Hurston having published a work under that title.

23. Zora Neale Hurston, "How It Feels to Be Colored Me," *World Tommorrow* (May 1928).

24. See Mary Helen Washington's introduction "Zora Neale Hurston: A Woman Half in Shadow" to *I Love Myself When I Am Laughing . . . And Then Again When I Am Looking Mean and Impressive: A Zora Neale Hurston Reader,* ed. Alice Walker (Old Westbury, N.Y.: The Feminist Press, 1979).

25. The festival was advertised in newspapers and featured in the widely circulated *South Dakota High Liner Magazine* (July 1996), a monthly publication sent to the 83,000 members of rural electric cooperatives across the state.

26. Bison Book Editions, both 1994.

27. At the time of the 1900 census there were more than 450 African Americans in South Dakota and in 1910, over 800.

28. Awards have been given to such people as Eubie Blake, Ruby Dee, Katherine Dunham, Lorraine Hansberry, Clarence Muse, Gordon Parks, Sr., Lincoln Theodore Perry, Paul Robeson, Diana Sands, and Leigh Whipper. "There is, after all, a long and unbroken chain in our community's achievements, one age linked to the next, one generation to another, one filmmaker to those that follow. If we are to appreciate at all what we have become, we must comprehend where we have been" (Angela Noel, "About: Oscar Micheaux, 1884–1951," Eighteenth Annual Oscar Micheaux Award Ceremony Program, Oakland, Calif., 1991).

# Bibliography

## Collected Papers

Charles W. Chesnutt Papers, Western Reserve Historical Society, Cleveland, Ohio.
Hatch Show Print Collection, Nashville, Tennessee.
George P. Johnson Negro Film Collection, Department of Special Collections, Charles E. Young Research Library, University of California, Los Angeles.

## Interviews

The authors conducted interviews in 1993–1994 with people who remembered Race pictures in Roanoke, Va., Jackson, Miss., and Memphis, Tenn. These interviews are in the collection of the Schomburg Center for Research in Black Culture, New York, N.Y.

The authors also drew on interviews conducted in 1990–1992 for the film *Midnight Ramble: Oscar Micheaux and the Story of Race Movies* (Bester Cram and Pearl Bowser, 1994), in the collection of Northern Light Productions, Boston, Mass.

In 1987–1988, the authors (with Richard Grupenhoff) interviewed people associated with Race pictures for the American Museum of the Moving Image. These interviews are in the collection of the American Museum of the Moving Image, Astoria, N.Y.

In addition, Pearl Bowser conducted interviews from 1970 to 1987 with Oscar Micheaux's family and people associated with Race films. These interviews are in the collection of African Diaspora Images, Brooklyn, N.Y.

## Newspapers and Periodicals

*The Atlanta Independent*
*The (Baltimore) Afro-American* (*Afro-American Ledger* before 1915)
*The California Eagle*
*(Chicago) Broad Ax*
*The Chicago Defender*
*Chicago Whip*
*(Indianapolis) Freeman*
*(Los Angeles) Daily Herald*

*Louisville (Ky.) News*
*The New York Age*
*New York Amsterdam News*
*The New York News*
*Norfolk (Va.) Journal and Guide*
*The Philadelphia Tribune*
*The Pittsburgh Courier*
*St. Louis Argus*
*The Billboard*
*The Champion Magazine*
*The Competitor*
*The Crisis*
*The Half-Century Magazine*
*The Messenger*
*Moving Picture World*
*The Negro World*
*NY Dramatic Mirror*
*Variety*

## Books and Journal Articles

Adero, Malaika, ed. *Up South: Stories, Studies and Letters of This Century's African American Migrations.* New York: New Press, 1993.

Anderson, Benedict. *Imagined Communities: Reflections on the Origin and Spread of Nationalism.* London: Verso, 1983.

Aptheker, Herbert. *A Documentary History of the Negro People in the United States: From the Reconstruction Era to 1910.* New York: Citadel Press, 1970.

_____. *A Documentary History of the Negro People in the United States, 1910–1932.* New York: Citadel Press, 1973.

Baker, Houston A., Jr. *Modernism and the Harlem Renaissance.* Chicago: University of Chicago Press, 1987.

Baker, Ray Stannard. *Following the Color Line.* 1908. Reprint, New York: Harper Torchbooks, 1964.

Baldwin, James. *The Devil Finds Work.* New York: Dell Publishing, 1976.

_____. *Notes of a Native Son.* New York: Beacon Press, 1955.

Bernstein, Matthew, and Dana F. White. "'Scratching Around' in a 'Fit of Insanity': The Norman Film Manufacturing Company and the Race Film Business in the 1920s." *Griffithiana* 21: 62/63 (May 1998): 81–127.

Bogle, Donald. *Toms, Coons, Mulattoes, Mammies, and Bucks: An Interpretive History of Blacks in American Films.* New York: Viking, 1973.

Bone, Robert. *The Negro Novel in America.* 1958. Reprint, New Haven: Yale University Press, 1976.

Brooks, Peter. *The Melodramatic Imagination: Balzac, Henry James, Melodrama, and the Mode of Excess.* New Haven: Yale University Press, 1976.

Brown, Sterling. *Negro Poetry and Drama and the Negro in American Fiction.* 1937. Reprint, New York: Atheneum, 1969.

_____. "Our Literary Audience." *Opportunity,* February 1930.

Carbine, Mary. "'The Finest Outside the Loop' . . . Motion Picture Exhibition in Chicago's Black Metropolis, 1905–1928." *Camera Obscura* 23 (May 1990): 9–41.

Carby, Hazel. "Policing the Black Woman's Body in an Urban Context." *Critical Inquiry* 18:4 (summer 1992): 738–755.

_____. *Reconstructing Womanhood: The Emergence of the Afro-American Woman Novelist.* New York: Oxford University Press, 1987.

BIBLIOGRAPHY

Chesnutt, Charles Waddell. *The Colonel's Dream*. Boston: Houghton Mifflin,1905.
_____. *The Conjure Woman*. Boston: Houghton Mifflin, 1899.
_____. *The House Behind the Cedars*. Boston: Houghton Mifflin,1900.
_____. *The Wife of His Youth and Other Stories of the Color Line*. Boston: Houghton Mifflin, 1899.
Chesnutt, Helen M. *Charles Waddell Chesnutt: Pioneer of the Color Line*. Chapel Hill: University of North Carolina Press, 1952.
Chicago Commission of Race Relations. *The Negro in Chicago*. Chicago: University of Chicago Press, 1922.
Cohen, Lizabeth. "Encountering Mass Culture at the Grassroots: The Experience of Chicago Workers in the 1920s." *American Quarterly* 41:1 (March 1989): 6–33.
Cone, James H. *Speaking the Truth: Ecumenism Liberation, and Black Theology*. Grand Rapids, Mich.: William B. Eerdmans, 1986.
Cox, Oliver Cromwell. *Caste, Class, and Race: A Study in Social Dynamics*. Garden City, N.Y.: Doubleday, 1948.
Crimp, Douglas. "Right On, Girlfriend!" *Social Text* 33 (1992): 2–18.
Cripps, Thomas. "The Making of *The Birth of a Race:* The Emerging Politics of Identity in Silent Movies." In *The Birth of Whiteness: Race and the Emergence of United States Cinema*, ed. Daniel Bernardi. New Brunswick, N.J.: Rutgers University Press, 1996.
_____. "Oscar Micheaux: The Story Continues." In *Black Cinema: History, Theory, Criticism*, ed. Manthia Diawara. New York: Routledge and Chapman, Hall/American Film Institute, 1993.
_____. "Paul Robeson and Black Identity in American Movies." *Massachusetts Review* 11:3 (summer 1970): 468–485.
_____. "'Race Movies' as Voices of the Black Bourgeoisie: *The Scar of Shame*." In *American History/American Film*. ed. John E. O'Connor and Martin Jackson. New York: Ungar, 1979.
_____. *Slow Fade to Black: The Negro in American Film, 1900–1942*. New York: Oxford University Press, 1977.
Cruse, Harold. *The Crisis of the Negro Intellectual*. New York: Quill, 1984.
Dash, Julie. *Daughters of the Dust: The Making of an African American Woman's Film*. New York: New Press, 1992.
Davis, Angela. *Women, Race, and Class*. New York: Random House, 1981.
Dent, Gina, ed. *Black Popular Culture*. Seattle: Bay Press, 1992.
Detweiler, Frederick. *The Negro Press in the United States*. Chicago: University of Chicago Press, 1922.
Diakité, Madubuko. *Film, Culture, and the Black Filmmaker: A Study of Functional Relationships and Parallel Developments*. New York: Arno, 1980.
Diawara, Manthia, ed. *Black Cinema: History, Theory, Criticism*. New York: Routledge and Chapman, Hall/American Film Institute, 1993.
_____. *In Search of Africa*. Cambridge, Mass.: Harvard University Press, 1999.
Douglas, Ann. *Terrible Honesty: Mongrel Manhattan in the 1920s*. New York: Farrar, Straus and Giroux, 1995.
Drake, St. Clair, and Horace R. Cayton. *Black Metropolis: A Study of Negro Life in a Northern City*. New York: Harcourt, Brace, 1945.
Duberman, Martin Bauml. *Paul Robeson*. New York: Knopf, 1988.
Du Bois, W.E.B. *The Souls of Black Folk*. 1903. Reprint, New York: Signet Classic, 1969.
_____. "Propaganda and World War," from *Dusk of Dawn*, 1940. In *W.E.B. Du Bois Writings*, ed. Nathan Huggins. New York: Library of America, 1986.
_____. "The Talented Tenth." In *The Negro Problem: A Series of Articles by Representative Negroes of Today*, ed. Booker T. Washington. New York: James Pott, 1903.
Dyer, Richard. *A Matter of Images: Essays on Representation*. London: Routledge, 1993.
Edmunds, Randolph. "Some Reflections on the Theater." *Opportunity*, October 1930.

Edwards, Paul K. *The Southern Urban Negro as a Consumer.* 1932. Reprint, New York: Negro Universities Press, 1969.

Elder, Arlene A. *The "Hindered Hand": Cultural Implications of Early African American Fiction.* Westport, Conn.: Greenwood Press, 1978.

———. "Oscar Micheaux: The Melting Pot on the Plains." *The Old Northwest* 2:3 (1976): 299–307.

Fabre, Michel. *The Unfinished Quest of Richard Wright.* New York: William Morrow, 1973.

Faulkner, Virginia, ed., with Frederick C. Luebke. *Vision and Refuge: Essays on the Literature of the Great Plains.* Lincoln: University of Nebraska Press, 1982.

Fisher, Rudolph. *The Walls of Jericho.* 1928. Reprint, New York: Arno Press, 1969.

Foner, Philip S. *Organized Labor and the Black Worker, 1619–1973.* New York: Praeger, 1974.

Foxx, Redd, and Norma Miller. *The Redd Foxx Encyclopedia of Black Humor.* Pasadena, Calif.: Ward Ritchie Press, 1977.

Franklin, John Hope. *From Slavery to Freedom: A History of Negro Americans.* New York: Knopf, 1974.

Frazier, E. Franklin. *Black Bourgeoisie.* New York: Free Press, 1957.

Fuller, Kathryn H. *At the Picture Show: Small-Town Audiences and the Creation of Movie Fan Culture.* Washington, D.C.: Smithsonian Institution Press, 1996.

Gaines, Jane. "Fire and Desire: Race, Melodrama and Oscar Micheaux." In *Black Cinema: History, Theory, Criticism,* ed. Manthia Diawara. New York: Routledge and Chapman, Hall/American Film Institute, 1993.

———. "Mixed Blood Marriage in Early 'Race' Cinema." In *Oscar Micheaux and His Circle: The Silent Era,* ed. Pearl Bowser, Jane Gaines, and Charles Musser. Forthcoming.

———. "SCAR OF SHAME: Skin Color and Caste in Black Silent Film." *Cinema Journal* 26:4 (summer 1987): 3–21.

Gates, Henry Louis, Jr. *Figures in Black: Words, Signs, and the "Racial" Self.* New York: Oxford University Press, 1987.

———. Preface. *Come Sunday: Photographs by Thomas Roma.* New York: Museum of Modern Art, 1996.

———, ed. *"Race," Writing, and Difference.* Chicago: University of Chicago Press, 1986.

Gevinson, Alan, ed. *Within Our Gates: Ethnicity in American Feature Films, 1911–1960.* Berkeley: University of California Press, 1997.

Gibson-Hudson, Gloria. "The Norman Film Manufacturing Company," *Black Film Review* 7:4 (1992): 16–20.

Gilroy, Paul. *Black Atlantic.* Cambridge, Mass.: Harvard University Press, 1993.

Gloster, Hugh M. *Negro Voices in American Fiction.* Chapel Hill: University of North Carolina Press, 1948.

Goellnicht, Donald C. "Passing as Autobiography: James Weldon Johnson's *The Autobiography of an Ex-Coloured Man.*" *African American Review* 30:1 (spring 1996): 17–33.

Golden, Thelma, ed. *Black Male: Representations of Masculinity in Contemporary American Art.* New York: Whitney Museum of American Art, 1994.

Gomery, Douglas. *Shared Pleasures: A History of Movie Presentation in the United States.* Madison: University of Wisconsin Press, 1992.

Green, J. Ronald. "The Micheaux Style." *Black Film Review* 7:4 (1992): 32–34.

———. "Micheaux v. Griffith." *Griffithiana* 60/61 (1997): 32–49.

———. "Oscar Micheaux's Production Values." In *Black Cinema: History, Theory, Criticism,* ed. Manthia Diawara. New York: Routledge and Chapman, Hall/American Film Institute, 1993.

Green, J. Ronald, and Horace Neal, Jr. "Oscar Micheaux and Racial Slur: A Response

to 'The Rediscovery of Oscar Micheaux.'" *Journal of Film and Video* 40:4 (fall 1988): 66–71.

Grossman, James R. *Land of Hope: Chicago, Black Southerners, and the Great Migration.* Chicago: University of Chicago Press, 1989.

Grupenhoff, Richard. *The Black Valentino: The Stage and Screen Career of Lorenzo Tucker.* Metuchen, N.J.: Scarecrow Press, 1988.

——. "The Rediscovery of Oscar Micheaux." *Journal of Film and Video* 40:1 (winter 1988): 40–48.

Gwaltney, John Langston. *Drylongso: A Self-Portrait of Black America.* New York: Random House, 1980.

Hall, Jacquelyn Dowd. "'The Mind That Burns in Each Body': Women, Rape, and Racial Violence." In *Powers of Desire: The Poitics of Sexuality,* ed. Ann Snitow, Christine Stansell, and Sharon Thompson. New York: Monthly Review Press, 1983.

Hall, Stuart. "The Rediscovery of 'Ideology': Return of the Repressed in Media Studies." In *Culture, Society, and the Media,* ed. M. Gurevitch, T. Bennett, J. Curran, and J. Woollacott. London: Methuen, 1982.

Handlin, Oscar. "The Goals of Integration." *Daedalus* 95 (winter 1966): 268–286.

Handy, W. C., ed. *A Treasury of the Blues: Complete Words and Music of Sixty-seven Great Songs from Memphis Blues to the Present Day.* New York: C. Boni, 1946.

Hansen, Miriam. *Babel and Babylon: Spectatorship in American Silent Film.* Cambridge, Mass.: Harvard University Press, 1991.

Harper, Frances E. W. *Iola Leroy, or Shadows Uplifted.* 1892. Reprint, Boston: Beacon Press, 1987.

Harris, Kwasi. "New Images: An Interview with Julie Dash and Alile Sharon Larkin." *Independent,* December 1986.

Harrison, Alferdteen B. *Piney Woods School: An Oral History.* Jackson: University of Mississippi Press, 1982.

Harrison, Hubert H. *When Africa Awakes: The "Inside Story" of the Stirrings and Strivings of the New Negro of the Western World.* New York: Porro Press, 1920.

Haynes, George Edmund. *The Negro at Work in New York City.* 1912. Reprint, New York: Arno Press, 1968.

Hebert, Janis. "Oscar Micheaux: A Black Pioneer." *South Dakota Review* 11:1 (spring 1973): 62–69.

Hilton, Bruce. *The Delta Ministry.* New York: Macmillan, 1969.

Hoberman, J. "A Forgotten Black Cinema Resurfaces." *Village Voice,* 11/17/75.

Hofstadter, Richard. *The Age of Reform.* New York: Vintage Books, 1955.

——, ed. *The Progressive Movement, 1900–1915.* Englewood Cliffs, N.J.: Prentice-Hall, 1963.

hooks, bell. "Micheaux: Celebrating Blackness." In *Black Looks: Race and Representation.* Boston: South End Press, 1992.

——. "Talking Back." *Discourse* 8 (fall–winter 1986–1987): 123–128.

hooks, bell, and Cornel West. *Breaking Bread: Insurgent Black Intellectual Life.* Boston: South End Press, 1991.

Huggins, Nathan Irvin. *Harlem Renaissance.* New York: Oxford, 1971.

Hull, Gloria T., ed. *Give Us Each Day: The Diary of Alice Dunbar-Nelson.* New York: Norton, 1984.

Ikonné, Chidi. *From Du Bois to Van Vechten: The Early Negro Literature, 1903–1926.* Westport, Conn.: Greenwood Press, 1981.

Johnson, James Weldon. *Along This Way: The Autobiography of James Weldon Johnson.* 1933. Reprint, New York: Viking Press, 1945.

——. *The Autobiography of an Ex-Colored Man.* 1912. Reprint, New York: Penguin, 1990.

——. *Black Manhattan.* 1930. Reprint, New York: Antheneum, 1972.

_____, ed. *Book of American Negro Poetry*. 1931. Reprint, New York: Harcourt Brace and World, 1959.

Johnson, S. Charles. *The Negro in American Civilization: A Study of Negro Life and Race Relations in the Light of Social Research*. New York: Henry Holt and Company, 1930.

Jones, Jacqueline. *Labor of Love, Labor of Sorrow: Black Women, Work, and the Family from Slavery to the Present*. New York: Basic Books, 1985.

Jones, LeRoi [Amiri Baraka]. *Blues People*. New York: William Morrow, 1963.

_____. *Home: Social Essays*. New York: William Morrow, 1966.

Jones, William H. *Recreation and Amusement Among Negroes in Washington, D.C.: A Sociological Ananlysis of the Negro in an Urban Environment*. 1927. Reprint, New York: Negro Universities Press, 1970.

Katz, William Loren. *Eyewitness: The Negro in American History*. New York: Pittman, 1967.

Kinney, James. *Amalgamation! Race, Sex, and Rhetoric in the Nineteenth-Century American Novel*. Westport, Conn.: Greenwood Press, 1985.

Koszarski, Richard. *An Evening's Entertainment: The Age of the Silent Feature Picture, 1915–1928*. New York: Charles Scribner's Sons, 1990.

Lawrence, Versie Lee. *Deep South Showman*. New York: Carlton Press, 1962.

Lawson, Thomas W. *Frenzied Finance: The Crime of Amalgamation*. New York: Ridgeway, 1906.

Leab, Daniel J. *From Sambo to Superspade: The Black Experience in Motion Pictures*. Boston: Houghton Mifflin, 1975.

Lemann, Nicholas. *The Promised Land: The Great Black Migration and How It Changed America*. New York: Vintage Press, 1991.

Lester, Julius. *Black Folktales*. New York: Grove Press, 1970.

Levine, Lawrence W. *Black Culture and Black Consciousness: Afro-American Folk Thought from Slavery to Freedom*. New York: Oxford University Press, 1977.

Lewis, David Levering. *W.E.B. Du Bois: Biography of a Race, 1868–1919*. New York: Henry Holt, 1993.

_____. *When Harlem Was in Vogue*. New York: Vintage Books, 1982.

Lincoln, C. Eric, and Lawrence H. Mamiya. *The Black Church in the African American Experience*. Durham: Duke University Press, 1990.

Locke, Alain, ed. *The New Negro: An Interpretation*. New York: A. and C. Boni, 1925.

London, Jack. *Martin Eden*. New York: Macmillan, 1908.

Lott, Eric. *Love and Theft: Blackface Minstrelsy and the American Working Class*. New York: Oxford University Press, 1995.

McKay, Claude. *Home to Harlem*. 1928. Reprint, Boston: Northeastern University Press, 1987.

Meier, August. *Negro Thought in America, 1889–1915: Racial Ideologies in the Age of Booker T. Washington*. Ann Arbor: University of Michigan Press, 1963.

Mellencamp, Patricia. *A Fine Romance: Five Ages of Film Feminism*. Philadelphia: Temple University Press, 1995.

Memmi, Albert. *Dominated Man*. Boston: Beacon Press, 1968.

Micheaux, Oscar. *The Case of Mrs. Wingate*. New York: Book Supply Company, 1945.

_____. *The Conquest: The Story of a Negro Pioneer*. Lincoln, Nebraska: The Woodruff Press, 1913.

_____. *The Forged Note*. Lincoln, Nebraska: Western Book Supply Company, 1915.

_____. *The Homesteader*. Sioux City, Iowa: Western Book Supply Company, 1917.

_____. *The Masquerade*. New York: Book Supply Company, 1947.

_____. *The Story of Dorothy Stanfield*. New York: Book Supply Company, 1946.

_____. *The Wind from Nowhere*. New York: Book Supply Company, 1943.

Morrison, Toni. *The Bluest Eye*. 1970. Reprint, New York: Penguin, 1994.

_____. *Jazz*. New York: Penguin, 1993.

_____. *Playing in the Dark: Whiteness and the Literary Imagination.* Cambridge, Mass.: Harvard University Press, 1992.

_____, ed. *Race-ing Justice, En-gendering Power: Essays on Anita Hill, Clarence Thomas, and the Construction of Social Reality.* New York: Random House, 1992.

Mullings, Leith. "Images, Ideology, and Women of Color." In *Women of Color in U.S. Society,* ed. Maxine Bava Zinn and Bonnie Thornton Dill. Philadelphia: Temple University Press, 1994.

Muse, Clarence, and David Arlen. *Way Down South.* Hollywood, Calif.: David Graham Fischer, 1932.

Nielson, David Gordon. *Black Ethos: Northern Urban Life and Thought, 1890–1930.* Westport, Conn.: Greenwood Press, 1977.

Osofsky, Gilbert. *Harlem, the Making of a Ghetto: Negro New York, 1890–1930.* New York: Harper and Row, 1968.

Ottley, Roi. *New World A-Coming: Inside Black America.* 1943. Reprint, New York: Arno Press, 1968.

Ottley, Roi, and William J. Weatherby. *The Negro in New York: An Informal Social History.* New York: New York Public Library, 1967.

Painter, Nell Irvin. *Exodusters: Black Migration to Kansas after Reconstruction.* New York: Norton, 1992.

Peiss, Kathy. *Cheap Amusements: Working Women and Leisure in Turn-of-the-Century New York.* Philadelphia: Temple University Press, 1986.

Perry, Margaret, ed. *The Short Fiction of Rudolph Fisher.* Westport, Conn.: Greenwood, 1987.

Peterson, Bernard L., Jr. *Early Black American Playwrights and Dramatic Writers: A Biographical Directory and Catalogue of Plays, Films, and Broadcasting Scripts.* Westport, Conn.: Greenwood Press, 1990.

Proceedings of the Annual Convention of the National Negro Business League, 1901–1924.

Regester, Charlene. "African American Extras in Hollywood during the 1920s and 1930s." *Film History* 9 (1997): 95–115.

_____. "Black Films, White Censors: Oscar Micheaux Confronts Censorship in New York, Virginia, and Chicago." In *Movie Censorship and American Culture,* ed. Francis G. Couvares. Washington, D.C.: Smithsonian Institution Press, 1996.

_____. "Oscar Micheaux's *Body and Soul*: A Film of Conflicting Themes." In *In Touch with the Spirit: Black Religious and Musical Expression in American Cinema,* ed. Phyllis Klotman and Gloria Gibson. Bloomington, Ind.: Black Film Center, Indiana University, 1994.

_____. "Oscar Micheaux the Entrepreneur: Financing *The House Behind the Cedars.*" *Journal of Film and Video* 49:1–2 (spring–summer 1997): 17–27.

_____. "Oscar Micheaux's Multifaceted Portrayals of the African American Male: The Good, The Bad, and The Ugly." In *Me Jane: Masculinity, Movies, and Women,* ed. Pat Kirkham and Janet Thumin. New York: St. Martin's Press, 1995.

Reid, Mark. *Redefining Black Film.* Berkeley: University of California Press, 1993.

Rosenzweig, Roy. *Eight Hours for What We Will: Workers and Leisure in an Industrial City, 1870–1920.* New York: Cambridge University Press, 1983.

Said, Edward W. *Orientalism.* New York: Random House, 1978.

Sampson, Henry T. *Blacks in Black and White: A Source Book on Black Films.* 2nd ed. Metuchen, N.J.: Scarecrow Press, 1995.

_____. *The Ghost Walks: A Chronological History of Blacks in Show Business, 1865–1910.* Metuchen, N.J.: Scarecrow Press, 1988.

Sanders, Leslie Catherine. *The Development of Black Theater in America: From Shadows to Selves.* Baton Rouge: Louisiana State University Press, 1988.

Schell, Herbert S. *History of South Dakota.* Lincoln: University of Nebraska Press, 1975.

Scott, Emmett J. "Additional Letters Negro Migrants of 1916–1918." *Journal of Negro History* 4 (October 1919): 412–475.

——. "Letters Negro Migrants of 1916–1918." *Journal of Negro History* 4 (July 1919): 290–340.

——. *Negro Migrants During the War.* 1919. Reprint, New York: Arno Press, 1969.

Smith, Valerie. *Representing Blackness: Issues in Film and Video.* New Brunswick, N.J.: Rutgers University Press, 1997.

Snead, James. "The Visual Rhetoric of Black Independent Film." Program notes to "Recoding Blackness" film series, Whitney Museum of American Art, 6/18–7/3/85.

Slotkin, Richard. *The Fatal Environment: The Myth of the Frontier in the Age of Industrialization, 1800–1890.* New York: Atheneum, 1985.

Southern, Eileen. *The Music of Black Americans: A History.* 3rd ed. New York: Norton, 1997.

Spear, Allan. *Black Chicago: The Making of a Negro Ghetto, 1890–1920.* Chicago: University of Chicago Press, 1967.

Stallybrass, Peter, and Allon White. *The Politics and Poetics of Transgression.* Ithaca, N.Y.: Cornell University Press, 1986.

Stephens, Nan Bagby. *Glory.* New York: John Day, 1932.

——. *Roseanne.* unpublished manuscript.

Stewart, Jeffrey C., ed. *Paul Robeson: Artist and Citizen.* New Brunswick, N.J.: Rutgers University Press, 1998.

Streible, Dan. "A History of the Boxing Film, 1894–1915: Social Control and Social Reform in the Progressive Era." *Film History* 3:3 (1989): 235–257.

Stribling, T. S. *Birthright.* New York: Century, 1922.

Stuart, M. S. *An Economic Detour: A History of Insurance in the Lives of American Negroes.* College Park, Md.: McGrath, 1940.

Taylor, Clyde. "Crossed Over and Can't Get Black." *Black Film Review* 7:4 (1993): 22–27.

Thompson, Sister M. Francesca, O.S.F. "The Layfayette Players, 1915–1932." Ph.D. dissertation, University of Michigan, 1972.

Thurman, Wallace. *The Blacker the Berry.* New York: MacCaulay, 1929.

——. "Negro Artists and the Negro." *New Republic,* 8/31/27.

Toll, Robert. *Blacking Up: The Minstrel Show in Nineteenth-Century America.* New York: Oxford University Press, 1974.

Tomasevskij [Tomashevsky], Boris. "Literature and Biography." In *Readings in Russian Poetics: Formalist and Structuralist Views,* ed. Ladislav Matejka and Krystyna Pomorska. Ann Arbor: University of Michigan Press, 1978.

Tompkins, Jane P. "Sentimental Power: *Uncle Tom's Cabin* and the Politics of Literary History." In *The New Feminist Criticism: Essays on Women, Literature, and Theory,* ed. Elaine Showalter. New York: Pantheon, 1985.

Walker, Alice, ed. *I Love Myself When I Am Laughing . . . And Then Again When I Am Looking Mean and Impressive: A Zora Neale Hurston Reader.* Old Westbury, N.Y.: The Feminist Press, 1979.

Waller, Gregory A. *Main Street Amusements: Movies and Commercial Entertainment in a Southern City, 1896–1930.* Washington, D.C.: Smithsonian Institution Press, 1995.

Washington, Booker T. *My Larger Education.* Garden City, N.Y.: Doubleday, 1911.

——. *Up from Slavery: An Autobiography.* 1901. Reprint, Garden City, N.Y.: Doubleday, 1963.

Waters, Ethel (with Charles Samuels). *His Eye Is on the Sparrow: An Autobiography.* Garden City, N.Y.: Doubleday, 1951.

Watkins, Mel. *On the Real Side: Laughing, Lying, and Signifying—The Underground Tradition of African American Humor That Transformed American Culture from Slavery to Richard Pryor.* New York: Simon and Schuster, 1994.

Wells, Ida B. "Southern Horrors: Lynch Law and All Its Phases." In *The Selected Works of Ida B. Wells-Barnett,* ed. Trudier Harris. New York: Oxford University Press, 1991.

Williams, Raymond. "Structures of Feeling." In *Marxism and Literature.* New York: Oxford University Press, 1977.

Williamson, Joel. *The Crucible of Race: Black-White Relations in the American South Since Emancipation.* New York: Oxford University Press, 1984.

Wright, John S. "A Scintillating Send-off for Fallen Stars: The Black Renaissance Reconsidered." In *A Stronger Soul Within a Finer Frame: Portraying African-Americans in the Black Renaissance.* Minneapolis: University (of Minnesota) Art Museum, 1990.

Wright, Richard. *Black Boy.* 1945. Reprint, New York: HarperCollins, 1993.

Young, Joseph A. *Black Novelist as White Racist: The Myth of Black Inferiority in the Novels of Oscar Micheaux.* Westport, Conn.: Greenwood Press, 1989.

# Filmography

COMPILING A FILMOGRAPHY of Oscar Micheaux's silent films is not as easy as it might seem. Micheaux's penchant for publicity and fierce optimism often led him to announce films, casting, and deals that may have never come about. Sometimes he would change a film's title in mid-production. In the later years, the lack of coverage in the press, indeed, the lack of newspaper advertising for "Colored" theaters, sometimes makes it difficult to confirm that a film was actually released.

Therefore, the list below is a filmography of Oscar Micheaux's silent films and the dates of their release, in chronological order, to the best of our knowledge at this time.

*The Homesteader* (1919)

*Within Our Gates* (1920)

*The Brute* (1920)

*The Symbol of the Unconquered* (1920)

*The Gunsaulus Mystery* (1921)

*The Dungeon* (1922)

*The Virgin of Seminole* (1922)

*Deceit* (1923)

*Birthright* (1924)

*A Son of Satan* (1925)

*The House Behind the Cedars* (1925)

*The Devil's Disciple* (1925)

*Body and Soul* (1925)

*The Conjure Woman* (1926)

*The Spider's Web* (1927)

*The Millionaire* (1927)

*Thirty Years Later* (1928)

*The Broken Violin* (1928)

*The Wages of Sin* (1928)

*When Men Betray* (1929)

# Index

Note: The titles of the films of Oscar Micheaux are followed by their release date in parentheses.

Mix, Tom, 70, 159
mob violence, 111, 125
Monagas, Lionel, 43
Moncrieff, A. A., 70
Moore, Charles, 43
Moore, Tom, 70
morality, 21, 25, 26, 39, 154, 176, 177, 183, 185, 200, 206, 217; moral project of Micheaux, 143; physical, 162
Morrison, Toni, and fetishization of "Black blood," 164
Morton, Edna, 210
Mosely brothers, 79
*Motion Picture Classic*, 11
Motion Pictures Directors Association, 94
Mount Olivet Baptist Church (New York), 88
Movie Making Exhibition, 76
movies, Race. *See* Race films
*Moving Picture World*, 66
muckrakers, 39
Muray, Nickolas, 194
Muse, Clarence, 81, 97, 240n14
music, 35; recordings, 60; in *Roseanne*, 205; sheet, 59
musicals, Hollywood, 211, 212
myths, racist, 133, 162

naming, 57–60
narrative strategies, 140, 141, 202, 203
National Afro-Art Co., 58
National Baptist Jubilee (Nashville), documentation of, 103
National Colored Soldiers Comfort Committee, 108
National Negro Business League, 90, 102, 107; documentation of fourteenth meeting of, 103
National Negro Improvement Association, 107
National Theatre (Louisville), boycott of, 63–64
Native Americans, 222, 224n2
*Native Son* (Wright), 216
*Natural Born Shooter, A* (film), 93
*Negra, La* (The Black Woman), 223n5. *See also Within Our Gates*
Negro Business League, 240n32
Negro Doll Factory, 58
"Negro problem," 24, 25, 165, 169
*Negro Soldiers Fighting for Uncle Sam* (documentary), 104
*Negro's End of a Perfect Day, The* (film), 108
New Deal, 18

New Douglas Theater (New York), 68
New Lincoln Theater (New York), 74
New Negro, 26
*New York Age,* 56, 59, 84, 90, 93–94, 103, 112, 169; advertisement for *Roseanne* in, 192; advertising for *The Symbol of the Unconquered* in, 158; "Bethel Pastor Denies Inebriation in Pulpit," 191; *Body and Soul* in, 176; "Charge Ministers Are Muzzled by the Bootlegging Crowd," 191; and citizenship, 109; coverage of lynchings in, 127–128; film reviews in, 73; "Ministers and Churchmen Are Alleged to Be Addicts to the 'Numbers' Gambling," 191; reporting of New York opening of *The Symbol of the Unconquered,* 85; reports on persecution of educated Negroes, 138–139; reports on segregated theaters, 82; review of *The Symbol of the Unconquered,* 170; A. B. Smith in, 138; Lester Walton in, 99–102, 113–114
*New York Amsterdam News,* 75, 211
*New York News,* 74, 91
newspapers, Black, 236n60. *See also* press, Black; weeklies, Black; *individual names*
Newsome, Carman, 171
"nigger," 176, 257n73, 258n76
night riders. *See* Ku Klux Klan
nightmare, 201, 202
Ninth Cavalry, 108
noble, triumph of the, 142
*Nobody's Children* (film), 116
Noisette, Katherine, 44
Nolan, Kid, 116
*Norfolk Journal and Guide,* 17, 68, 79, 80, 89; "Race Progress in Movies," 105
Norman, Richard E., 115, 116, 242–243n65
Norman Film Manufacturing Co., 115, 242–243n65
Normand, Mable, 117
novels, Black, 191
Nu-Art Motion Picture Co., 116

*Octoroon, The* (play), 101
Odd Fellows Convention (Boston), documentation of, 103
Olio Theater (Louisville), 63
opportunity, 23
*Opportunity* (magazine), 181
oppression, images of, 178
optimism, 123, 165, 180
oral tradition, African American, 39

INDEX

veterans, 111. *See also* soldiers

victims: humanization of, 128; images of, 181

vigilantism, 125

Vincent, Illa, 104

violence, 80; in *The Brute*, 176; and hatred, 160; mob, 111, 125; personalization of, 128; racial, 124, 180

*Virgin of Seminole, The* (1922), shooting of, 33, 34

Vitagraph Film Co., 68, 210

*Voice from the South by a Black Woman of the South, A* (Cooper), 95

voting, discourses on, 155

vulnerability, stories of, 135

*Wages of Sin, The* (1928), 44, 46, 232n98

Walker, Alice, 154–155

Walker, George W., 66

Walker-Hogan-Cole Theater (New York), 66

Walton, Lester A., 73, 84, 93–94, 99–102, 113–114, 118, 177, 180, 205, 210, 236n65, 251n33; "When Is a Negro a Negro to a Caucasian?" 169

Washington, Booker T., 3, 19, 58, 59, 65, 107, 129, 137, 172, 228n62; attachment to land, 23; dedication of *The Conquest* to, 20, 228n55; film newsreels of, 103; image of in films, 20; philosophy of, 21; and self-help, 102; *Up from Slavery*, 9, 23; use of film by, 102; use of minstrelsy by, 165

Waters, Ethel, 238n97

Watkins, Mel, 150

*Way Down South* (Muse and Arlen), 81

"We Shall Overcome" (song), 222

wealth, accumulation of, 24

Weatherby, William J., 202

Webb, Rev. James M., 88

weeklies, Black, 44, 60, 72, 170; reports of lynchings in, 127; stories of torture in, 127. *See also individual names*

welfare, 24

Wells-Barnett, Ida B., 12

Western Book Supply Co., 9, 10

Westerns, 82, 156, 165; Black cast, 249n4; dime, 9; hero in, 157; in Race theaters, 157, 159

*When True Love Wins* (film), 89

"Where the Negro Fails" (Micheaux), 39

Whipper, Leigh, 153

White, Armond, 228n59

Whitney, Salem Tutt, 44

whiteness, 160, 167, 168; and black-ness, 164; fantasy of, 134

"Why We March" (leaflet), 111

wilderness story, 156

*Wilderness Trail, The. See The Symbol of the Unconquered*

William Foster Music Co., 240n34

William Foster Record and Rolls Supply, 59

Williams, Bert, 18, 59, 96, 150, 191, 250n21, 251n33

Williams, Katherine E., 226n32

Williams, Leon, 116

Williams and Walker, 30

Wilson, Eddie, 70, 81, 83

Wilson, Tom, 70

Wilson Brothers, 70

Wilson, Cyril A., 191

*Wind from Nowhere, The* (Micheaux), 24, 143, 217

Wister, Owen, *The Virginian*, 9

*Within Our Gates* (1920), 5, 14, 28, 30, 39, 153, 175, 189; advertising of, 15–16, 132; allusions to racism in, 138; attempted rape in, 133; audience participation at, 84; audiences' interpretation of, 135; authorial intrusions in, 142; betrayal in, 148, 150, 152, 154; censoring of, 16, 125, 144; characters in, 129; Chicago premiere, 15, 123; concubinage in, 135; different lifestyles in, 131; education in, 137, 138; ending of, 141; icons in, 129; lynchings in, 132, 139; opening of, 84; opposition to, 143; premiere at Vendome Theatre, 126; press releases for, 133; promotion of, 143; resolution of, 201; white paternity in, 135

womanhood, white, 133, 134

women: abuse of, 14; and church, 190, 193; Race, 39, 172

Wood, Clement, 203

Woods, Granville T., 202

Woollacott, Janet, 170

Woollcott, Alexander, 203, 204, 206

work, 23; avoidance of, 23–24; and duty, 21; ethic, 29, 39

working class, urban Black, 208

World War I, 51–52, 57, 66, 67, 107–110, 124, 141, 182

Wright, Edward H., 125

Wright, John S., 95

Wright, Richard, 110, 128, 215–216, 219

YMCA, 39, 98, 104, 241n45

Young, Charles A., 59

# About the Authors

**Pearl Bowser** is a programmer and archivist, specializing in African American and African film. She is the director and founder of African Diaspora Images, a collection of historical and contemporary films and memorabilia documenting black film history. She is a pioneer in the promotion, marketing, and exhibition of independent African and African diasporan film and video. Bowser codirected and coordinated the research for the award-winning documentary *Midnight Ramble: Oscar Micheaux and the Story of Race Movies.* Her production credits include *Namibia Independence Now!, Mississippi Triangle,* and *Stories about Me: A Black Film Video Catalogue.*

**Louise Spence** is associate professor and coordinator of Media Studies at Sacred Heart University (Fairfield, Connecticut). She earned her Ph.D., with distinction, from the Department of Cinema Studies at New York University and has published articles on film, race, and gender in such academic journals as *Screen, Cinema è Cinema, Cinema Journal, Quarterly Review of Film and Video,* and *Journal of Film and Video,* and has contributed to several anthologies.